Islamic Art

Islamic Art

Gift of
Joan Palevsky

The
Nasli M. Heeramaneck
Collection

Edited by
Pratapaditya Pal

Los Angeles County Museum of Art

Library of Congress
Catalog Card Number 73-88144

I.S.B.N. 0-87587-056-2
Copyright © 1973 by
Museum Associates of the
Los Angeles County Museum of Art

Published by the
Los Angeles County Museum of Art

Contents

Acknowledgments

The Nasli M. Heeramaneck Collection of Islamic Art, which forms the substance of this catalog, was acquired by the Museum in June of this year thanks to the generous donation of Mrs. Joan Palevsky. The Collection consists of well over six hundred objects which had to be catalogued in less than three months. It is understandable, therefore, that this catalog is far from being definitive, and many of the attributions, especially in the sections The Art of Metalwork and Other Arts, must be accepted by the reader as tentative. It was felt, however, that the immediate publication of this material was essential. Hopefully, the Museum will benefit from the future comments of scholars and experts, and a more definitive catalog may then be prepared at a future date.

The Museum is particularly fortunate that Professor Katharina Otto-Dorn of the University of California at Los Angeles — an eminent scholar of Islamic art — has written the ceramic section of the catalog, thereby considerably augmenting the importance of the publication. I would also like to express our gratitude to Mr. Edwin Binney, 3rd, who was not only instrumental in the acquisition of the Collection, but who has also written the section on painting and calligraphy. He has given generously of his time and his enthusiasm has been a source of inspiration to the Department. A special word of thanks is also due to Abbas Daneshvari and Donald R. Bierlich. The former has kindly read all the inscriptions and catalog. The latter has diligently assisted Mary Kahlenberg with the section on textiles.

The organization of both an exhibition and a catalog is impossible without the cooperation of the entire staff of an institution. I would like to thank all those who have given us their generous support. In particular, I wish to thank the following: Ben Johnson and his staff; Patricia Nauert and her staff; James Kenion; all members of Technical Services and, especially, Paul Martin; Walter Wilson and his assistants; George Hernandez and his staff; Jeanne Doyle and her staff; Edward Cornachio and his staff; Catherine Glynn, Rochelle Yeker, Marilyn Wyman, and Virginia Dofflemeyer; and, finally, Elizabeth Sanchez, Karole Thomas, Kitty Morris, Micky Holiver, and Sima Pollock, who have for months generously volunteered their services to the Department.

Pratapaditya Pal
Curator of Indian and Islamic Art

This collection of Islamic art, like a treasure guided by destiny in a Persian legend, has come to Los Angeles through the interaction of four extraordinary personalities: the collectors, the donor, and the curator.

Nasli Heeramaneck was a man with an unquenchable thirst for the beauty of works of art. It is our good fortune that he had also a superb taste, a keenness of vision, and an unflinching determination in the pursuit of objects. He was born in Bombay in 1902, a Parsee, heir to two cultures, Indian and Iranian. The Parsees had come to the West Coast of India fleeing the Arab invasion of Persia in the early eighth century. They retained a strong consciousness of their cultural heritage, including the Zoroastrian religion. At the same time they contributed greatly to making Bombay an important Indian center of trade. Nasli, as the name Heeramaneck — meaning "diamonds and rubies"— implies, was the descendant of a long line of traders and collectors of precious objects. His father, whom he respected to the point of reverence and whose name he was proud to perpetuate, was a dealer in Chinese ceramics. The philosophy of art dealing which his father passed on to him was, in Nasli's words, "to persevere, trust, and be lionhearted." At the age of seventeen the "lionhearted" young man was sent by his father for a brief period to New Delhi to manage his branch there, then to London to study at the British Museum and the Victoria and Albert, and at the age of twenty-two to Paris to open a gallery. But his goal was not London or Paris but New York, where the collecting potential seemed limitless and the dealers were few.

Leaving the Paris business to his brother, he went to New York in 1927 with $75 and a trunk of objects. His knowledge and connoisseurship inspired the confidence of scholars and collectors. This, together with the splendid quality of the works he offered, made him for many decades the leading dealer in Central Asian art in America. His clients were the most sophisticated private collectors and museums with the most distinguished Asian collections: Boston, Cleveland, Kansas City, and Seattle. The word "dealer" does not properly describe Nasli Heeramaneck. He was more of the eighteenth-century type of *marchand-amateur,* essentially a collector who loved his objects

so much that when he sold a favorite one he was impelled to use every cent of the proceeds to acquire additional works of art to compensate for the loss. Many of the objects he acquired were never available for purchase individually; they were reserved for one of the several collections he formed and continuously refined over the decades so that each could eventually be offered to a museum as a comprehensive representation of a cultural area. In 1966 he gave a collection of more than 200 works of Pre-Columbian art to the National Museum of India in New Delhi. In 1969 the Los Angeles County Museum of Art acquired his extraordinary collection of Indian, Nepalese, and Tibetan art. This year the Museum acquired his collection of 650 works of Islamic art to which this catalog is devoted. At the same time, the Museum received from Mrs. Heeramaneck the comprehensive Heeramaneck research library, the second collection-in-formation of Pre-Columbian ceramics, and the splendid group of sixty-three Chinese ceramics, which includes among many masterworks a fine large T'ang horse, notable T'ang grave figures, a rare and unusual Y'uan decorated head rest, and a representative variety of vessels and plates of high aesthetic quality. They are being shown for the first time in the Ahmanson Gallery concurrently with this exhibition. Although Nasli Heeramaneck died in 1971, these collections will keep alive for future generations his name and his special gift of connoisseurship which Russell Lynes graphically defined when he described Nasli's eye as "one of the single most penetrating instruments of esthetic measurement in the world." I hope they will also be able to transmit his zealot's devotion to the arts and cultures of Asia.

In 1939 Nasli Heeramaneck married Alice Arvine, a portrait painter born in New Haven, reared in Florence, and trained as an artist at Yale. She combined a sensitivity to form and color acquired through years of familiar association with Florentine Renaissance art with a Yankee dauntlessness and a natural expressiveness worthy of a diva. The Heeramanecks complemented each other so perfectly that they became a kind of composite personality. In her devotion to

Nasli, Alice accords him full credit for all their accomplishments. But from Nasli's own accounts of their joint decisions, even when that meant shared hardship, the credit too must be shared. The paintings and ceramics in the Islamic collection were an intimate part of the Heeramanecks' life. Alice recalls that they were the type of object which she associates with Nasli from even before their marriage, and they are the objects which they were never without. Alice was, therefore, as eager as Nasli had been to keep the Islamic collection together in one museum, and it was she who made it available to the Los Angeles County Museum of Art.

No matter how selectively the Islamic collection had been assembled, it would have been lost to Los Angeles if it had not been for Mrs. Joan Palevsky. Mrs. Palevsky is an Angelino by birth, a graduate of the University of Wisconsin, and for some time has been a member of the Romance Language staff of UCLA. As an educator, she was eager to expand the cultural opportunities available to the people of Los Angeles, especially the youth, and to add to the store of tangible documents of man's creativity at the Museum which would be of especial value to our educational institutions. The Islamic collection, which documents a civilization with aesthetic principles entirely different from the Western Greco-Roman humanistic tradition, offered just such an opportunity. "I hope that these beautiful objects will give the same pleasure to budding artists and scholars that I experienced as a youngster in Los Angeles in the 1930s when I regularly took the old 'V' streetcar to the museum at Exposition Park," said Mrs. Palevsky. "It was there that I learned to love art and acquired a sense of the past." To the students and teachers of Near Eastern cultural history, it will give even more, since it will provide the raw material for research heretofore lacking in Southern California. It conceals thousands of term papers and dissertations waiting to be written.

The distinguished scholar and author Dr. Pratapaditya Pal was born in Calcutta. After receiving a double doctorate from the University of Calcutta and from Cambridge University, he was Keeper of the Indian Collection at the Boston Museum of Fine Arts. In 1970 he accepted the position of Curator of Indian and Islamic Art at the Los Angeles County Museum of Art, to catalog, publish, and expand the newly acquired Indian collection and to develop

collections in contiguous areas. When the Islamic collection became available, he studied it with great care. Being convinced of its quality and historical importance, he proceeded with unflinching perseverance to convince all those concerned that its acquisition was indispensible to the Museum collection. Following the acquisition, Dr. Pal in the course of a few months planned the inaugural exhibition, edited the catalog, and wrote a large part of it.

The list of those either responsible for the acquisition of the collection or the exhibition and catalog does not stop here. Mr. and Mrs. Richard Sherwood should be mentioned next for their practical and psychological support of this acquisition and of the Department of Indian and Islamic Art. It was they who acted as liaison between the Museum and Mrs. Palevsky and who have given unfailing encouragement to the formation and growth of the Central Asian collections. Dr. Edwin Binney, the noted collector of Indian, Persian, and Turkish painting, also played a major role in the acquisition through the sincere and convincing enthusiasm which he expressed in his reports on the collection to the appropriate authorities.

We are indeed indebted to Mrs. Palevsky as the donor and to all those listed above and the many more included in Dr. Pal's acknowledgments, each for his role in bringing the collection to Los Angeles, in preparing the catalog, and in presenting it to the public through this exhibition. They have provided the Museum with a splendid representation of a unique and extensive area of man's visual production heretofore completely lacking in the collections. They have at the same time given us the challenge of devising creative means of using it for the greatest benefit to the people of Los Angeles.

Kenneth Donahue
Director

Introduction
by
Pratapaditya Pal

Let it be clear that the wonderful phantasy and strange native
force *(angiza)* of the artists are known in all countries and witnessed by
men possessed of sight.... The image which the portrait-painter
reveals on the tablets of the mind cannot be reflected in everybody's
mirror of beauty.

Qāḍī Ahmad[1]

Islam is primarily the name of a religion
founded by the Prophet Muhammad who died
in the year A.D. 632. In the course of
time, however, Islam, like Judaism, has
become a way of life rather than just a
religion. In less than a century following the
death of the Prophet, the Arabs, who first
espoused the cause of Islam, arose from their
desert obscurity to accomplish one of the
most phenomenal feats in the history
of mankind. Riding their famed Arab steeds
and brandishing the damascened blades
of their swords, they zealously spread Islam
as a vital religious force — from Spain in
the west to Sind in the east. Thereafter in
North Africa as well as in west and parts of
south Asia, Islam not only became the
predominant religious system but the nucleus
around which the civilization of these areas
developed.

Only in this latter, cultural sense is it
legitimate to describe as "Islamic" the art
produced after the seventh century from
Egypt to Afghanistan. Indeed, little of the arts
discussed and illustrated in this catalog was
specifically intended to serve the religion of
Islam and their function was fundamentally
secular. As a religion Islam did not develop
an artistic or iconographic tradition as
Christianity or Buddhism did, but rather
remained closer to Judaism in its emphasis
upon the abstract. Hence the predominance
of geometric forms in Islamic art. Much
has been written about the antipathy of Islam
towards imagery of any kind. In actuality
the Koran condemns only idolatry, and the
authority from which the prohibition against
art is drawn is the *Hadith* (or traditions)
which in Islamic law enjoy as much power
and sanctity as the Koran itself. This
austerity no doubt derives from Islam's Jewish
heritage, which taught that to produce a
representation of a living creature was to
usurp the creative prerogative of God.
This idea was perpetuated by a semantic
factor: the same word *musawwar* was used to
designate God the Creator and the painter
of an image.

While it is true that orthodox religious feeling was inimical to painting, the followers of Islam, like many other peoples, were not in practice bound by this attitude. Whether or not the *Hadith's* prohibition against figurative art was obeyed depended largely upon attitudes and personalities of those who had power. For example, the Mughal emperor Akbar, a latitudinarian and altogether independent personality, brushed aside tradition and encouraged the arts. It was his belief that painters had a special facility for appreciating the greatness of God; while they were not able to *create* life, they were able to reproduce it. The far more austere and orthodox Mughal emperor Aurangzeb, on the other hand, actively opposed and suppressed both painting and music.

The Arabs who first espoused the cause of Islam had little art of their own, but wherever they went they encountered cultures with rich artistic heritages. And, as zealous and fanatical as they were, the Arabs could not suppress traditions as deeply rooted as those of Persia (modern Iran) and Mesopotamia (modern Iraq). As a result, one of the curious dichotomies of Islamic culture has always been that while the religion was extremely austere, the courts were known for their ostentation and lavishness. Had the princes not fostered this dichotomy, the world of art would have been poorer!

Although Persia is situated at the easternmost extremity of the geographical area dominated by Islamic culture, it commands a central position in Islamic art, as is attested by this catalog and would be by any comparable study. Not only a great majority of the objects discussed here come from Persia, but, whether ceramics, painting, textiles, or metalwork, it was the Persian tradition and Persian artists that largely determined the development of Islamic art. Even though Arabic enjoyed a special prestige as the tongue chosen for the words of the Prophet, and notwithstanding the fact that the Arabic script exerted a significant influence upon Islamic ornamentation, it was Persian literature that inspired the greatest Islamic miniatures. It was also the Persian potter who determined the types and styles of Islamic ceramics. And, it was the ancient tradition of Persian metallurgy that inspired Islamic metalsmiths, whether in Iraq or in Egypt. Indeed, to say that Persian aesthetics and taste shaped the art of Islam would not be an exaggeration.

Even after converting to Islam, Persia retained a vital tradition deeply rooted in its past. Most of west Asia and Egypt, however, were less precisely defined national units than Persia. Culturally, if not politically, they were under the strong sway of Byzantium. No doubt this was the reason why the European classical tradition — as manifested in Byzantine art — was the second strongest influence on the art of Islam. Not only did Islamic artists and craftsmen borrow and assimilate styles and motifs from Byzantine art, but at least in the formative years of Islamic culture, they were often Christian. Indeed, a considerable portion of the renowned Mosul metalwork was produced by Chaldean craftsmen, Christian in faith. The most apparent example of the influence of Byzantine culture on the development of Islamic art can be seen in the Egyptian woodcarvings of the Umayyad period. In some of these, the only perceptible trace of Islamic influence is the Kufic inscriptions. And, had it not been for Armenian and Byzantine illuminated manuscripts, Islamic art might never have developed a miniature tradition at all.

A third influence on the imagery of Islamic art derived from Central Asia. In the seventh century when the Arabs began to move into Central Asia, the area was a crucible where many cultural and religious strains had been commingling for centuries. The caves and grottoes, the monasteries and temples of the Buddhists, Manichaeans, and Nestorian Christians were richly decorated with sumptuous wall paintings in a variety of styles. The more predominant traditions that exerted their influence upon Central Asian painting were those of India, Persia, and China. In turn, it was these Central Asian wall paintings that directly influenced Islamic painting of the thirteenth century. Not only did the Chinese exert an influence on Islamic painting[2] — albeit indirectly, through the medium of Central Asian art — but they influenced the Islamic ceramic tradition as well, as is discussed at length in the introduction to the ceramic section of this catalog. Suffice it to state here that, whereas in the case of painting the Chinese influence was essentially stylistic, in the case of ceramics it was more technical in nature.

The ubiquitous use of calligraphy is perhaps the most distinctive characteristic of Islamic art. Script is not only employed as an integral part of a design, but may be considered the *leitmotiv* that runs through the art. To a Muslim the written word has always possessed the same power and inspired the same awe that iconic symbols have had in such religions as Christianity and Hinduism. Indeed, calligraphy enjoys such an exalted position in Islamic culture that Maulana Sultan-'Ali began his "Epistle" *(risala)* on writing with the following apostrophe to the pen, or *qalam:*

O *qalam!* Sharpen the tongue of explanation
For the glorification of the Lord of the two worlds,
The Lord who created the *qalam*
And traced the decree of creation with the *qalam*.[3]

Through calligraphy the *qalam* exerted a profound influence upon the strokes of the painter's brush and made Islamic art one of the most linear and abstract of all the traditional arts.

Despite the emphasis on calligraphy — and hence on geometric form — Islamic art did also develop a rich figurative imagery. Again it was the Persians who took the lead, continuing to draw upon their ancient and well-established visual repertory. Although extant examples show that the miniature tradition originated in the late twelfth or early thirteenth century, already by the eighth century some Islamic princes were adorning the walls of their private chambers and even of public baths with murals strongly figurative in style. In ceramics, especially in those of Nishapur, as early as the tenth century both human and animal figures were integrated into decorative designs of striking beauty. Still to be determined definitively is whether the figurative subjects adorning pots and metalwork in the early Islamic period had any specific iconographic significance or simply continued an ancient custom. In the case of certain images, however, such as the *sidra* (tree of life), or sphinxes and harpies, plausible attempts have been made to associate them with Islamic cosmological ideas, with solar symbolism, or with concepts of eternal life. Still other images have been explained in terms of Sufi mysticism, but, nevertheless, the majority of the animated motifs in Islamic art have still to be interpreted. Whatever

his symbolic intent, however, the Islamic artist delighted in combining his figurative and non-figurative motifs and designs into compositions of enduring charm.

The objects included in this exhibition are from different cultural and political areas, principally Egypt, Syria, Iraq, Turkey, and Persia. But, characteristic of all Islamic art, they possess certain common denominators irrespective of differences of material or medium, although these differences — like differences of function — do, of course, affect the forms of the objects. The basic common denominators grew out of a homogenous aesthetic intent and the application of certain principles of design that persisted throughout the Islamic world.

Whether the object is a brass candlestick (cat. no. 280), a textile (cat. no. 443), a stucco fragment used as an architectural embellishment (cat. no. 352), a carved door (cat. no. 359), or a ceramic bowl (cat. no. 59), its ornamentation includes certain basic elements, among them inscriptions, the arabesque, and complex geometrical or floral designs. Indeed, the inscription and the arabesque have been aptly called "the soul of Islamic ornament," and either one or the other is almost always present in some form in an Islamic art work. It must not be surmised, however, that these were in any sense delimiting factors for the artist. On the contrary, rarely has the human mind revealed such power of inventiveness and imagination as the Muslim artists did in exploiting these two conjoint principles of ornamentation. The variations upon the theme seem as inexhaustible as the complexity of the design appears bewildering to the beholder's eye. Nor should these be considered inventions of the Islamic culture. For, the origins of the geometric designs and arabesques may be traced back to older traditions. But as the principal elements of the Islamic repertory, and combined with that purely Islamic innovation — the use of the script — they acquired a new life of immense vitality.

The homogenous aesthetic intent fostered by Islamic culture becomes evident when a candlestick manufactured in Persia (cat. no. 283), is compared with another executed in Iraq (cat. no. 285), both of approximately the same date. Indeed, so close are they in form, shape, and ornamentation that the uninitiated would be unable to distinguish between the Persian work and the Iraqi. The same is true of painting, and only an expert eye would be able to tell the difference between a sixteenth-century Turkish miniature (cat. no. 260) and a Persian work of the same period (cat. no. 200).

Several factors were responsible for creating this astonishing similarity among works of art in the Islamic world. No doubt the principal one was the religion itself which acted as an adhesive, binding the different cultures, making it easy, for example, for artists to migrate and serve under different patrons, all of whom had Islam in common. The most classic instances are of poets and artists from Persia who found enlightened patronage at the Mughal court in India. Ultimately, they gave birth not only to a new style of painting (known as the Mughal style), but also to a new language, Urdu. Apart from the general mobility of the artists themselves, it was common for emperors and kings to customarily invite famous artists from distant lands to work at the royal ateliers or to help build palaces and mosques. When Abd al-Rahman III was building his palace, Madinat az Zahram, near Cordova, he hired artists from as far away as Syria and Persia. Another significant unifying factor was that most of the art objects, being modest in dimensions, were easily portable; hence the wide diffusion of styles and techniques. Pots, manuscripts, and miniatures especially were so readily carried from one place to another that their attribution out of context is extremely conjectural. And, in the case of paintings, a glance at a Turkish or an early Deccani miniature (cat. nos. 262, 266) reveals their close dependence on a Persian original.

Although inscription and the arabesque were the principal motifs employed by Islamic artists, they were by no means the only ones. And, while for objects specifically intended for religious use, such as *mihrabs* (cat. no. 70) or mosque lamps, the orthodox attitude prevailed so that only geometric or floral designs and inscriptions were used for ornamentation, in other instances, from

about the eleventh century on, Islamic artists increasingly favored the representation of animals and human beings. It is not exactly clear how this came about, but there can be no doubt that even Islam with its strict orthodoxy could not repress, especially in Persia, the image-making propensity of a people with such a glorious tradition of representational art. In fact, although the figurative style of the miniatures and metalwork does not appear to precede the thirteenth century, Persian potters were employing such motifs as early as the tenth century and certainly maintained links with the powerful and rich world of Sassanian imagery.

If in metalwork and miniatures the artists showed an overwhelming — sometimes perhaps excessive — concern with the aesthetics of the surface, in ceramics and glass they achieved a more harmonious balance between form and ornamentation. This was especially true of glass, a medium which constantly inspired experimentation with new and varied shapes. But here again we are speaking of the continuation and perfection of an ancient craft rather than of innovations inspired specifically by Islam.

It has been asserted repeatedly that calligraphy was of paramount importance in developing the Islamic aesthetic intent. Often the calligrapher not only transcended the apparent limitations of his form to invent exciting and imaginative linear designs, but in many respects imposed its qualities and character upon other forms of aesthetic expression. The Palevsky-Heeramaneck Collection is exceptionally rich and varied in its examples of calligraphy belonging to many different countries.

The special reverence for calligraphy resulted in the belief that any religious book was as sacred as the words contained within its covers. This attitude, in turn, was responsible for the growth of the very specialized craft of bookbinding. Possibly it was the Manichaean tradition of ornately binding books and illuminating them with gold and silver that inspired the Arabs and the Persians. For, the leather covers of the Persian books, whether sacred or profane, were invariably richly tooled with geometric patterns and arabesques. Because of the sanctity attached to the religious book, the calligrapher and the bookbinder enjoyed a very high position in the traditional Islamic society.

As in many other traditional cultures, in that of Islam, art was not a separate and unrelated phenomenon. Rather, an aesthetic attitude was inexorably interwoven into the texture of life itself. For the artist or the craftsman the aesthetic aspect of art was as significant as its functional aspect. And, perhaps to a still greater extent than in any other Asian tradition, in that of Islam patronage determined the norm as well as the form of art. Certainly painting was fostered exclusively by the rich and the elite, and both in theme and style it catered to the tastes of the monarchs and princes who sustained the ateliers. Thus, miniatures painted during the vigorous Il-khanid Dynasty possess a strength and vitality never again seen in later works, while the miniatures painted during the Safavid period reflect the languid grace and almost effete charm of that court.

In contrast to miniatures, the majority of works produced in other media, particularly metalwork and ceramics, may be termed (and certainly no derogation is meant) "industrial arts," for they were manufactured in great abundance for the consumption of the masses. In metalwork it is evident that the degree of refinement and sumptuousness was determined as much by the craftsman's skill as by the affluence of his patron, but it is difficult to know just how much the style reflected the taste of a particular donor. In ceramics it has yet to be determined which factors caused the stylistic changes that occurred during the long and continuous history of this art form. The prosaic functions performed by these wares in no way made them less inventive in form. Rather, the humble pot of the Persian craftsman fully reveals the joy and delight of his aesthetic adventure.

Certainly, the beauty of the objects must have affected the life experience of these people. One wonders to what extent the sumptuousness of the bowls, plates, and jugs here illustrated was able either to alleviate or to sublimate the drudgery of daily life. If indeed some of these pots graced the huts of peasants and simple shepherds, even if there were little to eat, the pots must have provided a feast for the eyes. And how enthralling the religious experience must have been for the devotee when he recited from a well-bound, beautifully decorated, and exquisitely written Koran; or when he prayed, and still does, in a mosque ornamented with tiles so lustrous that they capture something of the brilliance of divine effulgence.

Notes

1.
V. and T. Minorsky, *Calligraphers and Painters,* a treatise by Qāḍī Ahmad, son of Mir Munshi (circa A.H. 1015/A.D. 1606) (Washington, 1959), p. 175.
2.
According to Qāḍī Ahmad, one of the styles of painting in Persia, derivative of the Chinese tradition, was known as *Khiṭā-'-ī.* Another known as *firangi,* perhaps meaning "Frankish," probably refers generally to the Christian style. The influence of Central Asian and Chinese Buddhist paintings on Persian art is not only evident from the facial features of the figures but also from the direct adoption of such motifs as the phoenix — adapted to represent the Islamic *simurgh* — the cloud patterns, etc. As early as the tenth century one of the Persian kings is said to have invited Chinese painters to illuminate a manuscript, and it is curious that the poet Sa'di (1200-1290) in his *Gulistan* writes, while praising his sovereign:
"Perused with a kind glance,
Adorned with approbation by the sovereign,
It will be a Chinese picture gallery
 or design of the Arzank..."

(E. Rehatsek [Tr.], *The Gulistan or Rose Garden of Sa'di* [New York, 1966], p. 58). The Arzank, it may be pointed out, is the name of the atelier of Mani, the founder of the Manichaean sect and a painter.
3.
Minorsky, *op. cit.,* p. 106.

Katharina Otto-Dorn
Professor of History of Art
U.C.L.A.

Introduction
Early Islamic Ceramics, Ninth and Tenth Centuries

In the early Abbasid era during the ninth and tenth centuries,
a revolutionary phase began in the production of Islamic ceramics in
southern Mesopotamia. Apparently the center where this new
development occurred was Baghdad, and the cause of the sudden and
surprising upsurge was a dramatic change of taste, and a new desire
to use ceramic objects as luxurious tableware, inspired by precious,
highly developed Chinese T'ang porcelain and polychrome stoneware.
According to Arabic historical sources and based on original finds
in Mesopotamia, this precious Chinese ceramic material — imported
from the Far East to Baghdad and Samarra, the two Abbasid
capitals in Mesopotamia — was used, we must assume, as the tableware
of the court.

An increasing demand for these luxurious wares forced native Islamic
potters to imitate the Chinese originals and to improve their own
skills. While they were unable to reproduce the substance of
the Chinese cream-colored porcelain, they were able to achieve a similar
effect by applying an opaque white tin glaze to a fine buff earthenware.
But in addition to imitating the Chinese, the Mesopotamian
potters began to invent their own designs (half-palmettes, tree and
branch patterns, or Arabic calligraphic motifs), especially in blue
and green which were absorbed in the glaze "like ink on snow." It was
by Islamizing the Chinese prototype that the first step was taken
in developing an original Islamic ceramic ware.

Admired to the same extent as Chinese cream-colored porcelains, was
the stone-hard, polychrome-painted, mottled ware. This, too, was
imitated, and, again, what was copied was not the body structure but the
effect — in this case the splashes in green, brown, and purple applied
under a yellowish lead glaze and often enriched by half-palmette
patterns in *sgraffiato* technique (incised designs), which itself had
forerunners in the Chinese T'ang ware.

cat. no. 1

Most striking for its originality, however, was a type of early Abbasid
luster ware which was exported throughout the Islamic world from
India to southern Spain. It was this ware which really signalled
the beginning of a new epoch in Islamic ceramic art. In this luster ware
a painting substance which produced a metal-like shimmering effect
and which until then had only been used for decorating glass was
applied for the first time to a ceramic body. It was added to the surface
in a complicated procedure before a second firing above a colorless
glaze. In this early phase of luster painting during the first half
of the ninth century, the colors employed were unique in richness and
included a ruby red and many shades of brown and yellow. In about
AD 860 this varied palette was reduced to a bichrome scheme of brown
and yellow, and about AD 883, after the evacuation of Samarra, cat. no. 2
it was simplified still further to a greenish- or yellowish-brown
monochrome. However, with this reduction to a monochrome luster cat. nos. 3, 4
there appeared a new element, a rich figurative scheme. For the
first time ceramics illustrated court events, for instance the enthroned
Abbasid Khalif in the Central Asian cross-legged posture, carrying
power and paradise symbols (cup and flowers); the cavalier on
horseback; the musician; the ram's fight; or the "booty"-like deer or
hare. Typical is the isolation of these figures, their strong stylization and
silhouetting. Although a new Islamic ceramic type had been born
with this luster ware, memories of Chinese T'ang ware persisted in
specific patterns such as dotted backgrounds, lobed lip-friezes,
flower motifs, and petal-shaped body forms.

Under the local rule of the Persian Samanids, who depended on the suzerainty and cultural influences of the Abbasid dynasty, two ceramic centers arose during the ninth and tenth centuries in West Turkestan and in Eastern Persia at Afrasiyab and Nishapur. The ceramics produced at these centers were quite different from the contemporary wares of Mesopotamia. The Afrasiyab potters made an important discovery: they began painting in a "slip" technique, applying their colors in a light relief on a ground-coat of slip under a transparent lead glaze. Besides white — the most common ground color — they also used tomato red and purple-black. The same colors were used for painting with additional shades of brown and a soft yellowish green. The exquisite delicacy and beauty of Afrasiyab wares result from their being decorated in a highly sophisticated manner, with Kufic inscriptions transmitting blessings and ethical proverbs to the owner. The appearance of the varied lettering, the way the inscriptions were used compositionally, and the dramatic effect of juxtaposing purple-black letters against a white background brought Arabic calligraphy to its first peak. Birds occasionally appear in these ceramics, cat. nos. 5-10 and, when they do, it is as stylized calligraphic emblems; human forms are never found. On a special group of these wares are stylized palmette patterns surrounding flower medallions echoing Chinese T'ang patterns. This ware, like the Mesopotamian luster cat. nos. 1-11 ceramic, was widely exported not only to sites in Persia, such as Nishapur, but also to Beluchistan and Sind.

A rougher provincial group, belonging to the tenth through eleventh century and employing the same kind of "slip" technique, was apparently made in northern Persia, south of the Caspian at Sari. In these, isolated, stylized birds are dominant and are surrounded by radiating stalks and flower medallions. cat. nos. 13, 14

The second "school" arising under the Samanids in Persia at Nishapur during the ninth and tenth centuries has a direct rustic quality in comparison with the refinement of Afrasiyab ware. Although the same "slip" technique was used, the color scheme was much brighter, combining a carnelian red with green, a brown-black, and a distinctive mustard yellow which often filled the whole background. What distinguishes this ware most decisively from the Afrasiyab ceramics is the dominance of a figurative subject matter — suggesting connections with the figurative "court program" of the Abbasid Mesopotamian luster ware. Among the subjects ornamenting this ware cat. no. 16 can be found depictions of feasts; enthroned rulers sitting cross-legged; hunting scenes — in which the princely figure appears on horseback, or a cheetah pounces on a horse, or in which the cat. no. 17 "booty" (especially rams) appears either isolated or together with the cheetah; there are also dancers and peacock-like birds which are cat. no. 18 arranged around a central motif or are grouped in triangles. *Horror* cat. nos. 19-21 *vacui* rules the composition, and backgrounds are dense with animals, flowers, and Kufic devices. All these figures tend toward an abstract stylization in which the facial types in particular are striking, drawn with powerful lines, giving an effect close to Picasso's style.

Seljuk and Mongolian Ceramics between the Eleventh and Fourteenth Centuries

Another revolutionary phase in the history of Islamic art and culture began with the Seljuks. Originally a Turkish nomadic tribe from Western Turkestan, the Seljuks ruled the eastern Islamic world from Turkestan to Asia Minor between the eleventh and thirteenth centuries and established two main empires in Persia ("Great Seljuks") and

Asia Minor ("Rum Seljuks"). The Seljuks brought with them Central Asian traditions which gave new impulses to Islamic architecture (wooden structures of mosques in Asia Minor or reflections from shamanistic burial rites in their mausolea), as well as to the minor arts which were inspired by the Seljuk figurative style. The sultan enthroned in the Central Asian cross-legged posture, for instance, became the rule, as did the bearded or "moon-shaped" Central Asian facial types and garments. We even find the Central Asian-Chinese animal cycle. But, in addition, there was also a strong Chinese influence which manifested itself especially in Seljuk pottery, as it had in early Abbasid art. Features common to Chinese porcelain and hardware were reflected in ceramic shapes (lobed rims) as well as in techniques (*sgraffiato* and relief, irregular running glaze). Style and subject matter, too, reflected a Chinese influence. There was now a tendency toward a new realism in flower patterns, in the lively postures of animals (especially horses and birds), in the idea of rendering landscape, and in the use of the sitting dancer as a motif. Under the Mongols the Chinese influence increased and even Chinese imagery — such as the lotus and peony, the phoenix and dragon — was adopted.

Indeed, during the reign of the Seljuks, ceramic art reached its most brilliant phase, and its fascination lies in its multi-faceted aspects. The centers famous for these products were concentrated in northern Persia, in sites such as Rayy, Kashan, Gurgan, or Sultanabad.

Sgraffiato and Carved Wares

The earliest type of this ceramic seems to date from the tenth century, and it belongs to the group of *sgraffiato* ware decorated under a yellowish lead glaze and with geometric or scale patterns encircling stylized animals. Stylistically these may derive from early Islamic metalwork which in turn had roots in Sassanian silver work. Closer to Chinese T'ang *sgraffiato* ware were the later examples of this type produced between the eleventh and thirteenth centuries in such smaller sites as Amol near the Caspian. Characteristic of these later specimens are green streaks overlapping bird patterns, reminiscent of the Chinese T'ang mottle technique, or a combination of incised designs with green-painted cross-hatched medallions or stylized flower patterns under yellowish lead glaze. Still more impressive effects were achieved in another ware which also occurred near the Caspian in the Garrus district (formerly called "Ghabri ceramic"). From the twelfth or thirteenth century, this ceramic was more monumental in the style of its decoration which included such motifs as Kufic calligraphy and palmette patterns, wild-looking animals (lions and eagles), sphinxes and sirens, and even human forms. They were produced in a *champlevé* (carved) technique, with a black or dark brown background under a green or cream glaze. Among the variety of ewers are interesting types with mouths shaped like animals. Sets of tiles are preserved, and they too are decorated with impressive Kufic calligraphy, with Seljuk arabesques, and with holes in their centers. Apparently, they were used as wall revetments and "light filters."

cat. no. 103

cat. no. 104

cat. nos. 101, 102

cat. no. 100

cat. no. 99

Another ware utilizing the technique of sharp carving is a pottery covered with a thick black slip with designs cut through — usually consisting of Naskhi writing and stripes or geometrical patterns, the whole under a transparent turquoise glaze. The ware, probably from Rayy, must be dated in the second half of the twelfth century.

cat. nos. 28, 29

Chinese spirit also permeated an exquisitely refined white, carved
Seljuk ware which originated in Rayy or Kashan during the first half
of the twelfth century. Attempting to imitate the texture of Chinese
porcelain, especially the Ying-Ching and Ting types, Seljuk potters
used a white, hard, compact and fine paste which they covered with
a colorless, transparent glaze. Like their Chinese forerunners, the finest
pieces are translucent, and a Chinese taste is also reflected in the
glaze-filled piercing decoration, in such motifs as the gadroon cat. no. 47
ornament and "cloud scrolls," as well as in the lobed rims. A group
of this delicate ware is Islamized in its use of the "split palmette"
and Naskhi writing. In later examples from thirteenth-century Kashan
ware or from early fourteenth-century Sultanabad ceramic,
cobalt blue patterns were painted under the glaze. cat. nos. 92, 94

Pottery with Underglaze Painting

The most impressive ware belonging to this group has a black slip
silhouette under a clear, or sometimes turquoise, glaze. Probably made
in Kashan during the second half of the twelfth century, these
objects are fascinating for their decoration in an abstract animal style,
but even more, in their use of human forms. Musicians and a more
effective set of "magical" dancers, full of dramatic action as they strive
or perform a "sitting dance," may have derived from Far Eastern cat. no. 26
traditions. It is possible that their dance echoes cultic scenes from
Central Asian shamanistic rituals rather than scenes from the
Near Eastern puppet theater as has been assumed.

Among this pottery which is painted under glaze, an important type
is one with black or cobalt blue decoration under a clear or turquoise
glaze. The earliest group of these wares was made in Kashan
between 1204 and 1215, according to the evidence of dated objects.
Like the white carved or pierced Seljuk ceramic which imitates
Chinese porcelain, these Kashan wares were extremely fine in
technique and are among the most refined, attractive Seljuk ceramic
objects ever produced in Persia. Typical of this group is its diversity
in the arrangement of decoration. Austere in character is a whole
group of vessels decorated with diagonal, radiating cobalt blue stripes
centered in a medallion. Another series is characterized by a richer cat. nos. 48-51
design in which diagonal or cross-shaped stripes (the latter filled with
cursive Naskhi writing in white on a black ground) alternates
with a Tree of Life motif shaped like a Seljuk arabesque. In other
examples a more realistic flower and leaf pattern is obviously
Chinese in inspiration. And, finally, this decoration culminates in the
elegance of the more favored, wavy water-weed motif. Sometimes cat. nos. 53, 57
the Tree of Life motif is flanked by stylized birds drawn with
calligraphic delicacy. In other vessels, vivaciously rendered fish fill cat. nos. 58, 59
the centers of dishes or encircle the bodies or necks of ewers.
They are symbols expressing "good wishes and blessings for eternal
life to the owner of the object."

At the end of the thirteenth and the beginning of the fourteenth
centuries under-glaze painted ceramic wares continued to be produced
under the Mongols in Sultanabad emphasizing Chinese subject matter cat. nos. 86, 87, 94
in the use of flower patterns (the lotus and peony), animal motifs
(fish, flying birds, phoenix, and dragon), and human figures in
Mongolian dress.

Ceramics with Luster Painting

Under the Seljuks, particularly in Persia, the technique of luster
painting over an opaque white glaze was revived for the third time and

reached its zenith. The technique, a secret known to a handful of families, originated in Mesopotamia under the early Abbasids in the ninth and tenth centuries. It passed to Egypt under the Fatimids apparently because Mesopotamian potters migrated to Cairo from Baghdad. The most elaborate and delicate luster ware was produced in such Seljuk ceramic centers as Kashan, Rayy, or Gurgan. As in Mesopotamia and Egypt, luster pottery was the favored luxurious "china" of the court, and its importance was enhanced by the rich inscriptions, usually love poems, that adorned it. These inscriptions provide us with dates and sometimes masters' signatures. Thus, we can date these from 1179 until 1220 when Rayy was sacked by the Mongol invaders. Production continued in Kashan until 1334.

The finest Rayy and Kashan luster pottery was produced in the late twelfth and early thirteenth centuries. New color effects dinstinguish these from earlier products. Blue glaze alternated with the usual opaque white glaze, both grounds for luster painting. Additional areas were painted blue, or blue was used for relief decoration. The luster also appears in a style of silhouetted decoration against the white ground or at times is reserved in the dark luster ground. Under the Seljuks, luster ceramics chronicled the events and pleasures of court life in a very effective figurative scheme featuring portraits of the enthroned ruler seated in the Central Asian cross-legged posture, hunting scenes, tournaments, polo players, musicians, dancers, lovers, feasts, combined with fabulous beings like sphinxes and harpies (sirens), the favorite magical symbols believed to protect the object's owner from evil.

cat. nos. 31, 34

Comparable in quality to the luster tableware are the tiles, the most famous products of Kashan. These were used as wall revetments in palaces and were usually arranged in a star-and-cross pattern. Produced between 1203 and the last quarter of the thirteenth century, they bear rich inscriptions and are decorated with motifs similar to those of the vessels. A variety of Seljuk palace tile revetment is a square-shaped plaque with relief decoration produced between the second half of the thirteenth and early fourteenth century. The most elaborate group are the Kashan tiles which decorated the *mihrabs* (prayer niches) and were produced between 1226 and the fourteenth century. Their typical shape is a flat rectangle with a central triangular niche in the upper portion supported by columns with capitals in high relief. There are smaller triangular niches below. The whole is framed by wide border zones. Typical of the decoration are Kufic and Naskhi friezes in the borders and layers of arabesque tendrils in relief in the niches. The motifs are painted cobalt blue against white scrollwork, reserved on the luster ground. In a given group, the borders of the prayer niches contain animal motifs consisting of birds, hares, and foxes. Though unusual in the sacred Seljuk art of Persia, these are more frequent in Seljuk religious monuments in Asia Minor.

cat. no. 73

cat. no. 70

Minai Ceramics

The most luxurious and precious Seljuk tableware is Minai (enamel) ware, painted under and over the glaze in the "seven color" *(haft rang)* palette with black outlines. The colors are black, chestnut, red, white, pale blue, deep blue, green, and sometimes shades of lilac. Exquisite effects are obtained in luster painting over turquoise glaze. In a group of Minai ware strongly "baroque" in character, the pieces are also gilded and decorated in relief. In addition to dishes, Minai ware included square tiles decorated with figurative motifs. The ware was produced probably in Kashan, Rayy, or Savah during the last quarter

of the twelfth and the middle of the thirteenth century. The "classical" period occurred at the end of the twelfth and the beginning of the thirteenth century. By the middle of the thirteenth century the technique had been simplified. Only one layer of luster was applied over the glaze, and the color scheme too had been reduced.

The figurative scheme followed the subject matter of the luster ware especially in the depiction of court events, with images of the enthroned ruler seated in the cross-legged Central Asian posture being the most frequent. Yet, whether the Minai ware illustrated events of the court or themes borrowed from Persian poetry — especially from Firdousi's *Shah Nama* (Book of the Kings) — it is clear that there was a strong taste for miniatures. Further, it is evident that the painters of illuminated Seljuk manuscripts were also responsible for the decoration of Minai ware. And, once again, Chinese art is echoed in such specific elements as the lobed rims of dishes or a motif like the sitting dancers — often repeated in friezes framing the central subject.

cat. no. 43

A variation of the polychromed Minai ware is the so-called *lajvardina* ceramic. It was produced both as tableware and as a tile revetment during the second half of the thirteenth and the beginning of the fourteenth century. Characteristic of this ware are grounds glazed in cobalt blue or turquoise with painted decoration in white, red, black, and gold leaf. The designs usually include white scroll-spirals. An entire group from the Mongol period, painted with Chinese lotus, phoenix, and dragon motifs, indicates that these wares, too, were strongly influenced by Chinese taste.

cat. no. 105

Safavid Ceramics

A later revival of ceramic art took place in Persia in the sixteenth and seventeenth centuries during the dynasty of the Safavids; especially noteworthy was the production of luxurious tableware of various types. Luster painting in particular enjoyed a late renaissance during the second half of the seventeenth century with the center of production probably in Shiraz or Kashan. A coppery luster shade was preferred, and sometimes an exquisite effect was achieved when luster painting occurred over a turquoise glaze — an effect which had been arrived at before in Seljuk luster techniques. Typical motifs were feathery bushes and iris plants.

cat. no. 109

Strongly influenced by Chinese Ming porcelain was the Persian "Blue and White" which began in the fifteenth century in the northwestern "Kubachi" group and continued in the sixteenth and seventeenth centuries in the Kirman. While the earlier Kirman pieces were very close to Chinese originals, the later ones were more simplified and stylized versions of Chinese designs. A third "Blue and White" group was manufactured in Meshed. The best pieces are excellent in technique and design, more refined than the Kirman "Blue and White," and more faithful to the Chinese prototypes. They belong probably to the second half or to the end of the sixteenth century. In seventeenth-century Meshed "Blue and White," there was also a strong tendency to Islamize Chinese designs.

cat. nos. 111, 112

Most original in style is a polychrome Safavid ceramic from northwestern Persia known as Kubachi ware. It was produced from the middle of the sixteenth to about the middle of the seventeenth centuries. The typical Kubachi palette — which came into use after 1550 — is characterized by black outlines, a deep blue, turquoise, dull

green, a thick yellow ochre, and a thick brownish red related to the Isnik Bolus red in Turkish ceramics. In fact, it would seem that the whole Kubachi color scheme was adopted from the polychrome Isnik ware. Apart from Kubachi tableware, we also know of hexagonal or square tile palace revetments — in all of which the ware reached its highest standards. Regardless of the function of the wares, similar figural motifs were employed. Typical were bust and full-length portraits which appeared on plates at the beginning of the seventeenth century. A special variety of wall revetments used to embellish palaces was brightly colored tiles painted with scenes of court diversions or animal motifs in a *cuerda secca* (enamel) technique.

cat. no. 114
cat. no. 117

Isnik (Ottoman) Ceramics

After the decline of Seljuk and Mongolian pottery work in Persia, a new center of ceramic art arose in Turkey under the Ottoman Sultans. Its most famous manufactories were in Isnik (Nicaea), where the kilns were flourishing from the first half of the fifteenth century until the end of the seventeenth. During the first phase — between the first half of the fifteenth century and until the first half of the sixteenth — different groups of "Blue and White" strongly influenced by Chinese Ming porcelains were produced.

From the middle of the sixteenth century a totally different type of luxurious tableware and wall tile was developed. Its most striking characteristic was a new palette of polychromed, brilliant colors: intense black, deep cobalt blue, copper green, turquoise, and the typical Bolus red, applied slip-like in relief. Simultaneously there evolved a new taste for realistic flower and leaf patterns. Tulips, roses, hyacinths, violets, peonies, blossoming branches, and cypress trees were favored, and a particular long, feathery, curved leaf appeared frequently, either growing from the ground or emerging from vases, in assymetrical compositions, overlapping each other in a windblown effect. This same leaf was arranged more symmetrically in tile decoration. The use of a composite of flowers recalls a garden in full bloom, and at a deeper level suggests paradise itself. This ware declined at the end of the seventeenth century.

cat. nos. 128, 129

The Isnik tiles used as wall revetments for religious buildings and palaces were as splendid as the tableware, especially in Istanbul. Because the buildings decorated with them are dated, we have evidence that the highest standards of color and drawing were reached between the middle of the sixteenth and the beginning of the seventeenth century. Isnik tiles, not only beautiful but world-famous, were sold by the Venetian and Genoese merchants living in Istanbul and found their way through Venice into Germany and the North.

cat. no. 124

The Art of Ceramics

1.
Bowl (illustrated)
Mesopotamia (Baghdad), 9th century
h: 2½ in. (6.3 cm.); d: 8½ in. (21.5 cm.)
M.735.148

Small bowl with flaring sides and ring foot;
decorated with turquoise and patches of light brown
under lead glaze with *sgraffiato* (incised)
design, imitation of Chinese T'ang ware; large
half-palmette leaves, the center filled with
half-palmettes arranged in a lozenge.

2.
Bowl (illustrated)
Mesopotamia (Baghdad), about 850
h: 2¾ in. (7 cm.); d: 9½ in. (24.2 cm.)
M.73.5.238

Bichrome-painted luster bowl in shades of yellow
and brown; small bowl with flaring sides and
ring foot, projecting rim. Decorated with "split
palmette leaves" around a central lozenge filled
with a cross motif; rimmed with zizag border.

2.

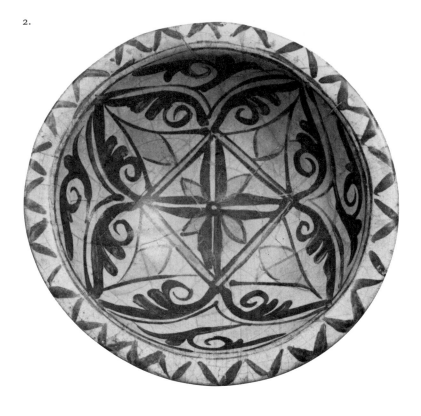

3.
Bowl
Mesopotamia (Baghdad), 9th-10th century
h: 5⅛ in. (13 cm.); d: 1⅝ in. (4 cm.)
M.73.5.240

Small bowl, flaring sides and ring foot;
monochrome painted in gold and yellowish
luster over a tin glaze; decorated with a stylized
deer in a silhouette style with white contour
line, walking from right to left, against a dotted
background; lobed frieze under the rim;
Kufic device above the deer. Reverse with
medallions between dotted lines.

4.
Bowl (illustrated)
Mesopotamia (Baghdad), 9th-10th century
h: 1¾ in. (4.5 cm.); d: 5⅛ in. (13 cm.)
M.73.5.272

Small bowl, flaring sides and ring foot;
monochrome-painted in brown luster over a tin
glaze; decorated with a stylized hare walking
from left to right in a silhouette style with white
contour line, against a dotted background;
lobed frieze under the rim; "eye" ornament to
the right. Reverse with medallions between
dotted lines.

4.

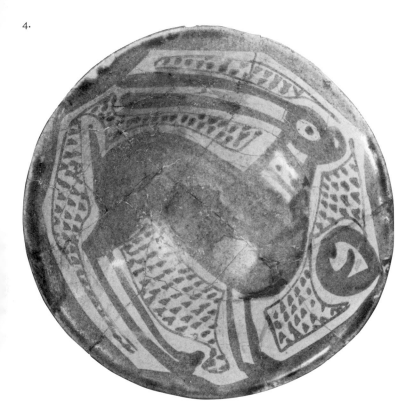

5.

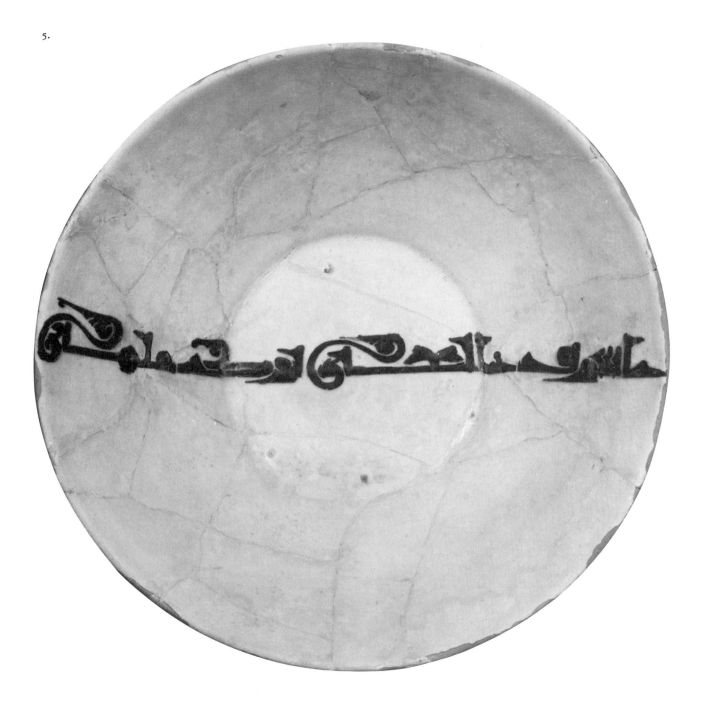

5.
Bowl (illustrated)
West Turkestan (Afrasiyab), 9th-10th century
h: 2⅞ in. (7.5 cm.); d: 8⅝ in. (22 cm.)
M.73.5.295

Bowl with flaring sides and ring foot; painted in slip
technique in purple-brown, on a white slip
ground under an ivory-tinted transparent lead glaze;
horizontally running Kufic band of the austere
flourishing type.

6.
Bowl
West Turkestan (Afrasiyab), 9th-10th century
h: 3⅜ in. (8.5 cm.); d: 10⅜ in. (26.5 cm.)
M.73.5.202

Bowl with flaring sides and ring foot; painted in slip
technique in purple-brown on a white slip
ground under an ivory-tinted transparent lead glaze;
radiating Kufic writing with vertical stems,
one ending in a spiral-shaped arabesque.

7.
Bowl (illustrated)
West Turkestan (Afrasiyab), 9th-10th century
h: 3⅛ in. (8 cm.); d: 8⅞ in. (22.5 cm.)
M.73.5.199

Bowl with flaring sides and ring foot; painted in slip
technique in purple-brown on a white slip
ground under an ivory-tinted transparent lead glaze;
radiating Kufic writing with vertical stems;
interspersed bird-like dotted fillings in purple,
black, and red; zigzag frieze below the rim;
cross-shaped half-palmette in the center.

8.
Bowl (illustrated)
West Turkestan (Afrasiyab), 9th-10th century
h: 3 in. (7.6 cm.); d: 7¼ in. (18.4 cm.)
M.73.5.382

Bowl with flaring sides and ring foot; painted in slip
technique in purple-brown on a white slip
ground under an ivory-tinted transparent lead glaze;
horizontal band of Kufic writing with S-curved
stems; S-curves filling upper and lower part. Reverse
with frieze of comma-like designs below the rim.

7.

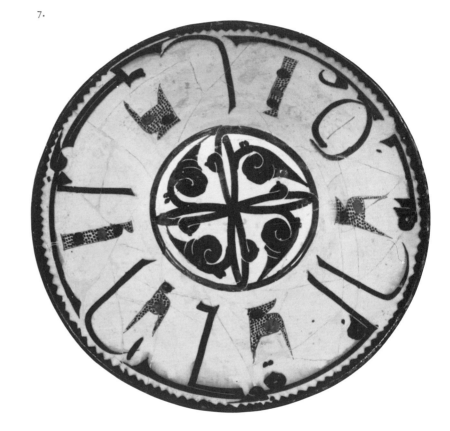

8.

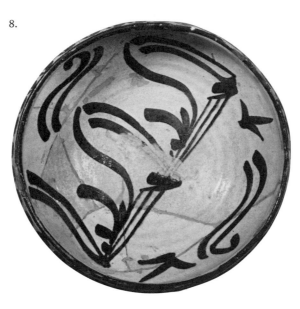

9.

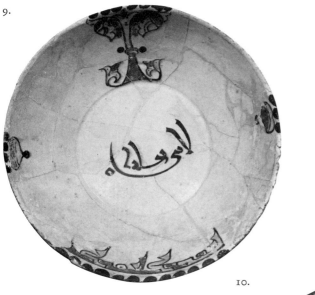

10.

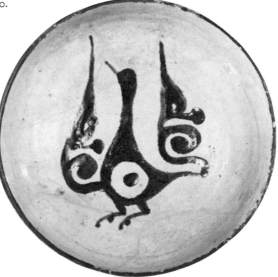

9.
Bowl (illustrated)
West Turkestan (Afrasiyab), 10th century
h: 3½ in. (8.9 cm.); d: 10 in. (25.4 cm.)
M.73.5.330

Bowl with flaring sides and ring foot; painted in slip
technique in purple-brown on a white slip
ground under an ivory-tinted transparent lead glaze;
Kufic devices in the center and the lower part;
balanced by a Tree of Life motif in the shape of an
arabesque —"chandelier"; small circle-like
designs to the right and left; groups of dots on
the rim.

10.
Bowl (illustrated)
West Turkestan (Afrasiyab), 9th-10th century
h: 1¾ in. (4.4 cm.); d: 5½ in. (14 cm.)
M.73.5.129

Bowl with flaring sides and ring foot; painted in slip
technique in purple-brown on a white slip
ground under an ivory-tinted transparent lead glaze;
decorated with a flying bird in a calligraphic
style with a silhouette effect, its upraised wings
ending in half-palmettes.

11.
Bowl
West Turkestan (Afrasiyab), 9th-10th century
h: 2¾ in. (7 cm.); d: 7¾ in. (19.7 cm.)
M.73.5.186

Bowl with flaring sides and ring foot; painted in slip
technique in purple-black, tomato red, and
smooth green on a white slip ground under an
ivory-tinted transparent lead glaze; decorated
with lotus-like flowers filled with S-curved
half-palmettes, alternating with wedge-like floral
shapes; the center with a four-lobed flower
echoing T'ang patterns.

For a similar piece see A. Lane, *Early Islamic
Pottery*, fig. 17b.

13.

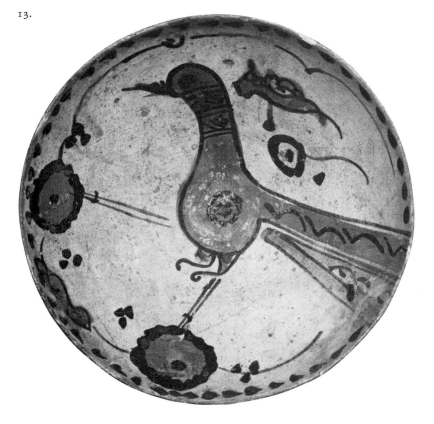

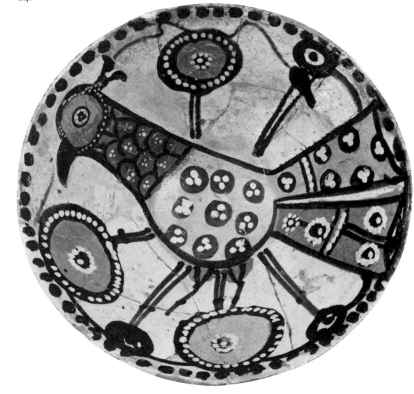

14.
Bowl (illustrated)
Southern Caspian area (Sari), 10th-12th century
h: 2½ in. (6.4 cm.); d: 6⅞ in. (17.5 cm.)
M.73.5.144

Bowl with flaring sides and ring foot; painted in slip
technique under a translucent glaze in a smooth
green, pinkish brown, and purple-black; the center
filled with a stylized bird surrounded by
medallions with pearl bands and radiating stems;
dotted rim; rougher provincial ware.

15.
Bowl
Persia (Nishapur), 10th century
h: 2½ in. (6.4 cm.); d: 8½ in. (21.6 cm.)
M.73.5.225

Bowl with flaring sides and ring foot; painted in
slip technique under lead glaze in tomato red, olive
green, purple-black, and the typical Nishapur
mustard yellow; decorated with leaves in a cross
pattern, alternating with arabesque spirals.

12.
Bowl
West Turkestan (Afrasiyab), 10th century
h: 3 in. (7.6 cm.); d: 7⅛ in. (18 cm.)
M.73.5.139

Bowl with flaring sides and ring foot; painted in slip
technique in tomato red, purple-black, and olive
green on a white slip ground under an ivory-tinted
transparent lead glaze; decorated with cartouches
composed of bands of broad strokes producing a
calligraphic effect recalling Chinese taste, the
inside filled with pseudo-Kufic; alternating with
wedge-like floral shapes.

13.
Bowl (illustrated)
Southern Caspian area (Sari), 10th-11th century
h: 3¾ in. (9.5 cm.); d: 9⅛ in. (23.2 cm.)
M.73.5.136

Bowl with flaring sides and ring foot; painted in the
Afrasiyab slip technique under a translucent
glaze in light brown, olive green, and purple-black;
the center filled with a stylized bird surrounded
by lobed medallions on radiating stems; dotted rim;
rougher provincial ware.

For a similar piece see A. Lane, *Islamic Pottery from
the Ninth to the Fourteenth Century in the
Collection of Sir Eldred Hitchcock* (London, 1946),
fig. 7; and A. U. Pope, *A Survey of Persian Art,*
V, pl. 621.

14.

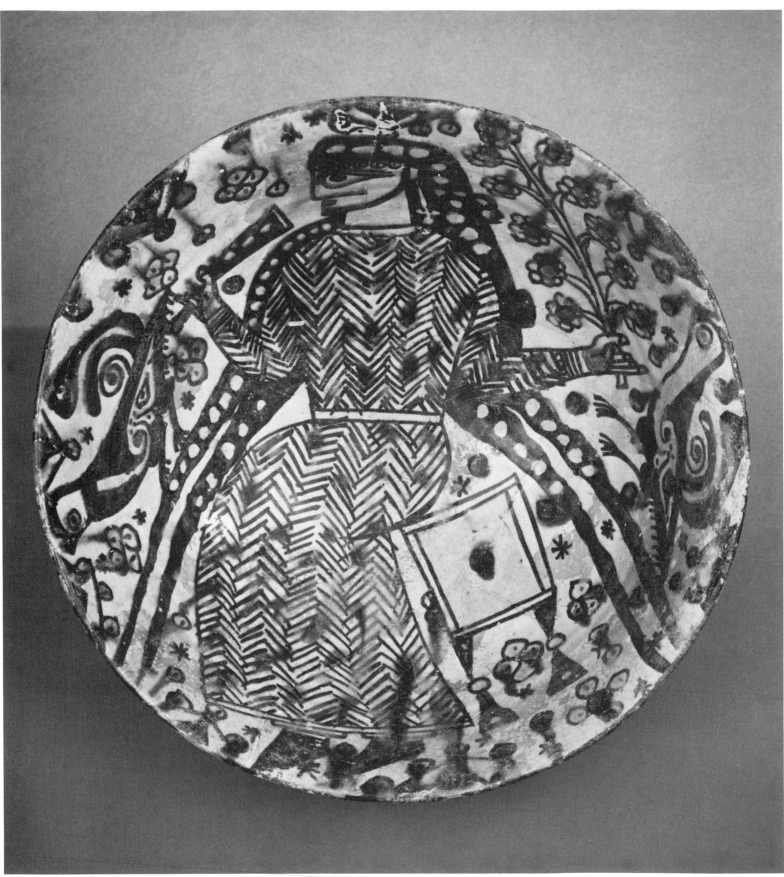

16.
Bowl (illustrated)
Persia (Nishapur), 10th century
h: 3¼ in. (8.3 cm.); d: 9 in. (22.8 cm.)
M.73.5.203

Bowl with flaring sides and ring foot; painted in slip
technique under lead glaze in purple-black and
mustard yellow with patches of turquoise; decorated
on a yellow ground with a monumental long haired,
stylized figure sitting on a stool, the body in frontal
view, head and feet in profile, framed by the
waving ends of a veil; the head strongly stylized
with a "Picasso effect," the dress with zigzag
patterns; the figure carries a branch of flowers and
a beaker; the background densely filled with stylized
birds, rosettes, and dots (*horror vacui* effect).

A similar figure appears twice in another context in
E. Grube, *The World of Islam,* fig. 6, and in
Binney, *Islamic Catalog,* fig. 77.

17.
Bowl
Persia (Nishapur), 10th century
h: 3½ in. (8.8 cm.); d: 8½ in. (21.6 cm.)
M.73.5.291

Bowl with flaring sides and ring foot; painted in
mustard yellow, purple-black, with turquoise
patches in slip technique under a lead glaze; scene
with stylized animals: a cheetah riding on a
spotted horse; animals with white contour lines;
below the horse a stylized bird; the rim filled
with stripes and circles.

18.
Bowl
Persia (Nishapur), 10th century
h: 2½ in. (6.4 cm.); d: 6½ in. (16.5 cm.)
M.73.5.135

Bowl with flaring sides and ring foot; painted in
mustard yellow, purple-black, with turquoise
patches in slip technique under a lead glaze;
decorated with a stylized ram walking to the left,
caught by a cheetah; the animals surrounded
by angular Kufic devices; the ground densely filled
with rosettes and dots (*horror vacui* effect).

19.
Bowl
Persia (Nishapur), 10th century
h: 3 in. (7.6 cm.); d: 7 in. (17.8 cm.)
M.73.5.239

Bowl with flaring sides and ring foot; painted in
mustard yellow, purple-black, with purple patches
in slip technique under a lead glaze; in the
center a stylized ram walking from right to left;
surrounded by four stylized birds; flourishing
Kufic writing in the center around the rim; ground
filled with rosettes.

20.
Bowl (illustrated)
Persia (Nishapur), 10th century
h: 3¼ in. (8.2 cm.); d: 8⅝ in. (21.9 cm.)
M.73.5.226

Bowl with flaring sides and ring foot; painted in
purple-black with turquoise patches in slip
technique under a lead glaze; five stylized
peacock-like birds in interlaced medallions against
a mustard yellow background; wedges filled with
scales and hatching.

21.
Bowl
Persia (Nishapur), 10th century
h: 2⅞ in. (7.3 cm.); d: 7¼ in. (18.4 cm.)
M.73.5.289

Bowl with flaring sides and ring foot; painted in
purple-black, green, and yellow with patches
of turquoise in slip technique under a lead glaze;
central wavy cross motif on purple background;
the wedges are filled with stylized peacock-like
birds and flower-like fillings against mustard yellow
or turquoise grounds.

20.

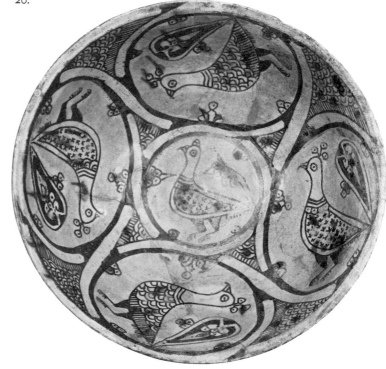

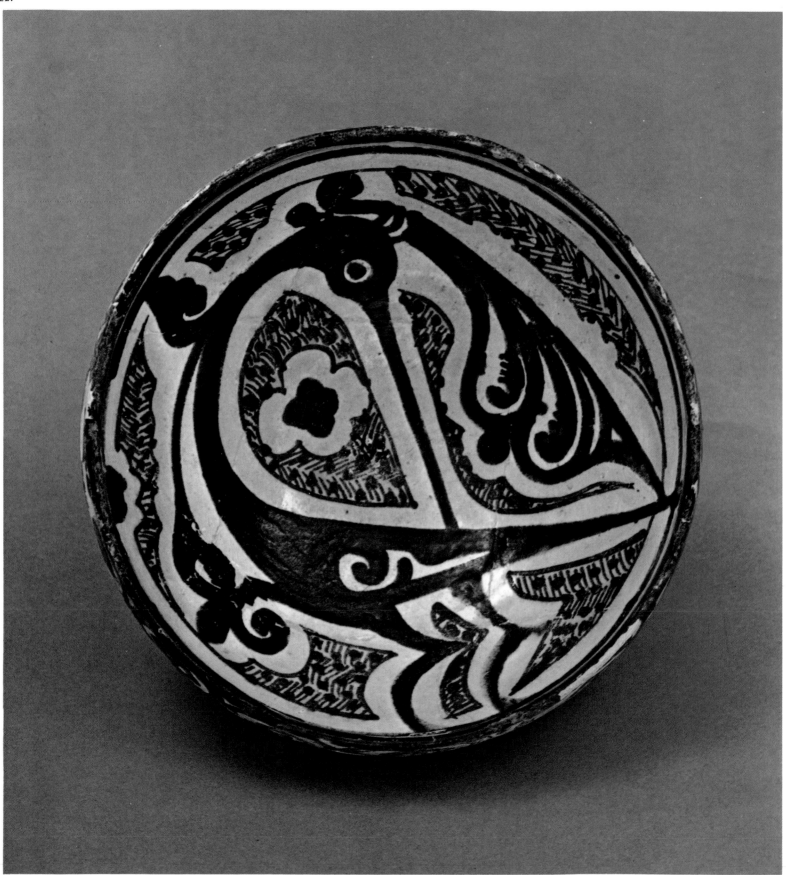

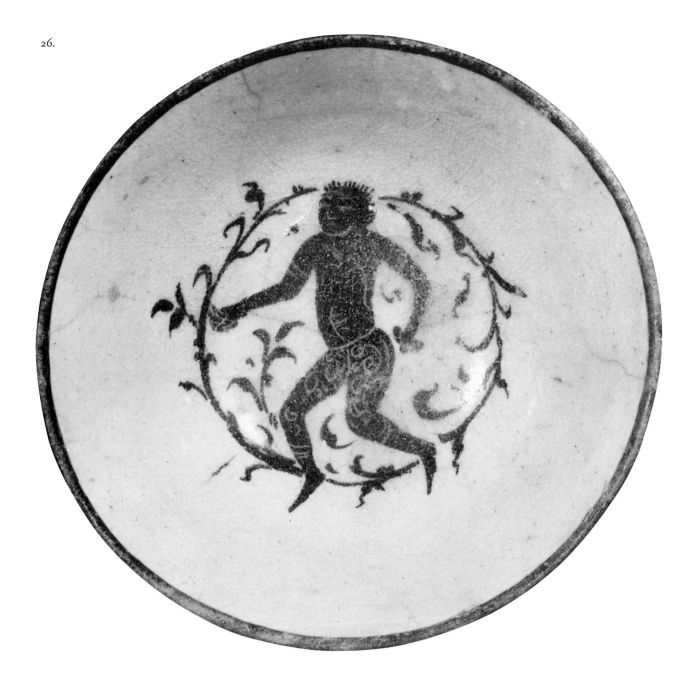

22.
Bowl (illustrated)
Persia (Nishapur), 10th century
h: 3½ in. (8.9 cm.); d: 7¼ in. (18.4 cm.)
M.73.5.130

Bowl with flaring sides and ring foot; painted in
purple-black against a mustard yellow background
in slip technique under a lead glaze; isolated
bird with white contour lines, in dramatic
movement, the head turned backwards, head
feathers ending in a large half-palmette; dotted
and hatched fillings; combination of the
calligraphic Afrasiyab style and the color scheme
of Nishapur.

23.
Bowl
Persia (Nishapur), 10th-11th century
h: 3⅞ in. (9.8 cm.); d: 8½ in. (21.6 cm.)
M.73.5.328

Bowl with flaring sides and ring foot; painted in
mustard yellow and purple-black with turquoise
patches in slip technique under a lead glaze;
isolated stylized ram, walking from left to right,
surrounded by angular Kufic designs, dense fillings
of rosettes, spiral shapes, and geometric designs;
less refined than classical Nishapur type.

25.

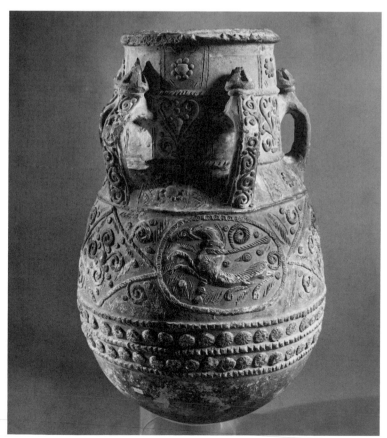

24.
Bowl
Persia (Nishapur), 10th-11th century
h: 3⅛ in. (8 cm.); d: 7 in. (17.8 cm.)
M.73.5.286

Bowl with flaring sides and ring foot; painted in
purple-black in slip technique under a lead glaze;
recumbent stag facing to the left with a
half-palmette in its mouth; spiral-shaped fillings;
less refined than classical Nishapur type.

Seljuk-Mongolian Ceramics (11th-14th century)

25.
Jar (illustrated)
Mesopotamia (probably Mosul), 12th-13th century
h: 24 in. (61 cm.); d: 15½ in. (39.4 cm.)
M.73.5.710

Unglazed jar *(habb);* water cistern or cooler of
porous clay; in molded and barbotine relief
(ornament applied to the surface in wet clay, like
icing on a cake); pear-shaped body without
base, offset straight neck with projecting lip; five
turreted strap handles between shoulder and
neck, covered with spiral-shaped tendrils; the body
decorated with alternating oval medallions
and lozenges filled with stylized animals—ram, lion,
horse—and cross-shaped spirals; below, two
lines of rosettes framed by scalloped bands; neck
with friezes of medallions and stylized
palmettes in panels.

Published: G. Reitlinger, "Unglazed Relief Pottery
from Northern Mesopotamia," *Ars Islamica,*
15-16 (1951), fig. 10.

26.
Bowl (illustrated)
Persia (probably Rayy), 1150-1200
h: 3¾ in. (9.5 cm.); d: 8½ in. (21.6 cm.)
M.73.5.259

Bowl with flaring sides and ring foot; decorated
in slip technique in black under clear glaze;
black rim; figure of a "magical" dancer in
a silhouette effect, inside a "magical" circle of
seaweed tendrils; the figure with a demon-like
face with bristling hair, in dramatic movement
stepping from right to left; carrying castanets
in his hands, wearing a skintight suit with scroll
motifs; indication of *tiraz* bands on the sleeves; the
scene apparently reflects a ritual dance alluding to
Central Asian shamanistic cults.

For the same type of figures, see A. Lane,
Early Islamic Pottery, fig. 51a, and Pope, *Survey,*
V, fig. 750 a and b; for the topic see
R. Ettinghausen, "The Dance with Zoomorphic
Masks and Other Forms of Entertainment
Seen in Islamic Art," *Arabic and Islamic
Studies in Honor of Hamilton A. R. Gibb,*
ed. G. Makdisi (Leiden, 1965).

27.
Bottle (illustrated)
Persia (Rayy), about 1200
h: 9¼ in. (23.4 cm.)
M.73.5.360

Wine bottle with globular body, ring foot, ribbed
neck, and lobed cup-shaped mouth, echoing
Chinese forms; transparent light blue glaze, running
irregularly without covering lower part of the
body and the foot; the shoulder carved under the
glaze with an angular Kufic frieze sitting against
arabesque spirals; a band of scrolls below.

28.
Ewer (illustrated)
Persia (Rayy), about 1200
h: 8⅜ in. (21.2 cm.)
M.73.5.293

Spouted ewer with globular body, ring-like swelling
on the neck, flat handle and ring foot; decorated
with thick black slip through which are cut a
Naskhi inscription on the shoulder and stripes on
the body, neck, and spout; the whole under
turquoise glaze.

For a similar technique, see A. Lane, *Islamic
Pottery in the Collection of Sir Eldred Hitchcock,*
fig. 51.

29.
Bowl
Persia (Rayy), 13th century
h: 3¼ in. (8.3 cm.); d: 8½ in. (21.6 cm.)
M.73.5.210

Bowl with flaring sides and ring foot; decorated
with thick black slip through which is cut a
design of a flower-shaped star interlaced with
geometrical patterns.

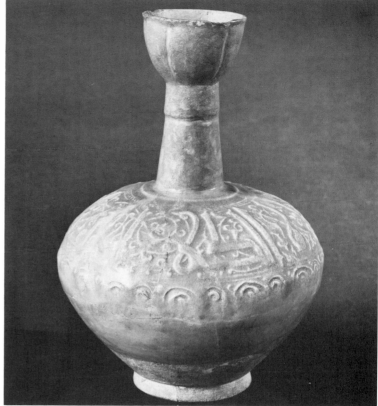

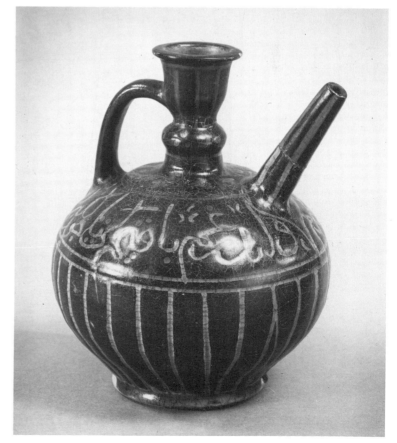

30.

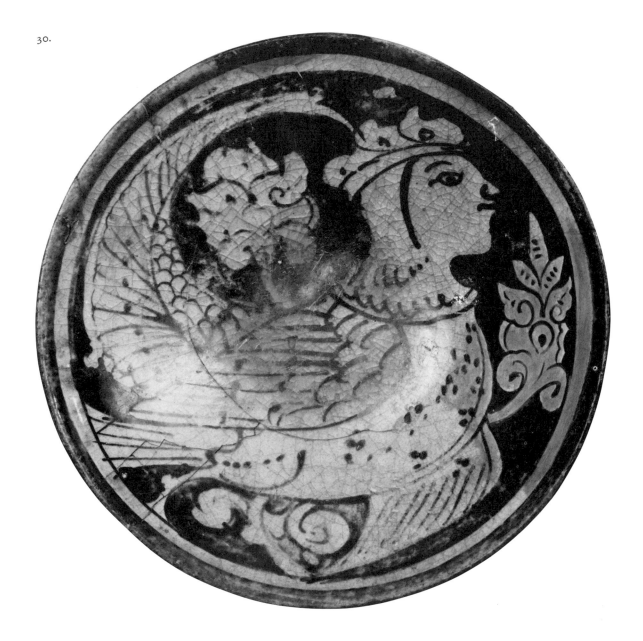

30.
Bowl (illustrated)
Persia (Rayy), about 1200
h: 1¾ in. (4.4 cm.); d: 6¾ in. (17.2 cm.)
M.73.5.269

Bowl with flaring sides and ring foot; background
painted in a chocolate brown luster, the decoration
in reserve on luster ground; figure of a harpy
(siren) in profile, walking to the right, on the
body details painted in luster; one wing raised in a
wide curve, the other down; she wears a
three-lobed cap, a collar is indicated, dots on the
body; two palmette branches surround the
figure, which is encircled by a white band.

31.
Bowl
Persia (Rayy), about 1200
h: 1⅜ in. (3.5 cm.); d: 7 in. (17.8 cm.)
M.73.5.288

Bowl with flaring sides and ring foot; background
painted in chocolate brown luster under a
transparent blue glaze; decoration in reserve in
luster ground; the figure of a wild looking
lion in profile with open mouth, walking from right
to left; the body covered with dots; surrounded
by arabesque branches and framed by a white circle;
below the rim a frieze with S-shaped patterns.
Reverse covered with transparent blue glaze.

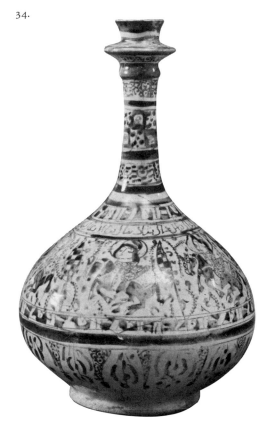

32.
Bowl
Persia (Rayy), about 1200
h: 3 in: (7.6 cm.); d: 7 in. (17.8 cm.)
M.73.5.217

Bowl with flaring sides and ring foot; painted in
brownish luster over opaque white glaze; in
the lower part, confronted stylized birds, the heads
addorsed and tails upright; flanking a Tree of
Life, composed in loose elements of cartouches
filled with scrolls and abstract half-palmettes;
the upper part framed by a semicircle; under the
rim a second semicircular frieze with panels,
filled with medallions and scrolls; the rim decorated
with short stripes.

33.

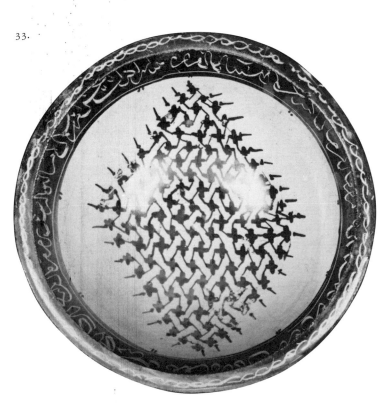

33.
Bowl (illustrated)
Persia (Rayy), 1200-1250
h: 2½ in. (6.4 cm.); d: 5¾ in. (14.5 cm.)
M.73.5.211

Bowl with flaring sides and ring foot; painted in
golden brownish luster over opaque white glaze;
decorated in an unusual geometrical pattern in
the form of an upright lozenge motif, filled with
intertwined cross patterns; below the rim a
frieze in pseudo-Kufic writing in reverse on the
luster ground; the rim decorated with a chain
motif.

34.
Bottle (illustrated)
Persia (Rayy), 1200-1250
h: 10½ in. (26.7 cm.)
M.73.5.262

Wine bottle; globular body with ring foot; narrow
neck with platform ridge and ring-like bulge;
painting in a brownish gold luster over opaque
white glaze; the body decorated with a cavalcade in
vivid motion in a silhouette style; the cavaliers
with halos, charbush-like headgear, and long hair
in a landscape (cf. cat. no. 71) indicated by
checkerboard-patterned cypresses and schematized
pomegranate branches; the scenery framed by
bands with square patterns and a frieze with Naskhi
writing, the neck covered with different zones,
filled with checkerboard motifs and scrolls; the
lower part of the body covered with abstract
arabesque cartouches and wedges filled with scroll
patterns.

For similar pieces see Sotheby and Co., *Catalogue
of Egyptian, Western Asiatic, Greek, Etruscan and
Roman Antiquities also Islamic Pottery,*
June 18, 1968, no. 61.

35.
Bowl
Persia (Rayy), 1200-1225
h: 2⅛ in. (5.4 cm.); d: 9⅜ in. (23.8 cm.)
M.73.5.376

Bowl with flaring sides and ring foot; painting in
coppery luster above opaque white glaze; the
decoration in two different effects, reserved in white
on the luster ground or painted in luster on the
white glaze; in the central medallion a princely
cavalier on horseback in vivid motion against
a ground of arabesque spirals; the figure is haloed,
long haired, with a cap-like headgear, wearing
a spotted dress with the indication of *tiraz* bands on
the sleeves; the spotted horse, typical for the
Seljuk luster style, is galloping from right to left;
around the medallion a pseudo-Kufic frieze,
repeated by a second one below the rim; in between
a zone filled with heart-shaped cartouches
alternating with three-lobed branches against a
dotted background. Reverse: decoration with
interlaced oval motifs.

36.
Bowl
Persia (Rayy), about 1250
h: 3¼ in. (8.3 cm.); d: 8 in. (20.2 cm.)
M.73.5.261

Bowl with flaring sides and ring foot; painted in
coppery luster over opaque white glaze; scene with
five haloed figures; in the center two "princely"
persons standing under a baldachin, flanked by
a standing and a seated "courtier," the latter in the
Central Asian cross-legged posture; portion of a
third accompanying figure in the background;
all wear long hair, charbush-like headgear, and
dresses with different patterns and with the
indication of *tiraz* bands on the sleeves; they are of
the unbearded, moon-shaped Central Asian
facial type which is characteristic in Seljuk and
Mongolian art; indication of landscape — the idea
obviously inspired by Chinese art — through
formula-like elements such as a pool in the
foreground, a checkerboard-patterned cypress,
and schematized pomegranate branches; below the
rim a pseudo-Kufic frieze; sketchy style.

38.

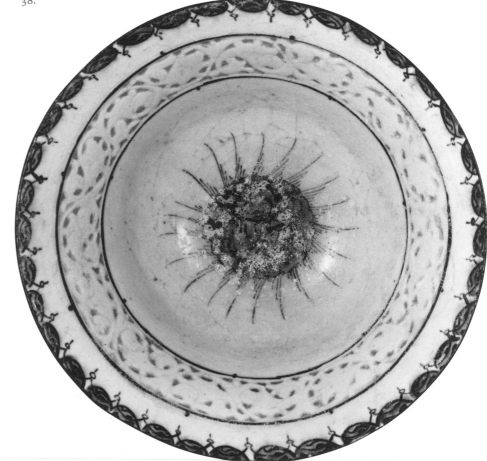

37.
Bowl
Persia (Rayy), about 1250
h: 4½ in. (11.4 cm.); d: 7¼ in. (18.4 cm.)
M.73.5.326

Deep bowl with flaring sides, convex shoulder,
and high foot; painted in a brassy luster over
opaque white glaze; the outside decorated with a
cavalcade; the horses drawn in a silhouette style in a
dramatic motion, the cavaliers depicted by means
of ornamental lines; all with halos, long hair, and
charbush-like headgear; a landscape (cf. cat. no. 71)
indicated through checkerboard patterned
cypresses and schematized pomegranate branches;
in between comma-like scrolls; the lower part
covered with abstract arabesques, repeated in the
inside of the bowl; sketchy style.

38.
Bowl (illustrated)
Persia (Kashan or Rayy), 1150-1200
h: 3¾ in. (9.5 cm.); d: 8½ in. (21.6 cm.)
M.73.5.197

Bowl with flaring sides and ring foot; white body;
transparent, almost translucent glaze; decorated
with a frieze of floral tendrils with pierced
transparencies in Chinese style; encircling a central
rayed medallion painted in cobalt blue under
the glaze; lobed frieze on the rim in cobalt blue,
reminiscent of ninth- through tenth-century
Mesopotamian luster ware. (Cf. cat. no. 3 for
Islamized imitation of Chinese porcelain.)

39.
Bowl
Persia (Kashan or Rayy), 1150-1200
h: 3⅝ in. (9.2 cm.); d: 8⅜ in. (21.4 cm.)
M.73.5.282

Bowl with flaring sides and ring foot; white body
and transparent glaze; carved with abstract
S-shaped half-palmettes filled with serrated leaves
forming reciprocal heart motifs; in the center
spiral-shaped tendrils.

40.
Bowl (illustrated)
Persia (Kashan or Rayy), 1150-1200
h: 4 in. (10.2 cm.); d: 8⅝ in. (22 cm.)
M.73.5.284

Bowl with flaring sides and ring foot; opaque
light blue glaze; carved with abstract S-shaped
half-palmettes, filled with serrated leaves;
surrounding central star motif.

40.

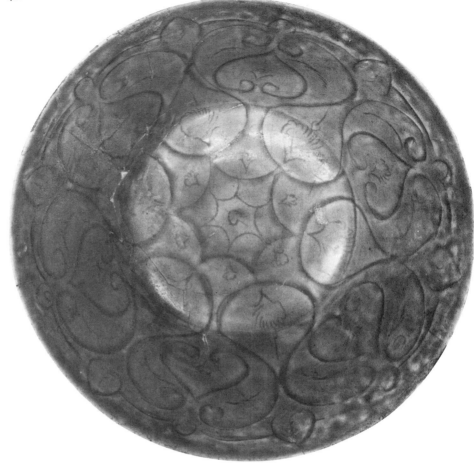

42.

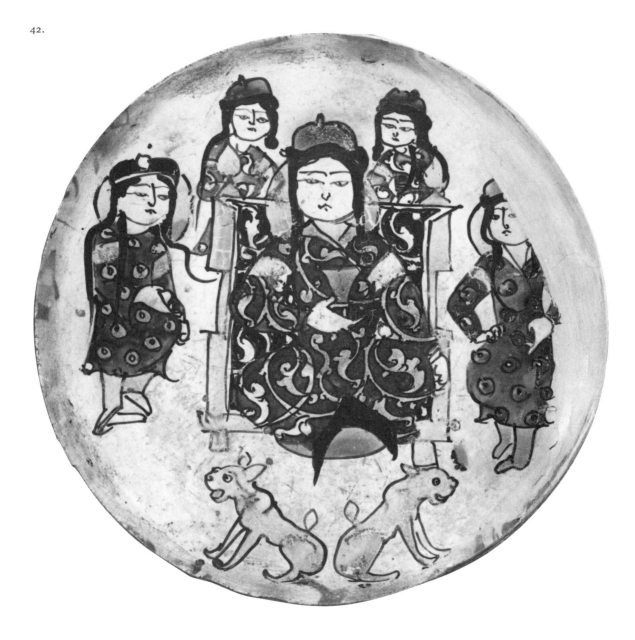

44.

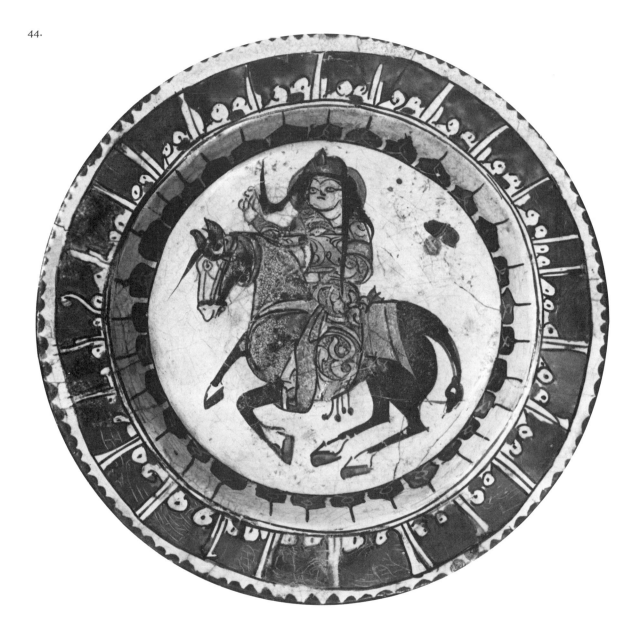

41.
Bowl
Persia (Rayy or Kashan), 1200-1225
h: 3 in. (7.6 cm.); d: 7⅜ in. (18.8 cm.)
M.73.5.300

Minai bowl with flaring sides and ring foot (partly restored); painted over white opaque glaze in red, turquoise, black, and white; a common scene of a confronted couple in three-quarter view, sitting in cross-legged posture, the left one holding a cup, against an arabesque background; the figures are haloed, long haired, of the moon-shaped Central Asian facial type, the hands with tattoo marks; they wear flat red caps and dresses richly ornamented in geometrical and arabesque patterns; the rim filled with pseudo-Kufic writing.

42.
Part of a Bowl (illustrated)
Persia (Rayy or Kashan), about 1250
h: 1½ in. (3.8 cm.); d: 4⅝ in. (11.8 cm.)
M.73.5.184

Lower portion with foot of Minai bowl with flaring sides and ring foot; painted over the white opaque glaze in chestnut, cobalt blue, turquoise, black, and white; typical Seljuk throne scene with the Sultan sitting on a throne, in a frontal view, in the Central Asian cross-legged posture, unbearded, long haired, and holding a beaker, a power and paradise symbol; his moon-shaped face, kaftan-like dress with lapels, high boots, and helmet-like headgear reflect Central Asian traditions; the dress is decorated with spiral-shaped arabesques, indication of *tiraz* bands; a pair of addorsed lions, also symbols of power, below his feet; four courtiers of the same type as the Sultan accompany him; three of the figures are haloed.

43.
Bowl
Persia (Rayy or Kashan), about 1250
h: 3¾ in. (9.5 cm.); d: 8½ in. (21.6 cm.)
M.73.5.227

Fragmentarily preserved Minai bowl with flaring sides and ring foot; painted under and over glaze in chestnut, pale turquoise, red, lilac, black, and white; unusual scene, probably illustrating an event from Firdousi's *Shah Nama;* group of five figures, all haloed, with charbush-like headgear and *tiraz* bands on their sleeves; to the left, an enthroned ruler under a baldachin in the typical Seljuk cross-legged posture, reflecting Central Asian traditions, wearing a striped dress under an open coat decorated with arabesques; two bodyguards with swords behind the throne (the left partly destroyed); in front of the ruler another swordbearer offering the head of a decapitated enemy; a fourth figure behind; eagle-like birds in the upper and lower part; landscape indication by means of schematized pomegranate branches; below the rim frieze of pseudo-Kufic writing; the rim filled with a scalloped band.

44.
Bowl (illustrated)
Persia (Rayy or Kashan), about 1250
h: 1½ in. (3.9 cm.); d: 6½ in. (16.5 cm.)
M.73.7.4
Gift of Nasli M. Heeramaneck

Shallow Minai bowl with flaring rim and three feet, rendered in the shape of lions; painted over the white opaque glaze in chestnut, pale blue, black, red, orange, and olive; spots of gilding; center dominated by a prince riding an animated horse; prince dressed in kaftan-like dress decorated with spiral-shaped arabesques and *tiraz* bands; hair in braids with a helmet-like headgear and stirrups reflecting Central Asian traditions; frieze of pseudo-Kufic writing on the rim. Excellent condition.

Ex-coll: Kevorkian Foundation.

45.
Bowl
Persia (Rayy or Kashan), about 1250
h: 3⅝ in. (9.2 cm.); d: 8¼ in. (21 cm.)
M.73.5.758

Minai bowl with flaring sides and ring foot; painted under and over glaze in chestnut, pale turquoise, lilac, red, black, and white; a common scene of a couple drinking beside a pool of water on either side of a stylized Tree of Life; seated in cross-legged position, wearing long dresses adorned with geometrical and arabesque designs; indications of *tiraz*-bands; both haloed, with long hair, red caps, and tatooed hands; one holding cup or flower; rim filled with pseudo-Kufic ornament and scalloped band.

Ex-coll: Kevorkian Foundation.

46.
Bowl
Persia (Ravyy or Kashan), 13th century
h: 3¾ in. (9.5 cm.); d: 8¼ in. (21 cm.)
M.73.5.331

Minai bowl with flaring sides and ring foot (strongly repaired); painted over turquoise glaze in black, red, cobalt blue, white, and brown, and richly gilded; in the central medallion a travelling scene with an elephant walking from left to right and a princely person sitting in a litter, accompanied by two drivers; around the center a fighting scene with galloping horsemen with spears, and a flagbearer; below the rim a frieze of pseudo-Kufic writing.

47.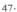

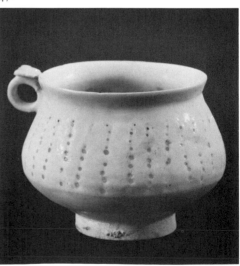

47.
Tankard (illustrated)
Persia (Kashan), about 1200
h: 3½ in. (8.9 cm.)
M.73.5.146

Globular with wide mouth and short concave
lip, small ring handle with button; white body,
thick colorless glaze running irregularly down to
the foot which is only partially covered; decoration
of radiating pierced transparencies. Body structure
and techniques imitating Chinese porcelain.

For tankards of a similar Chinese type with
incised or carved decoration see A. Lane, *Islamic
Pottery in the Collection of Sir Eldred Hitchcock,*
fig. 30, and Pope, *Survey,* V, pl. 592D.

48.
Bowl
Persia (Kashan), 1200-1225
h: 4 in. (10.2 cm.); d: 8⅜ in. (21.3 cm.)
M.73.5.245

Bowl with flaring sides and ring foot; white body;
painted under a colorless glaze inside and out
with cobalt blue radiating stripes; lozenge motif in
the center.

49.
Bowl
Persia (Kashan), 1200-1225
h: 3⅝ in. (9.3 cm.); d: 7⅝ in. (19.4 cm.)
M.73.5.283

Bowl with flaring sides and ring foot; white body;
painted under colorless glaze inside and out
with radiating cobalt blue stripes; stylized fish motif
in center.

50.
Bowl
Persia (Kashan), 1200-1225
h: 2¼ in. (5.7 cm.); d: 9¼ in. (23.5 cm.)
M.73.5.285

Bowl with flaring sides and ring foot; white body;
painted under colorless glaze inside and out with
densely arranged cobalt blue radiating stripes;
interlaced rosette motifs in the center.

51.
Bowl
Persia (Kashan), 1200-1225
h: 4 in. (10.2 cm.); d: 8⅛ in. (21 cm.)
M.73.5.271

Bowl with flaring sides and ring foot; white body;
painted under translucent turquoise glaze inside
and out; with cobalt blue radiating stripes; stylized
bird in the center.

52.

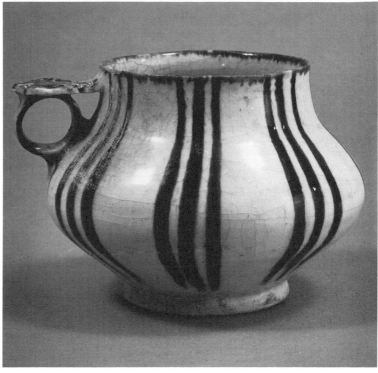

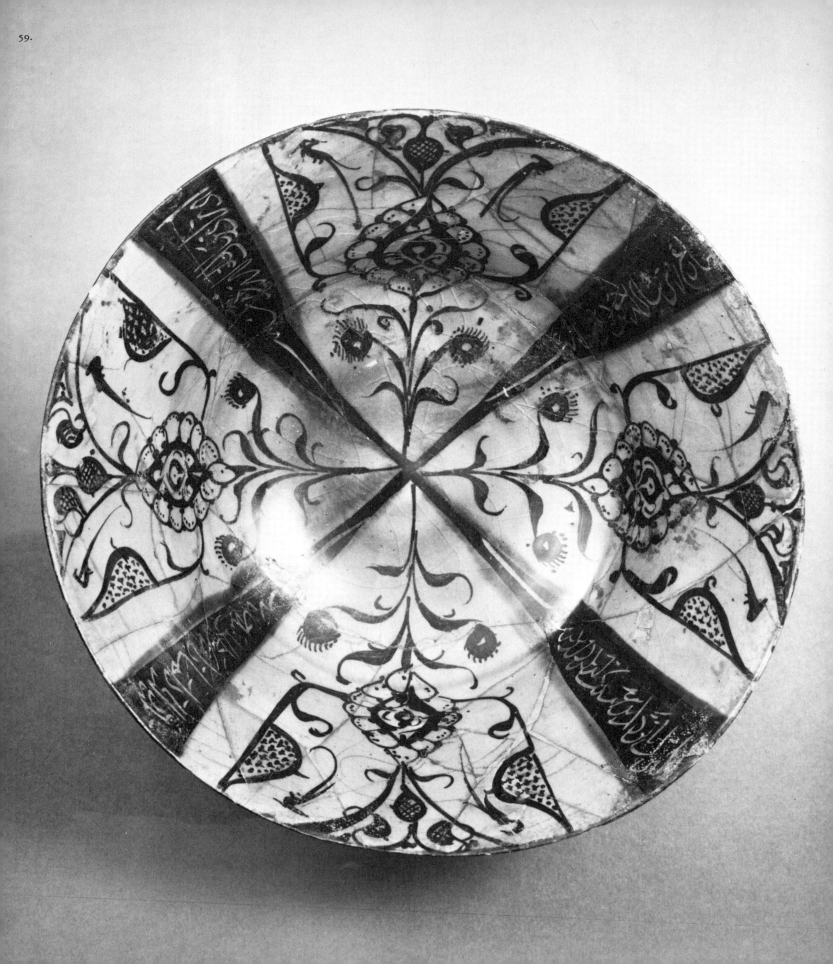

52.
Tankard (illustrated)
Persia (Kashan), 1200-1225
h: 7⅛ in. (18.1 cm.); d: 5 in. (12.7 cm.)
M.73.5.270

Globular body with wide mouth, ring foot, ring
handle with thumb rest; painted under colorless
glaze with cobalt blue stripes radiating in groups
of three.

For a similar piece see A. Lane, *Early Islamic
Pottery,* fig. 98.

53.
Bowl
Persia (Kashan), 1200-1225
h: 3¾ in. (9.5 cm.); d: 8⅝ in. (21.8 cm.)
M.73.5.277

Bowl with flaring sides and ring foot; painted
under transparent turquoise glaze inside and out in
cobalt blue radiating stripes; alternating with
branch-like seaweed patterns.

54.
Bowl
Persia (Kashan), 1200-1225
h: 3¾ in. (9.5 cm.); d: 7½ in. (19 cm.)
M.73.5.281

Bowl with flaring sides and ring foot; painted
under transparent turquoise glaze with black
radiating stripes; alternating with heart-shaped
flowers with scroll fillings.

55.
Bowl
Persia (Kashan), 1200-1225
h: 3 in. (7.6 cm.); d: 6 in. (15.2 cm.)
M.73.5.212

Bowl with flaring sides and ring foot; painted
under transparent glaze in black and cobalt blue
with stripes in a cross-shape alternating with
branch-like seaweed patterns.

56.
Bowl
Persia (Kashan), 1200-1225
h: 4 in. (10.2 cm.); d: 8⅜ in. (21.3 cm.)
M.73.5.243

Bowl with flaring sides and ring foot; painted
under translucent glaze in black and blue with
radiating stripes decorated with reserved Naskhi
writing on the dark ground; alternating with
bands filled with arabesque spirals; in the center
more realistic radiating daisy-like flowers
reflecting Chinese inspiration.

Similar piece dated 1204/5 in Pope,
Survey, V, pl. 734.

57.
Bowl
Persia (Kashan), 1200-1225
h: 2 in. (5.1 cm.); d: 8¾ in. (22.2 cm.)
M.73.5.279

Bowl with flaring sides and ring foot; painted
under translucent turquoise glaze in black with
cross-shaped stripes, filled with reserved Naskhi
writing on the black ground; alternating with
seaweed patterns.

58.
Bowl
Persia (Kashan), 1200-1225
h: 4 in. (10.2 cm.); d: 8¼ in. (21 cm.)
M.73.5.280

Bowl with flaring sides and ring foot; painted
under translucent glaze in black with cross-shaped
stripes, filled with reserved Naskhi writing on
the dark ground; alternating arabesque
"chandeliers" flanking stylized long-tailed birds.
Reverse with seaweed motifs.

For a similar piece see Pope, *Survey,* V,
pls. 735A and 737B.

59.
Bowl (illustrated)
Persia (Kashan), 1200-1225
h: 4 in. (10.2 cm.); d: 8¼ in. (21 cm.)
M.73.5.268

Bowl with flaring sides and ring foot; painted
under translucent turquoise glaze in black with
cross-shaped stripes, filled with reserved Naskhi
writing on the black ground; alternating with
stylized tree motifs showing at the same time more
realistic daisy-like flowers and pomegranates at
the top; flanked by stylized long-tailed birds.
Reverse with seaweed branches.

For a similar piece see Pope, *Survey,* V,
pl. 734A.

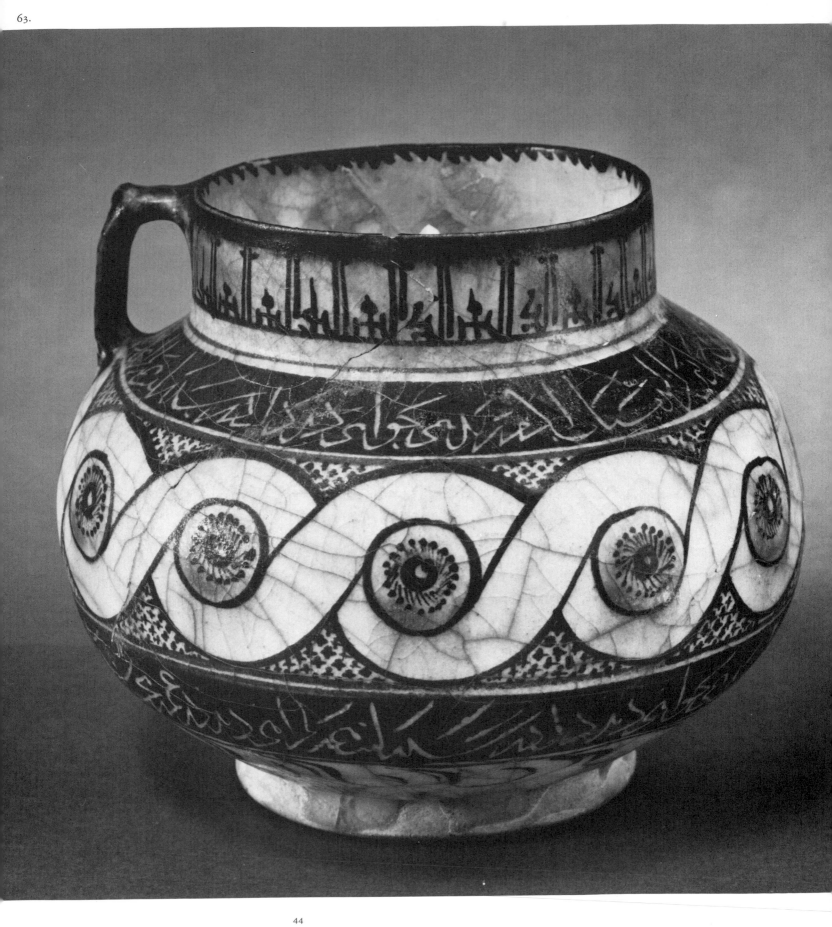

60.
Bowl
Persia (Kashan), 1200-1225
h: 2½ in. (6.4 cm.); d: 9 in. (22.8 cm.)
M.73.5.198

Bowl with flaring sides and ring foot; painted
under transparent glaze in black and blue with
cross-shaped stripes, filled with reserved Naskhi
writing on the black ground; alternating with
more realistic daisy-like flowers combined with
seaweed branches; the rim decorated with
seaweed tendrils. Reverse with three-lobed leaves.

61.
Bowl
Persia (Kashan), 1200-1225
h: 2⅞ in. (7.4 cm.); d: 6 in. (15.2 cm.)
M.73.5.189

Bowl with flaring sides and ring foot; painted
under transparent glaze in black and blue with
cross-shaped flower-like dotted medallions
surrounding a daisy-like central flower; alternating
with arabesque "chandeliers"; below the rim
Naskhi writing reserved in the black ground; on
the frieze a lobed pattern echoing the earlier
ninth through tenth century luster ware
(cf. cat. no. 3). Reverse with vertical stripes
alternating with seaweed branches.

62.
Bowl
Persia (Kashan), 1200-1225
h: 4½ in. (11.4 cm.); d: 8 in. (20.3 cm.)
M.73.5.255

Bowl with flaring sides and ring foot; painted
under transparent glaze in blue and black with
cross-shaped "split" half-palmettes, ending in
spirals around a dotted lozenge motif; fillings of
three-lobed leaves; between the half-palmette
groups, panels with pseudo-Kufic writing; below
the rim reversed Naskhi writing in the black
ground; rim with scalloped frieze. Reverse with
reserved Naskhi writing on the rim; flowers
and arabesques on the body.

Published: R. Ettinghausen, *Islamic Art,
An Exhibition at the Ohio State Museum,*
Columbus, July-August 1956, fig. p. 10.

63.
Jug (illustrated)
Persia (Kashan), 1200-1225
h: 5 in. (12.7 cm.)
M.73.5.195

Globular body with small vertical buttoned handle,
straight offset rim and ring foot; painted under
transparent glaze in blue and black; decorated with
painted band filled with daisy-like motifs;
shoulder and lower part with reserved Naskhi

writing in the black ground; neck with
pseudo-Kufic; inside rim with scalloped frieze.

Published: R. Ettinghausen, *Islamic Art,
An Exhibition at the Ohio State Museum,* Columbus
July-August 1956, fig. 8. For a similar piece
dated 1214 see Pope, *Survey,* V, fig. 734B, and
Lane, *Early Islamic Pottery,* fig. 84b.

64.
Bowl (illustrated)
Persia (Kashan), 1200 1225
h: 2½ in. (6.3 cm.); d: 9½ in. (24.2 cm.)
M.73.5.278

Bowl with flaring sides and ring foot; painted
under translucent turquoise glaze in black with
seaweed tendrils and scalloped frieze on the rim;
in the center a pair of stylized fish in vivid
motion, obviously animated through Chinese art;
probably with a special symbolic meaning
expressing "blessings and good wishes for eternal
life to the owner of the object."

For the central fish motif, see E. Baer, "Fish-pond
Ornaments on Persian and Mamluk Metal
Vessels," *Bulletin of the School of Oriental and
African Studies,* University of London,
XXXI, pt. 1 (1968).

64.

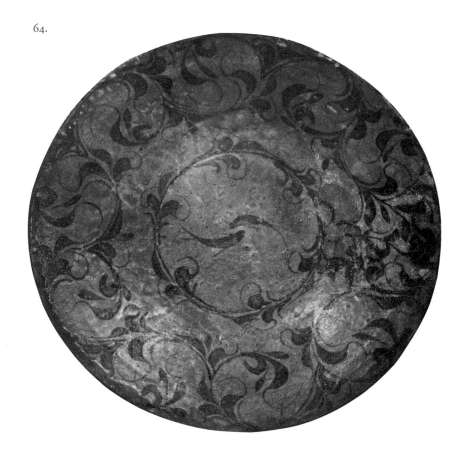

45

65.
Bowl
Persia (Kashan), 1200-1225
h: 3⅞ in. (9.9 cm.); d: 8½ in. (21.6 cm.)
M.73.5.275

Bowl with flaring sides and ring foot; translucent turquoise glaze; the decoration reserved in a black background; central medallion with two addorsed harpies (sirens) flanking a stylized Tree of Life, the ground filled with arabesques; under the rim a pseudo-Kufic inscription against arabesques, alternating with big daisy-like flowers.

For the harpies, see E. Baer, *Sphinxes and Harpies in Medieval Islamic Art.*

66.
Bowl
Persia (Kashan), 1200-1225
h: 2¾ in. (7 cm.); d: 6½ in. (16.5 cm.)
M.73.5.214

Bowl with flaring sides and ring foot; painting in brassy luster, the decoration reserved on the luster ground; the central medallion with radiating strokes, filled with confronted birds, flanking a Tree of Life with branching half-palmettes, standing against a background densely filled with scrolls; below the rim a pseudo-Naskhi inscription. Reverse with pseudo-Kufic frieze reserved on luster ground.

67.
Tile
Persia (Kashan), 1200-1225
d: 12⅛ in. (31.1 cm.)
M.73.5.355

Octagonal luster tile belonging to a palace revetment; painted in brownish luster (partially faded); the center filled with three bearded princely figures with halos, long hair, wearing charbush-like headgear, reserved on the luster ground; the moon-shaped facial type typically Central Asian; they sit in a cross-legged posture in three-quarter view, surrounded by flying ducks, the hallmark of Kashan pottery; the background densely filled with scrolls; the border of the star painted with Naskhi writing over white opaque glaze.

68.
Tile
Persia (Kashan), 1200-1225
h: 11 in. (28 cm.); w: 11¼ in. (28.6 cm.)
M.73.5.222

Square luster tile, part of a palace revetment; painted in golden brownish luster and blue painting with high relief work and flower branches in the background; main panel depicting the travelling of a high ranking person sitting in a litter on an elephant walking from right to left; the main driver crouched on the elephant's neck; two others wearing high boots and richly decorated dresses, one with a stick, walking in front of and behind the elephant; in the upper frieze walking animals depicted with the typical "Kashan dots."

Published: *Antiquities, Property of the Kevorkian Foundation,* Parke-Bernet Galleries, New York, April 28, 1970, fig. 122.

69.
Tile
Persia (Kashan), 1200-1225
M.73.5.274

Unusual square luster tile, belonging to palace revetment; painted in brassy luster (partly faded); obviously a hunting scene with a princely horseman riding from left to right, with three courtiers in the background; all with halos, the main figure in profile and bearded, wearing a wing-shaped headgear and long hair, the dress filled with scroll patterns indicating *tiraz* bands; the horse covered with a striped saddle cloth decorated with "Kashan dots" and half-palmettes; two of the courtiers, unbearded with the Central Asian moon-faced facial type, appear in three-quarter view; the third one in profile view similar to the princely figure, bare-headed; indication of *tiraz* band with Naskhi writing on the sleeve of the left figure; a hunting dog with a necklace below the horse in the right corner; indication of landscape

70.

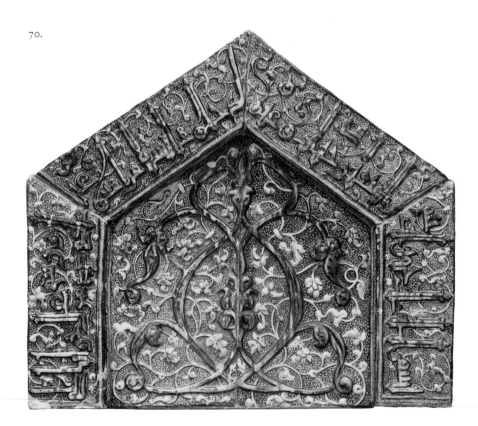

by means of typical checkerboard cypresses
and schematized pomegranate branches; "Kashan
birds" behind the main figure and below the horse.

The drawing of the piece in Pope, *Survey,* II (text),
fig. 544.

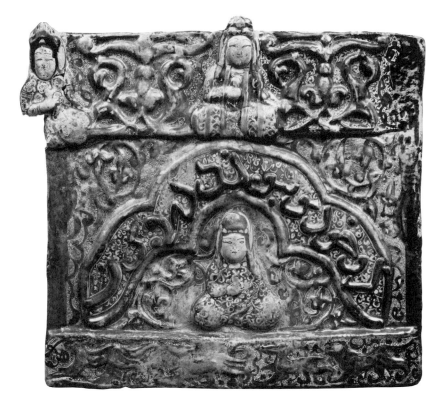

73.

70.
Mihrab (illustrated)
Persia (Kashan), 1200-1225
h: 40½ in. (102.9 cm.); w: 46⅞ in. (119 cm.)
M.73.5.1

Upper panel from the central part of a luster
mihrab (prayer niche), with a typical triangular
arch; painted in a brownish luster and in cobalt
blue with high relief work above a dotted
background; decorated with intertwined
arabesque foliage and spiral-shaped arabesques
in two layers; the border covered with Kufic
writing of verses from the Koran above arabesque
tendrils. Partly repaired.

For a color reproduction see *Antiquities, Property
of the Kevorkian Foundation,* Parke-Bernet
Galleries, New York, April 28, 1970, fig. 127.
A similar whole *mihrab* in Lane, *Early Islamic
Pottery,* fig. 66, and Pope, *Survey,* V, pl. 704.

71.
Bowl
Persia (Kashan), 1200-1250
h: 4¼ in. (10.8 cm.); d: 8⅜ in. (21.2 cm.)
M.73.5.327

Bowl with flaring sides and ring foot; painted in
brownish luster; the decoration reserved on
the luster ground, additional cobalt blue painting
under the glaze; six interlaced medallions
surrounding a central circle; filled with branching
half-palmettes and flower-like motifs, the ground
densely filled with scrolls; smaller circles in the
wedges; the contour lines painted in cobalt blue;
under the rim a frieze of pseudo-Naskhi.

72.
Tile
Persia (Kashan), about 1250
d: 5½ in. (14 cm.)
M.73.5.375

Luster tile in an unusual hexagonal shape; the
decoration reserved on a coppery luster ground; in
the center the figure of a princely unbearded
horseman in three-quarter view, with a halo, short
hair, and the moon-shaped Central Asian facial
type; wearing a striped kaftan-like dress, indication
of a *tiraz* band on the sleeve; the horse with
the typical "Kashan spots" in dramatic movement;
the background densely filled with scrolls and
half-palmettes; the border of the tile decorated with
Naskhi writing; sketchy style.

73.
Tile (illustrated)
Persia (Kashan), 1250-1300
h: 17 in. (43.2 cm.); w: 18 in. (45.7 cm.)
M.73.5.141

Square luster tile, part of a palace revetment;
painted in coppery luster and cobalt blue with high
relief work and a lower layer of scrolls; the
main panel decorated with a three-lobed blind niche
in which a princely figure, probably the Sultan,
is enthroned in frontal view in the typical Central
Asian cross-legged posture, with a cup in his
hand, a power and paradise symbol; he has the
typical Central Asian moon-shaped face, tattoo
marks, long hair, wears a balloon-shaped headgear,
and a dress with scroll patterns; the ground of
the main field and the spandrils are filled with
spiral-shaped arabesques; the three-lobed arch with
Naskhi writing in cobalt blue painting; in the
upper frieze two figures similar to the "Sultan"
sitting in the cross-legged posture against branching
arabesques; the lower frieze filled with animals
in flight, the typical Seljuk reduction of the
hunting ground (cf. cat. no. 64). It is possible to

restore the tile by adding two standing figures
with swords flanking the main scene, apparently
bodyguards. For such restoration see Pope,
Survey, V, fig. 726B.

Published: *Antiquities, Property of the Kevorkian
Foundation,* Parke-Bernet Galleries, New York,
April 28, 1970, fig. 121.

75.

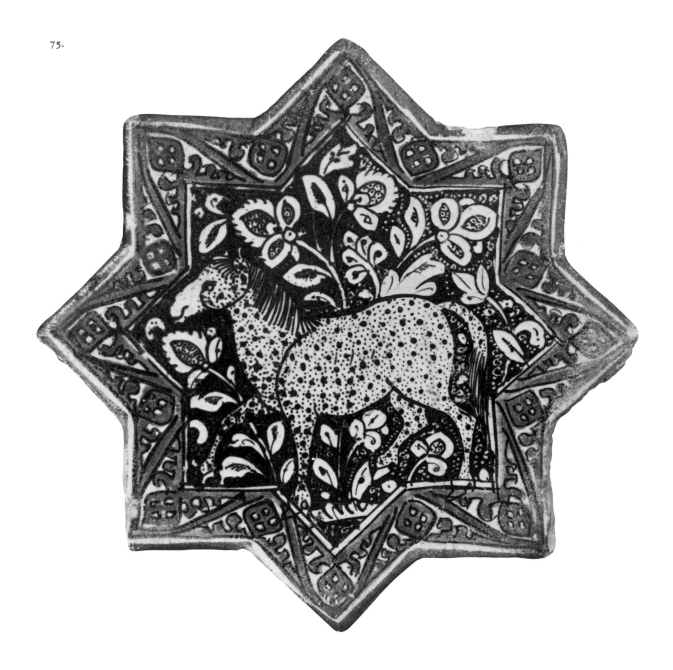

74.
Architectural Fragments
Persia (Kashan), 1250-1300
h: 15¾ in. (40 cm.); w: 15¾ in. (40 cm.)
M.73.5.221

Fragments of a luster revetment belonging to a
sacred building, arranged in the typical Seljuk
star-cross system usually used for palace decoration;
painted in coppery luster, the decoration reserved
on the luster ground and at the same time painted in
luster on the white opaque glaze; the stars and
the central diagonally-arranged cross decorated with
radiating arabesque motifs and filled with scroll
and dot patterns; the borders covered with Naskhi
inscription; in the corners are cross arms with
blue painted foliage in relief. Text of the *namaz*
(main Moslem prayer).

75.
Tile (illustrated)
Persia (Kashan) 1275-1300
d: 8¼ in. (21 cm.)
M.73.5.377

Octagonal luster tile belonging to a palace
revetment; the painting reserved on a dark brown
luster ground; in the center the rare motif
of a horse, walking from left to right; the body
densely spotted in the typical Kashan style;
indication of landscape in groundline and in more
realistic patterns of blossoming trees and plants,
inspired by Chinese art; the border of the star with
an unusual zigzag pattern in cobalt blue with
lozenge and scroll-like fillings.

76.
Tile
Persia (Kashan), 13th century
h: 6¾ in. (17.2 cm.); w: 9 in. (22.9 cm.)
M.73.5.750

Rectangular tile, part of a palace revetment;
turquoise glaze with high relief work; main panel
depicting several riders on an elephant, another
on a horse, a groom walking behind the elephant; in
the upper frieze walking animals, very likely
panthers confronting each other.

77.
Section of a Mihrab Border
Persia (Kashan), 13th century
h: 12¼ in. (31.2 cm.); w: 10 in. (25.4 cm.)
M.73.5.224

Part of the side border of a luster *mihrab* (prayer
niche); main panel with Thulth writing of
text from the Koran in high relief in cobalt blue
against arabesque tendrils reserved on the coppery
luster ground; framed by small chain borders;
the upper frieze with interlaced "split" palmettes
in high relief against the luster ground.

78.
Section of a Mihrab Border
Persia (Kashan), 13th century
h: 14½ in. (36.8 cm.); w: 12¼ in. (31.2 cm.)
M.73.5.223

Part of the side border of a luster *mihrab* (prayer
niche); elaborate knotted Kufic writing of
text from the Koran in high relief; painted in cobalt
blue, overlapping a lower layer of spiral-shaped
arabesque tendrils; splashes of turquoise
blue; background with scroll work reserved on
the luster ground.

79.
Crouching Man (illustrated)
Persia (probably Kashan), 13th century
h: 8⅛ in. (20.7 cm.); w: 5 in. (12.7 cm.)
M.73.5.361

Unusual type of Seljuk ceramic sculpture, probably
a type of pitcher, with a large hole in the neck,
two smaller holes in the head, and a spout in the
front; painted in coppery luster over white
opaque glaze; crouched figure holding the spout
with both hands; glaring eyes, moustache, big
tattoo marks, and long hair; *tiraz* bands with Kufic
writing; figure wearing pointed cap and garment
decorated with large contour lines and spiral-shaped
arabesque cartouches.

For a similar type of sculpture see Pope, *Survey,*
V, pl. 740.

80.
Musician (illustrated)
Persia (Kashan), 13th century
h: 5 in. (12.7 cm.)
M.73.5.191

Small figural sculpture of a seated musician; hollow
and open at the top of the head; probably used as a
container; outlines painted in black under light
blue glaze; iridescence.

81.
Section of a Mihrab Border
Persia (Kashan or Sultanabad), about 1300
h: 7⅞ in. (20 cm.); w: 16 in. (40.6 cm.)
M.73.5.142

Part of the side border of a luster *mihrab* (prayer
niche); Thulth writing of text from the Koran in
high relief; painted in cobalt blue; the ground
filled with spiral-shaped arabesque tendrils and
birds in realistic postures, inspired by Chinese
art, reserved on the luster ground; belonging to the
rare group of objects with figural motifs in
Seljuk-Mongolian sacred art.

Published: *Antiquities, Property of the Kevorkian
Foundation,* Parke-Bernet Galleries, New York,
April 28, 1970, fig. 118. For animal representations
in luster tiles see cat. nos. 91 and 97.

82.
Tile
Persia (Kashan), about 1300
d: 4½ in. (11.4 cm.)
M.73.5.374

Octagonal luster tile; the decoration reserved on
brownish luster; in the center of the figure
of a recumbent deer facing right, the body covered
with "Kashan dots"; surrounded by more
realistic flourishing branches, under Chinese
inspiration, the ground filled with scrollwork.

83.
Bowl
Persia (Kashan), 1200-1250
h: 3 in. (7.6 cm.); w: 7¾ in. (19.8 cm.)
M.73.5.256

Bowl with flaring sides and ring foot; translucent
turquoise glaze; the decoration reserved in a black
ground; the central medallion filled with a
recumbent deer facing left in the midst of trees
and branches; the upper part filled with a wide band
of pseudo-Kufic writing; below the rim a frieze
of animals — deer and panthers being pursued by a
hunting dog; a typical scene commonly found
in Seljuk art. Reverse: medallions with confronted
ducks in black under turquoise glaze; alternating
with Naskhi writing; at the bottom a lobed frieze.

For a bowl with similar reversed decoration dated
1219, see Pope, *Survey,* V, fig. 707B.

84.
Bowl
Persia (Kashan), 13th century
h: 3⅞ in. (9.9 cm.); d: 7¾ in. (19.7 cm.)
M.73.5.254

Bowl with flaring sides and ring foot; painted
under translucent turquoise glaze in black with
cross-shaped stripes, filled with reserved
pseudo-Naskhi writing on the black ground;
alternating with seaweed patterns. Reverse
with seaweed branches.

85.
Bowl
Persia (Kashan), 13th century
h: 3½ in. (8.9 cm.); d: 7½ in. (19 cm.)
M.73.5.273

Bowl with flaring sides and ring foot; painted
under translucent turquoise glaze in black with
cross-shaped stripes, filled with reserved
pseudo-Naskhi writing on the dark ground;
alternating with seaweed patterns.

86.
Jug
Persia (Kashan or Sultanabad), 1250-1300
h: 7⅜ in. (18.7 cm.)
M.73.5.385

Globular body, vertical buttoned handle, high foot,
straight offset neck with ring between neck and
body; painted in black under translucent turquoise
glaze, irregularly running and only partially
covering the foot in the Chinese manner; the body
covered with a seaweed frieze, the neck with
a double line of stylized fish in vivid motion; for
their origin and symbolic meaning see cat. no. 64.

80.

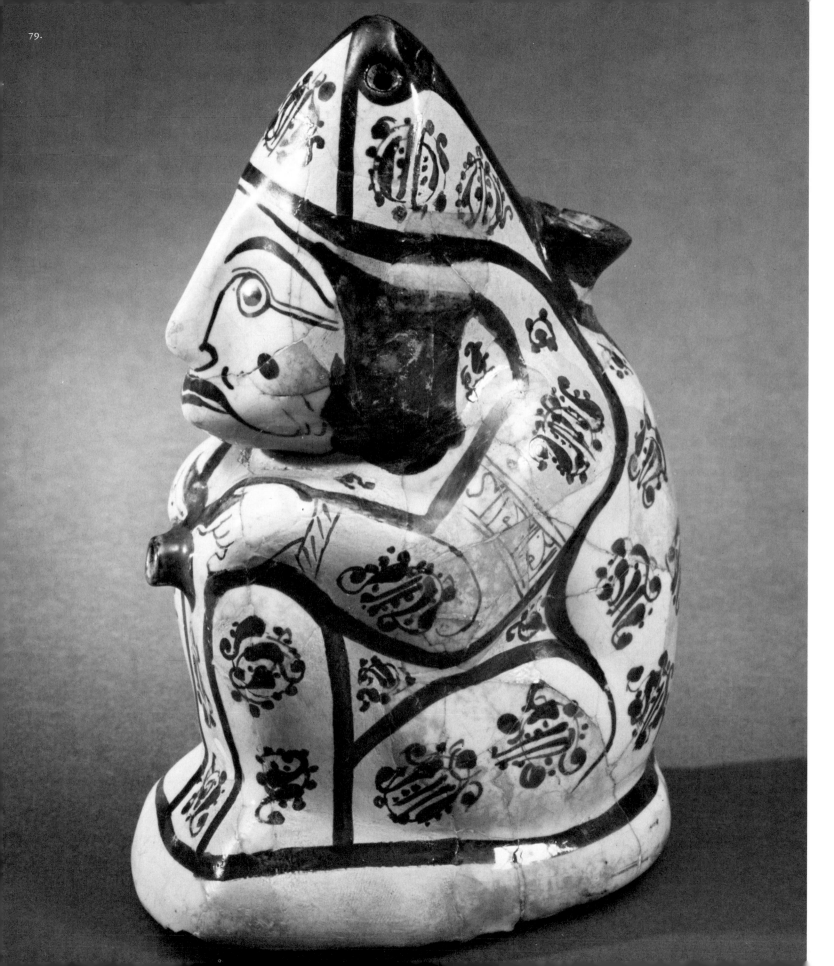

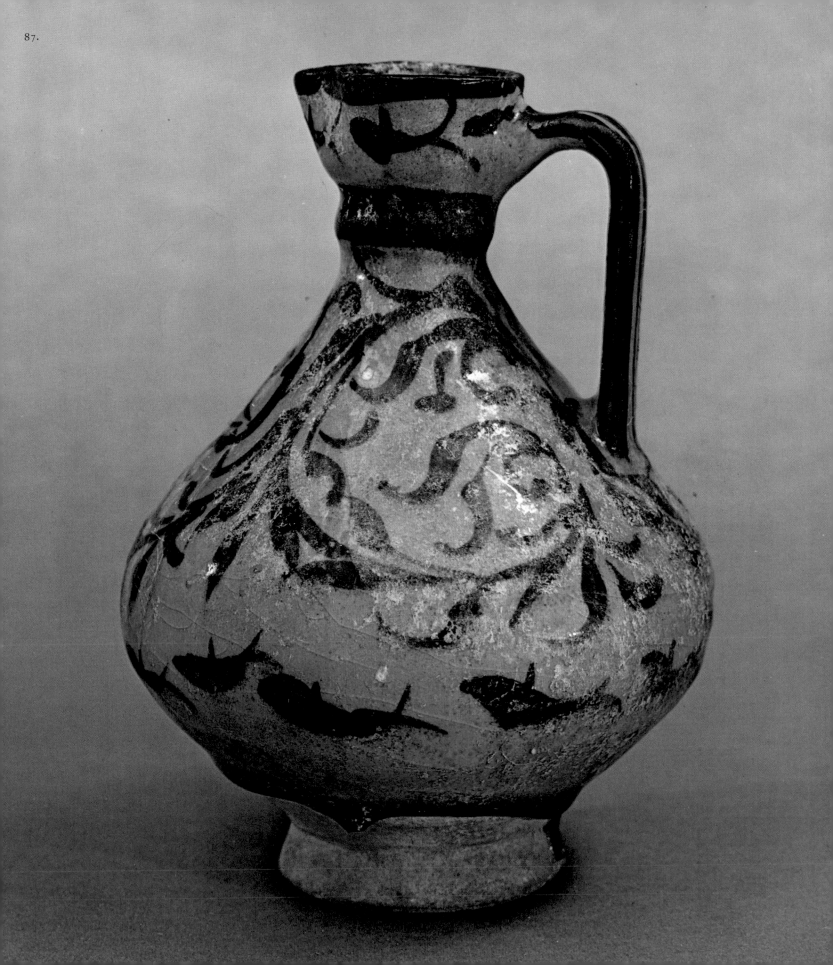

87.
Jug (illustrated)
Persia (Kashan or Sultanabad), 1250-1300
h: 6 in. (15.2 cm.)
M.73.5.258

Pear-shaped jug with vertical handles, ring-like
swelling around the neck, pinched lip and high foot;
painted in black under translucent turquoise
glaze, irregularly running without covering the foot
in the Chinese manner; the body decorated with
seaweed spirals; friezes of stylized fish in vivid
motion around the neck and on the lower part
of the body; for their origin and symbolic meaning,
see cat. no. 64.

For similar ware with a school of fish see
A. Lane, *Early Islamic Pottery,* fig. 91.

88.
Jug
Persia (Kashan or Sultanabad), 13th century
h: 7 in. (17.8 cm.)
M.73.5.359

Pear-shaped jug with tall handle and high foot;
painted under colorless glaze running irregularly
without covering the foot; decorated with
densely arranged cobalt blue stripes, the neck
decorated with reserved Naskhi writing on
the blue background.

89.
Jug
Persia (Sultanabad), 1200-1250
h: 10 in. (25.4 cm.)
M.73.5.194

Pear-shaped jug with straight offset neck; painted
under translucent turquoise glaze in black; the body
decorated with hatched and dotted stylized
flower trees; the neck filled with flower medallions
and half-palmettes, encircled by two bands of
pseudo-Naskhi writing, reserved in a black ground;
in the lower part a double line of fish, for their
symbolic meaning compare cat. no. 64; peeling of
glaze at foot indicates this might have been a waster.

90.
Bowl
Persia (Sultanabad), 1250-1300
h: 3⅞ in. (9.9 cm.); d: 8 in. (20.3 cm.)
M.73.5.384

Bowl with flaring sides and ring foot; painted in
black under translucent turquoise glaze; decorated
with a hatched and dotted stylized flowering tree.

94.

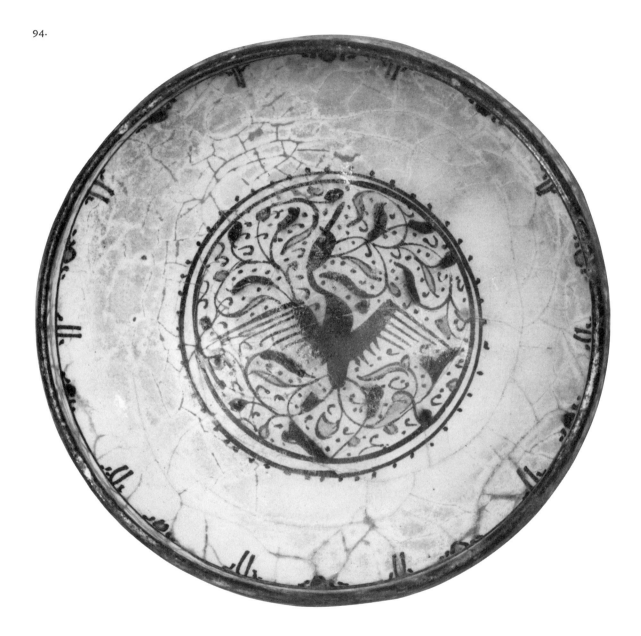

96.

91.
Bowl
Persia (Sultanabad), 1275-1300
h: 3½ in. (8.9 cm.); d: 8¼ in. (20.7 cm.)
M.73.5.267

Bowl with flaring sides and ring foot; painted with
spiral-shaped and dotted arabesque tendrils
against a ground of tiny scrolls; with black outlines
under clear glaze on a greyish background.

92.
Bowl
Persia (Sultanabad), about 1300
h: 2⅝ in. (6.7 cm.); d: 5½ in. (14 cm.)
M.73.5.185

Bowl with flaring sides and ring foot; white body;
cobalt-blue painting under transparent glaze;
almost translucent; decorated with a monumental
five-petalled flower in Chinese style; the wedges
filled with pierced transparencies in a leaf pattern;
below the rim appear criss-cross motifs. Islamized
imitation of Chinese porcelain.

93.
Bowl
Persia (Sultanabad), about 1300
h: 3½ in. (8.9 cm.); d: 7½ in. (19 cm.)
M.73.5.216

Bowl with flaring sides and ring foot; decorated in
greyish black under clear glaze; with a large
central medallion filled with radiating lozenges,
surrounded by smaller dotted medallions
and three-lobed motifs; the ground filled with
scroll motifs.

94.
Bowl (illustrated)
Persia (Sultanabad), about 1300
h: 3⅝ in. (9.2 cm.); d: 8¼ in. (21 cm.)
M.73.5.190

Bowl with flaring sides and ring foot; painted under
clear glaze in black and pale blue; the central
medallion decorated with a soaring goose in between
spiral-shaped tendrils; strongly under Chinese
influence in style and meaning, the bird expressing
good luck for the owner; rim with pseudo-Kufic
frieze.

95.
Bowl
Persia (Sultanabad), 1300-1325
h: 4 in. (10.2 cm.); d: 8½ in. (21.5 cm.)
M.73.5.215

Bowl with flaring sides and ring foot; painted in
black and raised with white or grey slip; four
phoenixes soaring between Chinese foliage; the
outside decorated with a motif of colonnades.

96.
Bowl (illustrated)
Persia (Sultanabad), 1300-1325
h: 3½ in. (8.9 cm.); d: 8⅜ in. (21.3 cm.)
M.73.5.297

Bowl with flaring sides and ring foot; painted in
black and raised with white on grey slip;
central medallion with stag walking from right
to left amid a landscape with flowering
bushes. Chinese lotus flowers and a ground line;
the upper part filled with the Chinese motif of
soaring geese and Chinese foliage.

97.
Section of a Mihrab Border (illustrated)
Persia (Sultanabad), 1300-1350
h: 15 in. (38.1 cm.); w: 14 in. (35.6 cm.)
M.73.5.143

Part of the side border of a luster *mihrab* (prayer
niche); Thulth writing of text from the Koran in
high relief, painted in cobalt blue; the ground
filled with spiral-shaped foliage and animals — birds,
fox, and hare — in realistic postures reflecting
Chinese influence, reserved on the coppery luster
ground; frieze with Chinese phoenix flying
from left to right, painted in blue; belonging to
the rare group of objects with figural motifs
in Seljuk-Mongolian sacred art. Cf. cat. no. 81.

Published in *Antiquities, Property of the Kevorkian
Foundation,* Parke-Bernet Galleries, New York,
April 28, 1970, fig. 27.

For other examples of animal representations in
mihrab tiles, see R. Ettinghausen, "Evidence for
the Identification of Kashan Pottery," *Ars
Islamica,* 1936, III/1, figs. 1 and 5; *Sept Mille
Ans d'Art en Iran,* October 1961-January 1962,
pl. CXIII; Binney, *Islamic Catalogue,* fig. 83.

98.
Dish (illustrated)
Persia (Garrus District), 11th-12th century
h: 2 in. (5.1 cm.); d: 9½ in. (24.2 cm.)
M.73.5.213

Dish with a flat rim; decoration in "champlevé"
technique against a black background in green lead
glaze; central rectangular cartouche with
palmette design; on the rim angular Kufic writing
against a hatched background.

98.

99.
Plaque
Persia (Garrus District), 11th-12th century
h: 8¾ in. (22.3 cm.); w: 8¾ in. (22.3 cm.)
M.73.5.218

Square plaque with central hole; decorated in
"champlevé" technique against a black background
in green lead glaze; belonging to a wall revetment
in which the holes served as light fixtures;
angular flourishing Kufic against arabesque tendrils.

For a similar piece, see Pope, *Survey*,
V, pl. 613.

100.
Bowl
Persia (Garrus District), 11th-12th century
h: 6⅞ in. (17.5 cm.); d: 13⅞ in. (35.3 cm.)
M.73.5.263

Large deep bowl with flaring sides and ring foot;
decoration in "champlevé" technique against a
brown background under cream yellowish lead
glaze, with turquoise patches; monumental figure
of a sphinx walking from left to right, the
right paw lifted, tattoo marks on face and body,
double-stranded necklace; flanked by two
small panthers, appearing upside down; Kufic
device above the left panther.

For the topic of Seljuk sphinx, see E. Baer,
Sphinxes and Harpies in Medieval Islamic Art;
compare especially a similar piece, fig. 18;
For a similar piece, see C. L. A. Leth, *C. L. David's
Samling af Islamic Keramik* (Copenhagen, 1948),
fig. 77A.

101.
Bowl
Persia (Amol), 13th century
h: 3¾ in. (9.5 cm.); d: 6½ in. (16.5 cm.)
M.73.5.220

Bowl with flaring sides and high ring foot;
decorated in *sgraffiato* technique and painting in
olive green and brown under cream yellowish
glaze; central cross design with hatched *sgraffiato*
patterns inside; wedges filled with hatched
medallions and dot motifs.

102.
Bowl
Persia (Amol), 13th century
h: 3⅛ in. (7.9 cm.); d: 7½ in. (19 cm.)
M.73.5.150

Bowl with flaring sides and ring foot; decorated
in *sgraffiato* technique and painting in olive green
and brown under cream yellowish glaze; sides
decorated with flower-like motifs surrounded by
dotted bands; the wedges filled with wavy
lines and dots; wavy lines surrounding inner circle
filled with a stylized bird (?).

103.
Bowl (illustrated)
Persia, 10th-11th century
h: 3¼ in. (8.3 cm.); d: 7¼ in. (18.4 cm.)
M.73.5.253

Bowl with flaring sides and ring foot; *sgraffiato*
(incised) decoration imitating metalwork
under cream yellowish lead glaze; green rim;
in the central medallion a stylized bird
with a cross design behind, against a hatched
background; the sides densely filled with
scale patterns.

104.
Bowl
Persia, 11th century
h: 3¼ in. (8.3 cm.); d: 7¼ in. (18.4 cm.)
M.73.5.132

Bowl with flaring sides and ring foot; *sgraffiato*
(incised) decoration under cream greenish
lead glaze; rim and inside two splash-like stripes
painted in green; stylized birds alternating
with tree-like motifs.

105.
Section of a Mihrab Border (illustrated)
Persia, about 1300
h: 13¼ in. (33.6 cm.); w: 12¾ in. (32.4 cm.)
M.73.5.260

Part of the side border of a *mihrab* (prayer niche);
lajvardina ware painted and partly gilded over
cobalt blue *(lajverd)* glaze with white scrolling
foliage and Thulth inscription in high relief with
red contour lines; upper frieze with Chinese
lotus flowers in relief.

103.

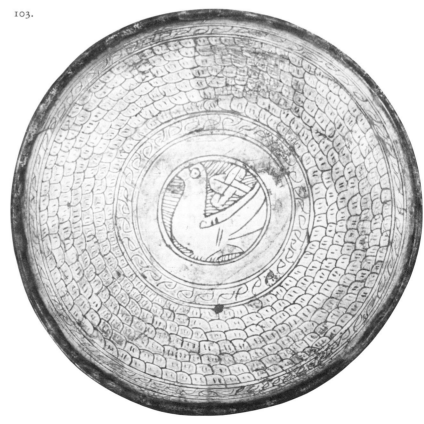

106.
Tile (illustrated)
Persia, 14th-15th century
h: 15¾ in. (40 cm.); w: 10¼ in. (26 cm.)
M.73.7.5
Gift of Nasli M. Heeramaneck

Curved tile, probably architectural fragment of the
Mongol period painted in *cuerda secca* (enamel)
technique; large floriate Kufic letters in white and
palmettes and tendrils in turquoise with white
specks on deep blue ground.

107.
Bowl (illustrated)
Syria (Damascus), 14th century
h: 3¼ in. (8.3 cm.); d: 6¼ in. (15.9 cm.)
M.73.5.219

Bowl with flaring sides, convex shoulder, and ring
foot; painted in cobalt blue and black under
colorless, strongly iridescent glaze, typical for Syrian
products; in the central medallion a blue-colored,
eight-petalled flower with black radiating stalks and
feather-like leaves; the shoulder decorated with
intertwined circles.

108.
Bowl
Syria (Damascus), 14th century
h: 3½ in. (8.9 cm.); d: 5⅝ in. (14.3 cm.)
M.73.5.358

Bowl with flaring sides and ring foot; painted in
cobalt blue and black under colorless, strongly
iridescent "Syrian" glaze; in the center a medallion
with a cobalt blue colored, six-petalled flower
with white contour lines; between the petals
stamen-like patterns ending in balls.

Safavid Ceramics (16th-18th century)

109.
Wine Bottle (illustrated)
Persia (perhaps Shiraz or Kashan), 1650-1700
h: 8½ in. (21.6 cm.)
M.73.5.196

Typical Safavid shape; pear-shaped, long neck and
ring foot, double band separating body and
neck; painted with coppery luster on turquoise
glaze; body decorated with feathery branches,
flowering bushes, and iris plants.

107.

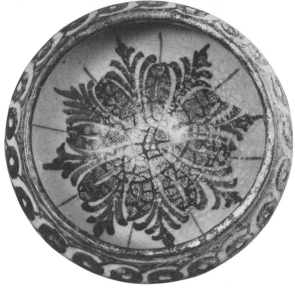

109.

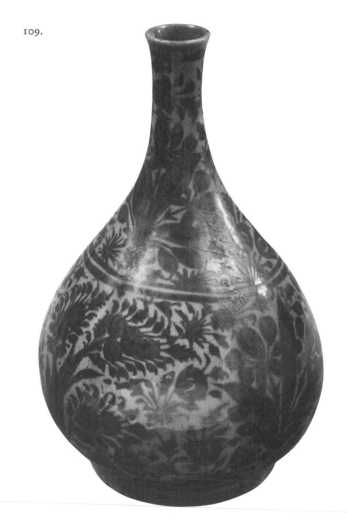

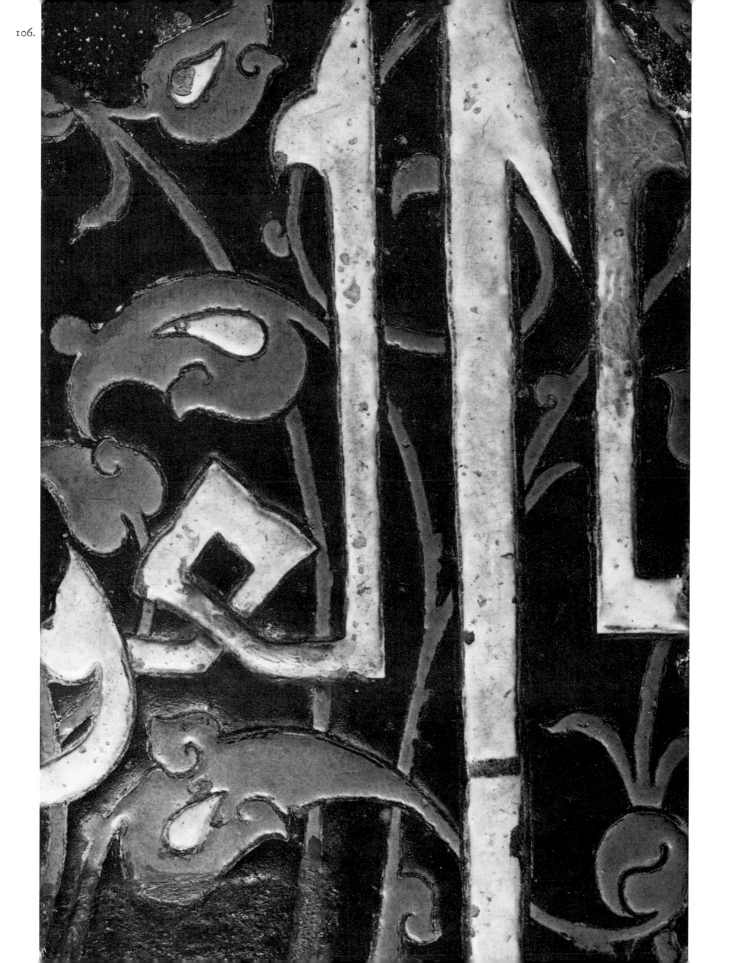

III.

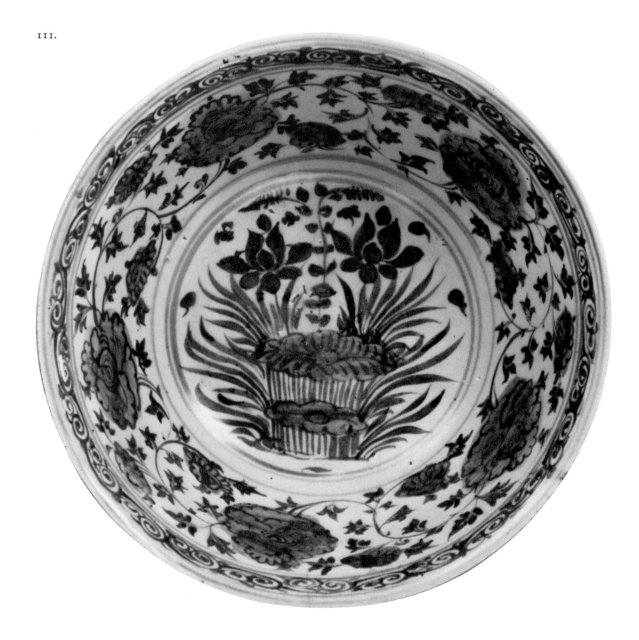

114.

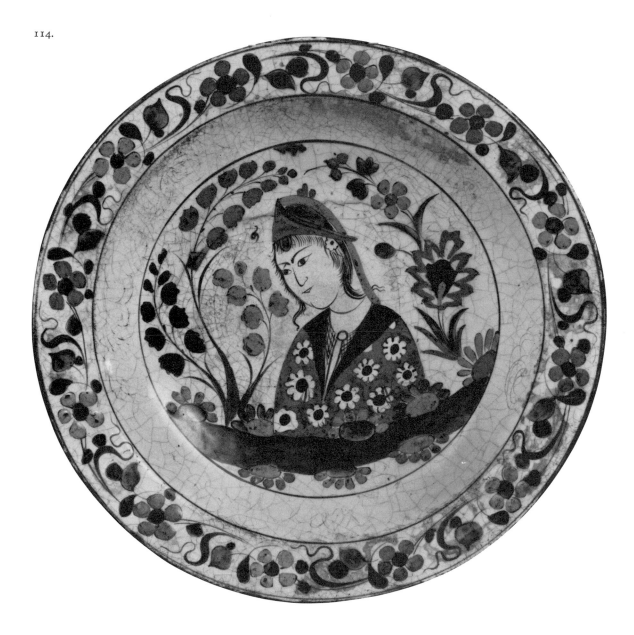

110.
Vase
Persia (perhaps Shiraz or Kashan), 1650-1700
h: 4 in. (10.2 cm.)
M.73.5.193

Globular-shaped with short flaring neck and
ring foot; coppery luster on opaque white glaze;
decorated with tendrils culminating in
chrysanthemum-like flower, surrounded by feathery
long leaves.

111.
Bowl (illustrated)
Persia (Meshed), 1600-1650
h: 5⅛ in. (13 cm.); d: 12⅞ in. (32.7 cm.)
M.73.5.351

Bowl with flaring sides and ring foot; painted in
soft cobalt blue on white ground under clear
glaze; strongly under the influence of Chinese "Blue
and White" Ming ware; central medallion with
two stylized tree stumps, Chinese lotus flowers, and
wavy leaves, surrounded by a frieze of flower
tendrils with stylized Chinese peonies; under the
rim is a border with stylized Chinese cloud scrolls.

112.
Vase
Persia (Meshed), 1600-1650
h: 4⅛ in. (10.5 cm.)
M.73.5.378

Globular-shaped with convex shoulder and flaring
neck and ring foot; in between body and shoulder,
collar in relief; body decorated with vine leaf-like
tendrils or flowers reserved in white against
cobalt blue ground; intense black outlines; on the
neck spiral-shaped tendrils; glaze running
irregularly in the Chinese manner without covering
the foot; strongly under Chinese influence.

For a piece with similar decoration see A. Lane,
Later Islamic Pottery, fig. 80 a.

113.
Dish
Persia (Meshed), 1600-1650
h: 3⅞ in. (8.6 cm.); d: 17⅜ in. (44.2 cm.)
M.73.5.276

Dish with flaring sides and ring foot; painted in
cobalt blue on white background under clear glaze;
in the center lobed cartouche motif filled with
peony branches, surrounded by peony bushes and
feathery leaves, the latter echoing Ottoman Iznik
patterns; indication of ground line and stones;
strongly under Chinese influence.

114.
Dish (illustrated)
Persia (Kubachi), about 1600
h: 2¾ in. (9.5 cm.); d: 13¾ in. (35 cm.)
M.73.5.380

Flat-rimmed dish; polychrome painting in reddish
brown, light brown, cobalt blue, "copper green,"
and black under clear glaze; bust portrait of a
woman in three-quarter view with a veiled cap and
lapelled dress decorated with flower patterns;
indication of landscape with river in foreground and
blossoming branches; the rim filled with flower
tendrils and wavy bands.

Similar piece see E. Kuhnel, *Islamische Kleinkunst*
(Braunschweig, 1963), fig. 82.

115.
Dish
Persia (Kubachi), about 1600
h: 2½ in. (6.3 cm.); d: 13⅜ in. (34 cm.)
M.73.5.244

Flat-rimmed dish with narrow foot; polychrome
painting in cobalt blue, reddish brown, light brown,
turquoise, and green; two figures in profile walking
from left to right in a rhythmic movement with
out stretched hands; wearing pointed caps and long
kaftan-like dresses; landscape indication by
means of hilly ground-line and growing, flourishing
trees, framing the scenery; rim covered with
flowering bushes.

116.
Plate
Persia (Kubachi), about 1600
h: 2½ in. (6.3 cm.); d: 13 in. (33 cm.)
M.73.5.379

Bowl with flaring sides and ring foot; central
medallion decorated in polychrome colors with a
landscape scene with a hilly ground — repeated
above in mirror-image effect — flourishing trees, and
a pair of quails below; the same motifs repeated
three times in the decoration of the sides.

117.
Tile Panel (illustrated)
Persia (Isfahan), 17th century
h: 45¼ in. (114.9 cm.); w: 41½ in. (105.4 cm.)
M.73.5.4

Spandrel of a doorway, part of a palace revetment;
painted in *cuerda secca* (enamel) technique in
blue, green, turquoise, white, and black on yellow
ground; a dramatic scene in a realistically rendered
landscape of a lion attacking an antlered bull;
surrounded by blossoming trees, lilies, and leafy
bushes and Chinese cloud motifs; birds in lifelike
attitudes in the trees; border filled with palmette
tendrils on a blue ground; probably the illustration
of the fight between the Lion King and the bull
Shanzaba in Bidpai's *Kalila va Dimna.*

See B. Gray, *Persian Painting* (Geneva, 1961),
pp. 78 and 82. Compare a similar dramatic
rendering of the same scene in an Ottoman Isnik
bowl in *Museum für Islamische Kunst Berlin,* no. 75,
(cat. no. 571). Compare also for the lion-bull
fight in general, W. Hartner-R. Ettinghausen, "The
Conquering Lion, the Life Cycle of a Symbol,"
Oriens, 17 (1964).

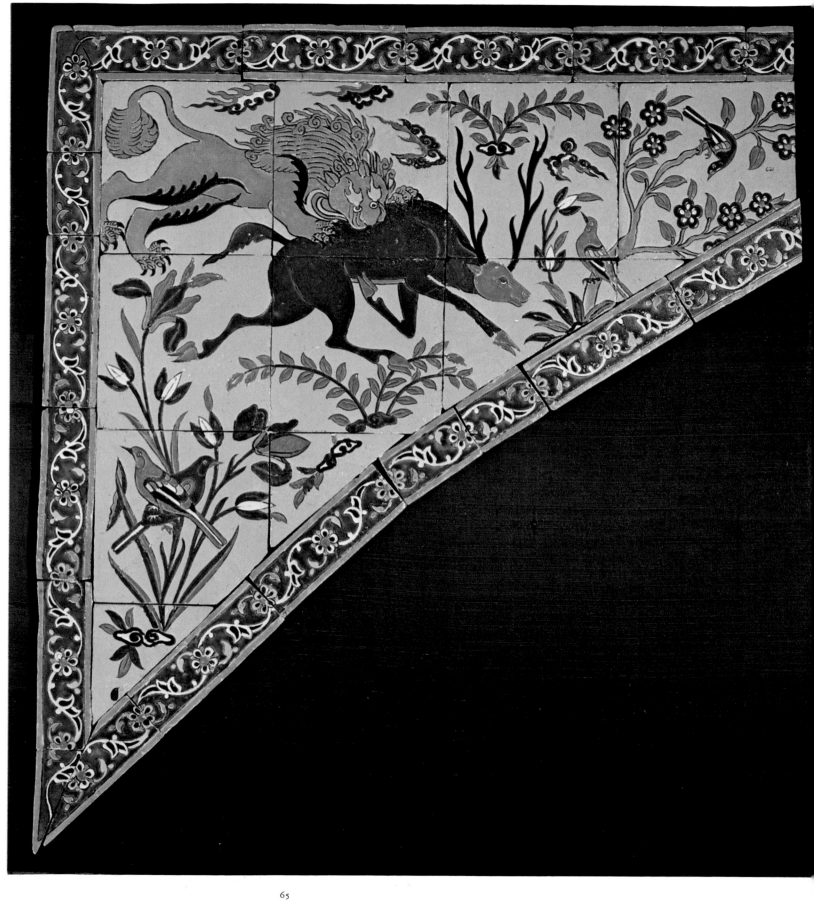

118.
Tile Panel
Persia (Isfahan), 17th-18th century
h: 18 in. (45.7 cm.); w: 18 in. (45.7 cm.)
M.73.5.759-762

Architectural segment of four square luster tiles
painted in enamel technique; violet, white,
yellow, blue, green, and deep brown flowers and
split-palmettes arranged in a symmetrical
design on cobalt blue ground.

119.
Tiles
Persia (Isfahan), 18th-19th century
h: 9¼ in. (23.5 cm.); w: 18½ in. (47 cm.)
M.73.5.756 and 757

Pair of square and matching luster tiles, parts of
a domestic building; painted in *cuerda secca*
(enamel) technique; bouquet of flowers and flying
birds; painted in blue, turquoise, green, yellow,
black, and brown on white.

120.
Tile Panel
Persia (Isfahan) (Kajar style), 19th century
h: 13½ in. (34.3 cm.); w: 13½ in. (34.3 cm.)
M.73.5.782

Group of small, multicolored glazed tiles arranged
concentrically around a larger square tile like
a mosaic panel; central square adorned with an
inscription, geometrical forms and interlaced
split-palmettes in relief technique; light blue,
brown, and grey.

Ottoman (Isnik) Ceramics (16th-17th century)

121.
Tile
Turkey (Isnik), 16th century
h: 9½ in. (24.2 cm.); w: 9½ in. (24.2 cm.)
M.73.5.755

Square tile; probably from a mosque; parts of
writing in white against cobalt blue in the upper
band, separated from the lower by a narrow
strip of red; sprays, feathery designs, and cloud
patterns in the lower band; cobalt blue, red, white,
and green.

122.
Tiles
Turkey (Isnik), 16th century
h: 39¾ in. (101 cm.); w: 12¼ in. (31.2 cm.)
M.73.5.28 a, b, c

Three square tiles; parts of rectangular wall
revetment; main field decorated with flowers and
leafy sprigs as well as bands of flowers shaped
into billowing cartouches; blues, greens, and Bolus
red against a greyish white and cobalt blue
background.

123.
Tiles
Turkey (Isnik), 16th century
Each:
h: 9½ in. (24.2 cm.); w: 9⅛ in. (23.2 cm.)
M.73.5.751-752

Two square tiles; parts of wall revetment; each
tile divided into two unequal bands; the broader
bands decorated with speckled flowers and leaves
in Bolus red and three shades of blue (dark,
turquoise, and lavender) on greyish white ground,
the narrower band has stylized flowers, buds,
and tendrils in turquoise, Bolus red, and white
against cobalt blue ground.

124.
Tile (illustrated)
Turkey (Isnik), 1550-1600
h: 29½ in. (75 cm.); w: 52¾ in. (134 cm.)
M.73.5.6

Rectangular tile; revetment of a mosque; Thulth
writing in white against deep cobalt blue
background under clear glaze; fillings with flower
rosettes, feathery leaves, and half-palmettes in
Bolus red, cobalt blue, green, and white; the border
decorated with palmette and flower tendrils
against a Bolus-colored ground.

124.

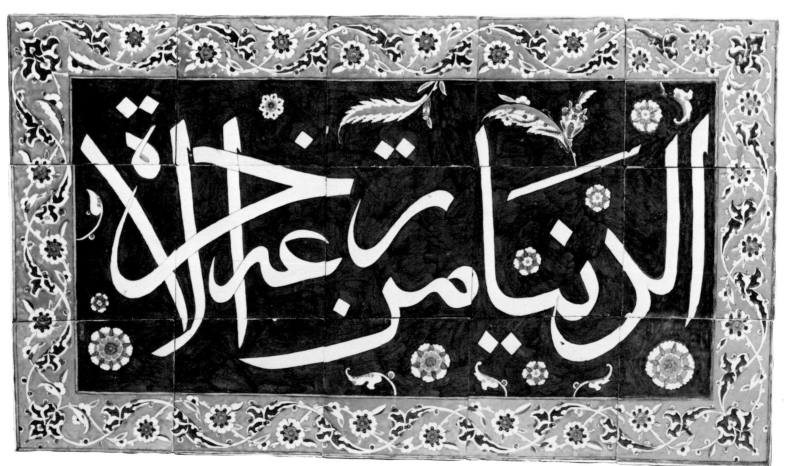

125.
Tile
Turkey (Isnik), 16th century
h: 9¾ in. (24.8 cm.); w: 10 in. (25.4 cm.)
M.73.5.754

Square tile; part of wall revetment; main field
decorated with floral motifs dominated by a red
half-palmette; red, three shades of blue, and
green on greyish white background.

126.
Tiles
Turkey (Isnik), 1650-1700
h: 61¼ in. (155.6 cm.); w: 22¾ in. (57.8 cm.)
M.73.5.763-780

Together this group of tiles make a complete
section of a wall embellishment; main field
decorated with lobed, intertwined cartouches of
flowers and feathery leaves which spring from
a cup at the bottom; border with white half-palmette
tendrils against cobalt blue ground; color palette
restricted to two shades of blue and green;
background in greyish white.

127.
Tile
Turkey (Isnik), 1650-1700
h: 23½ in. (59.7 cm.); w: 23½ in. (59.7 cm.)
M.73.5.27

Square tile; part of wall revetment; main field
decorated with lobed cartouches, flowers, and
feathery leaves; complete composition is composed
of symmetrically arranged lozenge patterns; color
palette restricted to two shades of blue and
green; background in greyish white; the border
with white half-palmette tendrils against
cobalt blue ground.

128.
Dish (illustrated)
Turkey (Isnik), about 1555-1560
h: 2¾ in. (7 cm.); d: 13⅜ in. (34 cm.)
M.73.5.381

Flat-rimmed dish; wavy edge echoing Chinese
porcelain; painted over a bright white slip in
cobalt blue, "copper green," and the typical Isnik
Bolus red, applied in a slip relief under clear
brilliant glaze; the ground filled with loose,
asymmetrically arranged plants, peonies, and
tulips in elegant curves, and the typical
Ottoman long feathery leaves overlapping each
other; outlined in an intense black; the whole
decoration typical of the new realistic Ottoman
flower style; the rim covered with a Chinese
cloud-scroll motif.

For a similar piece see A. Lane, *Later Islamic
Pottery,* fig. 40b.

129.
Jug
Turkey (Isnik), 1570-1580
h: 8½ in. (21.6 cm.)
M.73.5.257

Jug in a characteristic Ottoman shape; pear-shaped
body, flaring neck, ring foot, S-shaped handle,
narrow band separating body and neck; painted over
bright white slip in cobalt blue, olive green, and
Bolus red under clear glaze; with loosely arranged
windblown tulips and hyacinths (cf. cat. no. 109),
shoulder and neck border filled with zigzag and
scroll motifs.

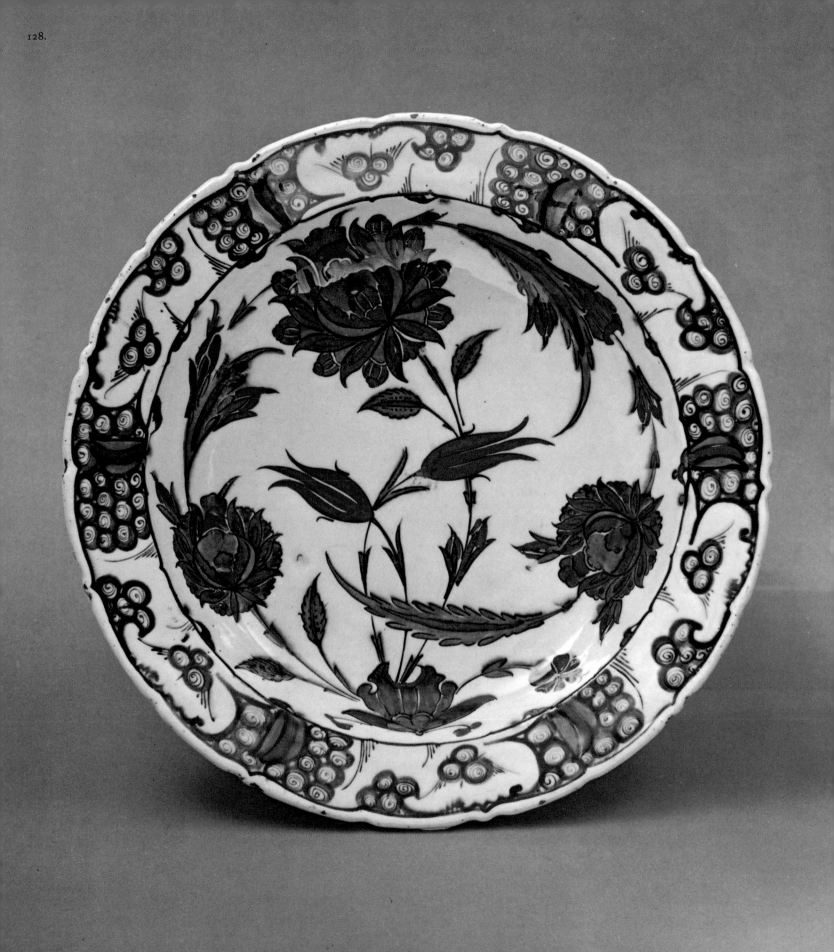

Edwin Binney, 3rd
Fellow for Research in Indian and Islamic Art

Calligraphy has always ranked foremost among the arts of the Islamic
book. For a Westerner, the term artist usually connotes painter first, and,
more specifically, a painter in oils. Beautiful penmanship ranks low
in the artistic hierarchy of Europe. Such is not the case for the Muslim
art connoisseur for whom beautiful calligraphy ranks above painting,
however magnificent. The reason is twofold — chronological and
religious. Even though painting was not absolutely prohibited in the
Koran, it was considered a usurpation of the creative principle of
God and, therefore, had the taint of idolatry. For this reason, the earliest
Islamic decoration was based solely on geometric designs and patterns
derived from vegetation.

The earliest aesthetic activity of the artists of the book was the
copying of the Koran. To recreate or copy the word of God as revealed
by the Prophet Muhammad was a task of religious merit and superior
aesthetic value. The painting of miniatures to accompany secular
texts — the Holy Book of Islam was never illustrated — first occurred at
a later date, after calligraphy had already established artistic hegemony.

The leaves from these first Korans were written on vellum or
parchment, made from animals skins. Paper, which began to be used
sparingly in the Islamic East from about the eight century, did not
completely surplant vellum for several centuries.

The earliest scribes used a style of writing called Kufic, after the town
of Kufa in Southern Mesopotamia. The earliest dated Koran
(eighth century, preserved in Cairo) used this script, as did contemporary
or slightly later examples. The thick, rounded letters feature
pronounced horizontals but short verticals. The evolution of complex
patterns brought about elaborate *unwans* (chapter headings) and
other decoration in gold, like the rosettes which marked the end of each
verse, and, somewhat later, the diacritical marks in colors, most often
in red. Further changes included the horizontals becoming more
angular and a growing insistence on the verticals. Kufic script was never
completely superceded in Islam. Its simple monumentality was suited
particularly to inscriptions and strong architectural decoration —
both in stucco and tile — as well as in ceramics.

cat. nos. 130-143

see particularly
cat. no. 140

Islamic calligraphers have continuously wrestled with the problem
of bypassing the stark, "four-square" qualities of Kufic script. They
evolved a "flowery" variation of it in which each stroke ended in
trefoils or other foliated decoration. One version was not even true
writing but only "pseudo-Kufic." The letters were there used for the
aesthetic value of their juxtaposition and are illegible.
("Pseudo-Kufic" was used mainly in pottery.)

The dominance of Kufic coincided with the importance of the
Abbasid Caliphate with its capital at Baghdad (A.D. 750-1258).
Despite periods when quasi-independent viceroys challenged the
political supremacy of their religious overlords, the caliphs, the
geographical area from Egypt into Persia comprised a unified artistic
region. It is particularly difficult, therefore, to attribute a precise
provenance for the early Islamic manuscripts in Kufic. Thus, in the
catalog these have been assigned simply to "Abbasid Caliphate."

Other experimentation produced more cursive scripts. Thulth and
Naskhi gradually supplanted Kufic as the script in which the Korans

cat. nos. 144-147

were written although some examples exist of Kufic *unwans* separating the Thulth text. The Cairene ateliers of the Mamluk Sultans (1250-1517) produced excellent calligraphers, as well as illuminators, who created the fine geometric patterns which appear at chapter headings and opening pages. Their products, the *unwans* and *shamsas* (introductory roundels), rivaled the most beautiful of the calligraphers' scripts.

cat. nos. 150, 151, 153, 156-159, 161, 163, 165, 168, 173

The apogee of elegant cursive writing was Nastaliq, a style of script reputedly invented by the famous scribe Mir Ali of Tabriz in the fifteenth century. It completely superceded all other kinds of calligraphy for the writing of the literary texts which included painted miniatures.

During the sixteenth and seventeenth centuries, collectors assembled albums with examples of both painting and calligraphy. Nowhere does Islamic art seem further from Western aesthetic canons than in the magnificent album leaves with panels of writing by the greatest of the Muslim calligraphers. In the most successful examples, the scribe and the decorator of the illuminated borders have produced a single, integrated masterpiece.

see particularly cat. nos. 171, 172, 174-179

Nastaliq remains the artistic culmination of Islamic calligraphy. It was used in ink, in colors, even in "cut-outs" glued onto contrasting backgrounds — the elegant *"découpé* work." Later experimentation produced greater complexity and derivations like *shikasta* which in no way detract from its sophisticated elegance. Indeed, so immediately does Nastaliq communicate that the Muslim who can understand the meaning of the written text gains no higher aesthetic message than his "illiterate" Western counterpart who is only able to judge the artistry of the result.

cat. no. 154
cat. no. 183

Painting
Arab Painting

The lack of a proper term to designate the oldest non-Persian miniature paintings of Islamic origin hampered the earliest scholars who wished to present a survey of that artistic tradition. The "Mesopotamian School" or "School of Baghdad," terms originally used to describe the first miniatures known from the twelfth and thirteenth centuries, were applicable only to the pictures by the artists of the Abbasid Caliphate. "Mamluk," as descriptive of works made in Egypt under various independent Mamluk Sultans from 1250 to 1517, was apt only for the Cairo ateliers. However, by extension the term could also include the artistic products of Syria after that province fell to the Mamluks. But, earlier Syrian works before the Mamluk takeover in the Levant could hardly be labelled "Baghdadi." With the additional complication of the presence of other centers of production in West Africa and Spain, as well as late works descended from the traditions of all of these earlier non-Iranian schools, the necessity for an all-embracing term was obvious.

It was not until 1962 that the problem of terminology was solved by Richard Ettinghausen with his publication entitled *Arab Painting.* The author in his preface explained that his title had supra-geographical significance, embracing all of Islam except where the earlier Persian traditions had remained strong enough to exclude it. Despite the extensiveness of Ettinghausen's subject — which ranges from a study of courtly sophistication to an examination of the later fumbling attempts to revivify the stagnating tradition — he finds that examples of "Arab painting" are extremely rare and not always subject to ironclad attribution.

Oldest of the miniatures in the Los Angeles collection are a group
of nine leaves from an unidentified manuscript in Arabic. The cat. no. 184
paintings are coarse and extremely schematic. They appear to be from
Fustat, in the remains of Old Cairo, and may be as early as the
eleventh or twelfth century. They may also be later copies
or adaptations of an earlier prototype, either from Cairo or some
provincial backwater like the Yemen, known to have produced copies
of earlier works even as late as the seventeenth century. The
diagrams seem to have medical or astrological meaning.

Next in importance are two leaves from an herbal. They are similar cat. no. 185
to illustrations from various manuscripts of the *De Materia Medica* of
Dioscorides, of which the best known, minus many of its most complex
pictures, remains in the Topkapu Saray in Istanbul.[1] The date of its
colophon corresponds to A.D. 1224. The presence of many of the leaves
detached from it in European and American collections originally
gave rise to the use of the title "School of Baghdad" for these early
miniatures.

Similar to illustrations from two manuscripts presenting the diagrams
of the *Automata* of al-Jaziri,[2] with colophons dated A.D. 1315 and
1354, is the slightly smaller and more delicate Los Angeles example. cat. no. 186
The survey of didactic work from the studios of "Arab painting"
is completed by an important leaf depicting several cosmological
subjects on its recto and verso. The didactic approach taken by early cat. no. 187
Islamic literature was perpetuated later in Persia and elsewhere in
the Arab world. The sixteenth-century Persian leaf, probably from
Qazvini's *Ajaib al-Makluqat,* retains an "Arab" quality despite its
chronological inclusion among works of Persian schools. cat. no. 223

Persian Painting, A.D. 1300-1450

Hulagu, grandson of Genghiz Khan and brother of Marco Polo's
Khublai, founded a dynasty which reigned over Persia and
Mesopotamia after the sack of Baghdad in 1258. He and his
descendants were called the Il Khans (deputy Khans) and owed a
titular allegiance to their overlord relatives, first in Karakorum, later
in Peking, China. They soon established complete independence
and rapidly became Persianized.

The earliest extant illustrated manuscript that is specifically Persian
rather than "Arab" is a *Manafi al-Hayawan* dated 1297-1299. It is from
the reign of Ghazan Khan, first of the Il Khan rulers to embrace
Islam. There is another group of manuscripts, from the beginning of
the fourteenth century — now dispersed — which reflects a strong
artistic milieu and a consciousness of the need to assimilate the
"Chinese influences" entering the mainstream of Persian arts. The
greatest of these books is the DeMotte *Shah Nama,* named after
the dealer responsible for dispersing it.

Contemporary with the large illustrations of the DeMotte *Shah Nama*
are those from a group of smaller manuscripts of the same text;
a typical example is cat. no. 188. The frieze-like placement of figures in
bands or rows reflects earlier Achaemenid and Sassanian custom.
It is still disputed whether the exact center of production of the "small
Shah Nama" was in Tabriz, the Il Khanid capital, or Shiraz, the center
of the province of Fars to the southeast, or some other area.
Another group of manuscripts, prepared for the Inju viceroys of the
Il Khans, are known to have come from Shiraz between 1333 and 1352.
No. 189 which shows the Sassanian King Khusrau enthroned is

from a *Shah Nama* manuscript whose colophon is dated A.D. 1341.
Its strong, unsophisticated red background is common in all the
Inju works.

The second half of the fourteenth century in Persia, a period of
unsettled conditions and political turmoil, ended with the invasions
of another Tartar conqueror, Timur-i-Leng ("the Lame"). Under
the dynasty he established, the arts of the Persian book reached their
first period of greatness. Timur's son Shah Rukh (d. 1447) reigned
over the whole of Persia during the first half of the fifteenth century.
His sons and nephews were among the greatest patrons of the arts
of the book the world has ever seen. From Shah Rukh's reign date cat. no. 190
histories, copies of the national epic, the *Shah Nama,* and still more cat. nos. 192, 193
rare album leaves such as the portrait of the warrior. cat. no. 191

The conventions basic to all subsequent Persian manuscript
illustrations gained complete acceptance during this period although
they had originated during the previous unsettled time immediately
before and during the reign of Timur. These conventions include: the
use of the high horizon — often a rounded hill in the case of an
outdoor scene — with spectators watching the action taking place in
front of it; a view of the action from several different vantage
points, either from above or from the same plane; brilliant colors
placed to maximize decorative value, their brightness never lessened
when the presence of a moon in the sky indicates a nocturnal episode.
These were among the conventions which remained the norm for
all subsequent Islamic painting.

After Shah Rukh's death his family continued to rule, but only in the
northeastern half of his domain. The western and southern parts
were conquered by tribes of Turkmen: the Karaquyunlu ("Black
Sheep") and Aqquyunlu ("White Sheep"), named for the tails hanging
from their battle standards. While Timurids in Herat patronized
artists who continued the Shah Rukh style and even improved it
through the genius of Bihzad, the greatest of the Persian painters,
excellent if less elegant paintings continued to be produced by the
Turkmen in Tabriz and Shiraz.

Painting under the Turkmen, 1450-1500

The Turkmen kings expelled the Timurid successors of Shah Rukh
from their western and southern domains and ruled from Tabriz and
Shiraz. For them, provincial artists produced illustrations for
Firdousi's *Shah Nama* and also for the *Khamsa* (Quintet of Tales)
by Nizami which had only recently begun to rival the older
literary masterpiece in popularity. Turkmen manuscripts are usually cat. no. 194
somewhat smaller in page size than the earlier Timurid ones. The
human figures are noticeably stocky with overly large heads. The grace
and sophistication of the contemporary masterpieces painted in Herat
for the later Timurids do not appear in works painted for the
Turkmen patrons. The best Turkmen pictures, however, like those
for the *Khavar Nama*[3] of ca. 1480 or the seven miniatures from a
fragmentary *Shah Nama* of ca. 1490 are excellent examples of the cat. no. 197
"classic" Persian miniature of the fifteenth century.

Herat and Bukhara Painting, ca. 1450-1600

The court of Sultan Husayn Mirza (1468-1506) made Herat the most
sophisticated cultural center of its time. The ruler's chief minister,
Ali Shir Nawai, was an accomplished writer; the poet Jami was in

permanent residence; and Bihzad, Persia's greatest painter, set the style for book illustration. He was not a great innovator but rather perfected already-established pictorial conventions. His placement of figures and use of color remain the finest in Persian miniature painting.

The 1501 defeat of the "White Sheep" Turkmen by Shah Ismail, the earliest Safavid, established the first native Persian dynasty since before the Arab conquest in the seventh century. Meanwhile, the Uzbeks from Transoxiania captured Herat and supplanted the later Timurids. They took over the royal studio of painters and continued its traditions in small works like cat. no. 198. When expelled from Herat by Shah Ismail in 1516, the Uzbeks kept the Herati style intact in their capital of Bukhara.

It is very difficult to differentiate between the best Bukhara work and that of the Timurid court of a half century earlier. The Bihzadian color range and the way figures were placed within a landscape or interior setting were retained. But, a certain "looseness" and static quality also appear. It was indicative of a desire to return to earlier artistic and literary successes from Herat that Jami's romance of *Yusuf and Zuleikha* (the Biblical *Joseph and Potiphar's Wife*) was so commonly chosen for illustration. By the end of the sixteenth century, painting in Bukhara had degenerated, and images were stereotyped and repetitious. Not very gifted artists in India began to imitate these tendencies so that it is sometimes difficult to determine whether such works were produced at Bukhara or in an unknown atelier in India.

cat. no. 201

Shirazi Painting in the Sixteenth Century

At the time that Shah Ismail made Tabriz his capital, an elegant court style once again reappeared and replaced that of Herat. An aging Bihzad was eventually named head of the royal studio by the king, and, no doubt, he oversaw the calligraphy and drawing lessons of the crown prince who was to succeed his father as Shah Tahmasp (1524-1576). Tabriz, located in the northeast, was uncomfortably close to the frontiers of the Ottoman Empire, particularly under the expansionist reign of Sulayman "the Magnificent" (1520-1566). And, upon several occasions the Safavid capital was occupied and many artists were removed to Constantinople by the conquering Turks.

The other major Persian art center, Shiraz, was the capital of the province of Fars in the south, although not the country's capital. It was sufficiently far removed from the Turks to avoid any forced migrations of its artisans. Home of the great lyric poet Hafiz in the fourteenth century, the city had a long artistic tradition. The Inju family had patronized a coarse style of painting in the middle of that century. Several Timurid princes, including a nephew and son of Shah Rukh, had made Shiraz their capital. A Shirazi style, slightly different from the court style of Herat, had evolved and had influenced the Turkmen works from the middle of the fifteenth century. It was a derivative of this Turkmen style, with newer Safavid conventions, that flourished in Shiraz during the entire sixteenth century. Hallmark of the new dynasty — and appearing in the paintings of the time — was the turban, wound around a distinctive, most often red, baton. This image had also been common in Tabrizi works but had disappeared there earlier. (This turban never appears in contemporary Bukharan work as the rulers of that realm were bitter rivals of the Safavids.)

see cat. no. 189

The Shirazi ateliers were extremely prolific. Unlike the painters of the royal studios whose work was created exclusively for the king or his court, those from Shiraz worked for numerous local nobles and rich merchants. The range of commissioned texts was also very large, although the *Shah Nama* and *Khamsa* were the most common. A typical Shirazi convention was the use of the margin beyond the line of the text panels to afford more room for the "spilled over" episodes. (Cat. nos. 204, 205, 207, 208 are typical; in 203e, 203h, and 203i, the unidentified artist has placed in the margins persons or vegetation with little physical connection to the bulk of the episode depicted.)

cat. nos. 207-210;
cat. no. 203

Although manuscript illustrations in the Shirazi style became increasingly static and derivative during the course of the sixteenth century, they continued until about 1600 when the local style disappeared by merging into the court style of Isfahan.

Other Sixteenth Century Styles

During his reign (1502-1524) Shah Ismail's capital, Tabriz, was the center of the royal studio. His son, Tahmasp, greatest of the art patrons of his dynasty, began his reign in Herat (1525) but moved shortly thereafter to his father's capital. However, as Tabriz was exposed to Turkish raids, Tahmasp removed the court to Qazvin in 1548. The Tabriz style is not well represented in the collection, but an early landscape in which the water has been oxidized provides some idea of it. Painting continued in the former capital even after the court's removal to Qazvin.

cat. no. 215

cat. no. 217

It was shortly before Qazvin became the capital that Tahmasp, the Safavid Maecenas, underwent a change of heart. From being a most liberal patron who commissioned two of the greatest masterpieces of the Persian book — the "Houghton *Shah Nama*"[4] (1527-1537) and the "British Museum *Khamsa*" (1538-1543) — Tahmasp became an introverted recluse. Master artists left his service to paint elsewhere. Two of the most important, Mir Sayyid Ali and Abdus-Samad, followed the exiled Mughal emperor Humayun first to Kabul and later to Delhi in 1555. They were responsible for training the first generation of Mughal artists in India.

Despite the fact that royal patrons became less interested in commissioning major manuscripts, artists continued to work for the court, and an easily identifiable Qazvin style emerged. It is associated with the painter Muhammadi, son of the Sultan Muhammad, who had taught the young Tahmasp to draw. Toward the end of the sixteenth century, the hallmark of the Qazvin style was what Basil Robinson calls "a boldly calligraphic line, varying considerably in thickness and thus effectively suggesting volume"[5]; the British scholar identifies this style with the artist Aqa Riza. Also characteristic and occurring in huge numbers are miniatures depicting single figures, fully painted or as finished drawings. These were collected in large albums. Indeed, it was the practice of painting "album leaves" that finally ended the belief that the sole matter worthy of the artist's brush was the great masterpieces of Persian literature. The vogue of the individual miniature mounted on an album leaf began in the sixteenth century and became completely dominant in the next.

cat. nos. 219-222

To catalog a picture as from Tabriz, Qazvin, or Shiraz and expect that it was necessarily painted in one of those cities or regions is an

over simplification. The survival of earlier styles or changes in the working situations of various painters account for many miniatures exemplifying a particular style without coming from the center associated with those styles. Certain pictures cannot be attributed to any specific center of production. This diversity of styles and the centers of production changed when, in 1598, Shah Abbas "the Great" again moved the capital, this time to Isfahan where it remained throughout the seventeenth century.

cat. no. 223

Isfahan and the Seventeenth Century

The aesthetic tenets of the Isfahan painters were dominant throughout the seventeenth century and well into the eighteenth. Other cities beside the capital must have produced paintings, but the metropolitan style of the capital was supreme and overpowered the individual regional styles of the sixteenth century. The earlier change in taste, from illustrated manuscripts to separate album pages, continued. The greatest artists, who occasionally accepted commissions to illustrate manuscripts of the *Shah Nama,* the *Khamsa,* or other literary texts, seemed to prefer producing separate works which could be included in albums assembled for wealthy connoisseurs.

The major painter of the first half of the seventeenth century, one whose talents best exemplify the canons of taste during his period, was Riza-i-Abbasi (d. 1635). Scholars debate whether he and the Aqa Riza of the late sixteenth century (see above p. 77) were one and the same or whether he was a different artist who assumed the honorific from the name of his sovereign-patron, Shah Abbas the Great (1587-1626). In any case, the name of Riza-i-Abbasi became identified with pictures of elegant youths and ladies, and of bearded men, langorously standing or seated in faintly-sketched landscapes. His fame was so great that other painters, both his pupils and his imitators, "signed" their pictures with his name. Thus, while the "signature" of Riza-i-Abbasi on a painting or a drawing is not always a guarantee, certain superior works can be attributed to him with a degree of authority.

cat. nos. 229-240

cat. nos. 231, 237

After Riza's death in 1635, his style was perpetuated by his pupils. Miniatures with signatures or attributions have established the existence of the painters Muhammad Qasim, Muhammad Yusuf, and Muhammad Ali, among others. Each exhibited personal idiosyncracies in his adaptations of his master's style.

cat. nos. 241, 245
cat. nos. 240, 246
cat. no. 247

The best-known of Riza-i-Abbasi's pupils was Mu'in, surnamed *musawir* ("the painter") (1617-1707 ?). Still a very young man at the time of his master's death, he evolved a somewhat independent style during the course of his very long life. He dominated the second half of the seventeenth century as his master had the first half. The magnificent drawing of a lion attacking a dragon whose coils surround a ram is a fine example of the way in which Mu'in's pen infused animal forms with vitality. The more placid standing youth, dated A.D. 1681, is also typical of his style.

cat. no. 254

cat. no. 255

Contemporary with the *oeuvre* of Mu'in was a growing awareness of European artistic canons. Prints and easel pictures brought to Persia by travellers and ambassadors introduced artistic conventions utterly foreign to Persian traditions. One painter, Muhammad Zaman, was even sent to Italy to study. The story of his conversion to Catholicism (he is often called Paolo Zaman) may be apocryphal, but the changes visible in painting techniques in general after about 1670 are

incontrovertible. Watercolors replaced the flat, brilliant colors formerly used. European perspectives were used in place of the multiple viewpoint. Even the fame of Mu'in, suddenly considered too traditional, was usurped by artists and patrons following the nefarious course of imitating or admiring the only partially understood European style.

The Qajar Revival

The eighteenth century in Persia was a time of political anarchy and artistic sterility. Isfahan was captured by Ghilzai Afgans in 1722, and the Safavid family was exterminated. The coronation of the successful usurper, Nadir Shah, in 1736 lent legitimacy to this ruler who sacked Delhi in 1739 and brought invaluable booty back to Persia. But in 1747 Nadir was murdered, and the Zands established a short-lived dynasty with the capital at Shiraz (1752). Finally, Agha Muhammad Qajar moved the capital to Teheran and established a dynasty which ruled from 1795 until the twentieth century.

Under the Qajar Dynasty there was a long period of political calm which once again allowed extensive royal patronage of the arts. The incompletely-assimilated Italianate style of Muhammad Zaman and his imitators which had surfaced toward the end of the seventeenth century reemerged under Fath Ali Shah (1797-1834).

Although the Los Angeles collection does not convey a sense of the variety of Qajar work, one picture deserves special notice. This is the large album page representing King Bahram's Master Shot. Even the cat. no. 258 damaged condition of the drawing cannot detract from the artistry of the unknown Qajar master. Had the artist finished this work, it is very likely that he would have employed watercolors rather than the brilliant, opaque colors of earlier ages. Qajar artists not only employed new hues but also a distinctive grisaille which readily lent itself to the depiction of flowers and bird images which were highly prized. Indeed, the fundamental difference between the earlier traditions and the Qajar style can best be appreciated by comparing this album page with an earlier work in which the same subject is represented. cat. no. 203i

Turkish Painting

The presence of Turkish miniatures in the Palevsky-Heeramaneck Collection is especially welcome as examples elsewhere in America are extremely rare. The major reason for this is that most of the significant Turkish paintings in Istanbul are preserved, and apart from the national collections in Paris, London, and Vienna, and the exceptional Beatty Library in Dublin, only in Istanbul can one find the whole range of the Ottoman miniature tradition represented.[6]

The Turkish Sultans, like their political rivals the Safavid Shahs, were great art patrons. Despite their early beginnings during the reign of Mehmet *Fatih* "the Conqueror" of Constantinople in 1453, Ottoman miniatures became reasonably common only after the successful military campaigns of Selim I (1512-1520) and Sulayman "the Magnificent" (1520-1566) in Syria, Persia, and Egypt. These campaigns resulted in the wholesale transplantation of foreign artists to Istanbul. Murad III (1574-1595) was the greatest art patron of his family. During his reign two uniquely Turkish genres of painting became preeminent: the historical manuscript, with lavish illustrations of the splendor of the ruler surrounded by his unconquerable armies; and the religious text. The marvellous scene within a mosque cat. no. 260 showing a prophet (probably Muhammad) seated in a *minbar* (pulpit) with five angels above is typical of Turkish religious works.

From the beginning of the seventeenth century is a fine scene of a
king with his courtiers. Far less typically Ottoman than the religious cat. no. 264
miniature described above, it may well have been painted by a Persian
artist working in Istanbul for a Turkish patron. Like the two album
pages with miniatures of ladies, the king and his courtiers are cat. nos. 262, 263
recognizable as Turkish only because of their costumes.

The earliest Turkish picture of the Los Angeles collection — of a
Chinese princess or maidservant with towering fan — is of an even rarer cat. no. 259
kind. It may well be an example of painting as practiced by Turkish
artists in Transoxiania (modern Soviet Southern Turkestan) in the
fifteenth century rather than from within the borders of present-day
Turkey. Even if it was a later Ottoman copy from the sixteenth or
seventeenth century, it is a unique masterpiece.

Indian Miniatures of Islamic Interest

The influence of Persian painting is not only perceptible in Turkey
but also in India. Even before the Mughal school was established by
Akbar, illustrated Persian manuscripts were being copied in India for
Muslim patrons. While the Mughal works can easily be distinguished
from Persian miniatures, the attribution of some, rendered in a strongly
Persian style, is more problematic. As there are one or two such
paintings in the Palevsky-Heeramaneck Collection, a few words should
be added here by way of explanation.

Two album pages formerly considered Persian should be attributed to
the Deccan, a region in south-central India which was the site of
several opulent sultanates responsible for lavishly patronizing the arts.
Bijapur and Golconda, as well as Ahmadnagar which had been
absorbed earlier by the Mughal Empire, were courtly centers, each with
a distinct style of miniature painting. The Deccani artists followed
the usual sixteenth- and seventeenth-century Persian practice of
mounting separate paintings or drawings on album pages and
frequently adding panels of calligraphy in the borders. The first
Deccani example heretofore considered Persian depicts a boy in green cat. no. 265
wearing a *katar,* an Indian stabbing dagger of a type not found in
Persia. His turban also is non-Persian. The second example also seems cat. no. 266
Persian at first glance. It shows a girl with her hands hidden by the
long sleeves of her overdress. The borders of marbled paper, however,
suggest a Turkish or Deccani provenance since both of those areas
particularly favored the complicated marbling process. The girl's pose
and the distinctive sleeves of her robe suggest that she belongs to one
of the Turkish orders of dervishes, often pictured in Ottoman
miniatures. However, as women never wore dervish dress in Turkey, by
a process of elimination a Deccani attribution can be assumed.

Kashmir is another Indian region with a distinctive miniature style
related to, but somewhat different from, that of either Persia or the
Mughal Empire. Beginning in the late seventeenth century and
continuing into the nineteenth, Kashmiri artists often illustrated
the major works of Persian literature. Frequently their color schemes
included an unattractive orange mated with a rancid purple, a
combination typical of the hack-work of the school. Occasionally fine
pictures emerged, and they provide a relief from the commonly-found
horrors. One such superior example is a curious miniature of an
enthroned king seated above a black rug in an open enclosure. The five cat. no. 267
illustrations of a *Khamsa* manuscript of about 1800 are still better. cat. no. 268
Two of these, depicting Majnun in the desert and Iskandar with the
sages Ilyas and Khirz, show that the earlier great traditions of Persian

illustrated manuscripts continued in Kashmir as late as the nineteenth century.

Minor Arts of the Book

Islamic bindings are of two kinds: leather and lacquer. (The term "morocco" used for fine European leather bindings reveals their Muslim origin.) The earliest bindings were stamped or tooled with geometric ornaments similar to the decoration of several of the Mamluk Koran pages included here. By the fifteenth century, particularly in Persia, overall geometric patterns had been replaced by cut-leather central medallions surrounded by matching corner decoration. A common sixteenth-century practice was to use the medallion-and-corner motif, often enhanced by colored-paper filigree, for the *doublures* (insides of the binding). The outsides were frequently stamped in panels and lavishly gilded. A complete binding included a triangular flap which covered the edge of the pages opposite the spine of the manuscript. This flap and the bulk of the "closed" volume account to a large extent for the intact preservation and pristine condition of so many miniatures and pages of calligraphy. (The Muslim connoisseur did not display his collection on the walls of his home. It was stored in closed chests, protected from damage by light and excessive contact with human hands.)

cat. no. 269

Lacquer bindings were made on a base of papier-mâché and gesso — decorated in watercolor. With the advent of the Qajar Dynasty (late 18th century), lacquer book-binding techniques were used for pen cases, mirror-covers, and other small objects. In addition to the painters, scribes, and binders of the Islamic book, there were the designers of textile and border patterns whose knowledge was also necessary for the complete success of the finished work of art.

cat. no. 274

Notes

1.
Aya Sofya no. 3703; see E. Grube, *Muslim Miniature Paintings* (Venice, 1962), nos. 1-3.
2.
Ibid., nos. 7-9.
3.
Ibid., nos. 46-49.
4.
S. C. Welch, *A King's Book of Kings* (New York, 1972).
5.
B. W. Robinson, *A Descriptive Catalogue of the Persian Paintings in the Bodleian Library* (Oxford, 1958), p. 153.
6.
There are two American collections of Turkish miniatures that deserve notice: those of H. P. Kraus in New York City (see E. Grube, *Islamic Paintings, The Kraus Collection* [New York, n.d.]) and of Edwin Binney, 3rd. The former has important material of several kinds. The latter is the only American collection with pretensions of covering completely the varied range of Turkish painting. — Editor

The Arts of the Book
Calligraphy

130.
Two Conjugate Leaves from a Koran with Kufic Script
Abbasid Caliphate, 9th-10th century
Ink on vellum, red diacritical marks
h: 5¾ in. (14.5 cm.); w: 18⅛ in. (46 cm.)
M.73.5.499

Seven lines of writing.

131.
Two Conjugate Leaves from a Koran with Kufic Script
Abbasid Caliphate, 9th-10th century
Ink on vellum, red diacritical marks
h: 5 in. (12.7 cm.); w: 15⅛ in. (38.5 cm.)
M.73.5.497

Five lines of writing.

132.
Two Leaves from a Koran with Kufic Script
Abbasid Caliphate, 9th-10th century
Ink on vellum, red diacritical marks
h: 9⅜ in. (23.8 cm.); w: 13¼ in. (33.7 cm.)
M.73.5.502, 504

Seven lines of writing.

133.
Leaf from a Koran with Kufic Script
Abbasid Caliphate, 9th-10th century
Ink on vellum, red and green diacritical marks
h: 6⅞ in. (17.5 cm.); w: 10 in. (25.4 cm.)
M.73.5.501

Five lines of writing.

134.
Leaf from a Koran with Kufic Script
Abbasid Caliphate, 9th-10th century
Ink on vellum
h: 8¾ in. (22.3 cm.); w: 11¾ in. (29.8 cm.)
M.73.5.608

Seven lines of writing on recto and verso.

135.
Leaf from a Koran with Kufic Script
Abbasid Caliphate, 10th-11th century
Ink on vellum
h: 9½ in. (24.2 cm.); w: 13¼ in. (33.6 cm.)
M.73.5.503

Fifteen lines of writing.

136.
Leaf from a Koran with Kufic Script
Abbasid Caliphate, 10th-11th century
Ink on vellum, red diacritical marks
h: 5 in. (12.7 cm.); w: 7¾ in. (19.7 cm.)
M.73.5.496

Five lines of writing.

137.
Leaf from a Koran with Kufic Script
Abbasid Caliphate, 10th-11th century
Ink on vellum
h: 5¾ in. (14.7 cm.); w: 8 in. (20.3 cm.)
M.73.5.495

Seven lines of writing surrounded by a border.

138.
Leaf from a Koran with Kufic Script
Abbasid Caliphate, 10th-11th century
Ink on vellum, red diacritical marks
h: 10¼ in. (26 cm.); w: 13⅝ in. (34.5 cm.)
M.73.5.500

Six lines of writing surrounded by a later border containing commentaries.

139.
Leaf from a Koran with Kufic Script
Abbasid Caliphate, 10th-11th century
Ink on vellum, red diacritical marks
h: 10½ in. (26.7 cm.); w: 16 in. (40.7 cm.)
M.73.5.505

Five lines of writing; the verso contains a rosette marking the beginning of a new verse.

140.
Fragment of a Leaf from a Koran with Kufic Script
Abbasid Caliphate, 10th-11th century
Ink on vellum
h: 5⅝ in. (14.2 cm.); w: 9¼ in. (23.5 cm.)
M.73.5.491

Thirteen lines of writing; an *unwan* (frontispiece) shows the beginning of a new *surah* (section of the Koran).

141.
Ten Leaves from a Koran with Kufic Script
(illustrated)
Abbasid Caliphate, 10th-11th century
Ink on vellum
h: 12⅝ in. (32 cm.); w: 15⅝ in. (39.6 cm.)
M.73.5.506-515

Sixteen lines of writing.

142.
Three Leaves from a Koran with Kufic Script
(illustrated)
Abbasid Caliphate, 11th-12th century
Ink on vellum with gold background, red diacritical marks
h: 7⅛ in. (18.1 cm.); w: 10¼ in. (26 cm.)
M.73.5.492, 493, 498

Six lines of writing.

143.
Two Leaves from a Koran with Kufic Script
Abbasid Caliphate, 11th-12th century
Ink on paper
h: 4⅞ in. (12.4 cm.); w: 8⅜ in. (21.3 cm.)
M.73.5.485, 494

The recto of the first leaf appears to have included a chapter heading or beginning of a verse; surrounded by stencilled borders.

144.
Illuminated Opening Page from a Mamluk Koran
Egypt or Syria, probably 12th-13th century
Ink and colors on paper
h: 9⅞ in. (25.1 cm.); w: 6⅝ in. (16.8 cm.)
M.73.5.556

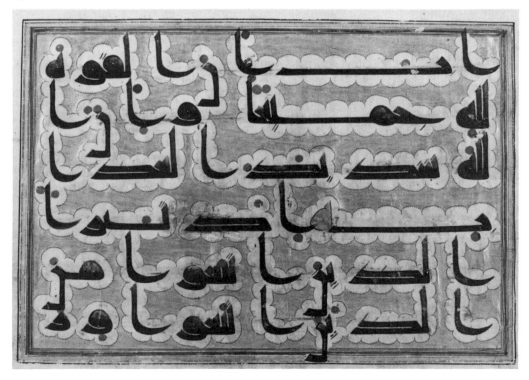

145.
Two Leaves with Geometric Decoration from
a Mamluk Koran
Egypt or Syria, 13th-14th century
Ink and colors on paper
h: 4⅛ in. (10.5 cm.); w: 5⅛ in. (13 cm.)
M.73.5.559, 595

146.
Three Leaves with Chapter Headings with Thulth
Script from a Manuscript of the Life of Ghazi Khan
Egypt or Syria, 13th-14th century
Ink and colors on paper
h: 10¾ in. (27.3 cm.); w: 7⅛ in. (18.1 cm.)
M.73.5.489, 521, 547

Commentaries added later on border.

147.
Leaf with a Chapter Heading with Thulth Script
from a Manuscript of the Life of Ghazi Khan
(illustrated)
Egypt, 13th-14th century
Ink and colors on paper
h: 10¾ in. (27.3 cm.); w: 7¼ in. (18.4 cm.)
M.73.5.22

Commentaries added. See also cat. no. 146.

148.
Two Leaves Forming the Double Page Frontispiece
of a Mamluk Koran
Egypt or Syria, 13th-14th century
Ink, gold, and colors on paper
h: 9⅝ in. (24.5 cm.); w: 7½ in. (19 cm.)
M.73.5.557, 558

الحمد لله رب العالمين ... وقعت ... مولانا المقام الزين الملك الاشرف ابو النصر قايتباي

نصرما الله تعالى بعض اعزا هذا الجزو على طلبة العلم ... في جعل مقر بدوة
... لا يخرج منها الا ... وبه ... بتاريخ تمام ... خمس وسعين

على مولانا المقام الزينية لك
...
احمد بن ... لطف الله

شهد على المقام الشريف
عبد الرزاق احمد

على القواعد الشريفة ... المك
... عبد النبي الله ...

على مولانا المقام الزينية لك
... احمد محمد ... للاحمدي

النالث عشر من فتاوى قاضي خان

خواصة المقام ...
السلطان الملك الا ...
... الصحيح ...

149.
Introductory Heading to a Mamluk Koran with Naskhi Script
Egypt or Syria, 14th century
Ink, gold, and colors on paper
h: 9½ in. (24.2 cm.); w: 10½ in. (26.6 cm.)
M.73.5.490

Verso: *shamsa* (introductory roundel).

150.
Illuminated Frontispiece to a Commentary of the Koran
Persia, 14th century
Ink, gold, and colors on paper
h: 10⅛ in. (25.8 cm.); w: 6¾ in. (17.2 cm.)
M.73.5.555

By the scribe Maulana Mahmud ibn Omar-allaz Mokhashia
verso: a page of text, Naskhi script.

151.
Illuminated Unwan (Frontispiece) of a Mamluk Koran in Naskhi Script
Egypt, 14th-15th century
Ink, gold, and colors on paper
h: 12⅜ in. (31.4 cm.); w: 8¼ in. (21 cm.)
M.73.5.516

Commentaries on top and bottom.

152.
Panel of Prayers in Naskhi Script (illustrated)
Persia, 14th-15th century
Ink, gold, and colors on paper
h: 6⅜ in. (16.2 cm.); w: 8⅞ in. (22.5 cm.)
M.73.5.789

Mounted onto an album page within a narrow border of marbled paper; above: a single line of monumental Naskhi script; below: four similar lines of Naskhi script between two vertical panels of illumination.

153.
Double Page Illuminated Unwan (Frontispiece) to a Koran (?) in Naskhi Script
Persia, 14th-15th century
Ink, gold, and colors on paper
h: 12⅜ in. (31.2 cm.); w: 8⅛ in. (20.2 cm.)
M.73.5.531

Verso of the left hand leaf, a page of text.

154.
Three Leaves with Panels of Découpé *Calligraphy*
Persia, 15th century
Ink, gold, and colors on paper
h: 8⅞ in. (22.5 cm.); w: 5-6/8 in. (14.2 cm.)
M.73.5.599

Mounted as an album binding; gilded lacquer with small clusters of flowers in vertical rows, nineteenth century; central panels of calligraphy have backgrounds of different colors; headings are magnificently illuminated.

155.
Two Pairs of Unwans (Frontispieces) with Verses from Koranic Surahs
Persia, 15th-16th century
Ink, gold, and colors on paper
h: 4 in. (10.3 cm.); w: 5 in. (12.7 cm.)
M.73.5.596, 597

Nastaliq script in the central roundels.

تعالیٰ پیغمبر اکرم عرب فصحاسی بلاغت زیورلاری

یله نمایش طریق و فصاحت گوهرلاری بلند ایشن

تی نظم رغبالارینه جلوه پذیرورلار و دعوی کوسی اوازه

نک کاتیکلور رلار اردی حضرت ملک علام

کلام نظامی جبریل حقیقته فرام و سطرسی یله خیر الانام

علیه الصلوات و السلام غه نازل اولدی یاس نظر غلی یا بل لاری خیر

یقال لاری کم دقایق در یا کی تبک بحر غماء و مساعی

نورحمت کاکم یاباب جهان ایسانی
املاک نوروز الف دین گل آرمانی

ییلدی یاساج عاج بوباغ روح آفرینی
نظم الین امیک بلبل خوش الحانی

و در و دا معد ود او ل غلامه معدوم و موجودقیم

رباعی

مالحمدرضا خدایی آیلدی نت
هنرطم اپسی مروطبع پرست

نظم ایلکه یاسینه پروردی
هم نظمی نی قیلدی فی او قواضعه نت

خوده بین ازخدینی دا وحدا این الا حضرت امعروض اوکم
نظم کلام ارتهیسی رتیسی او شو دلیل بین وورکم امیک

156.
Manuscript of a Book of The Lives of Muslim Saints
Persia, 15th-16th century
Ink and gold on paper
h: 10½ in. (26.7 cm.); w: 7⅜ in. (18.7 cm.)
M.73.5.600

Contemporary binding; misbound.

157.
*Double Page Illuminated Unwan (Frontispiece) in
Naskhi Script* (illustrated)
Persia, 15th century
Ink, gold, and colors on paper
h: 9½ in. (24.2 cm.); w: 6¼ in. (15.8 cm.)
M.73.5.543, 544

Verso of right half is a blank "end page" with
ink "doodle" in the form of a *shamsa* (roundel);
left half is a page of single-columned text;
twelve lines to the page.

158.
*Illuminated Hexagonal Shamsa (Roundel)
from a Koran in Nastaliq Script* (illustrated)
Persia, 15th century
Ink, gold, and colors on paper
h: 12½ in. (31.7 cm.); w: 8¼ in. (21 cm.)
M.73.5.542

159.
*Double Page Illuminated Unwan (Frontispiece)
to a Manuscript of the* Khamsa *by Nizami*
Persia, 15th-16th century
Ink, gold, and colors on paper
h: 10½ in. (26.7 cm.); w: 12 in. (30.5 cm.)
M.73.5.486

Verso: of the right half a blank "end page"
with later ink notes added; of the left half, a page
of text, four columns to the page, with illuminated
chapter heading above; first lines of text overpainted
with a wash of red ink; no calligraphy.

160.
Double Page Illuminated Unwan (Frontispiece)
Persia, 15th-16th century
Ink, gold, and colors on paper
h: 10¼ in. (26 cm.); w: 14⅛ in. (36 cm.)
M.73.5.529

Three pages of text; seven lines of text in central
panels; four columns to the page, twenty lines
to the page, each page with red and black chapter
headings.

Exhibited: New York, Persian Exhibition, 1940.

161.
*Double Page Illuminated Unwan (Frontispiece)
to a Manuscript of Nizami's* Khamsa
Persia, 15th-16th century
Ink, gold, and colors on paper
h: 11¾ in. (29.8 cm.); w: 14 in. (35.6 cm.)
M.73.5.605

Four lines of script in the center; a hole in top
of the left side.

162.
Seven Leaves from a Manuscript of the Shah Nama
Probably Shiraz, about 1550
Ink, gold, and colors on paper
h: 13 in. (33 cm.); w: 8½ in. (21.6 cm.)
M.73.5.540, 790 a-f

Twenty-one lines of Nastaliq script to the page;
four columns of text; includes an illuminated
introductory *unwan* and five chapter headings.

یا مادی پیر شمع نیم داعی نمایان نوبایی

نور ما دی پیر سپر و کسم فرس متین کنایی

بها دی سیر کل که تفواق الحجره نهای

نور ما دیم سیر زم جمعین کسم زیان

عام دوراند وقلمید ه فرمان

چند چیز بچهار چیز تمام شود دانش

بورع طاعت بتقوی عمل بصدق

نعمت بشکر باب سی و دوم درآنکه

چهار چیز چهار چیز آورد خاموشی

راحت فضولی ملالت سخاوت

مهتری شکر افزونی

درآنکه چهار چیز شخص ضعیف

کند و شمن بسیار قرض بسیار

163.
Double Page Illuminated Beginning of
Nizami's Khamsa
Persia, about 1550
Ink, gold, and colors on paper
h: 11⅛ in. (28.2 cm.); w: 14⅞ in. (37.8 cm.)
M.73.5.527, 528

Verso of right half, half of the illuminated
frontispiece of the volume; on the left half, page
of text, two columns divided by a blue shaft
similar to the inside border around the text; fifteen
lines.

164.
Panel of Five Lines of Naskhi Calligraphy
(illustrated)
Persia, about 1550
Ink, gold, and colors on paper
h: 12¼ in. (31.2 cm.); w: 7½ in. (19 cm.)
M.73.5.546

Illuminated panels on top, bottom, and both
sides; the whole mounted into a border of leaves
and flowers, eighteenth-nineteenth century.

165.
Leaf from a Manuscript Narrating
the Life of Firdousi
Persia, probably Shiraz, 1550-1600
Black and red ink on paper
h: 14⅛ in. (35.9 cm.); w: 9¼ in. (23.5 cm.)
M.73.5.594

Twenty-eight lines of Nastaliq script in a single
column of text.

166.
Text Page to a Manuscript of the Shah Nama *or*
Khamsa *in Nastaliq Script*
Persia, probably Shiraz, 1575-1600
Ink, gold, and colors on paper
h: 18¼ in. (46.4 cm.); w. 11½ in. (29.2 cm.)
M.73.5.534

Four columns, twenty-five lines; illuminated
chapter heading at center bottom; the calligraphy
is surrounded by "cloud forms" in gold;
surrounded by a border of floral decoration and
animals, a phoenix at the top.

167.
Illuminated Shamsa (Roundel) from a Koran
Persia, 16th century
Ink, gold, and colors on paper
h: 14⅛ in. (36 cm.); w: 9½ in. (24.2 cm.)
M.73.5.519

Nastaliq script in center; the style is close to
that of Tabriz in the early sixteenth century.

168.
Double Page Illuminated Unwan (Frontispiece)
of a Diwan of Hafiz
Persia, 16th century
Ink, gold, and colors on paper
h: 8¼ in. (21 cm.); w: 10 in. (25.4 cm.)
M.73.5.487

169.
Two Leaves from a Manuscript of the Khamsa
by Nizami
Persia, probably Shiraz, 16th century
Ink, gold, and colors on paper
h: 13½ in. (34.3 cm.); w: 9⅛ in. (23.2 cm.)
M.73.5.791, 792

Twenty lines of Nastaliq to the page; four columns
of text separated by columns with small floral dots.
Illuminated chapter heading on recto.

170.
Panel of Calligraphy with Verses from the
Gulistan *of Sa'di* (illustrated)
Persia, 16th century
Ink, gold, and colors on paper
h: 14½ in. (36.8 cm.); w: 9⅞ in. (25.4 cm.)
M.73.5.526

Eight lines of Nastaliq script with illuminated
top and bottom pieces; the whole within a narrow
green border, surrounded by a completely
illuminated second border; mounted on an album
page (?).

171.
Large Album Page with Panels of Calligraphy
from the Shah Nama *of Firdousi*
Persia, 16th century
Ink, gold, and colors on paper
h: 14⅛ in. (35.9 cm.); 9⅜ in. (23.9 cm.)
M.73.5.488

Recto: six panels of Nastaliq calligraphy divided
horizontally in the center by two verses; the inside
border formed by eight additional verses; verso:
three horizontal panels of Nastaliq calligraphy
en diagonale, separated by two additional panels of
calligraphy.

172.
Panel with Four Lines of Nastaliq en Diagonale
Persia, 16th century
Ink, gold, and colors on paper
h: 15¼ in. (38.7 cm.); w: 10½ in. (26.7 cm.)
M.73.5.545

Border formed of eleven verses on each side and
eight each at top and bottom; the whole mounted on
an album leaf decorated with gold flowers. Written
by the hand of the slave [of God] Ali.

173.
*Illuminated Shamsa (Roundel) with Subsidiary
Decoration from a Koran*
Persia, 16th century
Ink, gold, and colors on paper
h: 13¾ in. (35 cm.); w: 8½ in. (21.6 cm.)
M.73.5.530

Decorated above and below on a tan background
of leaves and flowers in gold; the calligraphy listing
title of the work was never included.

174.
*Panel with Six Lines of Islamic Prayers in
Nastaliq Script* en Diagonale
Persia, 16th century
Ink, gold, and colors on paper
h: 13¾ in. (34.9 cm.); w: 7½ in. (19 cm.)
M.73.5.541

Triangular illumination in upper and lower left,
the whole mounted on an album leaf, decorated with
gold leaves and flowers.

175.
Panels with Two Couplets en Diagonale
Persia, 16th century
Ink, gold, and colors on paper
h: 11¼ in. (26.6 cm.); w: 7⅛ in. (18.1 cm.)
M.73.5.784

Light blue background with flowers and deer in
gold; the inner border with ten smaller panels also
in Nastaliq — four on each side, one larger at
top and bottom; the whole is mounted on a dark
green album leaf speckled with gold.

176.
Panel with Four Lines of Nastaliq en Diagonale
Persia, 16th century
Ink, gold, and colors on paper
h: 11¼ in. (28.6 cm.); w: 7⅛ in. (18.1 cm.)
M.73.5.520

Surrounded on sides by four smaller calligraphies
and on top and bottom by two pairs of couplets
en diagonale integrated into the design; the whole
mounted on a gold flecked album leaf decorated
with two storks amid flowering bushes and Chinese
clouds outlined in gold.

177.
Panel with Calligraphy
Persia, 16th century
Ink, gold, and colors on paper
h: 11¼ in. (28.6 cm.); w: 7¼ in. (18.4 cm.)
M.73.5.563

Two lines of calligraphy *en diagonale* at top and
two horizontal lines below superimposed on a design
of storks and floral bushes outlined in gold;
within a border with two smaller lines of calligraphy
on each side and four panels *en diagonale,*
alternately tan and reddish, at top and bottom.
Tan paper with reddish floral decoration,
the whole mounted on an album leaf.

178.
Album Page with Verses from the Bustan *of Sa'di*
Persia, 16th century
Ink, gold, and colors on paper
h: 14 in. (35.6 cm.); w: 9⅝ in. (24.4 cm.)
M.73.5.524

Recto: two columns of text between two columns
en diagonale to the side; above and below,
verses *en diagonale;* at extreme top and bottom
four verses in larger Nastaliq; verso: a central
panel with four lines *en diagonale* between
triangles at upper right and lower left, above two
additional horizontal lines; the whole between
two side panels *en diagonale* and top and bottom
portions *en diagonale* and corner sections
horizontal; mounted in dark green; album border
decorated with gold floral motifs.

179.
Album Page with Verses from the Bustan *of Sa'di*
Persia, 16th century
Ink, gold, and colors on paper
h: 14 in. (35.6 cm.); w: 9⅝ in. (24.4 cm.)
M.73.5.525

Recto: cream ground with gold decoration, a panel
of four lines of Nastaliq *en diagonale* with
additional writing in triangles upper right and
lower left; verso: a panel of three columns
of Nastaliq *en diagonale,* the central panel with
smaller calligraphy; top and bottom, additional
verses; companion page to cat. no. 180.

180.
Manuscript of a Book of Prayers
Turkey, 16th century
Ink and gold on paper
h: 10¼ in. (26 cm.); w: 7 in. (17.8 cm.)
M.73.5.602

Double page frontispiece with geometric
decoration; black binding sixteenth century.

181.
Manuscript of the Koran in Naskhi Script
Persia or Turkey, 15th-16th century
Ink, gold, and colors on paper
h: 13¼ in. (33.7 cm.); w: 8 in. (20.2 cm.)
M.73.5.25

Includes a double page illuminated frontispiece, leaves, and colophon (?) giving the name of the scribe Yakut; many fine illuminations throughout; contemporary (color) binding with description of binding (?).

Exhibited: New York, Persian Exhibition, 1940 (MR S9a).

182.
Panel Text in Nastaliq with Verses from the Gulistan *of Sa'di*
Persia, 16th-17 century
Ink, gold, and colors on paper
h: 11 in. (28 cm.); w: 7 in. (17 cm.)
M.73.5.593

Single column, nine lines; mounted into a stencilled border of gold floral designs on a blue background (recto)and orange background (verso).

183.
Panel of Shikasta Script
Persia, 18th-19th century
Ink, gold, and colors on paper
h: 7 in. (17.7 cm.); w: 3⅝ in. (9.2 cm.)
M.73.5.583

Within a border richly decorated with intertwined floral tendrils with birds, a rooster at top and bottom.

Painting
All paintings are executed on paper in opaque watercolors unless otherwise indicated.

Arab Painting

184.
Nine Leaves from an Unidentified Text in Arabic
Egypt, 11th-12th century (?)
Irregular sizes, approx. h: 9 in. (22.7 cm.); w: 7 in. (17.7 cm.)
M.73.5.581 a-i

Similar fragmentary leaves have been attributed by Grube *(Kraus Catalogue,* p. 28-29) to Fustat in Egypt. If this attribution is correct, such fragments would be among the earliest known Islamic paintings. It is possible, however, that the leaves represent later and provincial adaptations of the earlier style.

a.
recto:
A Standing Man, His Head between Two Dragons
verso:
A Man with Animal Head Holding a Chain Attached to a Second Man.
b.
recto:
A Chained Jackal Held by a Turtle-Headed Man on a Tortoise
verso:
A Flayed Body Pierced by a Double-Headed Arrow
c.
recto:
Two Men Emerging from the Mouth of a Snake
verso:
A Naked Man with Bound Hands and a Man with a Fox-Head
d.
recto:
A Horse and Rider
verso:
Muhammad (?) on His Mount Buraq
(cf. cat. no. 203)
e.
recto:
A Tiger-Shaped Eel or Fish Attacking the Head of a Man
verso:
A Man in Yellow Boots (rubbed)
f.
recto:
A Man beside a Flowering Tree
verso:
A Man with a Cup in His Right Hand, the Ends of His Sash Hanging from His Shoulders
g.
recto:
Three Men under a Tree, the One in the Center Wearing a "Mongol Style" Hat (illustrated)
verso:
A Naked Man with a Moustache and Wearing a Green Hat
h.
recto:
One Man Surrounded by Snakes; a Second with an Elephant's Head
verso:
A Man Surrounded by Biting Snakes
i.
recto:
A Man with Two Fans Standing upon a Cat
verso:
A Man Holding Two Pots; Snakes Appearing from His Hips

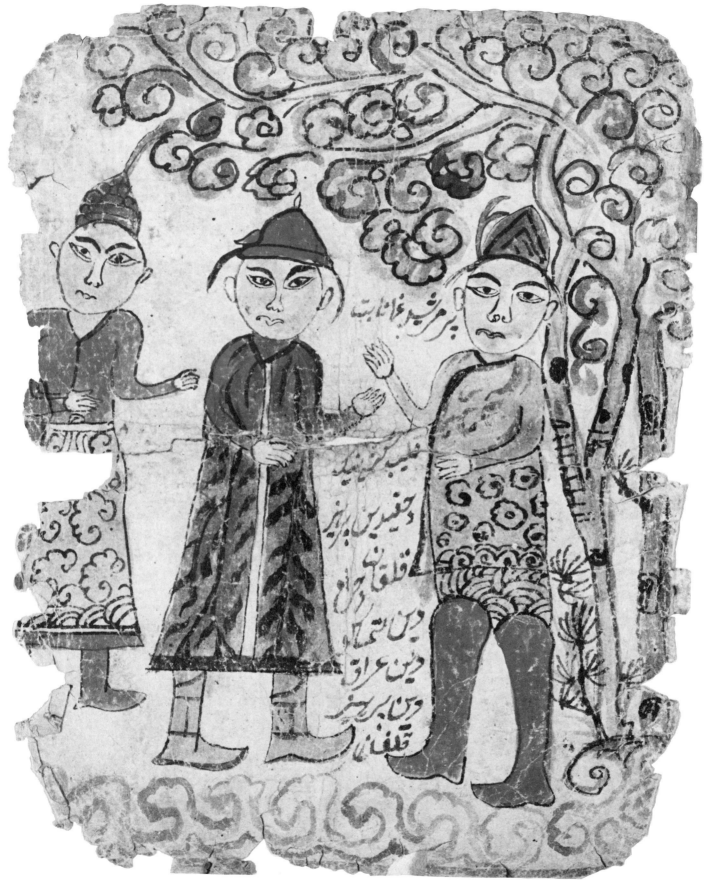

هذا السنى داس الكلب

185.
Two Leaves from a Dioscorides or Another Herbal
Syria or Baghdad, 13th century

a.
recto:
A Plant with Red Flowers and a Prominent Root
(illustrated)
verso:
A Smaller Radish-Like Plant
h: 9½ in. (24.2 cm.); w: 6¾ in. (17.2 cm.)
M.73.5.408
b.
recto:
A Plant with Star-Like Flowers
verso:
Three Stalks with Three Blooms on Each
h: 9¾ in. (24.8 cm.); w: 6 in. (15.2 cm.)
M.73.5.407

186.

*A Small Automaton of a Man Holding a Stand
with a Seated Monkey* (illustrated)
Probably from a manuscript of the *Automata*
of al-Jaziri
Syria or Egypt, probably 14th century
h: 9½ in. (24.2 cm.); w: 6½ in. (16.5 cm.)
M.73.5.572

187.

187.
A Leaf from an Unidentified Cosmological Work
Syria or Egypt, 13th century (?)
h: 9¾ in. (24.7 cm.); w: 7¼ in. (18.4 cm.)
M.73.5.585

recto:
A Winged Horse and a Winged Angel
(illustrated)
The Arabic inscriptions identify the horse as
"Salsaiel" and the recumbent angel as "Kalkaiel."
verso:
Pairs of Black and Mauve Birds

Persian Painting (1300-1450)

188.
King Khusrau Giving Audience (illustrated)
Leaf from the "second small *Shah Nama*"
Tabriz or Shiraz, ca. 1335-1350
h: 6 in. (15.3 cm.); w: 5⅛ in. (13 cm.)
M.73.5.406

For other leaves see Grube, *Muslim Miniature
Paintings*, pp. 15-18.

189.
King Khusrau Anushirwan Enthroned (illustrated)
Leaf from the Inju *Shah Nama*
Colophon of the manuscript dated:
741 A.H./A.D. 1341
h: 11¼ in. (28.5 cm.); w: 9½ in. (24.2 cm.)
M.73.5.18

For other leaves see Grube, *Muslim Miniature
Paintings*, pp. 23-26.

ثما راد زمین بعد از مُدتی فذلک حناب عمرش بآخر آمد وکشتی وجودش نموج باد مخالفت در اضطراب واقلاب
ودر آن شهر کبندی از بلور مانند بکماله آفریده شد شاکمونی در آن کند رفت و همچون شیر بخفت و از بیرون کبند خلائق
اورا می دیدند از صفای جوهر بلور و در اندرون راه نبود و ابواب که مفتوح بودند مسدُود و کشتند

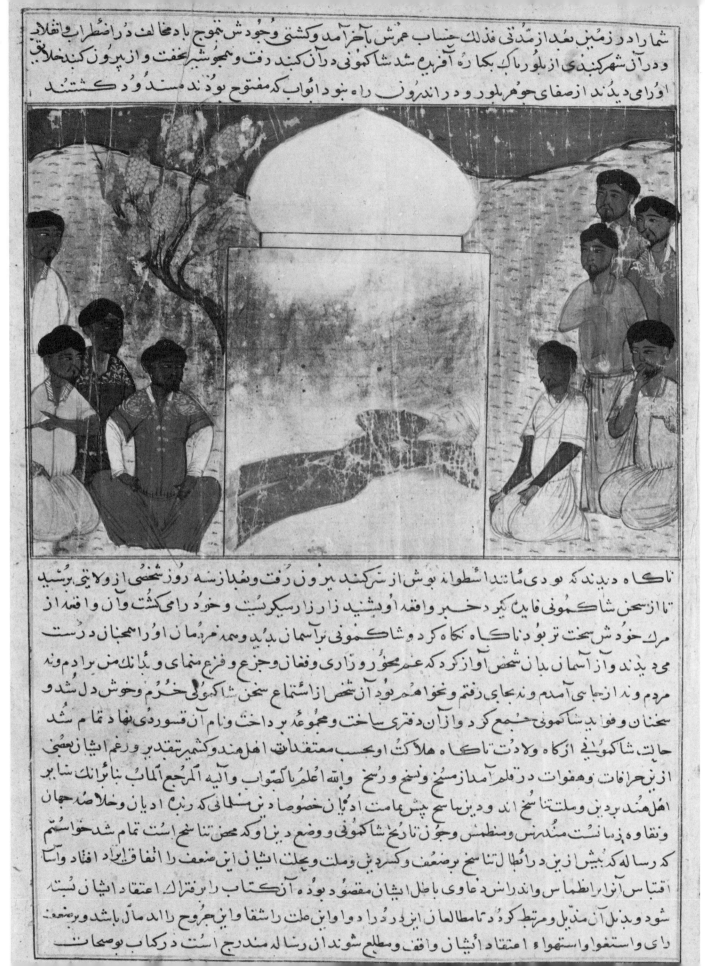

ناگاه دیدند که بودی مانند اسطوانه بوش از سر کبند بیرون رفت وعبادت زنه روز شخصی از ولایتی بوشید
تا از سخن شاکمونی فایده گیر دخبر واقعه اوبشنید زار زار سکریست و خود را می کشت و آن واقعه از
مرک خود شرسخت تر بُود ناگاه نگاه کرد و شاکمونی بر آسمان بدید و محمد مهربان اورا مهربان درست
می دیند و از آسمان بیان شخص آواز کرد که عمر محوُ رو زاری وفغان و جزع و فرع منمای و بُدانک من برادم وند
مردم وند از نجایی آمدم وند بجای رفتم وخواهم رفتم از آن شخص از استماع سخن شاکمونی خُرم وخوش دل شدو
سخنان وفواید شاکمونی جمع کرد و از آن دفتری ساخت ومجموعه بر داخت ونام آن قسوردی نهاد تمام شد
جابت شاکمونی اکرگاه ناکت ولادت ناکت هلاکت اوبحسب معتقدات اهل هند وکشمیر تقدیر ورغم ایشان بعض
از بنجرافات وهفوات در قلم آمدوز مسئخ ونسئخ و رسخ والله اعلم بالصواب والیه المرجع المآب بنابرانک سایر
اهل هند بردین وملت تناسُخ اند و دین مایع پیشر مایت ادیان خصوصا دین مسلمانی که رنج ادیان وخلاص جهان
ونقاوه زبانست مندرس ومنطمس وجوُن تاریخ شاکمونی که محض تناسخ است تمام شد خواسُتم
که رساله که بیش از این در ابطال تناسُخ بوضعف وکسروبی وملت وجلت ایشان این ضعف را اتفاق افتاد واسا
اقتباس آنوار اظما س واندراس د عاوی باطل ایشان مقصود بوده آن کتاب را برقرار اعتقاد ایشان نسبت
شود و بدل آن مذیل ومرتبط کرده تا مطالعان ایزد دارد و دوای ملت را اشفاق وایح جروح را ادمال باشد و بضعف
رای واستغفوا واستهوا د اعتقاد ایشان واقف ومطلع شوندان رساله مندرج است در کباب بوصیحات

190.
The Appearance of Sakyamuni (the Buddha) to
the People after His Death (illustrated)
Leaf from the *Majma at-Tavarikh* by Hafiz-i-Abru
Herat, ca. 1425
h: 13 in. (33 cm.); w: 8¾ in. (22.3 cm.)
M.73.5.412

For other pages see Grube, *Muslim Miniature
Paintings,* nos. 37-40.

191.
Portrait of a Warrior in Armor (illustrated)
Herat, ca. 1425
h: 7¼ in. (18.4 cm.); w: 3⅞ in. (9.8 cm.)
M.73.5.24

For a similar portrait see Grube, *The Classical
Style in Islamic Painting,* no. 25.

191.

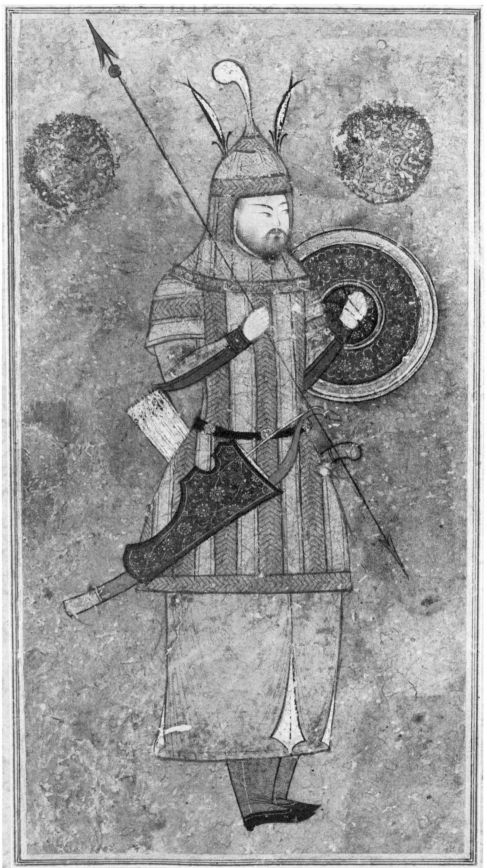

192.
*Sam Recognizes His Son Zal in the Nest of
the Simurgh*
Leaf from a *Shah Nama*
Shiraz, ca. 1425-1450
h: 10 in. (25.4 cm.); w: 7⅝ in. (18.5 cm.)
M.73.5.409

193.
The Wedding of Zal and Rudaba
Leaf from a *Shah Nama*
Shiraz, ca. 1425-1450
h: 8 in. (20.2 cm.); w: 5 in. (12.7 cm.)
M.73.5.575

194.
Bahram Gur with the Dragon
Leaf from a *Khamsa*
Shiraz, ca. 1425-1450
h: 7⅛ in. (18 cm.); w: 6¾ in. (17.2 cm.)
M.73.5.589

195b.

196.

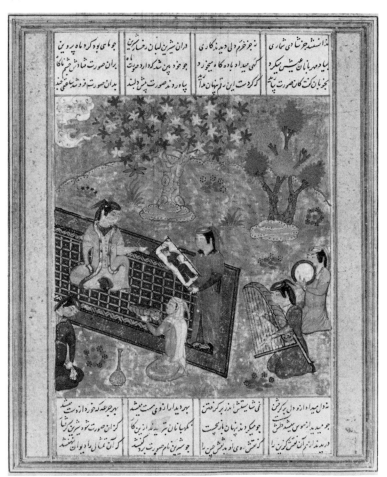

Painting under The Turkmen (1450-1500)

195.
Two Leaves from a Khamsa *of Nizami*
Shiraz, ca. 1475-1500
a.
*Iskandar (Alexander the Great) at the Kaaba
in Mecca*
h: 6⅞ in. (17.5 cm.); w: 5½ in. (14 cm.)
M.73.5.414
cf. cat. no. 197b
b.
Nurshaba with the Portrait of Iskandar (illustrated)
h: 6⅞ in. (17.5 cm.); w: 5½ in. (14 cm.)
M.73.5.433

196.
Sultan Sanjar with the Old Woman (illustrated)
Leaf from a *Khamsa* of Nizami
Shiraz, ca. 1475-1500
h: 6¾ in. (17.2 cm.); w: 5¾ in. (14.6 cm.)
M.73.5.20
cf. cat. nos. 203b and 206, fol. 16R

197.
Eight Leaves from a Shah Nama
Shiraz, ca. 1490
a.
*Isfandiyar Attacks the Simurgh from an
Armored Vehicle* (illustrated)
h: 8⅞ in. (22.5 cm.); w: 6 in. (15.2 cm.)
M.73.5.410
b.
Iskandar at the Kaaba
h: 8⅞ in. (22.5 cm.); w: 6 in. (15.2 cm.)
M.73.5.462
cf. cat. no. 195a
c.
*Iskandar Finds Khizr and Ilyas at the Fountain
of Life*
h: 8⅞ in. (22.5 cm.); w: 6 in. (15.2 cm.)
M.73.5.590
d.
*Ardashir Feeds Molten Metal to Haftdad's Worm
in Kirman*
h: 8⅞ in. (22.5 cm.); w: 6 in. (15.2 cm.)
M.73.5.411

e.
*The Discomfiture and Death of Piruz and the
Persian Army in the Great Ditch Dug
by Khushnawaz, King of the Hephthalites*
h: 8¾ in. (22.3 cm.); w: 6⅛ in. (15.6 cm.)
M.73.5.23
f.
A Banquet Scene (illustrated)
h: 8⅞ in. (22.5 cm.); w: 6 in. (15.2 cm.)
M.73.5.413
g.
Hormuz Tied to a Column and Beaten
h: 8⅞ in. (22.5 cm.); w: 6 in. (15.2 cm.)
M.73.5.463
h.
Page with Text

Another miniature from the same series shows
Azararkshab dallying with a lady while his soldiers
come to seek him. Formerly in the Binney
Collection, it is now in the Portland Art Museum
(see Binney, *Islamic Catalogue,* no. 33).

Herat and Bukhara Painting (ca. 1450-1600)

197a.

197f.

198.
A Female Dancer with Two Musicians in a Garden
(illustrated)
Leaf from a *Khamsa* of Nizami
Herat, 1513
h: 6¾ in. (17.25 cm.); w: 3½ in. (9 cm.)
M.73.5.15

The colophon, in the Binney Collection, gives
the place of production and the date, as well as the
name of the calligrapher, Sultan Muhammad
Nur. The manuscript belonged to the Imperial
library of the Mughal Emperors Jahangir and Shah
Jahan. (Binney, *Islamic Catalogue,* no. 39.)
Another miniature is in the Portland Art Museum.

199.
Three Leaves, Probably from the Yusuf and
Zuleikha
Bukhara, 1525-1550
a.
Yusuf, after His Ordeal in the Pit,
Waiting in a Meadow
h: 7⅛ in. (18 cm.); w: 4⅜ in. (11 cm.)
M.73.5.443
b.
The Arrival of Yusuf in a Courtyard
h: 7¼ in. (18.5 cm.); w: 4⅞ in. (12.5 cm.)
M.73.5.442
c.
Zuleikha Fainting (illustrated)
h: 7⅛ in. (18 cm.); w: 4½ in. (11.5 cm.)
M.73.5.444

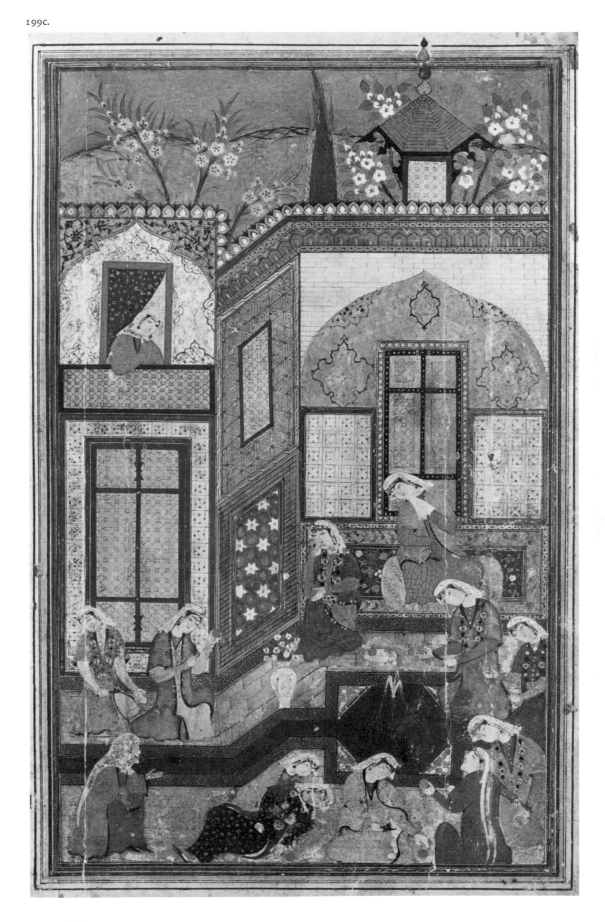

200.
A Prince Standing beside His Horse at the
Wall of a Courtyard (illustrated)
Probably Bukhara, ca. 1525-1550
h: 6⅞ in. (17.5 cm.); w: 4⅜ in. (11 cm.)
M.73.5.432

201.
Six Leaves from a Manuscript of the
Anwar-i-Suhaili
Bukhara, 972 A.H./A.D. 1564-1565
a.
A Hunting Scene with a Gazelle in the Center Being
Chased by Mounted Horsemen on Both Sides
The text above refers to a dervish who has fainted.
The gazelle is his friend.
h: 7⅞ in. (20 cm.); w: 4⅝ in. (11.75 cm.)
M.73.5.438
b.
A School Scene
h: 9¼ in. (23.5 cm.); w: 4⅞ in. (12.25 cm.)
M.73.5.440
c.
The Story of the Turtle and the Two Geese
(illustrated)
h: 9¼ in. (23.5 cm.); w: 5¼ in. (13.25 cm.)
M.73.5.17
d.
A Youth in a Courtyard with a Pool in Its Center
h: 7¼ in. (18.5 cm.); w: 4¾ in. (12 cm.)
M.73.5.439
e. and f.
Text and colophon
M.73.5.517
M.73.5.518

The colophon reads:
"The end of this book for God by the hand of
the obedient servant Ali Reza the Calligrapher in
the year of 972 A.H. of the prophet. May praise
be upon him."

A rubber stamp at the bottom of one of the
leaves indicates that the manuscript was once in a
collection in Lucknow, India.

202.
Seven Leaves from a Manuscript of the
Majalis-al-Ushshaq *(The Gathering of the Lovers)*
by Sultan Husayn Mirza
Bukhara or India, ca. 1600
a.
A Youth in a Room; a Second Youth Outside with
an Older Black-Bearded Man
h: 10 in. (25.4 cm.); w: 6½ in. (16.5 cm.)
M.73.5.580
b.
A Scene Like the Miraj *of Muhammad*
h: 10 in. (25.4 cm.); w: 6½ in. (16.5 cm.)
M.73.5.584
cf. cat. no. 203a
The saint or prophet appears unveiled and is not
riding upon Buraq.
c.
A Black-Bearded Noble Being Served Food While
Attended by a Man with a Fly-Whisk
h: 9¾ in. (24.75 cm.); w: 6½ in. (16.5 cm.)
M.73.5.567
d.
recto:
The Game of Chess between Shams-i-Tabrizi and
the Christian
verso:
A Youth Hands a Manuscript to a Sage
h: 10⅛ in. (25.5 cm.); w: 6½ in. (16.5 cm.)
M.73.5.579
e.
Text
M.73.5.786
f.
Text
M.73.5.787
g.
Text
M.73.5.788

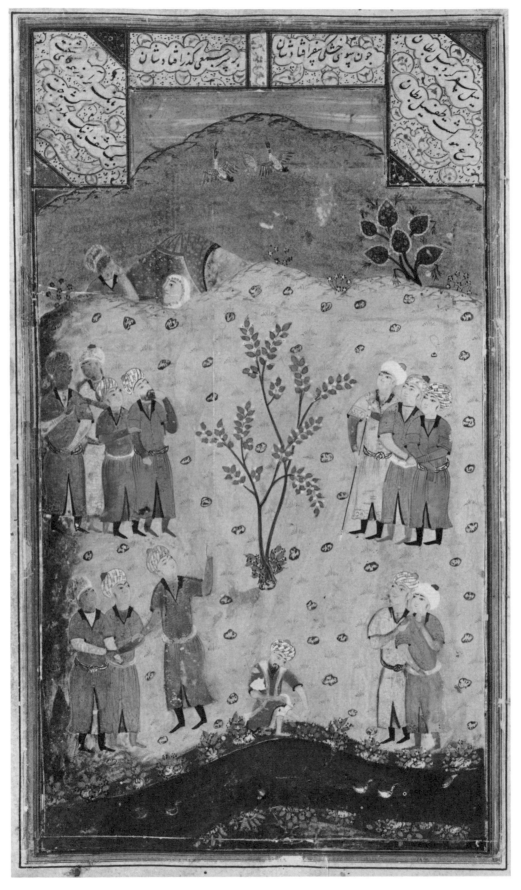

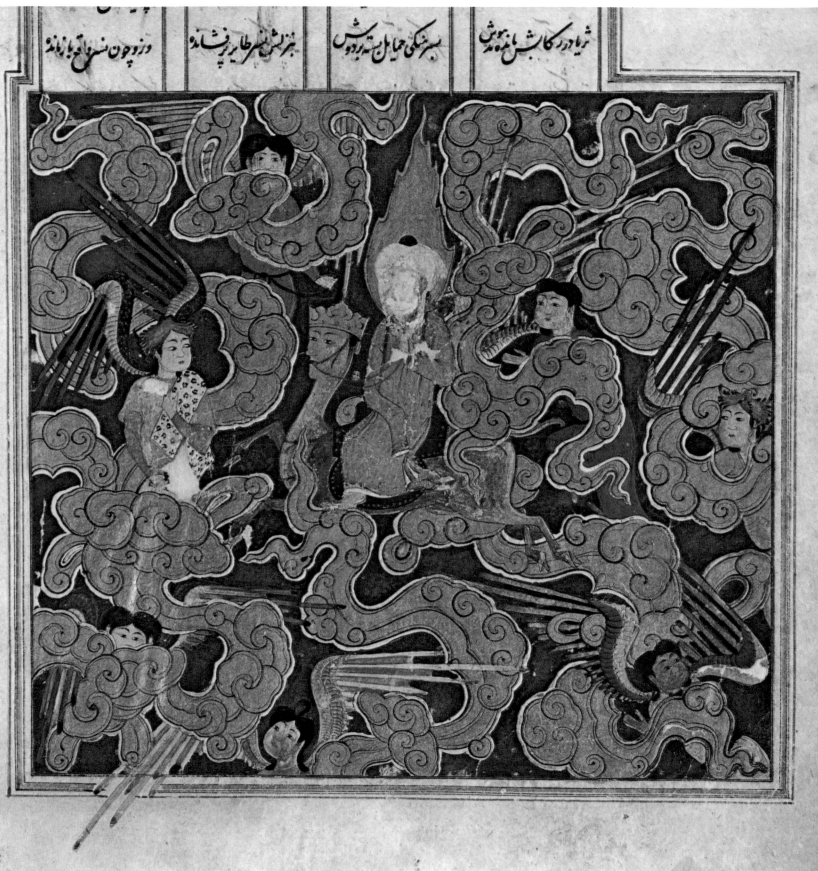

203.
Thirteen Miniatures and Three Pages of Text from a Manuscript of the Khamsa *of Nizami*
Shiraz, 924 A.H./A.D. 1517
a.
The Miraj, or Night Journey of Muhammad
(illustrated)
h: 7⅝ in. (19.5 cm.); w: 5⅜ in. (13.25 cm.)
M.73.5.421
The prophet of Islam reportedly visited the heavens mounted on Buraq, a fabulous steed with a woman's head. This nocturnal adventure supposedly started from and returned to the Dome of the Rock in Jerusalem, making the Holy City of the Jews and Christians equally hallowed for Muslims. The *miraj* is frequently used near the beginning of a text as semi-divine consecration.
b.
Sultan Sanjar and the Old Woman
h: 7⅜ in. (18.25 cm.); w: 4⅛ in. (10.25 cm.)
M.73.5.426
cf. cat. nos. 196 and 206, fol. 16R
c.
Khusrau Killing a Lion in Front of Shirine's Tent
h: 7½ in. (19 cm.); w: 4⅜ in. (10.75 cm.)
M.73.5.422
d.
Khusrau Murdered at the Command of Shiruye
h: 7⅜ in. (18.25 cm.); w: 4⅛ in. (10.75 cm.)
M.73.5.419
e.
Laila and Majnun at School
h: 9½ in. (24 cm.); w: 5½ in. (14 cm.)
M.73.5.417
cf. cat. nos. 205a and 206, fol. 122R
f.
Majnun's Father Taking Him to Visit the Kaaba
h: 9¾ in. (24.75 cm.); w: 4 in. (10.25 cm.)
M.73.5.423
The purpose of the visit is so that the youth's strange aberration, his love for the beautiful Laila, may possibly be cured by a miracle at the Holy Place of Islam.
g.
Bahram Gur Transfixes with a Single Arrow a Lion Which Has Leaped upon an Onager
h: 7½ in. (19 cm.); w: 4½ in. (11.5 cm.)
M.73.5.565
cf. cat. no. 206, fol. 178R
King Bahram's hunting prowess accounts for his honorific, as "Gur" means onager.
h.
The Shepherd Coming to King Bahram's Tent
h: 7½ in. (19 cm.); w: 6⅛ in. (15.5 cm.)
M.73.5.520
i.
Azada's Revenge on Bahram
h: 7½ in. (19 cm.); w: 5½ in. (14 cm.)
M.73.5.418

One day when the King was startled by the sight of a woman carrying a full-grown bullock up a flight of stairs, Azada offered him the following explanation: she had started by carrying the new born calf, and her strength had grown as the animal's size had increased.
j.
Bahram Gur with the Chinese Princess in the Saffron Pavilion on Sunday
h: 9⅞ in. (25 cm.); w: 4 in. (10.25 cm.)
M.73.5.566
cf. cat. no. 205c
In the *Haft Paikar* (Seven Pavilions) section of the *Khamsa,* Nizami tells of Bahram who courted seven princesses during the course of a single week. Each princess told him a story which is recounted in detail in the text.
k.
Bahram Gur with the Tartar Princess in the Green Pavilion on Monday
h: 9⅜ in. (24 cm.); w: 4 in. (10.25 cm.)
M.73.5.564
cf. cat. no. 206, fol. 205V
l.
Bahram Gur with the Princess of Khwarizm in the Turquoise Pavilion on Wednesday
h: 9⅞ in. (25 cm.); w: 4 in. (10.25 cm.)
M.73.5.425
That there is a duplication of miniatures in a single manuscript can probably be explained by the fact that two artists were commissioned to "paint a pavilion" and that one of them failed to note properly the color of the building he was supposed to paint.
m.
The Battle of Iskandar with the Zangi (illustrated)
h: 7½ in. (19 cm.); w: 4 in. (10.25 cm.)
M.73.5.424
cf. cat. no. 206, fol. 273V
n.
Text
M.73.5.604
o.
Text
M.73.5.606
p.
Text
M.73.5.785

204.
Two Leaves from a Khamsa *of Nizami*
Shiraz, 1525-1550
a.
The Death of Majnun and a Lion Attacking a Bystander (illustrated)
h: 9¼ in. (23.25 cm.); w: 6⅜ in. (16.25 cm.)
M.73.5.435
b.
Bahram Gur with the Indian Princess in the Black Pavilion on Saturday
h: 10½ in. (26.75 cm.); w: 6½ in. (16.5 cm.)
M.73.5.464

افتاده دو یار سوزش رفته | آواز جهان ز کوشش رفت | کرد آمده آن دوان خونریز | گروه بهلاک جنگ رانیز

به ام آن و یار خسته | چون جنبش کوه حلقه بسته | زانبوه در آن بدان کنرگاه | نظاره نیافت در میان راه

ازان که در آن میان دوید | شخصی دو سه جادوان زرنگ | باقی و که ز میان جسته | رفته و به کوه شه نشسته

بود نه رفت و ه که گذرگاه | تا تیغ روز بر گذرگاه | زبد آمد و از کلاب و عنبر | کرد آن دو به بار زار زار

چون یار رسید نقش جامه خامش | ماننده نقش جامه خامش | لیلی به هزار شربت مینا کی | آمد ییان غریب خاکی

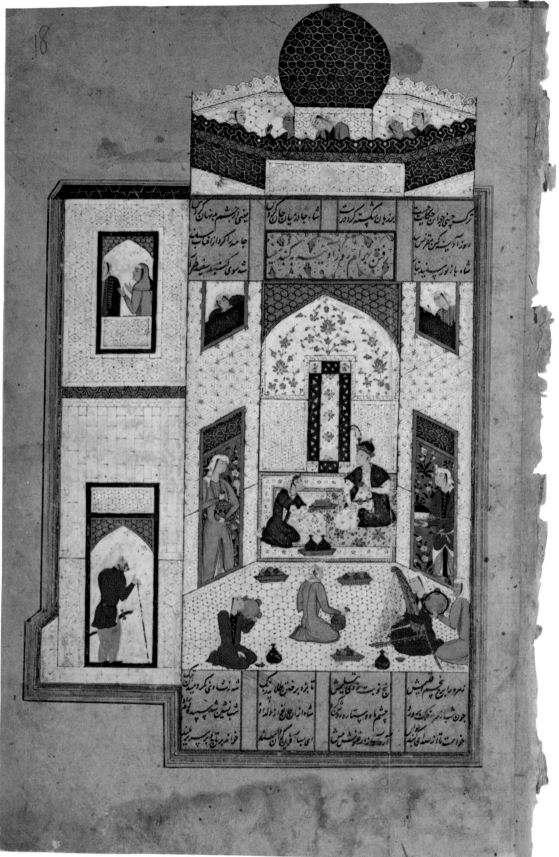

205.
Four Leaves from a Khamsa of Nizami
Shiraz, 1525-1550
a.
Laila and Majnun at School (illustrated)
h: 7¾ in. (19.75 cm.); w: 6¼ in. (16 cm.)
M.73.5.560
cf. cat. nos. 203e and 206, fol. 122R
b.
*Fahrad Carrying upon His Shoulders Shirine
Mounted on Her Horse*
h: 7⅝ in. (19.5 cm.); w: 5¾ in. (14.5 cm.)
M.73.5.427
cf. cat. nos. 203b, 206
c.
*Bahram Gur with the Chinese Princess in the
Saffron Pavilion on Sunday*
h: 10 in. (25.4 cm.); w: 5⅝ in. (13.5 cm.)
M.73.5.416
cf. cat. no. 203
d.
Iskandar with the Khaqqan of Chin
h: 7¾ in. (19.75 cm.); 5¾ in. (14.5 cm.)
M.73.5.454

206.
Manuscript of the Khamsa of Nizami
With a *shamsa* (introductory roundel), fourteen
miniatures, and a colophon
Shiraz, ca. 1550
M.73.5.603
fol. 16R
Sultan Sanjar and the Old Woman
h: 7⅞ in. (20 cm.); w: 4⅜ in. (11 cm.)
cf. cat. nos. 196, 203b
fol. 25R
The Story of the King and the Honest Old Man
h: 8 in. (20.25 cm.); w: 4⅜ in. (11 cm.)
fol. 57V
The Battle of Khograw and Bahram Chubina
(illustrated)
h: 8 in. (20.25 cm.); w: 4¼ in. (10.75 cm.)
fol. 74R
*Fahrad Carrying upon His Shoulders Shirine
Mounted on Her Horse*
h: 8 in. (20.25 cm.); w: 4⅜ in. (11 cm.)
cf. cat. no. 205b
fol. 83V
Khusrau Talking to Shirine
h: 7⅞ in. (20 cm.); w: 6⅜ in. (16.25 cm.)
fol. 122R
Laila and Majnun at School
h: 7⅞ in. (20 cm.); w: 6⅜ in. (16.25 cm.)
cf. cat. nos. 203e and 205a
fol. 149R
Salim Ameri Visiting a Majnun in the Desert
h: 7⅞ in. (20 cm.); w: 6⅜ in. (16.25 cm.)
cf. cat. nos. 212a and 268, fol. 90V
fol. 178R
*Bahram Gur Transfixes with a Single Arrow
a Lion Which Has Leaped Upon an Onager*
h: 5 in. (12.7 cm.); w: 4½ in. (11.9 cm.)
cf. cat. no. 203
fol. 202V

*Bahram Gur with the Tartar Princess in the Green
Pavilion on Monday*
h: 9½ in. (24.25 cm.); w: 6½ in. (16.5 cm.)
cf. cat. no. 203k
fol. 206R
*Bahram Gur with the Russian Princess in the
Red Pavilion on Tuesday*
h: 9⅞ in. (25 cm.); w: 6½ in. (16.5 cm.)
fol. 228R
*Bahram Hanging the Man Responsible for
Turning Him against His Vizier*
h: 8 in. (20.25 cm.); w: 6⅜ in. (16.25 cm.)
fol. 273V
Battle of Iskandar with the Zangi
h: 8 in. (20.25 cm.); w: 6½ in. (16.5 cm.)
cf. cat. no. 203
fol. 324R
Iskandar and Nushabah
h: 8 in. (20.25 cm.); w: 6½ in. (16.5 cm.)
fol. 357R
*Court Scene with Iskandar Attending a Meeting of
the Wise Men*
h: 8 in. (20.25 cm.); w: 4½ in. (11.5 cm.)
357 pages, 21 lines per page

207.
*Firdousi in a Bathhouse Receiving Wages for
Having Written the* Shah Nama (illustrated)
Shiraz, 1550-1575
h: 17¼ in. (43.75 cm.); w: 11¼ in. (28.5 cm.)
M.73.5.591

A miniature from a *Shah Nama* mounted as an
album leaf. Two other leaves are known from this
series, one in the Binney Collection (see Grube,
Muslim Miniature Paintings, no. 65; Binney,
Islamic Catalogue, no. 40); the second in
Dayton, Ohio.

208.
Rustam Approaching the Tents of King Kobad
(illustrated)
Shiraz, 1550-1575
h: 17¼ in. (43.75 cm.); w: 11¼ in. (28.5 cm.)
M.73.5.592

A second leaf from the same album as cat. no. 207.

209.
Rustam Rescues Bizhan from the Pit (illustrated)
Leaf from a *Shah Nama*
Shiraz, 1550-1575
h: 6¼ in. (15.75 cm.); w: 5⅝ in. (15 cm.)
M.73.5.434

210.
Four Miniatures of Episodes from the Shah Nama,
Remounted onto Horizontal Album Pages
Shiraz style, 16th century
a.
Raksh, the Steed of Rustam, Impaled in a Pit
h: 3½ in. (9 cm.); w: 6½ in. (16.5 cm.)
M.73.5.428
b.
*The Vizier Buzurghmihr Showing the Game of
Chess to King Khusrau Anushirwan*
The text above: "Knowledge is better than having
a name."
h: 3½ in. (9 cm.); w: 6½ in. (16.5 cm.)
M.73.5.586
c.
*A King Seated on a Throne Attended by Two
Servants*
h: 3½ in. (9 cm.); w: 6½ in. (16.5 cm.)
M.73.5.429
d.
*Bahram Gur Tramples His Mistress Azada under
the Hooves of His Horse* (illustrated)
h: 3½ in. (9 cm.); w: 6½ in. (16.5 cm.)
M.73.5.430
It should be noted that the person below the horse
is a male rather than a female. Perhaps the artist
confused different episodes in his text.

211.
A Camp Scene (illustrated)
Shiraz, 1550-1575
h: 9 in. (22.75 cm.); w: 7⅛ in. (18 cm.)
M.73.5.441

212.
Two Leaves from a Khamsa *of Nizami*
Shiraz, 1550-1575
a.
Majnun in the Desert
h: 7⅜ in. (20 cm.); w: 5½ in. (14 cm.)
M.73.5.578
cf. cat. no. 206, fol. 149R and 268, fol. 90V
b.
Laila Standing in the Palm Grove (illustrated)
h: 8 in. (20.25 cm.); w: 5¾ in. (14.5 cm.)
M.73.5.576

213.
*Four Leaves from an Unidentified Manuscript,
Probably the* Yusuf and Zuleikha *by Jami*
Shiraz, ca. 1590-1600
a.
Yusuf (?) Nimbate on a Throne in a Landscape
h: 7⅝ in. (20 cm.); w: 3⅞ in. (10 cm.)
M.73.5.449
b.
*Entertainment in a Meadow, a Boy Dances
Accompanied by a Tambourine*
h: 7⅝ in. (20 cm.); w: 3⅞ in. (10 cm.)
M.73.5.448
c.
Yusuf (?) Is Thrown Down the Well (illustrated)
h: 7⅝ in. (20 cm.); w: 3⅞ in. (10 cm.)
M.73.5.451
d.
*The Old Woman Buying Yusuf As He Is Being
Removed from the Well*
h: 8 in. (20.25 cm.); w: 5¾ in. (14.5 cm.)
M.73.5.576

214.
Three Leaves from an Unidentified Manuscript
Shiraz, ca. 1600
a.
A Youth in Blue Greeting Another in Red
h: 6¾ in. (17.25 cm.); w: 4⅝ in. (11.75 cm.)
M.73.5.574
b.
*A Bare-Chested Youth (like Majnun?) Greeting a
Lady under a Tent*
h: 6¾ in. (17.25 cm.); w: 4⅝ in. (11.75 cm.)
M.73.5.573
c.
*A Youth on a Black Horse Witnessing a Scene
of Flagellation*
h: 6⅞ in. (17.5 cm.); w: 5⅛ in. (13 cm.)
M.73.5.437

Other Sixteenth Century Styles

215.
*A King and a Sage Conversing in a Rocky
Landscape*
Tabriz, ca. 1510
h: 8½ in. (21.5 cm.); w: 5¼ in. (13.25 cm.)
M.73.5.29

The oxidized silver of the cave or the river below
has been overpainted in black. The episode does
not seem to relate to the text on the page.

216.
Two Men under a Tree (illustrated)
Tabriz, ca. 1525
h: 6⅛ in. (15.5 cm.); w: 3 in. (7.75 cm.)
M.73.5.561

Fragment of a much larger drawing, remounted
onto an album page, surrounded by calligraphy.

217.
Portrait of a Youth in Blue with a Fur Hat
Album page
Style of Tabriz, ca. 1550-1575
h: 6⅜ in. (16.25 cm.); w: 3 in. (7.75 cm.)
M.73.5.459

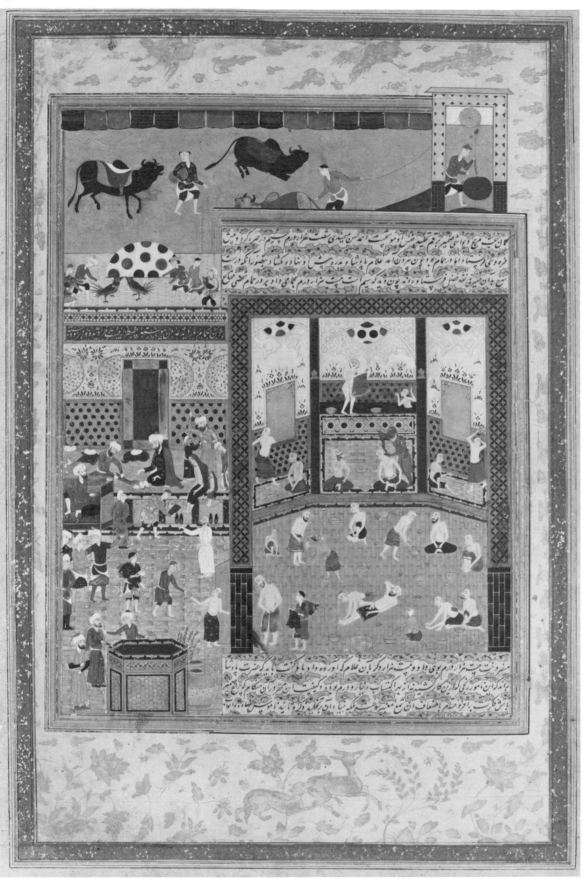

208.

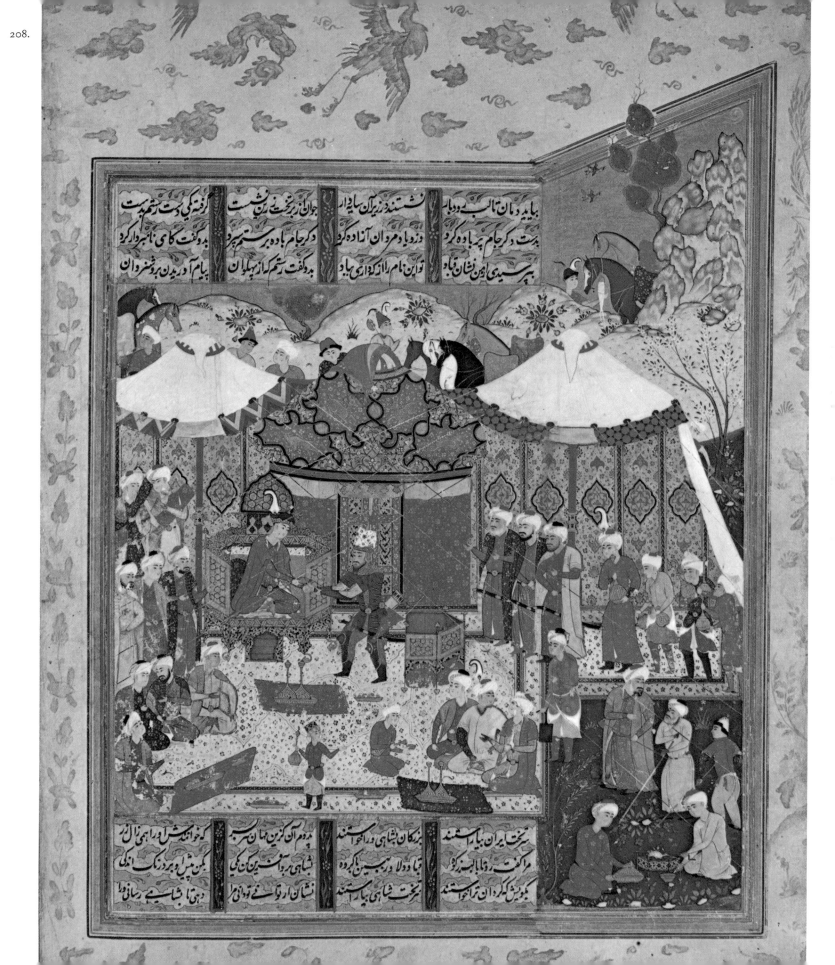

212b.

127

كه شنعت بود دجيه بربرى كا
برهم شد ارزوى من شهرسار

نكوش بجاى درانداختم
بتازيد ومن درپشت تاختم

بماند كند سعى در خون من
كه دانستم ارزنده آن برمن

مبادا كه ازمن برش كم آشكار
پسنده كه ازمن رزاور مار

طهارت معرفتش سکشکینه شود

امروز زر از غنیمت دان که بسی نیاید

218.

A Seated Youth in Red Leaning on a Bolster
(illustrated)
Album page
Khurassan, ca. 1575
h: 6¾ in. (17.25 cm.); w: 3¼ in. (8 cm.)
M.73.5.458

verso: sketch of an elephant.

219.

Khusrau, Mounted on Horse, Sees Shirine Bathing
Leaf from a *Khamsa* of Nizami
Qazvin, ca. 1550-1575
h: 8¼ in. (21 cm.); w: 5⅜ in. (13.75 cm.)
M.73.5.461

220.

*A Lady under a Tent Watching One of Her Maids
Draw Water from a Stream*
Qazvin, ca. 1560-1565
h: 8½ in. (21.5 cm.); w: 4⅞ in. (12.25 cm.)
M.73.5.19

Extensive overpainting.

221.

Zal in the Nest of the Simurgh (illustrated)
Leaf from a *Shah Nama*
Style of Muhammadi, Qazvin, ca. 1580
h: 9¾ in. (24.75 cm.); w: 5⅝ in. (14.25 cm.)
M.73.5.447

222.

Three Leaves from a Manuscript of the Shah Nama
Qazvin, ca. 1580
a.
A Major Personage Arriving on a White Elephant
h: 8⅝ in. (22 cm.); w: 6¼ in. (15.75 cm.)
M.73.5.11
b.
Maids Attending Prince and Princess in a Garden
h: 8½ in. (21.5 cm.); w: 6 in. (15.25 cm.)
M.73.5.16
c.
*A King Enthroned in a Garden Pavilion and a
Horse Being Attended Outside the Wall*
h: 8½ in. (21.5 cm.); 5¾ in. (14.75 cm.)
M.73.5.577

226.

227.

223.
A Leaf from a Manuscript of the Aja'ib
al-Makhluqat *(The Wonders of Creation)*
by Qazvini
Provenance unknown, 1550-1600
recto:
Island with People Living in Trees
verso:
Birds and Flowers
h: 8¾ in. (22.25 cm.); w: 4¼ in. (10.75 cm.)
M.73.5.588

Isfahan and the Seventeenth Century

224.
Drawing of a Seated Man and Two Birds on a Tree
Isfahan, ca. 1600-1610
Ink on paper
h: 6⅞ in. (17.5 cm.); w: 2⅛ in. (5.25 cm.)
M.73.5.482

225.
Album Leaf Portraying a Lady
Style of Isfahan, ca. 1600-1610
h: 5¾ in. (14.5 cm.); w: 3 in. (7.75 cm.)
M.73.5.455

The miniature is surrounded by panels of
calligraphy which are framed by a border decorated
with gold floral motifs on brown.

226.
A Reclining Youth (illustrated)
Isfahan, ca. 1610
h: 3¾ in. (9.5 cm.); w: 5⅜ in. (13.5 cm.)
M.73.5.470

Ink drawing with touches of gold and colors.

227.
A Kneeling Youth Holding Cup and Fruit
(illustrated)
Isfahan, ca. 1610
h: 8⅜ in. (22.25 cm.); w: 3⅝ in. (9.25 cm.)
M.73.5.460

Album leaf with panels of calligraphy surrounding
the central miniature.

228.
A Standing Youth in Brown Coat
Isfahan, ca. 1610-1620
h: 5⅞ in. (15 cm.); w: 3½ in. (9 cm.)
M.73.5.571

Album leaf with panels of calligraphy and border of marbled paper.

229.
A Robber Attacking a Traveller
Isfahan, ca. 1610-1620
Tinted drawing
h: 3½ in. (9 cm.); w: 6¼ in. (16 cm.)
M.73.5.473

Album leaf with panels of calligraphy.

230.
A Sage and His Disciple in Discussion under a Tree
Isfahan, ca. 1620
Tinted drawing
h: 6½ in. (16.5 cm.); w: 3⅛ in. (8 cm.)
M.73.5.465

231.
A Bearded Man Supported by a Cane in His Left Hand and Seated in a Landscape (illustrated)
Isfahan, ca. 1625
Ink drawing with touches of gold
h: 3¾ in. (9.5 cm.); w: 6¼ in. (15.5 cm.)
M.73.5.26

Miniature surrounded by panels of illumination. The inscription reads "this was made on Thursday, the twenty-fifth of the month of Rajab."

231.

232.
A Bearded Man Leaning on a Staff
Isfahan, ca. 1620-1630
Drawing with colored areas
h: 4¼ in. (10.75 cm.); w: 2¼ in. (5.5 cm.)
M.73.5.472

233.
Standing Man in a Green Pointed Hat
Style of Riza-i-Abbasi
Isfahan, ca. 1620-1630
Drawing in red and black
h: 6½ in. (16.5 cm.); w: 3 in. (7.75 cm.)
M.73.5.479

234.
A Man Seated under a Tree
Isfahan, ca. 1630
Ink drawing
h: 6⅛ in. (15.5 cm.); w: 3⅛ in. (8 cm.)
M.73.5.467

A panel of illuminated calligraphy above.

235.
*A Standing Youth Holding a Sprig of Narcissus
in His Right Hand*
Isfahan, ca. 1630
Tinted drawing
h: 7⅛ in. (18 cm.); w: 3½ in. (9 cm.)
M.73.5.562

On the reverse is an illuminated page of
calligraphy done by Abdul Rahim in the year
1033 A.H./A.D. 1623-1624.

236.
A Kneeling Youth with a Cup in His Left Hand
Isfahan, ca. 1630
Drawing with slight color tints
h: 3⅞ in. (10 cm.); w: 2 in. (5 cm.)
M.73.5.484

A version of the style of the late sixteenth century.

237.
*A Standing Man Using a Pitchfork to Brace
His Shoulders* (illustrated)
Signature of Riza-i-Abbasi
Isfahan, dated 1044 A.H./A.D. 1634
Drawing with color washes
h: 4½ in. (11.5 cm.); w: 2⅜ in. (6 cm.)
M.73.5.474

Inscribed: "On the day of Sunday, in the month of
Safar, year 1044 A.H."

238.
Shoeing a Horse
Isfahan, ca. 1630-1640
Drawing with touches of gold and colors
h: 5 in. (12.75 cm.); w: 8¼ in. (21 cm.)
M.73.5.468

239.
*Shah Abbas Seated Next to an Uzbek (?) at the
Signing of a Pact* (illustrated)
Isfahan, 1048 A.H./A.D. 1638
Drawing with color touches
h: 3½ in. (9 cm.); w: 4½ in. (11.5 cm.)
M.73.5.469

Inscribed: "On Saturday, 18th of the month of
Safar from the victorious hejira year 1048 this
meeting came to an end."

240.
A Standing Man Holding a Pear in His Right Hand
A "signature" of Riza-i-Abbasi, but probably by a
pupil, perhaps Muhammad Yusuf
Isfahan, ca. 1630-1640
Drawing with gold and color tints
h: 7 in. (17.75 cm.); w: 3½ in. (9 cm.)
M.73.5.471

A version of a drawing in the Victoria and Albert
Museum, London.

241.
A Man Standing Beside a Tree
Style of Muhammad Qasim
Isfahan, ca. 1640
Ink and color tints
h: 4½ in. (11.5 cm.); w: 2¼ in. (5.75 cm.)
M.73.5.483

242.
A Lady Suckling a Baby under a Tent
On an album leaf of marbled paper
Isfahan, ca. 1640-1650
Ink drawing with colors
h: 6½ in. (16.5 cm.); w: 4⅛ in. (10.5 cm.)
M.73.5.478

243.
A Game of Chess in the Countryside
Isfahan, ca. 1640-1650
h: 9⅝ in. (22 cm.); w: 5⅞ in. (15 cm.)
M.73.5.415

A later copy of the style of Riza-i-Abbasi.

244.
Two Bearded Men in Conversation in a Landscape
Stencilled album leaf
Isfahan, ca. 1650
h: 5½ in. (14 cm.); w: 2½ in. (6.25 cm.)
M.73.5.431

Completely repainted.

245.
*A Standing Youth in a Landscape, His Short Coat
Reversed across His Chest*
Style of Muhammad Qasim
Isfahan, ca. 1640-1650
Ink drawing with colors
h: 5⅝ in. (14.25 cm.); w: 2¾ in. (7 cm.)
M.73.5.568

Miniature surrounded by cartouches with
calligraphy and mounted as an album leaf.

246.
A Bearded Man with Flask and Cup
Style of Muhammad Yusuf
Isfahan, ca. 1640-1650
Ink drawing
h: 6½ in. (16.5 cm.); w: 3¼ in. (8.25 cm.)
M.73.5.476

247.
*A Youth Kneeling beside a Sleeping Prince in
a Landscape*
Style of Muhammad Yusuf or Muhammad Ali
Isfahan, ca. 1650
Tinted drawing
h: 6½ in. (16.5 cm.); w: 3¾ in. (8.75 cm.)
M.73.5.475

Possibly from a Hafiz manuscript in the Beatty
Library, Dublin. Another manuscript, with a large
number of tinted drawings similar to this one,
is in the Topkapu Saray in Istanbul.

239.

237.

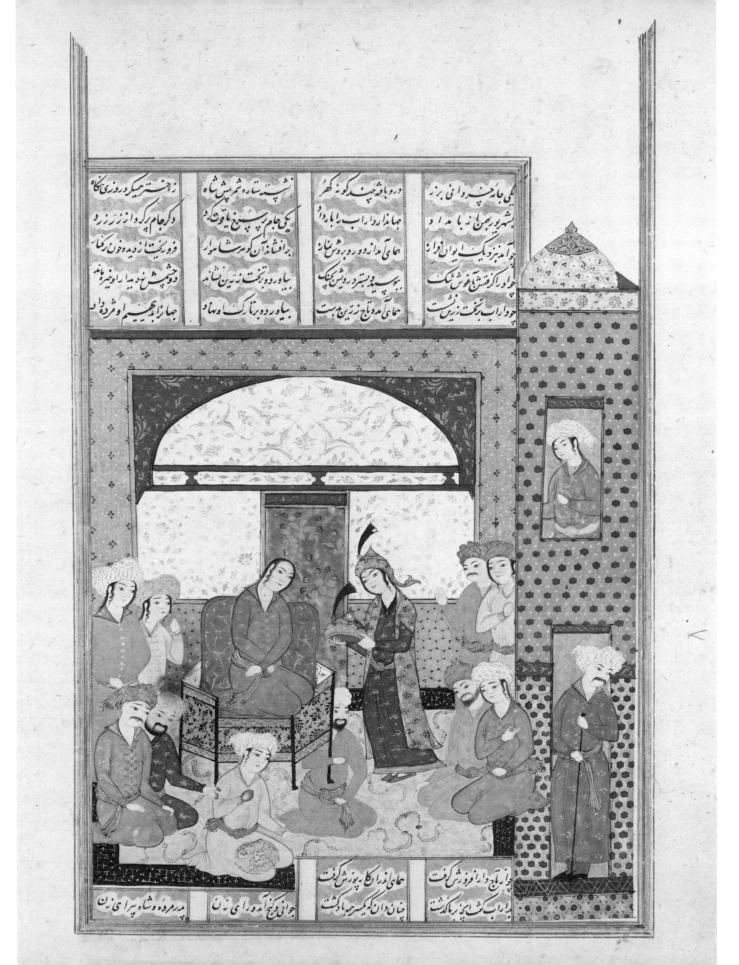

248.
*Portrait of an Armenian Bishop Holding
His Crozier* (illustrated)
Isfahan, ca. 1650
h: 7⅛ in. (18 cm.); w: 3⅞ in. (10 cm.)
M.73.5.456

249.
*A Standing Lady, Her Blue-Grey Cloak over
Her Right Shoulder*
Isfahan, ca. 1650
h: 5⅞ in. (15 cm.); w: 3⅛ in. (8 cm.)
M.73.5.452

250.
Humay Giving the Crown to Darab (illustrated)
Leaf from a *Shah Nama*
Isfahan, ca. 1650-1660
h: 9⅞ in. (25 cm.); w: 6¼ in. (16 cm.)
M.73.5.436

251.
A Standing Lady with Wine Bottle and a Cup
(illustrated)
Album leaf with panels of calligraphy
Style of Mu'in *musawir*
Isfahan, ca. 1650-1660
Drawing with gold and color tints
h: 4¼ in. (10.75 cm.); w: 2½ in. (6.25 cm.)
M.73.5.14

252.
A Drugged Sufi in a Landscape (illustrated)
Album page
Style of Mu'in *musawir*
Isfahan, ca. 1650-1660
Drawing with color washes
h: 6½ in. (16.5 cm.); w: 3⅝ in. (9 cm.)
M.73.5.582

253.
A Man Pulling a Dead Crane
Style of Mu'in *musawir*
Isfahan, ca. 1650-1660
Ink drawing
h: 2⅝ in. (6.75 cm.); w: 5½ in. (14 cm.)
M.73.5.13

254.
*A Lion Attacking a Dragon That Has Wrapped
Itself Around a Ram* (illustrated)
Attributed to Mu'in *musawir*
Isfahan, 1103 A.H./A.D. 1691
Drawing with color washes
h: 5 in. (12.75 cm.); w: 8 in. (20.25 cm.)
M.73.5.12

255.
A Standing Youth in Purple Pouring Wine
(illustrated)
Signature of Mu'in *musawir*
Isfahan, 1093 A.H./A.D. 1681
h: 7⅞ in. (20 cm.); w: 4 in. (10.25 cm.)
M.73.5.570

Inscribed: "Thursday, month of Moharram, 1093."

256.
Design for a Textile
Persia, 16th-17th century
Ink and gold on paper
h: 15 in. (38.1 cm.); w: 9½ in. (24.2 cm.)
M.73.5.607

Conjugate sprays of floral motifs.

251.

252.

255.

254.

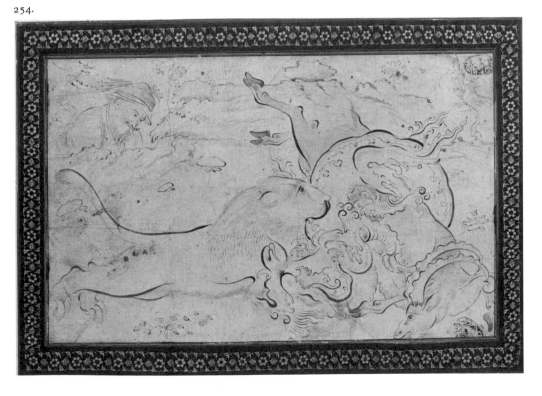

257.
Design for a Textile
Persia, 17th century
Ink and gold on paper
h: 11⅞ in. (30.4 cm.); w: 6 in. (15.2 cm.)
M.73.5.21

Overall pattern of a tree with leaves and branches.

258.
Bahram's Master Shot (illustrated)
Qajar, 1825-1850
Drawing in grisaille
h: 12½ in. (31.75 cm.); w: 16⅜ in. (41.5 cm.)
M.73.5.481

The king's prowess with his bow in changing the
sex of stags and does, by the symbolic shooting
away of the antlers of the former and adding arrows
in the heads of the females to suggest their
missing horns, was mocked by his mistress Azada
(for her revenge, see cat. no. 203i). This drawing
shows Bahram's creation of a three-legged beast to
counteract her scorn.

Turkish Painting

259.
*A Chinese Lady or Maidservant with a
Towering Fan* (illustrated)
Turkey, probably Transoxiania, 15th century
h: 9½ in. (24.25 cm.); w: 4¾ in. (12 cm.)
M.73.5.587

Ex. coll.: Jean Pozzi, Paris.

258.

259.

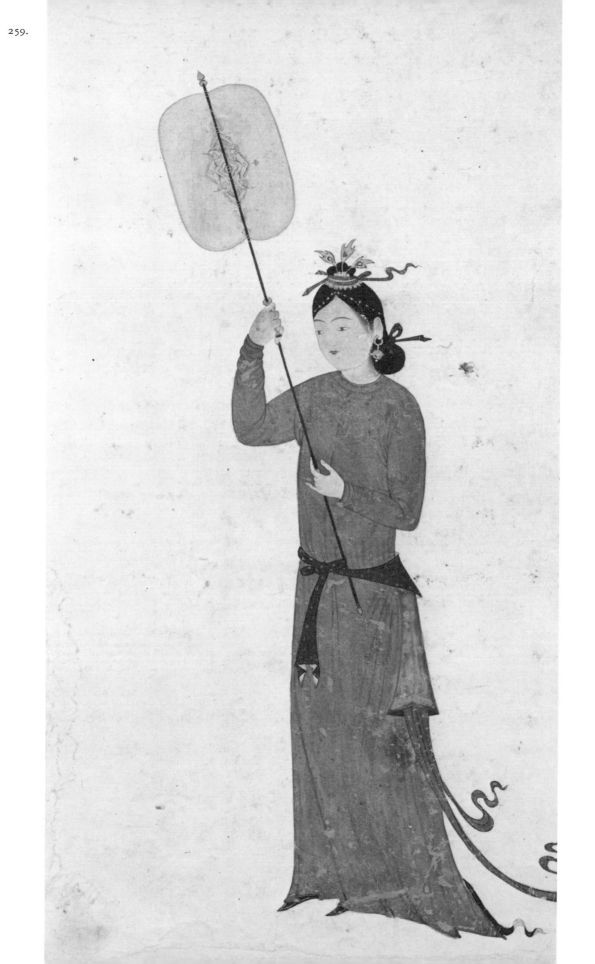

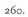

260.

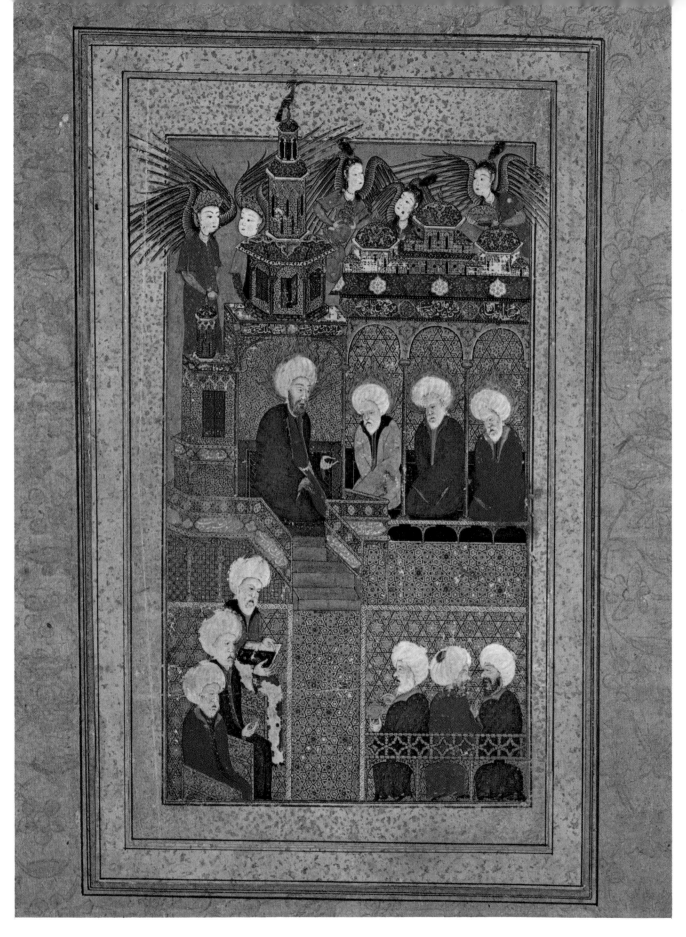

260.
*A Prophet (Muhammad ?) Seated in the Minbar of
a Mosque Lecturing to His Disciples* (illustrated)
Turkey, 1575-1600
h: 8⅝ in. (22 cm.); w: 5¼ in. (13.5 cm.)
M.73.5.446

Ex. coll.: Everett Macy.

261.
A Young Archer in a Landscape (illustrated)
Turkey, 1575-1600
Ink drawing with gold tints
h: 8⅞ in. (22.5 cm.); w: 5⅞ in. (15 cm.)
M.73.5.480

Mounted on an album leaf of marbled paper.

262.
A Standing Lady (illustrated)
Probably Turkey, 1575-1600
Drawing with color
h: 5¾ in. (14.5 cm.); w: 2¾ in. (7 cm.)
M.73.5.477

Mounted on an album leaf with several borders
of calligraphic panels.

261.

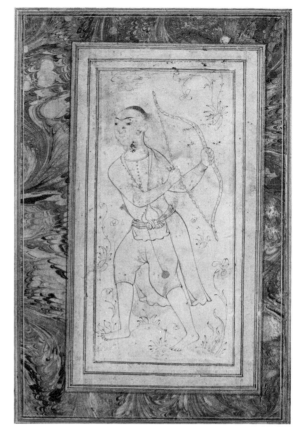

262.

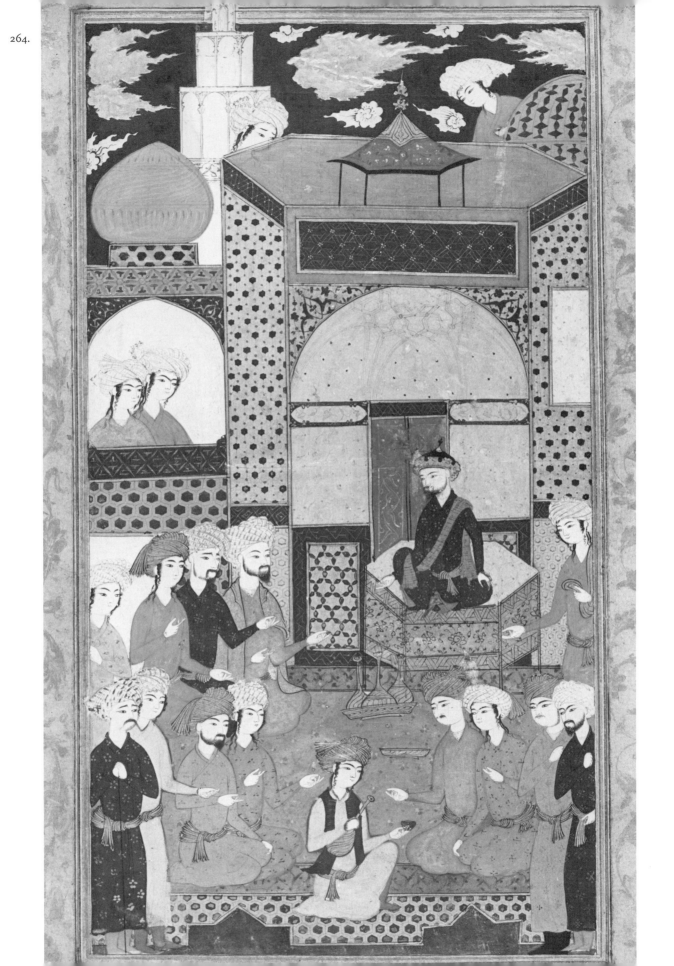

263.
A Standing Lady Carrying a Lute (illustrated)
Turkey, 1600-1610
h: 8⅝ in. (22 cm.); w: 4⅞ in. (12.5 cm.)
M.73.5.457

The attribution of this and cat. no. 262 is made on
the basis of the costumes which appear Turkish
rather than Persian. In technique, however,
the miniatures seem Iranian, recalling the fact that
Persian artists were present in Istanbul at this time.

264.
*A Court Scene (The Audience of King Khusrau
Anushirwan ?)* (illustrated)
Leaf from a *Shah Nama*
Turkey, 1600-1625
h: 11¼ in. (28.5 cm.); w: 6¼ in. (16 cm.)
M.73.5.445

Ex coll.: Everett Macy.

Indian Miniatures of Islamic Interest

265.
A Standing Youth in a Green Dress (illustrated)
Deccan, possibly Bijapur, ca. 1650
h: 9¼ in. (23.5 cm.); w: 5½ in. (14 cm.)
M.73.5.453

The *katar* at his waist, his Bijapuri-like turban,
and the folds of the youth's scraft reinforce a
Deccani provenance. Mounted as an album leaf
with panels of calligraphy.

265.

263.

266.
A Standing Lady Wearing a Short Jacket with
Long Sleeves That Cover Her Hands (illustrated)
Probably Deccan, 1650-1675
Drawing with color washes
h: 5¼ in. (13.25 cm.); w: 2¾ in. (7 cm.)
M.73.5.466

Album leaf with several borders of marbled paper.

267.
A King Enthroned on a Terrace
Leaf from a *Shah Nama*
Kashmir, 18th century
h: 6½ in. (16.5 cm.); w. 6 in. (15.25 cm.)
M.73.5.609

268.
Manuscript of the Khamsa *of Nizami*
Kashmir, ca. 1800
M.73.5.601
227 pages; 27 lines per page.
fol. 72R
Khusrau and Shirine in the Pavilion
h: 7⅞ in. (20 cm.); w: 5⅛ in. (13 cm.)
fol. 90V
Majnun in the Desert
h. 7⅜ in. (18.75 cm.); w. 5⅛ in. (13 cm.)
fol. 172V
The Birth of Iskandar in the Woods and His
Discovery by the Roman Emperor Philghus
h. 7⅜ in. (18.75 cm.); w. 5⅛ in. (13 cm.)
fol. 190R
Iskandar and the Dying Dara
h: 7¼ in. (18.5 cm.); w: 5¼ in. (13 cm.)
fol. 225R
Iskandar with the Sages Ilyas and Khirz
h: 7¼ in. (18.5 cm.); w: 5⅛ in. (13 cm.)

Minor Arts of the Book

269.
Pair of Bookcovers
Persia, 15th-16th century
Red morocco
h: 14⅝ in. (37.1 cm.); w: 7½ in. (19 cm.)
M.73.5.550 a, b

Simple cartouche shape in center of each part.

270.
Single Bookcover
Persia, 16th century
Black morocco
h: 9¾ in. (24.7 cm.); w: 6½ in. (16.5 cm.)
M.73.5.553

Gilt medallion and pair of subsidiary lozenges
within a gold border.

271.
Spine and Flap from an Ornate Binding
Persia, 16th century
Morocco with gilt and colored papers
h: 17 in. (43.2 cm.); w: 7 in. (17.8 cm.)
M.73.5.549

272.
Single Bookcover Depicting a Polo Scene
Persia, probably 17th century
Lacquer with paint
h: 8 in. (20.3 cm.); w: 11 in. (28 cm.)
M.73.5.554

273.
Pair of Bookcovers
Persia, about 1800
Lacquer with paint
h: 11¼ in. (28.6 cm.); w: 7½ in. (19 cm.)
M.73.5.551 a, b

Overall decoration of flowers within borders;
insides show a central cartouche with flowers upon
a ground of gilt floral decoration on black;
slight chipping.

274.
Pair of Bookcovers
Persia, 19th century
Lacquer
h: 8¼ in. (21 cm.); w: 6 in. (15.3 cm.)
M.73.5.552

Flowers in a cartouche upon a gilded background;
repetition of the central motif in the corners, the
insides show narcissuses upon long stalks.

266.

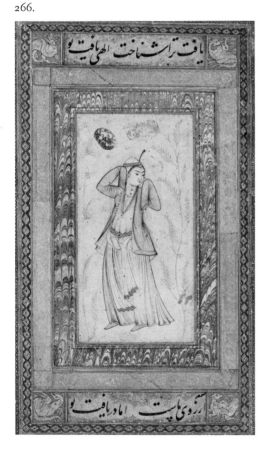

Pratapaditya Pal

The art of metalwork is perhaps the least explored among the major areas of Islamic art.[1] And yet, nowhere else but in metalwork can one observe visually the continuity between the ancient cultures of West Asia and the tradition of Islam. As one scholar has very appositely stated, "at least on the level of the existence of a semi-industrial manufacturing tradition, a certain continuity seems to exist and in Iran, as elsewhere in the Islamic world, there appeared a fascination, unknown since Antiquity, with the transformation of the everyday useful object into a work of aesthetic quality."[2]

Every object of Islamic metalwork in the Palevsky-Heeramaneck Collection was primarily meant to be used, as indeed were the ceramics, the glass, or textiles. And, almost every principal technique of metalwork, such as casting, engraving, inlay, filigree, chasing, repoussé, openwork, and *niello,* were known to the Islamic craftsman. Although the majority of the objects are from Persia, there are significant examples of metalwork from Iraq as well as from Egypt.

The tradition of metalwork is indeed an ancient one in Persia, and already by the first millenium B.C. the Persians were creating those charming and delighful bronze objects generally designated as "Luristan." Under the Achaemenids, Persia continued to excel in metalwork, borrowing styles and techniques from the Assyrians, the Scythians, and the Egyptians. The following statement from the foundation charter of the city of Susa not only reveals the continued vitality of the tradition but also provides a vivid picture of the cosmopolitan atmosphere that prevailed in Achaemenid Persia:

"Gold has been brought from Sardis and Bactria and has been treated here . . . the silver and copper were brought from Egypt . . . the goldsmiths who worked the gold were Medes and Egyptians . . ."

The same movement of materials, and artists as well, was to continue in the Islamic world, and hence, for the art historian, an exasperating stylistic uniformity characterizes the metalwork that was produced in Egypt, Persia, and Mesopotamia.

The Sassanian period (A.D. 224-642), considered one of the most brilliant in the history of Persian metallurgy, even exerted considerable influence upon the techniques and forms of European metalwork. Many of the works produced during the Islamic period derive directly from the Sassanian tradition both in style and iconography. A definite link with the Sassanian tradition is provided by an exquisite gold bracelet in the collection.

cat. no. 275

Of the other Islamic countries, a vigorous school of metalwork sprang up in the town of Mosul in Iraq during the twelfth and thirteenth centuries. Although inspired by contemporary Persian works, the Mosul artists developed a distinct idiom of their own. Perhaps the most significant difference lies in the fact that while the Persian artists chose to use "loose arabesques on the unworked brass background, the Mosul artist preferred, though not exclusively, a complete covering of the vessel with various angular motifs or closely curling arabesques."[3] It must be remembered, however, that such was the fame of Mosul as a center of metalwork that many of the artists from that city found employment elsewhere in the Islamic world.

Two other important centers of Islamic metalwork were Cairo in

Egypt and Damascus in Syria. Although there are literary references
to the sumptuous gold and silver objects used by the Fatimids
(A.D. 969-1171) in Egypt, little of it has survived. Much of Egyptian
metalwork, as represented in this Collection, belongs to the Mamluk
period (A.D. 1250-1517) when Egypt entered into a new phase
of prosperity. Already by the thirteenth century, however, both Syria
and Egypt were producing inlaid metalwork that distinctly reflects
the influence of the school of Mosul. It is rather significant that after
the destruction of Mosul in 1261/2 by the Mongols, a large number of
excellent metal pieces signed by Mosul artists were made in Cairo.

The principal metals used by Islamic metalworkers were gold, silver,
bronze, brass, and steel. The majority of the objects in the Collection
are rendered in brass or bronze. Bronze appears to have been popular
in the early Islamic period, but by the twelfth century the principal
medium was brass. While most of the bronzes are engraved or pierced,
brass became particularly attractive once the Islamic artists had
mastered the technique of inlay.

It has already been pointed out that virtually every metalwork
technique was known to the Persians prior to the Arab conquest. The
only exception seems to be that of inlay. It is easy to see why this
technique, once it was discovered, rapidly surpassed all others as a
means of decorating the surface. It not only permitted the artist to be
inventive with the surface design but also to brighten the object with
copper chips, gold, silver, and even enamel. The love of a bright surface
is indeed intrinsic to the Islamic aesthetic intent.

Although there are a few examples of inlaid metalwork of the
Sassanian period, the art of inlaying apparently became popular,
probably in eastern Iran, only in the twelfth century. As Douglas
Barrett has observed, the inlay technique of Sassanian metalwork
"seems to have less in common with the methods used by the later
schools of copper, silver, and gold inlay than it has with the earlier
cold incrustations of turquoise or colored glass common in Persia and
the Steppes."[4] It is somewhat curious that no Islamic inlaid
metalwork can be dated earlier than the mid-twelfth century. The gap,
therefore, between these works and post-Sassanian inlaid objects is
one of three centuries, a fact that led Barrett to observe: "this is all the
more surprising as gold and silver inlay had been used in China since
before the Han Dynasty (B.C. 202-220 A.D.) and copper and silver on
bronze images in North India for some centuries."[5]

When Barrett made this observation in 1949, the phenomenon of
Kashmiri bronzes was still unknown. Since then, Kashmiri-style
bronzes, dating as far back as the seventh and eighth centuries, have
been discovered in large quantities. It is not without significance that a
large majority of them are richly inlaid with copper and silver, and
occasionally with gold, in a technique similar to that employed by
East Persian craftsmen.[6] It may be pertinent that Mahmud of Ghazni
built up an empire which included Persia as well as northwest India
and which lasted until the Seljuks conquered Persia in A.D. 1041.
Moreover, Ghazni, the capital of the empire, became the splendor of
the Islamic world and remained so until A.D. 1151. There are reasons
to believe that it attracted artists and poets from all the realms. Thus,
it is not improbable that craftsmen from northwest India found
employment in Ghazni or Herat and introduced the technique of
inlay.[7] Herat was within the Persian province of Khurasan where the
technique was especially popular in the twelfth century.

Whether the elaborate technique of inlay was introduced from the outside or indigenously developed in Persia, it became the principal mode of decorating the surface of metalwork throughout the Islamic world. Briefly, the technique used was as follows: "Narrow lines of inlay, as in arabesques, were inserted in an undercut groove and burnished home or, in skimpier work, burnished on to a line of stippled dots. For larger parts of the design slightly sunken beds of the necessary shape were made in the bronze. The sides were undercut and the plates of the metal to be inlaid were burnished into position. Details had then to be chased on the silver inlay."[8] This, incidentally, is very much the same method that was applied to Kashmiri bronzes.

The Palevsky-Heeramaneck Collection possesses a number of excellent examples of inlaid metalwork both from Persia and Egypt. Most of these objects belong to the period between the twelfth and the fourteenth century, after which a general decline in the productivity, as well as quality, of Islamic metalwork set in. During the Safavid period in Persia inlaying was often used effectively in the arms and armor done in cut steel, but the great period of Islamic metalwork had already become a memory.

For the most part Islamic metalwork consists of such items of everyday use as candlesticks and lampstands, basins and bowls, jugs and ewers, drinking cups and plates, mortars and pestles, and penboxes and jewel-caskets. Rather more curious are the sculptures of birds and animals that are usually attributed to the Seljuk period. Modelled fully in the round, they were used either as incense burners or as finials to decorate other objects such as ewers. The majority of these are highly stylized, but often they reveal a certain spontaneous charm and naïveté both in their formal designs and in their ornamentation.

The Islamic craftsman used a variety of designs and motifs to decorate the surface of his object. The most ubiquitous designs are those involving calligraphy and arabesques. Although animal and bird motifs are found in Egyptian textiles as early as the seventh and eighth centuries, the use of these motifs in metalwork cannot be traced back much further than the tenth. Some of these motifs were no doubt borrowed from the literary traditions, but others may have been introduced by the artists themselves from the rich world of folklore.[9] Many of the figurative subjects, such as scenes of hunting or bands of musicians, had obvious appeal for the princely patrons. These subjects are frequently survivals from an earlier tradition and were given a new application, if not a new meaning, during the Islamic period. One such typical motif is that of the hunt which throughout the Islamic period was applied to objects rendered in many different media.

A prince hunting a lion, a panther pouncing on a stag, or a falcon attacking a duck appear to have been images particularly popular with Islamic artists. Scenes of the hunt were, of course, often portrayed in the art of Sassanian Persia. The significance of such themes for the ruling class is obvious — hunting involved valor, courage, skill, and stamina, and therefore was symbolic of kingship. The association of the hunt and royalty continued during the Islamic period, and, as the poet Farrukhi (d. 1037) wrote: "There were four things chosen for kings to do / Feasting, polo, war, and hunting."[10]

In Persian literature the king is not only described as a "lion-hunter," frequently he is compared to a lion. In a typical royal panegyric of the period the following verse occurs: "You be the sun and all your slaves

will be like stars / You be a lion and all your enemies will be prey."[11]
The scene of a lion attacking a deer, portrayed so vivaciously on a
spandrel of the Safavid period, thus might well be a symbolic
representation of the king's valor. A similar symbolic meaning may
also be attached to the recurrent motif of the hawk attacking a duck.
Poets often used the hawk or falcon as an analog to describe the patron,
as in the following lines: "Your majestic presence is like a falcon
which is so powerful / That it will even hunt the Angel of Death."[12]

cat. no. 117

cat. no. 285

Medieval Persian poetry is replete with metaphorical allusions to the
hunt suggesting many different levels of meaning. In some instances
the analogy has a didactic meaning, in others it may be used to convey
amorous feelings, and, not infrequently, it communicates a mystical
message. Both Rumi (d. 1273) and Hafiz (d. 1390) often used the
imagery of the hunt to express mystical ideas. A typical example from
Hafiz reads as follows: "Throw down Bahram's hunting lasso and take
up Jamshid's cup / For I have crossed this plain and there is neither
Bahram nor his wild ass."[13] Commenting on Hafiz' verse, Hanaway
pertinently remarks: "In one line Hafiz associates the hunt and the
cup, which, as has been shown, often go together as sources of earthly
pleasure. On another level the hunt and the cup stand for the opposites
which all mystics seek to reconcile through knowledge of the Ultimate
Unity."[14]

The one undeniable contribution of Islamic thought to the aesthetic
intent of the period was the inclination toward abstraction. And, in the
final analysis, it was this tendency, rather than the inclination toward
representation, that remained predominant in Islamic decorative arts. In
part this stems from the Islamic attitude toward aesthetics and in part
from the fact that the religion placed great emphasis upon calligraphy,
which, in turn, meant that what was stressed was the linear design of
the surface and the contour of the shape rather than the modelled mass.

Another characteristic of Islamic decorative arts, particularly evident
in metalwork, is the artist's *horror vacui*. Only in exceptional
instances are there empty spaces which provide some relief from the
ornamentation. Whether the object is a candlestick, a mortar, a
bowl, or a pencase, almost every inch of available space is enriched
with intricate and exquisite arabesques, scrolls, or inscriptions.
And, while *horror vacui* was not solely an obsession of the Islamic
artist, no other people abhorred empty space in their art as much as he.
Consequently, the decoration may at times appear overbearing and
may even hinder the appreciation of the form and shape it embellishes.
But in those instances where the ornamentation is surrounded by
open areas, the visual effect is one of unmatched clarity and harmony
of design.

cat. nos. 280, 282

cat. nos. 279, 301,
310, 320

Notes

1.
Apart from Harrari's chapter on metalwork in Pope's *Survey of Persian Art,* only one book is devoted exclusively to Islamic metalwork. Written by Douglas Barrett, *Islamic Metalwork in the British Museum* was published in 1949; this monograph still remains the best introduction to Islamic metalwork.

2.
O. Grabar, "The Visual Arts, 1050-1350," *The Cambridge History of Iran,* vol. 5, ed. J. A. Boyle (Cambridge, 1968), p. 642.

3.
Barrett, *op. cit.,* p. xii.

4.
Ibid., p. viii.

5.
Ibid.

6.
For examples of inlaid Kashmiri bronzes see P. Pal, "Bronzes of Kashmir: Their Sources and Influences," *Journal of the Royal Society of Arts,* CXXXI, 5207, pp. 726-749.
It may be of interest to note that Alberuni's account of Kashmir is remarkably detailed, and it is obvious that he gathered his material directly from Kashmiri scholars. Alberuni, of course, was attached to the court of Mahmud of Ghazni. (See R. C. Kak, *Ancient Monuments of Kashmir* [London, 1933], pp. 8-10.)

7.
That Indian swords were imported into the Islamic world and were highly regarded is evident not only from the *Shah Nama* but also from earlier Persian literature. For example the poet Daqiqi (d. ca. 978) wrote:
"For the kingdom is a prey which
Neither the soaring eagle nor the fierce lion can take.
There are two things which can subdue it though:
One is an Indian sword and the other is gold."
As quoted by William L. Hanaway, Jr., "The Concept of the Hunt in Persian Literature," *Boston Museum Bulletin,* LXIX, nos. 355 and 356 (1971), p. 29.

8.
Barrett, *op. cit.,* p. ix.

9.
For an excellent study of human-headed animals and birds, such as sphinxes and harpies, in Islamic art, see E. Baer, *Sphinxes and Harpies in Medieval Islamic Art,* (Jerusalem, 1965).

10.
Hanaway, *op. cit.,* p. 22.

11.
Ibid., p. 24.

12.
Ibid. That the motif of the predatory hawk or falcon attacking a docile bird, portrayed often in Islamic metalwork as well as in ceramic, has a symbolic meaning for the donor or patron has been suggested by E. Baer, "An Islamic Inkwell in The Metropolitan Museum of Art," *Islamic Art in The Metropolitan Museum of Art,* ed. R. Ettinghausen (New York, 1972), pp. 206-208.

13.
Hanaway, *op. cit.,* p. 30.

14.
Ibid.

The Art of Metalwork

275.
Bracelet (illustrated)
Persia, 10th-11th century
Gold
h: 2 in. (5.1 cm.); d: 5 in. (12.7 cm.)
M.73.5.371

Two semicircular plaques of gold are joined together by a hinge. Alternating rows of birds and cones decorate the outer surface. Each plaque has six rows of birds — four in a row — and six rows of cones — three in a row. An almost identical bracelet is in The Metropolitan Museum of Art in New York. Common to most such Persian jewelry of the period and producing a very attractive surface texture are the techniques of granulation and filigree.

For a complete study of other such bracelets see M. Rosen-Ayalon, "Four Iranian Bracelets Seen in the Light of Early Islamic Art," *Islamic Art in The Metropolitan Museum of Art,* ed. R. Ettinghausen (New York, 1972), pp. 169 ff.

276.
Amulet
Persia, 12th-13th century
Silver, openwork
h: 1⅜ in. (3.5 cm.); w: 1⅝ in. (4.2 cm.)
M.73.5.335

This amulet was probably worn around the neck as a pendant. Heraldic lions and Kufic inscriptions are the principal decorative motifs.

277.
Lamp Stand
Persia, 12th-13th century
Bronze, pierced and engraved; green patina
h: 23⅝ in. (60 cm.)
M. 73.5.299

Similar stands are in the Boston Museum of Fine Arts, the Musée du Louvre, Paris, and the Detroit Institute of Arts (see A. U. Pope, *A Survey of Persian Art,* VI, pl. 1284).

278.
Candle Stand (illustrated)
Persia, 12th-13th century
Bronze, engraved
h: 20 in. (50.75 cm.)
M.73.5.308

The exact function of such stands is not clear. They may have been used as lamp or candle stands. The design of the engraving is very similar to a less elaborate example in the British Museum (see D. Barrett, *Islamic Metalwork in the British Museum,* pl. 3).

275.

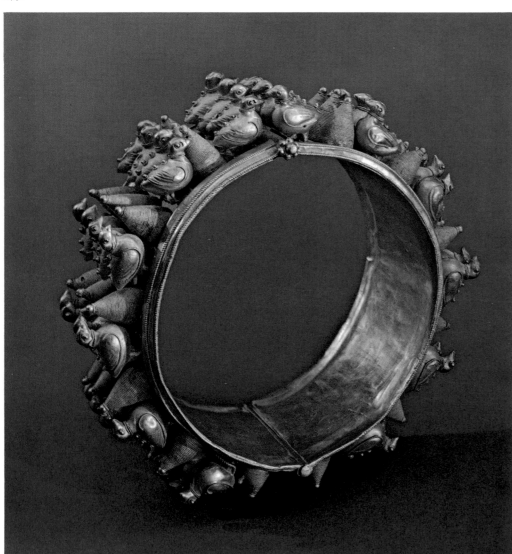

279.
Candlestick (illustrated)
Persia, 12th century
Brass with silver inlay
h: 6⅜ in. (16 cm.)
M.73.5.123

This candlestick may be from East Persia or even
modern Afghanistan. The workmanship is closely
related to Afghan metalwork of the Ghaznavid
period (cf. B. Rowland, *Art in Afghanistan* [Coral
Gables, Florida, 1971], figs. 200-201). The four
medallions enclose seated musicians, while the
Kufic letters terminate in human heads.

280.
Candlestick
Persia, 12th-13th century
Bronze, engraved
h: 4⅞ in. (12.5 cm.)
M.73.6.138

Bands of Kufic inscription, torsades, floriate scrolls,
and medallions with birds form the principal
decorative motifs. Large areas on the body are left
unadorned as in cat. no. 282, thereby providing
relief to the total visual design.
Published: *Persian Art Before and After the
Mongol Conquest*, p. 28.

278.

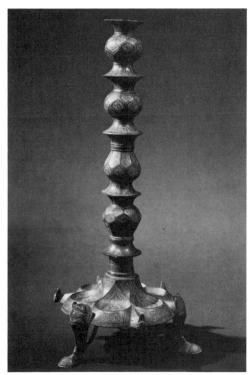

279.

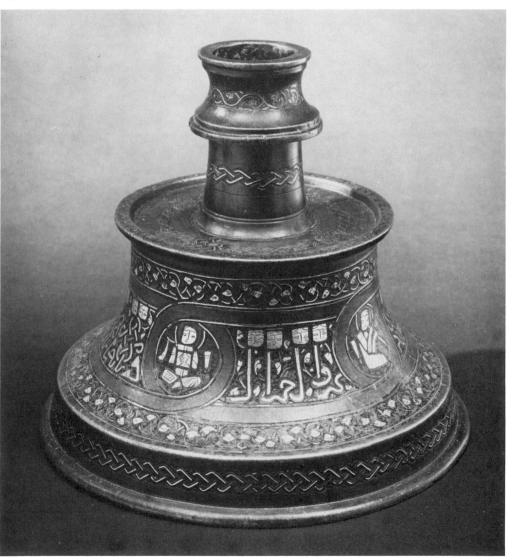

281.
Candlestick
Persia, 12th-13th century
Bronze, pierced
h: 14⅛ in. (36 cm.)
M.73.5.322

For a similar example see Pope, *Survey,* VI, pl. 1283.

282.
Candlestick
Persia, 12th-13th century
Bronze, with green patina, engraved
h: 4½ in. (11.5 cm.)
M.73.5.128

The neck of the candlestick is broken. The main body is decorated with medallions showing prancing animals with their necks turned in the opposite direction against a floral scroll design. Atypically, the artist has left sufficient space around the medallions to give the design greater clarity.

283.
Candlestick (illustrated)
Persia or Egypt, 12th-13th century
Brass with silver inlay, engraved
h: 6¾ in. (17.5 cm.)
M.73.5.137

What distinguishes this candlestick from the others (cat. nos. 279-282) in the Collection is the absence of figurative motifs in its ornamentation. The bell-shaped body of the candlestick is decorated with three bands of floral and geometric designs, and the dominant motif is the pseudo-Kufic inscription along the middle.

284.
Candlestick
Iraq or Persia, 13th-14th century
Brass with silver inlay, engraved
h: 7 in. (17¾ cm.)
M.73.5.127

Medallions containing scenes of the hunt with riders on horses form the principal decorative motif on the body of this candlestick. It is noteworthy that in both this and the previous candlestick (cat. no. 283), the faces of the figures are left blank and featureless.

285.
Candlestick (illustrated)
Iraq, 13th century
Brass with silver and copper inlay, engraved
h: 7⅞ in. (20 cm.)
M.73.5.287

In addition to two different types of Kufic inscriptions, interlaced vegetative arabesques, and plaited patterns, the body of this candlestick is decorated with alternating large and small medallions. The large medallions contain seated figures, many of whom appear to be musicians, while the smaller ones enclose the motif of a hawk attacking a duck. Very likely the candlestick was manufactured in Mosul, an important center of metalwork in ancient Mesopotamia.

286.
Shallow Bowl (illustrated)
Persia, 12th century
Silver, engraved
h: 1¼ in. (3 cm.); d: 5¾ in. (14.2 cm.)
M.73.5.149

The inside of this bowl is decorated with a central medallion containing a winged animal and a band of ornamental Kufic along the side. On the outside a solar symbol decorates the bottom. A band of prancing animals against a meandering rinceau motif adorns the side.

For a tray with similar ornamentation see Pope, *Survey,* VI, pl. 1288 A.

286.

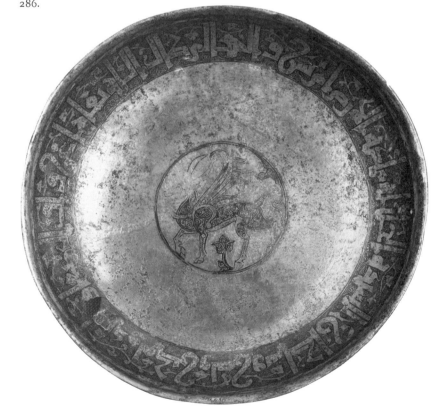

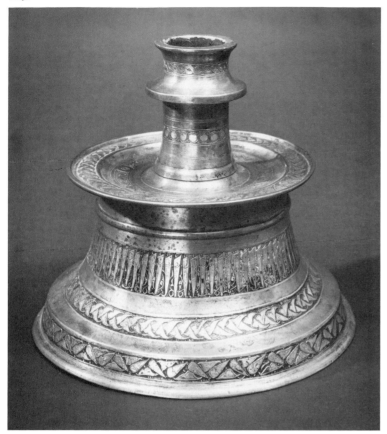

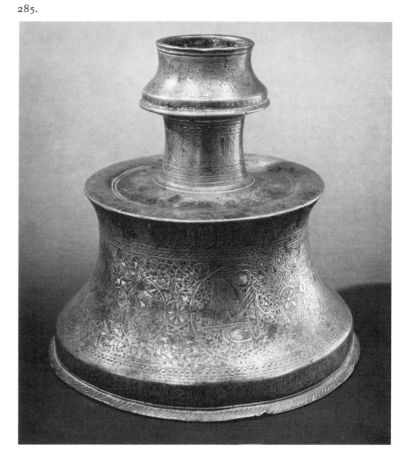

294.

287.
Shallow Bowl
Persia, 12th-13th century
Bronze, engraved; green patina
h: 1½ in. (3.8 cm.); d: 6⅛ in. (15.5 cm.)
M.73.5.311

288.
Finial in the Shape of a Lion
Persia, 12th century
Bronze, engraved
h: 2½ in. (6.4 cm.); w: 3¼ in. (8.2 cm.)
M.73.5.339

289.
Handle with a Lion's Head
Persia, 13th century
Brass, engraved
h: 6 in. (15.2 cm.)
M.73.5.309

Published: *Persian Art Before and After the Mongol Conquest*, pp. 31, 58.

290.
Finial in the Shape of a Winged Animal
(illustrated)
Persia, 12th-13th century
Bronze, engraved
h: 2⅜ in. (6 cm.); w: 1¾ in. (4.5 cm.)
M.73.5.312

291.
Leaping Lion (illustrated)
Persia, 12th-13th century
Bronze, engraved
l: 8 in. (20.2 cm.)
M.73.5.316

An atypical object, very likely it served as a handle.
The shape of the animal is rather unusual and
is reminiscent of the much earlier Luristan bronzes.
Although the form is greatly abstracted, the artist
has managed to express the movement of the
leaping animal very effectively.

292.
Bird
Persia, 12th century
Bronze, engraved
h: 4¼ in. (10.7 cm.); w: 3½ in. (9 cm.)
M.73.5.343

293.
Incense Burner in the Shape of a Bird
Persia, 12th century
Bronze, engraved
h: 2½ in. (6.3 cm.)
M.73.5.314

294.
Pair of Birds (illustrated)
Persia, 12th-13th century
Bronze, engraved
h: 7¼ in. (18.4 cm.); w: 5½ in. (14 cm.)
M.73.5.304 a, b

The holes on the bodies probably indicate that
the birds served as finials as well as incense burners.
The engraved and champlevé decoration is used
moderately to enhance the overall design of the
form. Although stylized, the birds reveal the Seljuk
artist's delightful sense of a purely visual design.

291.

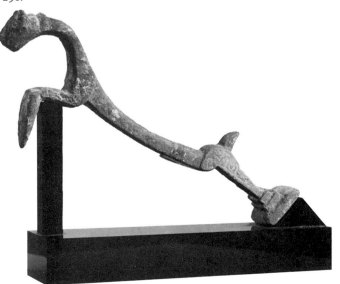

295.
Bird
Persia, 13th century
Brass, incised
h: 5 in. (12.7 cm.); d: 5¾ in. (14.7 cm.)
M.73.5.349

A stylized representation of a bird, the body is richly incised with decorative motifs. Very likely the bird served as some kind of finial.

For a bird incense burner of a similar shape, see Pope, *Survey*, VI, pl. 1298 B.

296.
Tray
Persia, 12th century
Brass with silver and gold inlay; engraved
h: 2¼ in. (5.75 cm.); d: 18 in. (45.75 cm.)
M.73.5.296

Although restored, the tray is an impressive example of inlaid metalwork of the Seljuk period. The most prominent feature of its ornamentation is the central medallion representing an astrological cycle with the signs of the zodiac and other allegorical figures. Other decorative elements include both vegetative and geometric forms, a lively fish motif, and bold Kufic lettering.

297.
Mirror
Persia, 12th century
Silver
d: 4¾ in. (11 cm.)
M.73.5.290

Two heraldic sphinxes are represented back to back in the center. They are surrounded by a border of Kufic inscription. Although the decorative motifs are altogether Islamic, the basic design and form of this mirror and others like it were probably inspired by Chinese prototypes. The back is plain and highly polished. As similar mirrors were produced in Mesopotamia, it is often difficult to establish an exact provenance. For identical mirrors see Pope, *Survey*, VI, pl. 1302 F; M. Dimand, *A Handbook of Muhammadan Art*, 3rd ed. (New York, 1958), p. 137.

298.

298.
Mirror (illustrated)
Persia, 12th century
Silver
d: 4½ in. (10.7 cm.)
M.73.5.292

Except for the fact that this mirror has a single sphinx in the center, it is almost identical to the previous example. The inscription — a verse from the Koran — is also identical. Some scholars believe that these objects served as weights rather than mirrors (D. Talbot Rice, *Islamic Art* [New York and Washington, 1965], p. 181; C. J. Du Ry, *Art of Islam* [New York, 1970], p. 104).

299.
Wine Cup (illustrated)
Persia, 12th century
Bronze with silver inlay, engraved
h: 4⅜ in. (11.2 cm.); d: 5½ in. (14 cm.)
M.73.5.131

Ornamental Kufic, strings of pearl motif, and floral designs decorate this wine cup. The rondels, circumscribed by pearls, are clearly a legacy of earlier Persian design of the Sassanian period.

300.
Kettle (illustrated)
Persia, 13th century
Bronze, engraved
h: 8 in. (20.25 cm.); d: 8 in. (20.25 cm.)
M.73.5.321

The kettle is decorated with three bands, two of which are wider than the third. The uppermost band contains a Kufic inscription superimposed on a floral scroll background. The central band has a design of connected floriated arches and delicate scrolls. The lower band contains a continuous row of floriated Kufic inscription.

For a similar kettle, see Pope, *Survey,* VI, pl. 1292.

301.
Mortar and Pestle (illustrated)
Persia, 12th-13th century
Bronze, engraved
Mortar:
h: 5⅝ in. (14.25 cm.); d: 8 in. (20.25 cm.)
Pestle:
l: 9¼ in. (23.5 cm.)
M.73.5.264 a, b

The mortar, with a flaring base and rim, is octagonal in shape. The base and the rim are decorated with a pseudo-Kufic inscription, while the upper band on the body is ornamented with cartouches containing knotted Kufic. Along the lower section of the body are eight rectangles, each engraved with an animal motif.

302.
Mortar
Persia, 12th-13th century
Bronze, engraved; green patina
h: 6½ in. (16.5 cm.); d: 9 in. (22.75 cm.)
M.73.5.153

The decorative scheme consists of a wide band in the center separated by two narrower bands at the top and bottom. The central band is divided into six segments by raised dividers. Each compartment is engraved with a floriated arch containing floral scrolls. The narrower bands are decorated with ornamental Kufic, alternating with medallions containing birds very similar to those that occur on a candlestick (cat. no. 280). Similar medallions with birds are also engraved on the flaring rim of the mortar.

300.

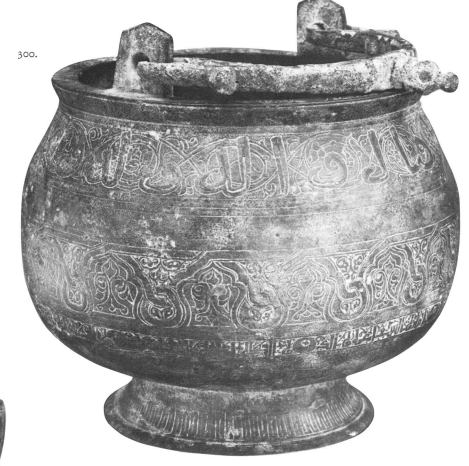

299.

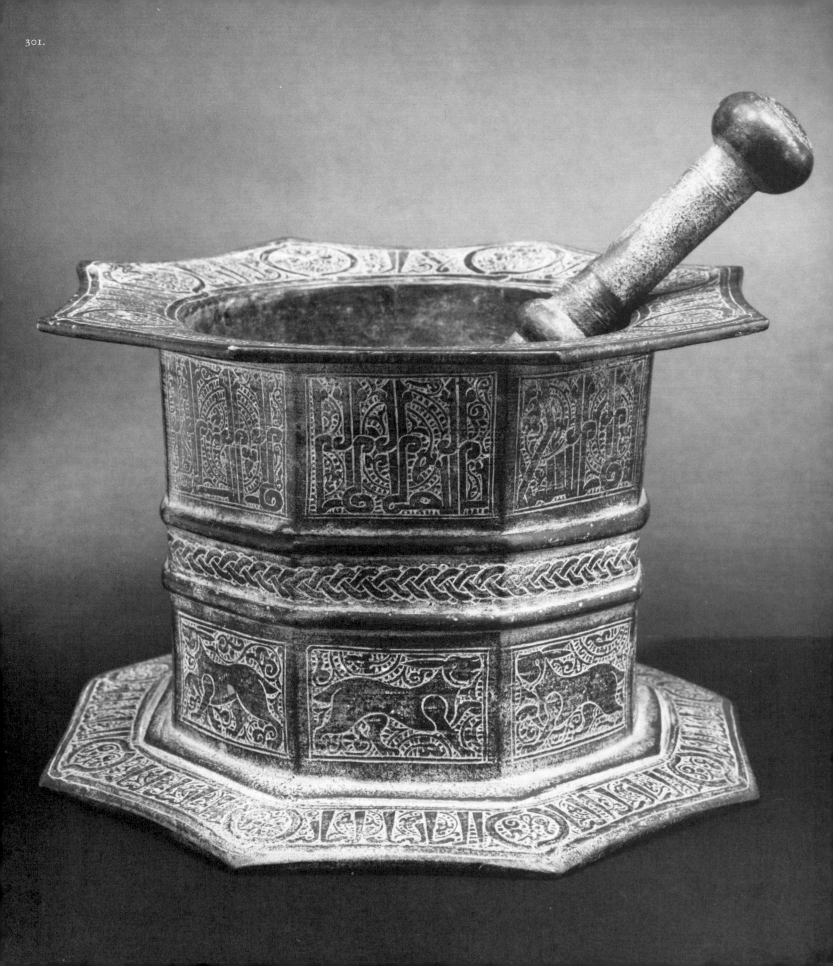

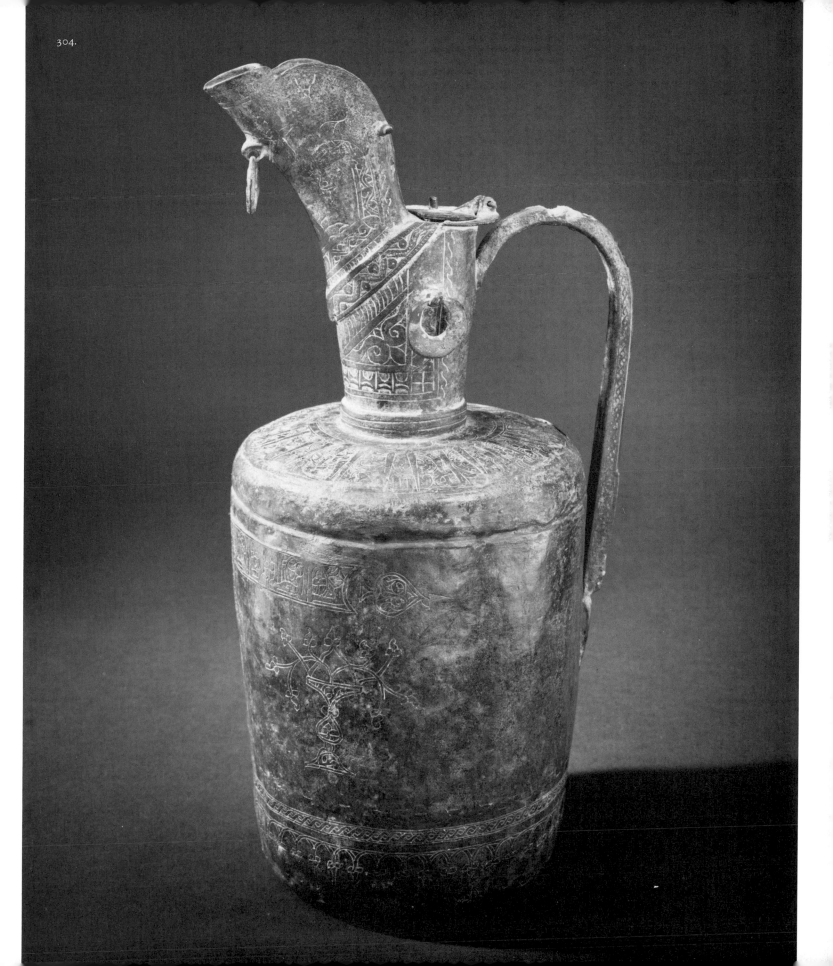

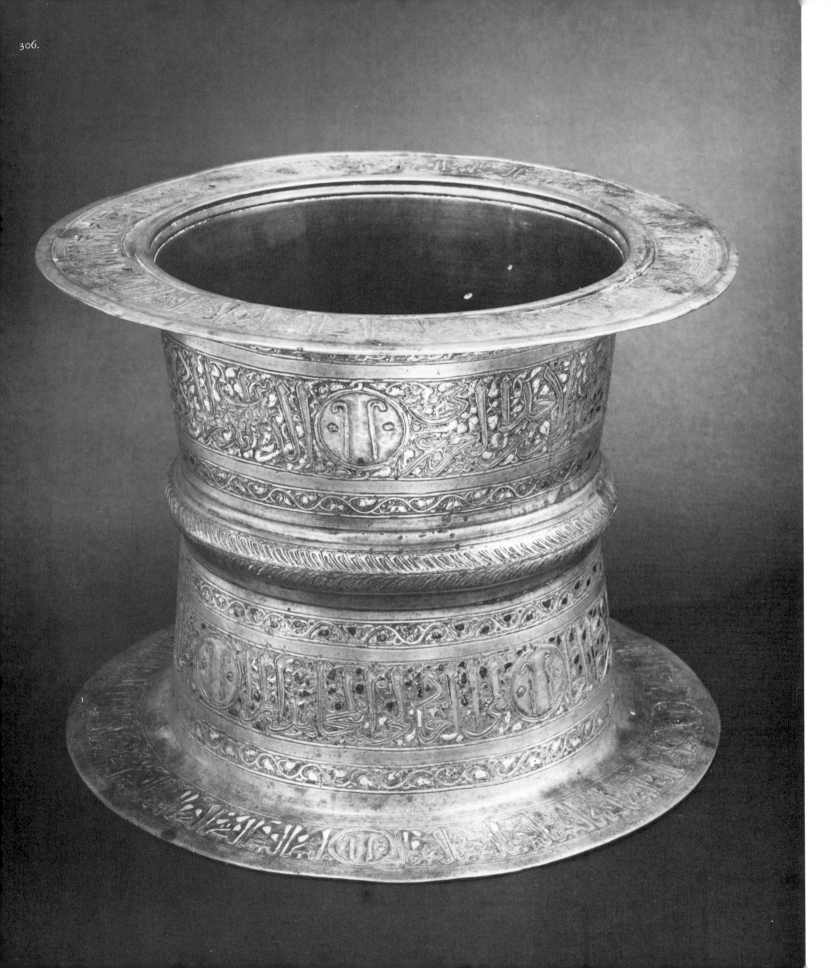

303.
Mortar
Persia, 12th-13th century
Bronze, engraved; green patina
h: 4½ in. (11.5 cm.); d: 7½ in. (19 cm.)
M.73.5.155

304.
Ewer (illustrated)
Persia, 13th century
Bronze, engraved
h: 15¾ in. (40 cm.)
M.73.5.161

Both ewers in the Collection (see cat. no. 305) are interesting for the simplicity of their forms and the restraint in their ornamentation. Apart from geometric and calligraphic motifs, birds in medallions and flowers in vases are the principal decorative motifs of this particular ewer.

305.
Ewer
Persia, 14th century
Bronze, engraved; green patina
h: 13⅞ in. (35.25 cm.)
M.73.5.317

Atypically, the body of this ewer is completely plain. Ornamentation, consisting of a Kufic inscription and interlaced floral motifs, is confined to the shoulders. A bronze bird, of a kind that is often seen by itself in Islamic collections, is attached to the top of the handle as a finial.

306.
Stand (illustrated)
Persia or Egypt, 14th century
Brass with silver inlay; engraved
h: 7⅜ in. (18.75 cm.); d: 9½ in. (24 cm.)
M.73.5.318

Although the object is shaped like a mortar, it does not appear to have served as such, for it is open at both ends. Rather interesting is the motif of polo sticks and balls employed in the medallions which alternate with bands of Kufic. A similar stand in The Metropolitan Museum of Art has been attributed to Egypt (see M. G. Lukens, *Islamic Art,* The Metropolitan Museum of Art, Guide to the Collections [New York, 1965], p. 25, no. 37).

307.
Basin (illustrated)
Egypt, 13th-14th century
Brass with silver inlay; engraved
h: 8 in. (20.25 cm.); d: 18⅛ in. (46 cm.)
M.73.5.125

The exterior of this large and impressive basin is decorated with a wide central band with a benedictory inscription in bold Kufic against a floriate scroll ground and two narrower bands with a continuous rinceau motif. On the inside the widely flaring rim is ornamented with a band of even bolder Kufic inscription against a scroll background and is interrupted by four medallions enclosing a geometric motif surrounded by additional scrolls. Two narrow bands of simple geometric and vegetative patterns enclose the inscription at the top, while the bottom is fringed by a continuous string of pendants.

308.
Bowl
Egypt, 14th century
Brass with silver inlay; engraved
h: 2⅜ in. (6 cm.); d: 6 in. (15.2 cm.)
M.73.5.122

The principal decorative element consists of a continuous band of bold Kufic interspersed with six medallions. Each medallion shows a figure holding a bow and standing in front of an animal.

309.
Bowl
Egypt, 14th century
Brass with silver and gold inlay; engraved
h: 2¾ in. (7 cm.); d: 6½ in. (16.5 cm.)
M.73.5.147

The gold inlay probably indicates that the bowl was used by a wealthy patron. The decoration, limited to a Kufic inscription and to geometric and vegetative motifs, reflects the austere attitude of the original owner.

307.

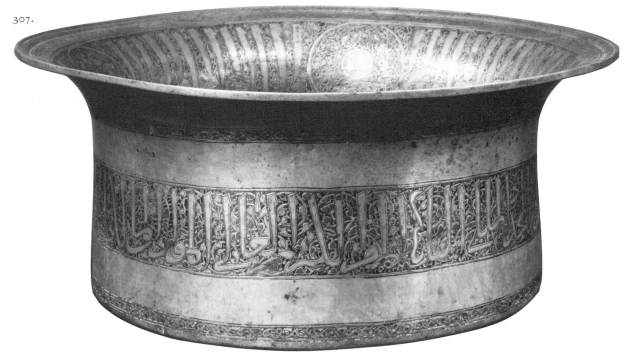

310.
Bowl (illustrated)
Egypt, 14th century
Brass, engraved
h: 4½ in. (11.5 cm.); d: 9⅞ in. (25 cm.)
M.73.5.154

Although of a slightly different shape, the
ornamentation is very similar to that of cat. no. 311.

311.
Bowl (illustrated)
Egypt, 14th century
Brass, engraved
h: 4¾ in. (12 cm.); d: 10 in. (25.5 cm.)
M.73.5.152

Such bowls (see also cat. nos. 308-310) were
very likely used for serving food. The outside of the
bowl is elaborately engraved with floral and
geometric motifs and alternating medallions with
hunters and a Kufic inscription. Inside schools
of fish swim both clockwise and counterclockwise
around a wheel that may have solar symbolism.
Once again the faces of the riders are featureless.

312.
Cock
Persia, 15th-16th century
Brass, engraved
h: 3¼ in. (8.2 cm.); w: 3¼ in. (8.2 cm.)
M.73.5.310

313.
Cock
Persia, 15th-16th century
Brass, plated with silver; engraved
h: 5½ in. (14 cm.); w: 4 in. (10.2 cm.)
M.73.5.342

The exact function of cocks of this type is not
clear. They may have served as finials crowning
other objects. It is of interest that the plume
of this cock serves as a stopper and is attached to an
applicator by a narrow stem, an indication
that the object may have been used as a container
for perfume or cosmetics.

314.
Cock
Persia, 15th-16th century
Brass, plated with silver; engraved
h: 4⅞ in. (12.5 cm.); w: 3¾ in. (9.5 cm.)
M.73.5.341

As this cock is identical to cat. no. 313, it is
possible that they originally formed a pair and were
attached to the same object. The plume is missing
in this example.

310.

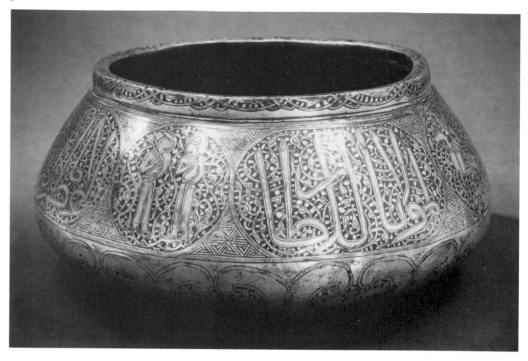

311.

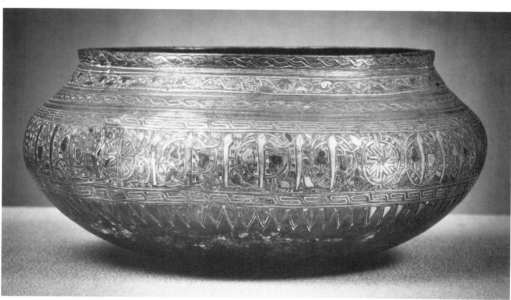

315.
Bird
Persia, 16th-17th century
Brass with silver inlay; engraved
h: 8 in. (20.2 cm.)
M.73.5.303

The exact function of this remarkably animated
study of a bird is difficult to determine. The bird's
neck is turned back in an elegant and unusual
sweep. Its feathers are inlaid with narrow strips of
silver, and it has an oval depression in the
middle of its back which probably once contained
an object which the bird was observing.

316.
Bird (illustrated)
Persia, 16th-17th century
Brass, incised
h: 9 in. (22.8 cm.); w: 6¾ in. (17.2 cm.)
M.73.5.158

From the number of rings attached at various
places it is obvious that the bird was used
as an appurtenance to some other object. Although
contemporary with cat. no. 315, the ornamentation
here is far more stylized. The design of the
feathers is incised freely and the intent was to
create a decorative rather than realistic effect.

316.

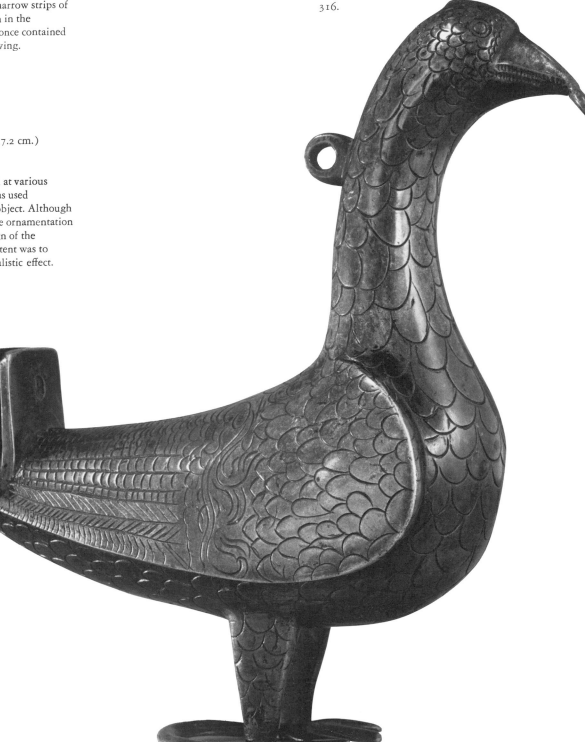

317.
Cover of a Pot
Persia, 15th century
Brass, repoussé
h: 2½ in. (6.3 cm.); d: 10⅞ in. (27.7 cm.)
M.73.5.365

The knob of this cover is decorated with four
stalking lions, the shoulder with twelve
intertwining medallions which contain the signs
of the zodiac, and the rim with a continuous
frieze of prancing animals resembling felines but
having rabbit ears.

318.
Shallow Cup
Persia, 16th century
Brass, engraved
h: 1⅝ in. (4 cm.); d: 5½ in. (14 cm.)
M.73.5.134

The outside of the cup is engraved in high relief
with a lively arabesque design. The inside,
however, is filled with very shallowly etched
motifs of rather unusual animals, hardly
recognizable as confronting elephants and tigers.

319.
Pill Box with Cover
Persia, 16th-17th century
Brass, engraved
h: 2½ in. (6.2 cm.); d: 2¼ in. (5.7 cm.)
M.73.5.306

320.
Pencase with Inkwell (illustrated)
Persia, 17th century
Silver, engraved
l: 11¼ in. (28.5 cm.); w: 2½ in. (6.2 cm.)
M.73.5.298

Arabesques, floral scrolls, and inscriptions
announcing conventional blessings decorate the
bodies of both the case and the inkwell.

321.
Sword (illustrated)
Persia, 17th century (?)
Steel, gold, silver, and leather
l: 37½ in. (95.2 cm.)
M.73.5.713

The blade of the sword is of damascened steel.
The handle consists of granulated goldwork. The
leather case has been enriched by decorative
bands and clasps of gold and silver.

322.
Helmet (illustrated)
Persia, 17th century
Steel with silver inlay
h: 11¾ in. (29.7 cm.); d: 9 in. (22.7 cm.)
M.73.5.323

323.
Breastplate
Persia, 17th century
Steel with silver inlay
h: 24 in. (61 cm.); w: 39 in. (99 cm.)
M.73.5.729a

324.
Pair of Vambraces
Persia, 17th century
Steel with silver inlay
l: 17½ in. (44.5 cm.)
M.73.5.729 g, h

325.
Pair of Vambraces
Made by Hassan
Persia, 1019 A.H./A.D. 1614
Steel with gold inlay
a.
l: 14¾ in. (37.5 cm.)
b.
l: 14 in. (35.5 cm.)
M.73.5.729 d, f

320.

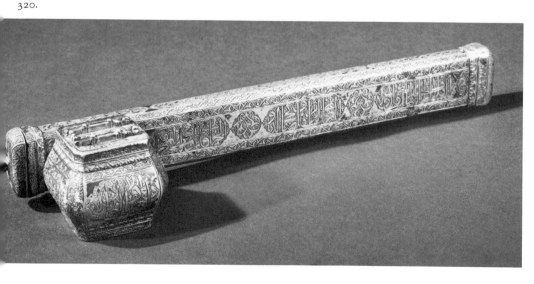

326.
Vambrace
Persia, 17th century
Steel with silver inlay
h: 15⅜ in. (39 cm.)
M.73.5.729 b

327.
Vambrace
Persia, 17th century
Steel with silver inlay
l: 15¼ in. (38.7 cm.)
M.73.5.729 c

328.
Pair of Shoulderplates
Persia, 17th century
Steel with silver inlay
h: 21 in. (53.2 cm.)
M.73.5.729 i, j

329.
Vambrace
Persia, 18th century
Steel with silver and gold inlay
l: 14½ in. (36.8 cm.)
M.73.5.729 e

330.
Shallow Bowl
Persia, 17th century
Silver plated copper, engraved
h: 1¾ in. (4.5 cm.); d: 5⅞ in. (15 cm.)
M.73.5.266

The outside of the bowl is ornamented with
boldly executed hunting scenes against bands of
arabesques and intricate floral patterns. The
neck of the bowl has a Naskhi inscription which
names the twelve Shi'ite Imams. This kind of
copperwork with silver or tin plating was popular
in Safavid Persia. For similar examples, see Pope,
Survey, VI, pls. 1385-1386.

332.
Bowl
Persia, 18th century
Silver, engraved
h: 1⅞ in. (5 cm.); d: 5⅛ in. (13 cm.)
M.73.5.727

322.

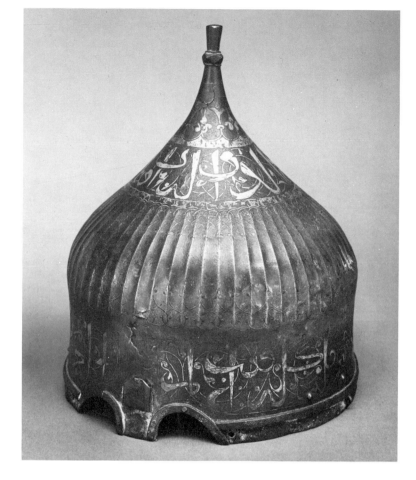

321.

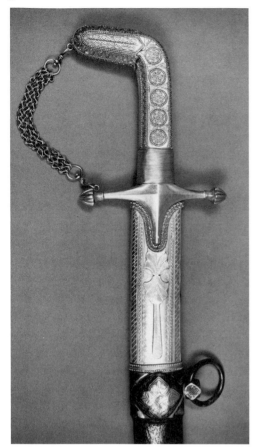

331.
Cup
Persia, 17th-18th century
Silver, repoussé and engraved
h: 3½ in. (8.9 cm.)
M.73.5.126

Although of the Safavid period or even later,
this cup employs the form and design that had been
popular in Achaemenid and Sassanian Persia. The
outside of the bowl is fluted in a repoussé technique
and is engraved with bands resembling a
plaited rope.

333.
Pestle
Persia, 18th century
Brass, engraved
l: 7⅜ in. (18.7 cm.)
M.73.5.265

334.
Plate or *Tray*
Persia, 18th century
Brass with silver and gold inlay
h: 1½ in. (3.75 cm.); d: 17¾ in. (45 cm.)
M.73.5.160

The principal decorative motif is a vine
interspersed with geometric patterns. Rather
unusual for Islamic metalwork, the use of the script
has been completely abandoned in this tray. Both
the workmanship and the style of ornamentation
are comparable to that seen in a pair of bowls
(cf. cat. no. 337).

335.
Cosmetic Container with Cover
Persia, 18th century
Silver, engraved
h: 3½ in. (8.9 cm.); d: 4¼ in. (10.7 cm.)
M.73.5.313

336.
Dish
Persia, 18th century
Brass with silver inlay; engraved
d: 5¾ in. (14.7 cm.)
M.73.5.294

This shallow dish has a hole in the center,
indicating that it was probably fitted to a stem.
The central medallion with six seated musicians is
surrounded by a band of Kufic inscription.
The raised rim is ornamented with an interlaced
vine motif.

337.
Pair of Bowls
Persia, 18th-19th century
Bronze with silver inlay; engraved
h: 5⅛ in. (13 cm.); d: 13½ in. (34.25 cm.)
M.73.5.320, 781

Although the bowls are of the same shape as
cat. nos. 286 and 287, the perforations at the
bottom probably indicate that they were used as
flower or plant pots. Vines with split-palmettes
and cartouches containing Naskhi inscriptions of
blessings are executed in silver in unusually
high relief against a scroll background.

338.
Cylindrical Container with Cover
Persia, 18th-19th century
Brass, engraved
h: 10 in. (25.2 cm.); d: 4⅝ in. (11.6 cm.)
M.73.5.307

339.
Jewel Box
Persia, 19th century
Silver with gold inlay
h: 4⅛ in. (10.5 cm.); d: 7 in. (17.9 cm.)
M.73.5.140

340.
Valve (?)
Persia, 19th century
Bronze with silver inlay
h: 7 in. (17.7 cm.); w: 7 in. (17.7 cm.)
M.73.5.124

Both the form and the function of this metal
object are intriguing. It has been suggested that it
may have served as a valve of some kind, possibly
as an attachment at the base of a hooka.

341.
Finial
Persia, ca. 1900
Gilded bronze with pierced silver encasings
h: 11¼ in. (28.4 cm.)
M.73.5.315

The object, which resembles a perfume sprinkler,
has a lotus-shaped bowl from which rises a
narrow stem. The bottom is pierced and open,
and the object may originally have been fixed
to a pole as a finial.

342.
Lime Container with Cover
India (?), 18th-19th century
Brass, engraved
h: 3¼ in. (8.2 cm.); d: 3¼ in. (8.2 cm.)
M.73.5.305

The inside of the box definitely indicates that
this circular container was used to store lime which
the Indians apply to betel nuts and leaves *(pan)*.
The decorative motifs, although derived from
Persia, have become thoroughly Indianized.

Pratapaditya Pal

Other Arts

343.

344.
Female Figure
Egypt, 8th-9th century
Bone
h: 2 in. (5 cm.)
M.73.5.338

The exact attribution of such figures is difficult.
This sculpture may have been used as a charm by
the Copts in Egypt. Stylistically, it seems related
to a similar, though larger, figure in this Collection
(cat. no. 345).

345.
Female Figure
Egypt, 8th-9th century
Bone
h: 3½ in. (9 cm.)
M.73.5.369

Similar in type to the previous example, the form
in this instance is more generously endowed,
particularly the breasts and the buttocks. Like the
sculptures it resembles (cat. nos. 344, 346),
this figure, too, probably served as a fertility symbol.
Although there is nothing "Islamic" about
sculptures of this type, their forms seem
to continue a more ancient and primitive
iconographic mode.

346.
Female Figure
Egypt or Persia, 11th-12th century
Bone
h: 7 in. (17.7 cm.); l: 48½ in. (123.2 cm.)
M.73.5.368

The emphasis on the breasts and the triangular
pelvic area indicates that the figure served
as a fertility symbol. The face is remarkably similar
to those seen in figures painted on pottery of
the Seljuk period although the eyes are much
larger. Stylistically it seems to be closely related
to the earlier Coptic figure (cat. no. 344) of a female.

347.
Inscribed Tablet
Egypt, 10th century
Marble
h: 11 in. (28 cm.); w: 9½ in. (24.2 cm.)
M.73.5.246

The inscription consists of deeply cut floriated
Kufic of a kind seen in the art of Fatimid Egypt.
In this type of writing the letters terminate in
variegated floral patterns while the circular forms
are delineated as rosettes.

348.
Carved Panel
Egypt, 9th century
Cypress wood
l: 31⅜ in. (80 cm.); w: 7 in. (17.8 cm.)
M.73.5.120

For a similar panel in The Metropolitan Museum
of Art see T. Bowie, *Islamic Art Across the World*
(Bloomington, Indiana, 1970), p. 12, no. 148. That
an almost identical design also occurs on a teak
door attributed to Samarra in Iraq (M. G. Luken,
Islamic Art, p. 4, no. 3) shows the proliferation
of artistic motifs across geo-political boundaries in
the Islamic world.

349.
Carved Panel
Egypt, 9th century
Cypress wood
l: 25¼ in. (64.2 cm.); w: 8 in. (20.3 cm.)
M.73.5.405

350.
Carved Panel
Egypt, 10th-11th century
Wood
l: 33¼ in. (84.5 cm.); w: 8½ in. (21.6 cm.)
M.73.5.121

Although somewhat similar to the earlier panels,
the design here seems slightly more complex.
In addition, a band of Kufic inscription runs along
the top of the panel.

351.
Carved Panel
Egypt, 10th-11th century
Wood
l: 32¾ in. (83.2 cm.); w: 17 in. (43.2 cm.)
M.73.5.119

352.
Architectural Relief
Persia, 10th-11th century
Stucco
l: 51 in. (129.5 cm.); w: 18½ in. (47 cm.)
M.73.5.2

The intertwining borders seem incapable of
containing the panels of convoluted foliate scrolls
and tendrils that twist and surge in endless
complexity. The fragmentary relief well illustrates
the Islamic artist's flight of imagination and
inventiveness even when working with a limited
repertoire.

Ex-coll: The Kevorkian Foundation.

343.
Male Bust (illustrated)
Yemen, 1st-3rd century
Marble
h: 13¾ in. (35 cm.); w: 6 in. (15.3 cm.)
M.73.5.356

Roughly rectangular in shape, the body — rendered
as an abstract mass — supports a short neck and
the head. The eyeballs, as well as the sockets near
the ears, were once inset with semi-precious stones,
as is the slit on the forehead with a piece of coral.

The attribution is tentative and is based on a
comparison with similar material in the Berlin
Museum. See *Museum für Islamische Kunst Berlin,*
p. 25, nos. 32-34 and pl. 24. Apparently, such
sculptures were used as gravestones in Yemen or
South Arabia in pre-Islamic times.

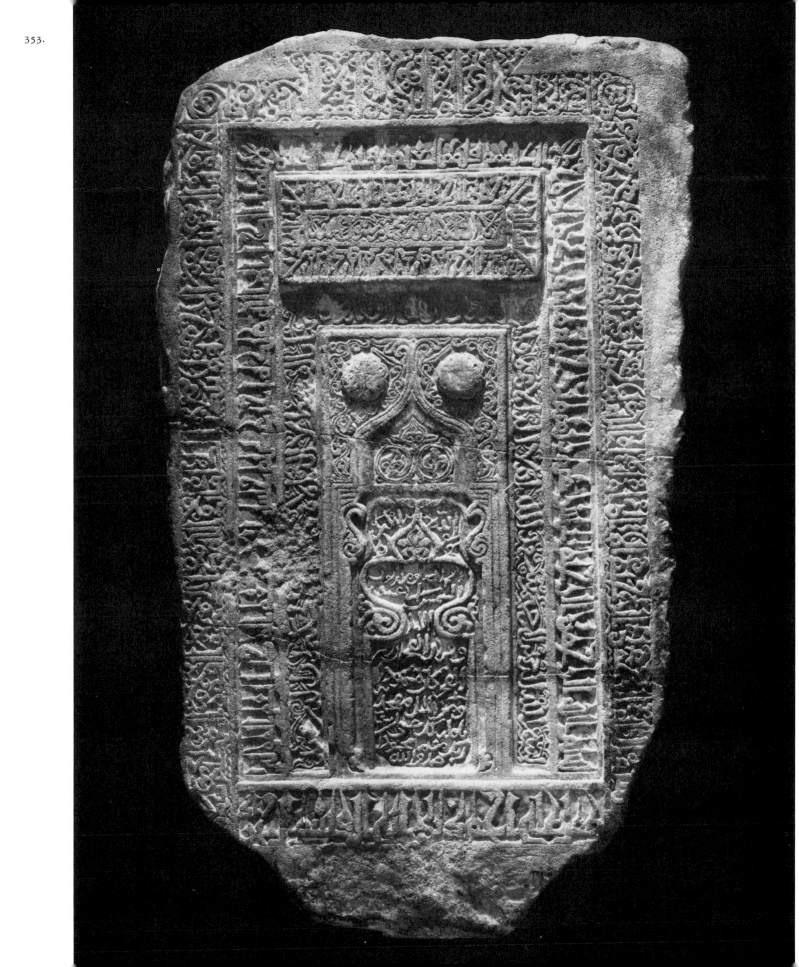

362.

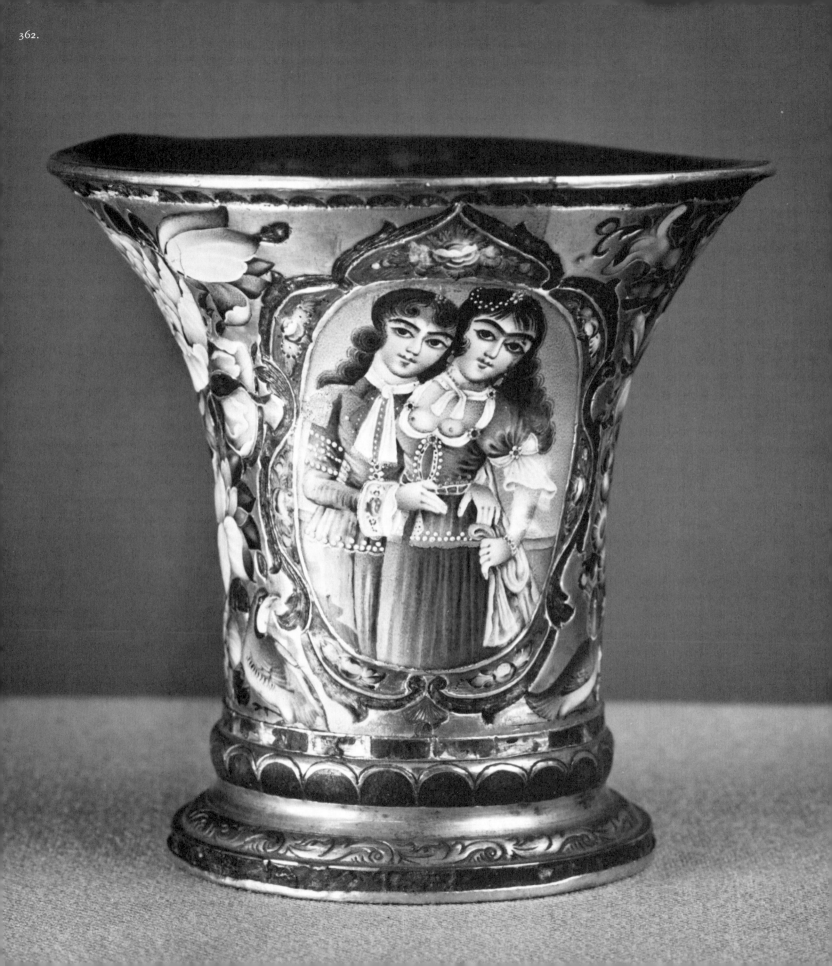

353.
Tombstone (illustrated)
Persia, 12th century
Marble
h: 29¼ in. (74.3 cm.)
M.73.7.1
Gift of Nasli M. Heeramaneck

The rectangular tombstone is carved with a central
niche enclosing inscriptions and bordered by
additional bands of Naskhi and Kufic inscriptions.
The arch above is decorated with rosettes.
The inscriptions are of verses from the Koran.

Similar tombstones are represented in major
Islamic collections in this country and Europe.
For an almost identical relief in The Metropolitan
Museum of Art, see T. Bowie, *Islamic Art Across
the World* (Bloomington, Indiana, 1970),
pp. 40, 68.

354.
Architectural Relief
Persia, 12th-13th century
Limestone
h: 27½ in. (69.7 cm.); w: 17¾ in. (45.2 cm.)
M.73.5.7

Bold Kufic letters and floral tendrils are strikingly
interlaced in a central band.

355.
End of a Balustrade
Persia, early 14th century
Limestone
h: 26¼ in. (66.7 cm.)
M.73.5.5

Similar balustrade ends are in The Metropolitan
Museum of Art (see M. Dimand, *A Handbook of
Muhammaden Art,* p. 110 and E. Baer, "A Group
of Seljuq Figural Bas Reliefs," *Oriens,* vol. 20,
1967, p. 112 and pl. VI) and the Cleveland
Museum of Art (see *Handbook of the Cleveland
Museum of Art,* Cleveland, 1969, p. 208).
Both The Metropolitan and the Cleveland pieces
have figurative decorations on one side while
the Los Angeles example is adorned only with
geometric motifs except for the two stylized lions
in the front. Nonetheless, it is possible that all
three originally belonged to the same monument.

356.
Bird Finial
Persia, 12th-13th century
Bone
h: 4 in. (10.2 cm.); l: 5¼ in. (13.3 cm.)
M.73.5.301

The eyes are inset with gold. The tail is adorned
with a motif combining circles and dots. For a
similar bird in metal which served as a finial, see
cat. no. 295.

357.
Elephant
Persia (?), 13th century (?)
Grey stone
h: 2⅝ in. (6.6 cm.); w: 3½ in. (8.9 cm.)
M.73.5.302

The hole in the tail suggests that the elephant
may have served as a toy. The body is decorated
with the circle and dot motif as is the bird
made of bone (cat. no. 356).

358.
Leaf of a Door
Persia, 16th century
Wood
l: 65½ in. (165.8 cm.); w: 26½ in. (67.2 cm.)
M.73.5.753

359.
Pair of Doors (illustrated)
Persia, 17th century
Lacquered wood, ivory, mother of pearl inlay
h: 74 in. (188 cm.); w: 19 in. (48.2 cm.)
M.73.7.3
Gift of Nasli Heeramaneck

This exceptionally handsome pair of lacquered
doors has two pierced central medallions
containing portraits of Safavid kings. One of them
is identified by an inscription as Shah Abbas.

360.
Hooka Bowl
Persia, 18th century
Brass and wood
h: 6⅝ in. (16.8 cm.)
M.73.5.366

The metal bowl is decorated with raised floral
motifs. Traces of gold inlay cling to the edges.

361.
Hooka Bowl
Signature of Mohammad
Persia, 19th century
Brass, enamel, and wood
h. 8⅜ in. (21.3 cm.)
M.73.5.156

While the upper section of the bowl is engraved
with floral medallions, the cup is richly adorned
with enamel. As is characteristic of the Qajar
period, the enamelling is carried out in vivid colors
and the figurative motifs are derived from
European types.

362.
Cup from a Hooka Bowl (illustrated)
Persia, 19th century
Brass and enamel
h: 3⅝ in. (9.2 cm.)
M.73.5.333

Medallions containing embracing European
couples, realistically rendered pairs of ducks, and
floral bouquets decorate the surface of this
cup, which is an outstanding example of Qajar
enamel decoration.

359.

363.
Pen Box
Persia, 19th century
Lacquered wood, mother of pearl inlay
l: 13⅝ in. (34.5 cm.); h: 2½ in. (6.3 cm.)
M.73.5.340

The inscriptions in cartouches are love poems.
The rest of the side surfaces are filled in with
ornate floriate scrolls. The drawer is painted
red and decorated with sprigs of flowers.

367.

364.
Pen Box
Persia, 19th century
Wood, lacquer, and paint
l: 9¼ in. (23.5 cm.); w: 1¼ in. (3.2 cm.)
M.73.5.157

Lacquered penboxes such as this example are
typical of the Qajar period. The outer surface of
such boxes are always painted with figurative
scenes that reflect a pronounced European influence.

365.
Pen Box (illustrated)
Persia, 19th century
Wood, lacquer, paint, and gold
l: 9⅜ in. (23.8 cm.); w: 1¾ in. (4.5 cm.)
M.73.5.159

One side of the box shows the Prophet riding
a horse onto a battlefield. The other sides portray,
in the typical Qajar style, scenes of the Day of
Judgment, the bridge between heaven and hell,
and the angel Michael holding a pair of scales.
The box was made by Shukru-allah Afsar in
1148 A.H./A.D. 1735.

366.
Plate
Persia, 19th century
Brass and enamel
h: ½ in. (2 cm.); d: 3⅞ in. (9.8 cm.)
M.73.5.337

367.
Box (illustrated)
Persia, 18th century
Wood, lacquer, and paint
l: 14⅝ in. (37.2 cm.); w: 10 in. (25.4 cm.);
h: 8¾ in. (22.3 cm.)
M.73.5.373

The central medallion on the lid shows a sphinx;
its head is turned back, and it shoots an arrow at
a dragon's head which is actually the end of its own
tail. This fantastic creature is artfully interwoven
with floral tendrils, some supporting flowers and
others terminating in the heads of birds and
animals *(waq-waq* pattern). The rest of the box is
ornately decorated with fighting animals,
dragons, and intertwining floral tendrils.

The sphinx with its tail terminating in the head
of a dragon, found in earlier Islamic art, is regarded
as the fusion of the zodiacal sign Sagittarius and
its planetary lord. The dragon's head symbolizes the
Jawzahr, whose exaltation is in Sagittarius.
(Baer, *Sphinxes and Harpies,* p. 73.)

365.

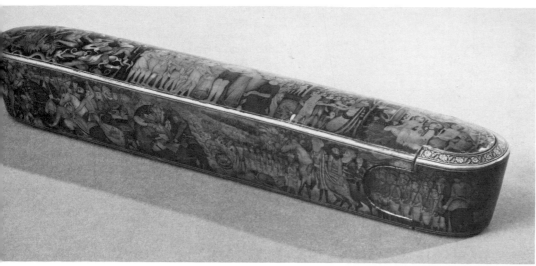

368.

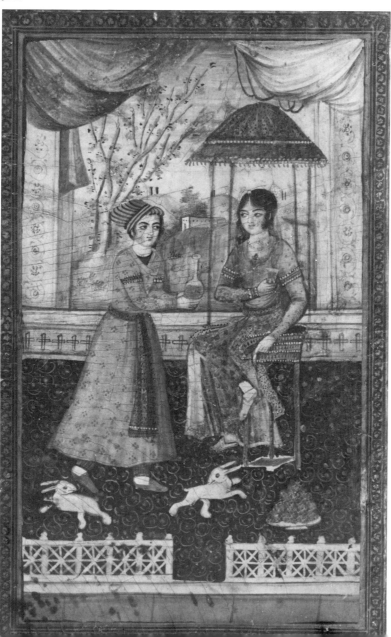

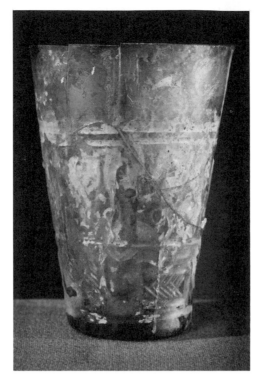

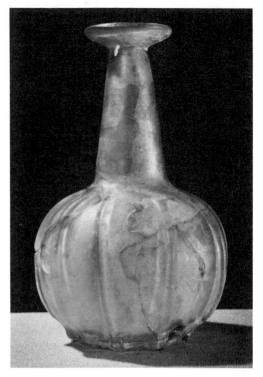

369.

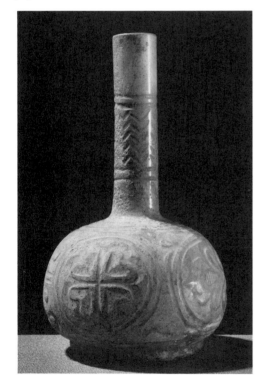

368.
Lid of a Mirror Case (illustrated)
Persia, 19th century
Lacquer, paint
h: 7¼ in. (18.4 cm.); w: 4½ in. (11.5 cm.)
M.73.5.598

The outside of this case depicts a seated Qajar lady
attended by a maid; inside are the Virgin with
the child Jesus attended by St. Anne and an old man
(perhaps Joseph) kneeling before him.

369.
Bottle (illustrated)
Persia, 8th-9th century
Glass
h: 6 in. (15.2 cm.)
M.73.5.387

An extremely rare example of early Islamic glass,
this buff colored bottle has a bulbous body,
a narrow foot, and a tall slender neck. The body
is decorated with four medallions, each enclosing
a floral motif resembling an acanthus. The neck is
adorned with carved cross-hatchings and circular
bands. Both in its refined ornamentation and in its
handsome proportions this bottle is an outstanding
work of art.

370.
Bottle
Persia, 8th-9th century
Glass
h: 4¾ in. (12 cm.)
M.73.5.388

Light green in color, this molded and iridescent
bottle has a plain neck and a body ornamented with
meandering circles and cartouche shapes.

371.
Bottle
Persia, 9th-10th century
Glass
h: 5½ in. (14 cm.)
M.73.5.397

The bulbous body of this white glass has molded
ribs and a narrow, tapering neck surmounted
by a flaring lip.

372.
Bottle
Persia, 9th-10th century
Glass
h: 5¾ in. (14.5 cm.)
M.73.5.390

This buff colored cut glass bottle has a bell-shaped
body and a flaring neck. Bands of incised
cross-hatchings and intertwined meandering lines
decorate the surface of the body while geometric
signs and connected lobes are engraved around
the neck.

373.
Ewer
Persia, 9th-10th century
Glass
h: 5¼ in. (13.4 cm.)
M.73.5.404

The tapering bell-shaped body, light blue and
iridescent, is molded, and rib marks are evident.
A band of twisted glass is at the base of the
neck. There are also a thick twisted glass handle
executed in late Roman technique and a wide
flaring lip.

374.
Beaker (illustrated)
Persia or Mesopotamia, 9th-10th century
Glass
h: 3⅞ in. (9.9 cm.)
M.73.5.396

Wafer-thin and of pale brown glass, this beaker
is ornamented with two bands of molded design.
One of the motifs is similar to designs which
appear in Egyptian or Mesopotamian wooden panels
(see cat. nos. 348, 349).

375.
Bottle (illustrated)
Persia, 8th-10th century
Glass
h: 8⅝ in. (22 cm.)
M.73.5.393

Pale brown with iridescent scum, this bottle, of the
water sprinkler variety, is similar in technique
and shape to cat. no. 369. The foot, however, is
more substantial and is of the flaring type and the
design, too, varies somewhat — the most prominent
motif in this instance being a spiral pattern.

376.
Jug with Handle
Persia, 10th century
Glass
h: 5¼ in. (13.5 cm.)
M.73.5.402

This greenish gold, iridescent jug has a flaring
bell-shaped body. The base of the neck is molded
into round ridges, and there is a twisted handle.

377.
Bowl
Persia, 10th-11th century
Glass
h: 2⅞ in. (7.5 cm.)
M.73.5.399

This deep bowl has high, straight walls, a body
decorated with molded and entwined diamond
forms, and the coloration is dark blue with
iridescence. Much repair has taken place.

378.
Cup
Persia, 10th-12th century
Glass
h: 4½ in. (11.5 cm.); d: 4¼ in. (10.6 cm.)
M.73.5.391

A large, straight-walled drinking cup, this example
is absolutely plain. In color it is pale cream with
gold iridescence.

379.
Bottle
Persia, 10th-12th century
Glass
h: 4½ in. (11.4 cm.)
M.73.5.389

A plain bottle with bulbous body, tapering neck,
and flaring lip, this example is white and iridescent.

380.
Bowl
Persia, 10th-12th century
Glass
h: 2¾ in. (7 cm.)
M.73.5.398

Bulbous in form and with a flaring lip, the bowl
is molded with ribs which radiate from the shallow
foot like a gourd. It is of colorless glass which
is iridescent.

381.
Jar
Persia, 10th-12th century
Glass
h: 3⅞ in. (9.8 cm.)
M.73.5.362

This jar is of rather thick dark green glass and
has a small, twisted handle. On the body is molded
a continuous cartouche pattern. The neck is wide
and straight-walled.

382.
Bowl
Persia, 11th-12th century
Glass
h: 1¾ in. (4.5 cm.)
M.73.5.386

Plain, with straight walls, this bowl is pale yellow
in color with golden iridescent scum.

384.

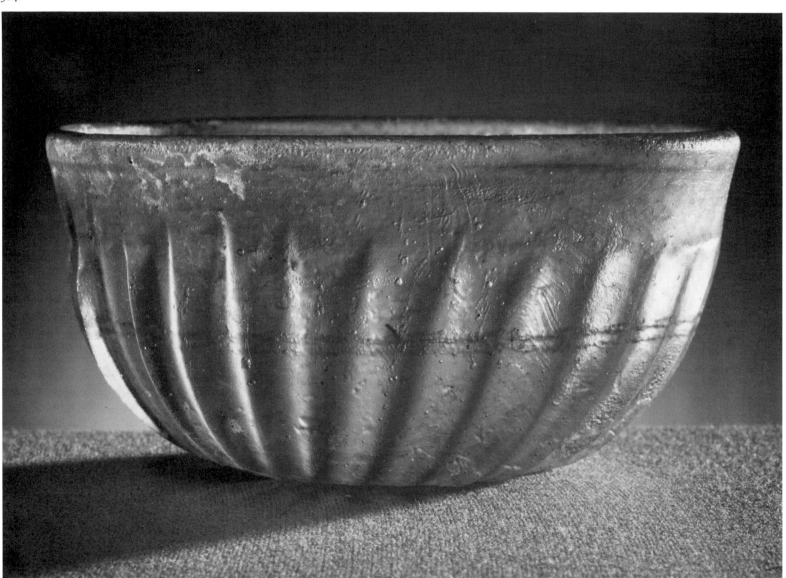

383.
Ewer
Persia, 11th-12th century
Glass
h: 3½ in. (8.9 cm.)
M.73.5.403

Heavily encrusted with iridescent scum, this
molded ewer with a handle has a band decorated
with an ornate floral motif in high relief
around the belly and an arch design below.

384.
Bowl (illustrated)
Persia, 11th-12th century
Glass
h: 2¼ in. (5.8 cm.)
M.73.5.400

Pale blue in color and iridescent, the bowl is
decorated on the outside with a molded petal-form
motif.

385.
Bottle
Persia, 11th-12th century
Glass
h: 8¾ in. (22.2 cm.)
M.73.5.394

Very likely, bottles such as this served as water
or perfume sprinklers. Pale brown in color and
iridescent, it has a bell-shaped body. The neck is
extremely long with a molded ridge and twistings
at its base. The body is molded with ornamental
decoration.

386.
Bowl
Persia, 10th-12th century
Glass
h: 2½ in. (6.5 cm.)
M.73.5.363

Light green and with an iridescent scum, this
bowl has flaring walls and a body decorated with an
abstract design comprised of ovals and a twisted
rope pattern.

387.
Jug
Persia or Syria, 10th-12th century
Glass
h: 6¼ in. (15.8 cm.)
M.73.5.401

This light green molded jug continues a Roman
technique. Molded diamond forms and double
circles ornament the body. The handle is of twisted
glass, and the straight-walled neck is pinched
in pie shape at the rim. There is an iridescent scum
on the surface.

388.
Bottle
Persia, 12th-13th century
Glass
h: 8¼ in. (21 cm.)
M.73.5.364

The bulbous body, pale green in color, is decorated
with medallions enclosing birds very much like
those that often appear in Seljuk metalwork
(see cat. no. 280). The tall, narrow neck has an
appliqué ribbon of glass encircling its base.

389.
Bottle
Persia, 18th century
Glass
h: 7 in. (17.8 cm.)
M.73.5.392

The bulbous body is molded with spiralling
circular patterns while the tall tapering neck has
a double flared lip and a frill of twisted glass
at the base. The coloration is pale green with
iridescence and mud encrustations.

390.
Bottle
Persia, 18th century
Glass
h: 7¼ in. (18.6 cm.)
M.73.5.395

The bulbous body is decorated with a molded
honeycomb pattern. The tapering neck ends in a
wide, flaring lip. The color is cobalt blue with
brown earth encrustations.

391.
Bottle
Egypt, 10th-11th century
Crystal
h: 2¼ in. (5.7 cm.)
M.73.5.711

A foliate composition decorates the body of this
rock-crystal bottle. Such objects are often known as
"tear" bottles. A similar example is in the
treasury of the Halberstadt Cathedral (see *Islamic
Art in Egypt,* the catalog of an exhibition held
in Cairo in 1969, pl. 3 [a]).

392.
Cover for a Bottle
Egypt, 10th-11th century
Crystal
h: 1¾ in. (4.5 cm.); d: 2¼ in. (5.7 cm.)
M.73.5.372

393.
A Stopper in the Form of a Horse's Head
Egypt, 10th-11th century
Crystal
h: 2⅛ in. (5.3 cm.)
M.73.5.370

394.
Cup
Persia or India, 17th century
Jade
h: 3⅜ in. (8.5 cm.); d: 6⅛ in. (15.5 cm.)
M.73.5.334

Of pale green jade, the cup has a ring foot; its two
solid flat handles and body are decorated with
flamboyant arches. While the exact provenance
of such jade objects is often difficult to determine,
this cup may have been carved in Mughal India.

395.
Bookstand (illustrated)
Persia or India, 17th century
Jade, steel; gold inlay
h: 6⅝ in. (42.2 cm.)
M.73.5.118

The green jade panels are set in steel frames inlaid
with gold floral and vine motifs. The outside
surface of the jade is carved mainly with lotus
motifs and a stylized flower. The top of the two
upper panels is decorated with steel crenelations.

396.
Inscribed Tablet
Persia, 19th century
Jade and iron
h: 15 in. (38 cm.)
M.73.5.367

Several olive green jade panels are inset as a
tablet within iron frames. The panels are inscribed
on either side with verses from the Koran. On
the obverse the inscriptions are carved in high relief
in elongated Kufic and cursive Naskhi. On the
reverse the inscriptions are etched more freely in
Nastaliq.

395.

M. H. Kahlenberg
Curator of Textiles and Costumes

The Palevsky-Heeramaneck Collection of Islamic textiles includes
pieces from Spain, the Greek Islands, Egypt, Turkey, Mesopotamia,
Persia, India, and Thailand. That the art of such an immense
area can be grouped into a single collection testifies to the unifying
power of the Islamic world.

Naturally, each region produced textiles with distinctive characteristics
based on the traditions and national perspectives which predated
the Muslim conquest. Because the Muslim faith theoretically prohibited
artists from depicting reality, the Islamic artist tended to seek
inspiration within himself rather than in the world of natural
phenomena. As a result, his subjects became stylized. The
determination of matters of shape or color owed little to the laws
of nature. Flowering vines became arabesques; individual
plants were made to curve and sway elegantly to create an overall
harmony within the textile design; a bud would be added to
a blossom to carry out the rhythm of a repeat. The decorative intent,
rather than botanical inspiration, determined the delicate color
harmonies achieved by the Safavids in Persia.

Contrasting with these graceful and harmonious floral patterns are
the exacting geometric patterns of Islamic textiles which are calm
and resolute. Although the geometric style was not invented by Islamic
artists, it achieved its fullest expression in their hands. The most
outstanding examples are the complex designs of interlaced spirals,
stars, wheels, and polygons of the Hispano-Moresque and later of the
Mudejar textiles of Spain. Both types of designs — floral and geometric
— employ the same decorative principles of pattern and repeat,
and the pattern always covers the entire surface, as if leaving a void
meant leaving the design incomplete. To cover these spaces fully,
small motifs were integrated into the central design.

Most textiles were made up of repetitive elements which constituted
an overall design rather than of a set of separate images. This required
that the designers be skilled in arranging the repeats to prevent their
being discernible. Rows of floral bands curve in various directions,
and seen as a whole, they seem to undulate. The same is true when
polygons and wheels are intertwined over the length of the textile.
What first attracts the eye is the cohesiveness of the pattern. Later
comes the visual delight of defining the individual elements of the
puzzle.

The design of Islamic textiles is abstract rather than emotive. It never
portrays emotion-laden figures as do European tapestries and
embroideries. But, within its chosen limits, its decoration shows infinite
virtuosity and variety. It has a harmony that is refined and sumptuous,
beautiful to the eye and to the touch.

The oldest textiles in the Collection were woven in Egypt where
tapestry weaving was known as early as the Eighteenth Dynasty
(1580-1350 B.C.). When the Arabs conquered Egypt in A.D. 641, they
did not exert an immediate influence on indigenous textile designs
which at that time were primarily pictorial representations in the
Hellenistic style. Rather, they took advantage of the flourishing textile
trade that had been built in the first six centuries of the Christian
era and continued to employ the Copts as weavers.

Coptic garments were unshaped linen or wool robes with narrow

decorative bands (*clavi* and *gammadia*) woven in tapestry technique running vertically on either side of the front and back and on the sleeves and shoulders. Arab robes of the era were similar in cut, the only difference being that narrow horizontal bands occurred just below the neck along the top of the sleeve. The Arabs did not introduce a new type of design to embellish their robes. Rather, they had the weavers of the Fatimid period (969-1171) adopt the Coptic animal motifs. The Coptic designs had been vigorous, deeply expressive, with violent color contrasts — intended to be forceful rather than graceful. Limiting themselves to images of birds and hares, the Fatimid weavers made bands comprised of animal silhouettes. Delineated so delicately, they are comparable to miniature paintings. They no longer create the impression of being real animals; instead, they have become symbols flatly placed on the garment.

The most characteristic decorative element in Islamic art is Arabic calligraphy. Initially it was used to offer homage to God. With the strong upward sweep and the inflected curves of its characters, Arab calligraphy formed elegant patterns quite apart from the meaning of the words. *Tiraz,* from the Persian word for embroidery, was the term used to designate textiles with inscriptions. Initially *tiraz* meant any embroidered decoration on a garment, but later it was used to refer to inscriptions — be they embroidered, tapestry woven, or painted. *Tiraz* was also the term used to designate the workshop where they were made.

Two types of *tiraz* factories existed. The first were the private enterprises of the *caliph (tiraz al-khassa)* which produced fabrics to be used by the royalty, as well as garments to be given as robes of honor. The second were public factories *(tiraz al-'amma)* which were controlled by the state and produced materials to be sold to the privileged class. The origin of these factories can be traced back to Byzantine times, and it is probable that they were merely absorbed by the Umayyad *caliphs* and adapted to their new needs.[1]

A basic protocol existed for the inscriptions on such textiles although it was not necessarily adhered to in every detail. It began with the *Basmala:* "In the name of God the Compassionate and Merciful." Then followed the name of the *caliph,* a pious wish for the ruler, the name and place of the factory, and the date.[2]

Two main types of Arabic script were used: Kufic, a square and angular form of writing; and after A.D. 1100, Naskhi, a round, cursive style. The textiles were not produced by calligraphers but by Coptic weavers. Very likely illiterate, the weavers enriched the texts with their own decorative flourishes, elongating, condensing, and arbitrarily spacing letters. Inscriptions from the eighth to the eleventh century were generally simple and more exacting, but from the eleventh century on more elaboration and distortion occurred.[3]

Spain was the western-most country to become part of the Islamic world. Although it is believed that *sericulture* was not known in Spain before the Mohammedan conquest in A.D. 711, an earlier tradition of wool weaving did exist. It is most likely that *tiraz* fabrics began to be produced in Spain as well when a branch of the Umayyad Dynasty (A.D. 756-1031) developed at Cordova — which became a center renowned both for the arts and sciences — and a friendly relationship with Syria led to an exchange of ideas and fashions. Two of the Hispano-Moresque fabrics of the Nasrid period in the Collection are interesting because of their highly developed

geometric patterns (cat. nos. 490, 491). They contain the same
interlacing and star motifs that exist in Islamic architecture,
but only in Spain did these motifs become established in textile design.
Fabrics of this style are attributed to Granada and resemble the
stucco and tile patterns decorating the walls of the Alhambra.[4]
In addition, these fabrics are jewel-like in their use of strong reds,
greens, and yellows.

A later style of textiles, referred to as Mudejar and woven in the
sixteenth century[5] by Muslims living in areas ruled by Christians, is
more limited in its pattern repertoire. A design in which lions
are framed by interlacing leaf motifs appears in many variations with
only slight color changes. The inspiration for these designs were
fabrics received as gifts from the Mamluk rulers of Spain. In these
fabrics, stripes and foliage pattern alternated, and an ogee
framing device — also seen in the Alhambra — was employed.[6]

From the earliest times it was traditional for Islamic courts to employ
an atelier of artists responsible for all the art produced for the
court. Within this vast court workshop system, artists produced both
manuscript illustrations and designs which were subsequently
used in textiles, metal ornaments, tiles, and woodcarvings. For this
reason many identical designs appear in a variety of media. Although
this system makes it impossible to establish the identity of
individual artists, it helps in the dating and placing of a great
number of art works.

Such an atelier system was used in the Ottoman Empire (1299-1893),
which during the fifteenth and sixteenth centuries was a major
power in both the Islamic world and Europe. A strong trade
relationship between the areas is reflected in the textile designs.
Like Persian textiles of the period, Turkish designs were basically floral
in character. They differed from Persian textiles in being bolder
and using a broader surface arrangement; an example is the simple
ogival motif which appears on many brocades in the Collection. cat. nos. 419, 420
But the bold design was softened when combined with the
finely drawn, detailed floral motifs. The floral elements were based
on tulips, hyacinths, and carnations, and were abstracted to
create flat planes of color. The strong stylization of floral motifs in
Turkish designs, as well as the absence of animals or human
figures, is generally attributable to the fact that, unlike the Persians
who belong to the Shiite sect of Islam, the Turks are Sunnis,
a sect traditionally averse to the representation of both human and
animal figures.[7]

The use of a limited number of colors also contributes to giving the
Turkish fabrics their strong effect. There are no subtle combinations as
there are in Persian textiles. A crimson red is frequently the color
of the ground; and gold, some silver, blue and white, as well as green
are occasionally used as background colors.

The existence of a commercial relationship between Venice and the
Ottoman Empire encouraged an exchange of designs and in particular
the development of the double ogival system into the pomegranate
designs of the Italian Quattrocento.[8] Later, during the seventeenth
century, in the Turkish textiles the detailed areas of the designs were
eliminated, leaving only the broad, flat carnation or pineapple
pattern. Thus, as Geijer suggests, the original oriental pomegranate
motif was adopted by the Italians, further developed in Italy, and
later returned and "reorientalized."[9]

The Turkish brocades and velvets in the Collection were woven both as dress and furnishing fabric. The broad, flowing textiles lend themselves to the voluminous kaftan robes which were constructed with a minimum of seams. They were also suited to covering the large pillows or "ottomans" which were a major component in Turkish domestic furnishings. Other pieces served as coverings for symbolic sarcophagi and as decorative panels and banners.[10]

When the Safavid Dynasty was founded in Persia in 1502, a tradition of high artistic and technical achievement in textiles had already existed since the Sassanian period (A.D. 224-642). Royal Safavid patronage of the arts commenced soon after the beginning of the Dynasty, and there ensued a national renaissance which coincided with a period of great luxury and elegance. The sumptuous Safavid silks employed almost every weaving technique used in Persia at that time; there were brocades, embroideries, tapestry weaves, double and compound weaves, as well as velvets. An equally great number of dyes were employed, producing a spectrum of colors which ranged from the most delicate pastels to the most vibrant shades and included all the subtle nuances of grey. And, using this extensive palette, the weavers devised still greater subtleties, combining shades of coral and yellow, salmon and emerald. They also invented new techniques. Gilt threads would be wrapped around different color silk cores to produce minute tonal variations, or they would be woven under the velvet pile to be visible only when the fabric was in motion.

Two basic design styles existed in the sixteenth century, one with figurative motifs and one with overall patterns comprised of arabesque ogivals or lattices. Fabric decorated with figurative motifs grew out of miniature painting, which it resembled both in drawing style and subject matter. Textiles were used to illustrate scenes from the great Persian epics, particularly the *Shah Nama* by Firdousi and the romantic poems of Nizami. Other favorite themes were the leisure pursuits of royalty. Generally they were portrayed hunting or enjoying the pleasures of the garden. A textile in the Collection which exemplifies the use of figurative motifs is a compound satin fabric from the third quarter of the sixteenth century. The image depicted — a cup bearer in a garden — is related in style to the painting of Tabriz, the first Safavid capital.[11] Textiles of a slightly earlier date are more successful than this example in their handling of the repeat. In this instance the repetition consists of a series of verticals created by the cypress trees and the standing figure. A slight horizontal emphasis is given by the animal figures. A phoenix, representing the power of good and royalty, flies in front of one of the trees, and a winged lion emerges from behind another. Both animals are borrowed from the Chinese whom the Persians greatly admired and with whom they traded textiles for many centuries. But, the Chinese influence extended far beyond the borrowing of animal motifs. An overall pattern of interlocking foliage had been a feature of Chinese design since the Han period (202 B.C.-A.D. 220), and this became a major feature in Persian textile design. So, too, did the ovoid form which first was used as an isolated motif and eventually became the basis of compositions. Both foliage and ovoid motifs developed in the sixteenth century into open-spaced designs in which there was greater continuity and less repetition, and which reflected a more refined and elegant taste.

Toward the end of the sixteenth century there appears to have been an increase in textile production. By the beginning of the seventeenth,

cat. no. 437

the character of textile design had changed; the strong and vigorous
style had given way to an interest in sentiment and pleasure.
It was a time of languid and voluptuous grace, a period when some
textile designers had become so established that they wove their
signatures into their fabrics. The name Ghiyath, for instance, appears
in seven known textiles.[12]

Persian painting, with its use of silhouettes and unshaded color areas,
was translated with little variation into woven textiles. What
change there was entailed the textiles' great adherence to the principles
of abstract design and ornamental patterns. Basically, however,
the units of composition and the method of using repeats remained the
same. Whether the subject was a flowering vine encircling a lotus
or a pair of swaying figures beside a pond, the laws of symmetry rather
than those of nature determined the composition.

Artists and craftsmen frequently migrated from one area of the Islamic
world to another. There were times when artists were brought
back as captives following invasions and other times when they were
influenced by high pay or the summons of a prestigious court.
The Mughal court took advantage of this mobility to bring
both painters and craftsmen to India beginning in the mid-sixteenth
century, and during the reign of Akbar (1556-1605) a Mughal
style originated. It was an amalgam of the contemporary Persian
court style (to which the Mughals felt an affinity although it was not
their direct heritage), of pre-Mughal Indian traditions, and of
European influences introduced by foreign visitors. No textiles in
this Collection can be assigned to this early period, but a study
of paintings of the time reveals that the textiles used, if not of Persian
manufacture, were at least direct copies of Persian fabrics.

In the first half of the seventeenth century the Persian influence
remained dominant, and textiles continued to be carefully organized
with graceful curves and arabesques and to reflect a feeling for
sumptuousness and splendor. Gradually, however, the Indian interest
in naturalism began to have an effect. The first change was a new
openness of design, with floral motifs treated less abstractly and a more
limited color palette. Whereas the Persian use of color was
inventive but unnaturalistic, the Indians were more likely to make
leaves green and blossoms various shades of one or two colors —
for example red and tan.

In 1620 Jahangir made a trip to Kashmir during the spring. Delighted
by the array of flowers growing there, he ordered his best animal
painter Mansur to make studies of them.[13] Nor was Jahangir alone in
this interest in botanical illustration; for, at this same time travellers
were bringing European herbals to both India and Persia.[14]

Upon Jahangir's return from Kashmir, designs of individual flowering
plants began to appear in architecture and on textiles.[15] By the
middle of the seventeenth century the use of the motif of a single bush
or of rows of flowering plants had increased tremendously.
But, although the flowers had become more naturalistic in treatment,
they still retained the excessively graceful curves, drooping
blossoms, and compositional fullness — with small motifs filling the
spaces — that connected them to the ornamental and opulent
fabrics of Persia.

A painter from the Persian court, Shafi-i-Abbasi, travelled to
the Mughal court at some time during the middle of the seventeenth

century and was inspired by the Indian interest in naturalism in general and in flowering plants in particular. Several of his paintings for textile designs exist today. One, which shows a stalk of a narcissus curving over a bullfinch,[16] could have been the model, at least in part, for several textiles in this Collection. These examples, which show a symmetrical flowering bush growing from a mound, are naturalistic in all respects except scale. The birds and animals are large in proportion to the butterflies, while the butterflies relate in size to the blossoms. Yet, the inconsistency in scale is not disturbing, nor is it in conflict with the naturalistic details, for it makes sense within the decorative convention.

By the end of the seventeenth century, fabrics decorated with rows of floral designs had come to dominate both Indian and Persian textile production. Gradually, the scale became smaller and the placement of the flowers in rows became more formal. By the middle of the eighteenth century the juxtaposition of elements and variations of scale had disappeared forever, as had the graceful curves, playful color sense, and lavish gold grounds. Textiles had ceased to represent an enchanted world where nature was clothed in the most sumptuous adornments.

Today, fabric coming off the loom is such a commonplace event that we find it difficult to imagine a time when textiles were a major luxury item. But Islamic fabrics certainly were. Designed by artists of the court and woven by the skilled craftsmen of the lands, these luxurious fabrics were known across Europe for their opulence and fine textures. They were important items of trade and exerted considerable influence on European fabrics. Many of the Islamic textiles in collections today have survived because they were sent to Europe either as gifts to royalty or as part of the commercial exchange between the East and the West. Many have survived as elements of Christian ecclesiastical garments and palace decorations.

A group of sashes in this Collection point to a direct relationship between Persia and Poland. The Polish nobility were believed to have descended from the ancient rulers of Eastern Europe, known as the Scrmatii, and an interest in their ancestors brought with it an interest in the arts of the Islamic world, in particular with the style of dress. There is no doubt that many fine Persian textiles arrived in Poland between the sixteenth and eighteenth centuries, but the group of sashes in question is of special interest because it includes not only those made in Persia, but Polish copies as well.

It was Stephen Bathory, King of Poland from 1575 to 1586,[17] who imposed an oriental style upon the national costume and popularized it. It began with a sash of solid color fabric twisted gracefully over the sword belt — similar in style to the fashion in Persia at the time. In the seventeenth century, sashes with decorated fields and borders began to appear in portraits. These sashes, woven mainly in Kashan, were exported through the Turkish market.[18] And, although it has not been documented, there was surely a time when the exported sashes ceased to be in the Persian tradition and began to be made especially to suit the Polish taste. That this transition occurred is obvious from the examples in this Collection. Initially delicate and refined, with an overall design of scrolls and blossoms, the sashes slightly later became less sensitive in color and more repetitious in design.

The Afghan invasion in 1722 put an end to the importation of sashes from Persia. But, by then the Armenians had begun producing

Stanbul sashes and exporting them directly to Poland. By 1740 workshops called "Persia" had been established in Poland, and they continued producing sashes distinctly eastern in design[19] abeit combining the Islamic taste for opulence and eighteenth-century French love of lightness. Some of these have a particular grace while others are rather flat and stylized.

In spite of the great technical diversity reflected in the more than one hundred Islamic textiles in this Collection, it is apparent that the Islamic religion exerted a strong unifying force. Although stylistic changes were numerous — following new conquests and infusions of new peoples — each new style continued to be developed and embellished until it had been completely assimilated into the visual vocabulary.

Notes

1.
Ernst Kühnel and Louise Bellinger, *Catalogue of Dated Tiraz Fabrics* (Washington, D.C., 1952), p. 3.

2.
Nancy Pence Britton, *A Study of Islamic Textiles in the Museum of Fine Arts, Boston* (Boston, 1938), p. 20.

3.
Ibid, p. 18.

4.
Louise W. Mackie, *Weaving Through Spanish History* (Washington, D.C., 1972), p. 3.

5.
Brief Guide to Turkish Woven Fabrics, (London, 1950), p. 7.

6.
Mackie, *op. cit.,* p. 3.

7.
Brief Guide to Turkish Woven Fabrics, op. cit., p. 7.

8.
Agnes Geijer, *Oriental Textiles in Sweden* (Copenhagen, 1951), p. 48.

9.
Ibid, p. 48.

10.
Walter Denny, "Ottoman Turkish Textiles," *Textile Museum Journal,* vol. 3, no. 3 (Washington, D.C., December 1972), p. 57.

11.
Phyllis Ackerman, "Safavid Luxury," *Ciba Review,* no. 98 (Basel, 1958), p. 3526.

12.
Phyllis Ackerman, "Textiles of the Islamic Period History," *A Survey of Persian Art,* ed. A. U. Pope, vol. 5, 2nd ed. (New York, 1947), p. 2045.

13.
Robert Skelton, "A Decorative Motif in Indian Art," *Aspects of Indian Art,* ed. P. Pal (Leiden, 1972), p. 151.

14.
Robert Skelton suggests that Mansur's picture shows a similar approach to an illustration in Pierre Vallet's *Le Jardin du très Chrestian Henry IV* of 1608, particularly in the way in which the butterfly is posed above the flower.

15.
Skelton, *op. cit.,* p. 151; Mary Kahlenberg, "A Study of Mughal Patkas in the Los Angeles County Museum of Art," *Aspects of Indian Art,* ed. P. Pal (Leiden, 1972), pp. 153-165.

16.
E. Blochet, *Musulman Painting* (London, 1929), pl. 168. See also, Basil Gray, "An Album of Designs for Persian Textiles," *Aus der Welt der Islamishen Kunst,* ed. R. Ettinghausen (Mann, Berlin, 1959), pp. 219-225.

17.
George E. Borchard, "Reflections on the Polish Nobleman's attire in the Sammatian Tradition," *Costume* (Journal of the Costume Society) (London, 1970), no. 4, p. 14.

18.
Borchard, *op. cit.,* p. 14.

19.
Borchard, *op. cit.,* p. 15.

The Art of Textiles

398.

405.

397.
Fragment
Egypt, 8th-9th century
Tapestry weave
Silk weft, linen warp
h: 11¾ in. (30 cm.); w: 5½ in. (14 cm.)
M.73.5.641

The band is decorated with a duck contained
within an ovoid medallion framed by a scallop motif
on a red ground. Narrow stripes with a circular
motif border the band. Yellow and light blue (faded
to natural) outlined by dark brown and red are
used throughout the motif and the strips.

398.
Fragment with an Inscription (illustrated)
Egypt, 8th-9th century
Paint on an undyed linen ground
h: 11¼ in. (28.5 cm.); w: 3½ (9 cm.)
M.73.5.639

A band set off by narrow orange borders has
an inscription in early Kufic with the phrase
"Shamesh Sames."

399.
Band
Egypt, 9th-10th (?) century
Embroidery
Silk on an undyed linen ground
h: 11⅜ in. (29 cm.); w: 2⅝ in. (7 cm.)
M.73.5.623

A geometric motif in red and dark blue is
repeated on a natural ground.

400.
Fragment with an Inscription
Egypt, 9th-10th century
Embroidery
Silk on an undyed linen ground
h: 12¼ in. (31 cm.); w: 2½ in. (6.5 cm.)
M.73.5.620

The inscription in red on a natural ground
translates in part: "In the name of God the
merciful, the compassionate, praise be upon
the Lord, the Creator,, blessings to the
Imam,,"

401.
Fragment with Inscription
Egypt, 9th-10th century
Embroidery
Silk on an undyed linen ground
h: 4¼ in. (10.8 cm.); w: 4⅜ in. (11.1 cm.)
M.73.5.621

The inscription is of part of a Koranic Surah in red
on a natural ground. It translates: "In the
name of the God the merciful, the compassionate,
blessings of God. . . ."

402.
Fragment with an Inscription
Egypt, 9th-10th century
Embroidery
Silk on an undyed linen ground
h: 8⅝ in. (22 cm.); w: 2⅞ in. (7.5 cm.)
M.73.5.622

The inscription, in blue angular Kufic, appears
on a natural ground.

403.
Fragment with an Inscription
Egypt, 900-950
Embroidery
Silk on an undyed linen ground
h: 9 in. (22.5 cm.); w: 13 in. (33.0 cm.)
M.73.5.613

The inscription in red Kufic script on a natural
ground translates, "In the name of God the
merciful, the compassionate, all praise to the Lord
of Creation. Praise of God upon Mohammed,
God's blessing to Ja'far Al Muqtadir, Bellah,
the commander of the faithful. May God praise
his days."

404.
Fragment with an Inscription
Egypt, about A.D. 950 (A.H. 337)
Embroidery
Silk on an undyed linen ground
h: 8¼ in. (21 cm.); w: 15¼ in. (38.8 cm.)
M.73.5.636

An inscription in red reads: "Done for the Vizir
Muhamad Ibn-Ali by the hand of the tailor
and calligrapher in Egypt in the year 337 AH."

405.
Fragment (illustrated)
Egypt, 10th century
Embroidery
Silk on an undyed linen ground
h: 13¼ (33.5 cm.); w: 5⅛ in. (13 cm.)
M.73.5.616

This fragment contains a black embroidered
inscription of blessing to the Caliph in Kufic script.

406.
Fragment with an Inscription
Egypt, 10th century
Tapestry weave
Silk on an undyed linen ground
h: 12 in. (30.5 cm.); w: 6¾ in. (17 cm.)
M.73.5.619

This fragment has a red inscription in Kufic script
on a natural ground.

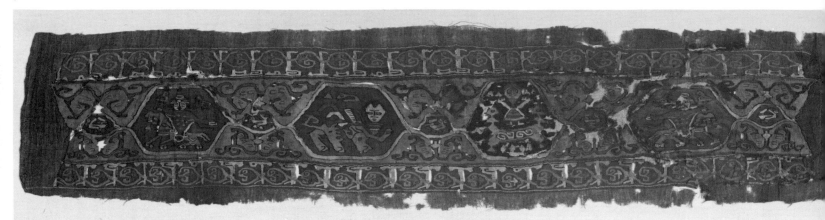

407.
Fragment with Inscription
Egypt, 10th century
Embroidery
Silk on an undyed linen ground
h: 5¾ in. (14.6 cm.); w: 8½ in. (21.6 cm.)
M.73.5.635

This fragment includes an inscription of part
of a Koranic Surah in black on a natural ground.
It reads: "In the name of the God the merciful,
the compassionate, . . . , the blessings of God
be upon . . ."

408.
Fragment with an Inscription
Egypt, 10th-11th century
Embroidery
Silk on an undyed linen ground
h: 5 in. (12.5 cm.); w: 6¾ in. (17.0 cm.)
M.73.5.612

This fragment has an inscription in dark blue
Kufic script on a natural ground; it translates in
part, ". . . in the name of God . . ."

409.
Band
Egypt, ca. 1000 (?)
Tapestry weave
Silk weft, linen warp
h: 8 in. (20.5 cm.); w: 3⅝ in. (9.5 cm.)
M.73.5.624

Alternating green and blue ovals enclose
star-shaped centers consisting of the natural ground.

410.
Tapestry Band (illustrated)
Egypt, ca. 1050
Tapestry weave
Linen and wool weft, wool warp
h: 7¼ in. (18.4 cm.); w: 32⅝ in. (82.8 cm.)
M.73.5.631

Small ovoid medallions enclose grotesque animal
and human figures and alternate with other
small medallions enclosing ducks. Between the two
types of medallions are blue and green arabesques.
Narrow borders with undulating vines which
bear blossoms overlay the Kufic script on a red
ground. Yellow (faded to natural), light
blue, green, and red outlined by dark brown are
used throughout.

411.
Band
Egypt, 11th (?) century
Embroidery
Silk and linen weft, linen warp
h: 10⅝ in. (27 cm.); w: 3½ in. (8.8 cm.)
M.73.5.625

A row of ovals, alternately green and yellow,
are flanked by narrow border stripes with a scrolling
red vine.

412.
Band
Egypt, 11th century
Silk and linen weft, linen warp
h: 9¾ in. (25 cm.); w: 9½ in. (24 cm.)
M.73.5.626

The banded design consists of repeats of rabbits
in green and light blue outlined with black,
and varied geometric motifs in blue and red with
black highlights and outlines.

413.
Band
Egypt, 11th-12th century
Tapestry weave
Silk and linen weft, linen warp
h: 15 in. (38.1 cm.); w: 15 in. (38.1 cm.)
M.73.5.614

A band of quilloche containing rabbits bordered
by stripes with an undulating floral vine decorate
this piece. A second pair of stripes shows an
undulating vine bearing blossoms which overlay
the Kufic script. Green, red, blue, and brown-black
are the background colors. Brown-black outlines
set off the motifs in natural linen or yellow.

414.
Band
Egypt, 11th-12th century
Tapestry weave
Silk and linen weft, linen warp
h: 14⅛ in. (36 cm.); w: 8 in. (20.5 cm.)
M.73.5.617

This fragment has a band of quilloche containing
birds, below which are narrow stripes of circular
motifs, a narrower band of quilloche, and a band of
Naskhi script. Yellow (faded to natural), blue,
and dark brown are used throughout.

415.
Tapestry Fragment
Egypt, about 1100
Silk and linen weft, linen warp
h: 6¾ in. (17 cm.); w: 4¾ in. (12 cm.)
M.73.5.615

The band consists of (blue) ovals containing
birds on a red star, and these alternate with red
medallions containing lamp motifs. Black scroll
work with blue and green highlights decorate
the field which is bordered by narrow stripes of
undulating linen vinework. The borders are
of simulated red Kufic inscriptions and green and
blue leaf scrolls.

416.
Band
Egypt, 1100-1150
Tapestry weave
Silk and linen weft, linen warp
h: 16 in. (40.5 cm.); w: 6⅝ in. (17 cm.)
M.73.5.618

The central field of this fragment shows alternately
affronted birds in blue with red wings, and
bowls of fruit in white outlined with red on a
ground of undyed linen. Bordering the field are
bands of quilloche forming ovoid compartments
that contain linen rabbits and affronted birds
alternately on red and blue grounds. Narrow stripes
of blue leaf scrolls flank the bands.

418.

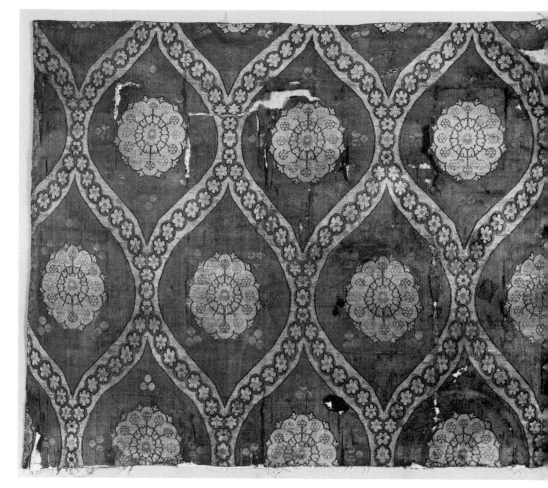

417.
Tapestry Medallion
Egypt, 12th century
Tapestry weave
Silk weft, linen warp
h: 6 in. (15.5 cm.); w: 5¾ in. (14.5 cm.)
M.73.5.638

The circular medallion contains a tan three-headed
eagle in a frontal position on a green ground.
The neck is highlighted in green; the body, in blue.
A small duck stands at the bottom left.

418.
Fragment of a Dress or Furnishing Fabric
(illustrated)
Turkey, 1500
Compound weave, satin ground
Silk, gilt on a yellow silk core
h: 19 in. (48.5 cm.); w: 22¾ in. (57.5 cm.)
M.73.5.668

On this fabric are rosettes enclosed by an ogival
framework composed of a chain of blossoms on a
red ground. The rosette, blossoms, and framework
are gilt outlined with black. Surrounding each
rosette are eight groups of three dots — four in gold
alternating with four in silver.

419.

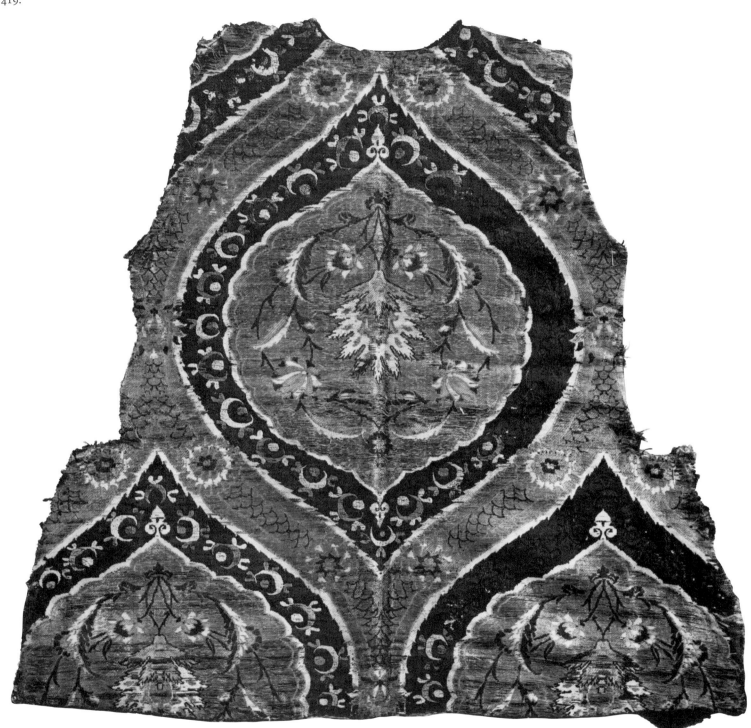

419.
Upper Rear Section of a Coat (illustrated)
Turkey, 1550-1600
Compound weave, satin ground
Silk, gilt on a yellow silk core
h: 20⅛ in. (51.1 cm.); w: 22⅛ in. (56.5 cm.)
M.73.5.627

An all-over ogival network is formed by gold bands
filled with blue, orange, and white floral motifs
and edged with white serrated lines. The
compartments of the network are filled with
gold scalloped medallions edged in white. In the
medallions are central palmettes of white and
orange outlined in blue, and a blue, orange, and
white floral motif. The blue ground between
the bands and the medallions is filled with crescent
and dot motifs. The coat has been cut up-side-down
on a directional fabric so that the palmette motif
is facing down.

420.
Fragment of a Dress or Furnishing Fabric
(illustrated)
Turkey, 1550-1600
Compound weave, satin ground
Silk, gilt on a yellow silk core
h: 24⅛ in. (61.5 cm.); w: 26¼ in. (66.5 cm.)
M.73.5.649

Serrated bands of gold and white create an
all-over ogival network. Each compartment of the
network contains a scalloped gold medallion
filled with blue cloud bands and a centrally placed
gilt palmette. The palmette has abstracted gold
flowers and is edged with black. Each medallion is
surrounded by radiating gold carnations, a stem
of each fitting into one of the scallops.

421.
Fragment of a Dress or Furnishing Fabric
Turkey, 1550-1600
Compound weave, satin ground
Silk, gilt on a yellow silk core
h: 8½ in. (21.6 cm.); w: 15⅝ in. (39.6 cm.)
M.73.5.651

A gold ogival network occurs on a red ground.
Each compartment formed by the network contains
a gold medallion filled with blue and white
cloud bands edged in red. A crescent at one end
of each of the medallions makes the fabric
directional. The gold bands are filled with red,
blue, and white floral motifs. Both the bands and
the medallions are bordered with white scallops
outlined in blue. Both selvages are present.

420.

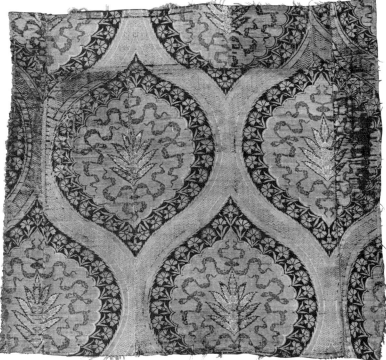

422.

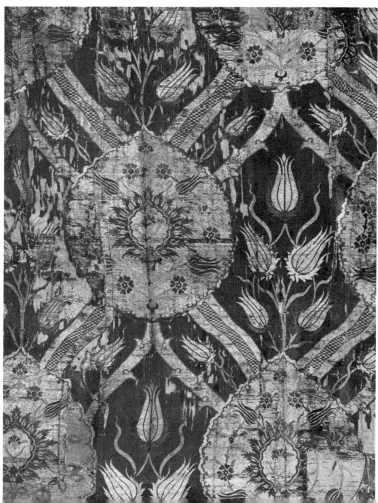

425.

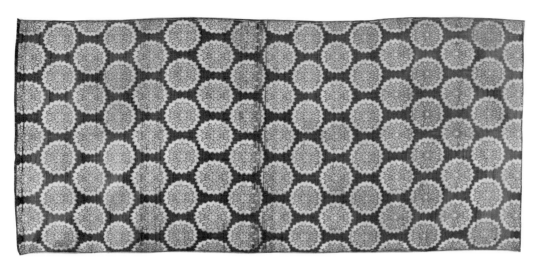

422.
Fragment of a Dress or Furnishing Fabric
(illustrated)
Turkey, 1550-1600
Compound weave, satin ground
Silk, gilt on a yellow silk core
h: 25¾ in. (65.5 cm.); w: 20 in. (51 cm.)
M.73.5.674

The fabric design consists of an all-over ogival network formed by two parallel bands of gold on a red ground. One of the bands resembles a thorned branch and the other has a central checkered stripe. The area between these bands has a white tulip with light green stems and leaves. Each ogival is filled with five white tulips with green and light green leaves and stems. At each intersection of the network is a scalloped gold medallion filled with a central palmette of red and green. Surrounding the palmettes are carnations and tulips of green and red.

423.
Length of Dress or Furnishing Fabric
Turkey, 1550-1600
Compound weave, twill ground
Silk, gilt on a yellow silk core
h: 23¼ in. (59 cm.); w: 26¼ in. (66.5 cm.)
M.73.5.707

The fabric has an all-over pattern composed of regular repeats of a floral unit on a gilt ground. The units have red tulips, pomegranates, carnations, and other conventionalized flowers and leaves accented with white. There are clusters of blue flowers which form a horizontal row across the fabric. Both selvages are present.

424.
Fragment of a Dress or Furnishing Fabric
Turkey, 1575-1600
Compound weave, twill ground
Silk, gilt on a yellow silk core
h: 29½ in. (75 cm.); w: 25½ in. (65 cm.)
M.73.5.669

A regular repeat of alternating rows of white, gilt-edged scalloped medallions filled with gilt tulips, carnations, and other stylized flowers occurs in this fragment. Within the medallions are accents of red and yellow-green. The red ground forms an all-over ogival network.

425.
Fragment of a Dress or Furnishing Fabric
(illustrated)
Turkey, 16th-17th century
Compound weave, satin ground
Silk
h: 58½ in. (148.5 cm.); w: 26½ in. (67 cm.)
M.73.5.667

The fabric has an all-over pattern composed of regular repeats of a circular floral unit which appears in alternating rows. The unit consists of an abstracted blue flower centered on a serrated yellow circle edged with blue. The ground is red. Both selvages are present.

426.
Fragment of a Dress or Furnishing Fabric
Turkey, 16th-17th century
Cut voided velvet
Silk, silver on white silk core
h: 47½ in. (120.5 cm.); w: 13¾ in. (32 cm.)
M.73.5.686

The field consists of regular repeats of a floral motif on a white ground. The primary motif is a stylized symmetrical flower of red, white, green, and silver. The petals are comprised of various stylized flowers. The secondary motif is a smaller stylized flower of the same colors. Two small conventionalized tulips are set between each of the primary floral motifs.

The border along one end and one side is separated from the field by a white stripe edged in red. It consists of a row of the same flower which serves as the primary motif of the field. Between these flowers are two large tulips of red, green, and silver. The arrangement of the border suggests that this fabric might have been combined with three others to form a large furnishing fabric with a complete border. Both selvages are present.

427.
Length of Dress or Furnishing Fabric
Turkey, 16th-17th century
Cut and voided velvet
Silk, silver on a white silk core
h: 76½ in. (194.31 cm.); w: 26 in. (66.04 cm.)
M.73.5.687

The fabric has an all-over pattern composed of
regular repeats of a large fan-shaped carnation in
staggered rows. The carnation is silver on a
red ground. Both selvages are present.

428.
Divan or Cushion Cover (illustrated)
Turkey, 1600-1650
Cut and voided velvet
Silk, gilt on a white silk core
h: 47¼ in. (120 cm.); w: 25 in. (63.5 cm.)
M.73.5.688

The field is filled with alternating rows of large
white fan-shaped carnations outlined in green on a
red ground. The petals of the carnations contain,
alternately, red tulips and carnations with green
leaves. The base of each carnation and two leaves
are silver edged with green and filled with small
red flowers and green leaves. The borders at the top
and bottom of the directional fabric are made
up of six cusped arches filled with red and green
flowers.

428.

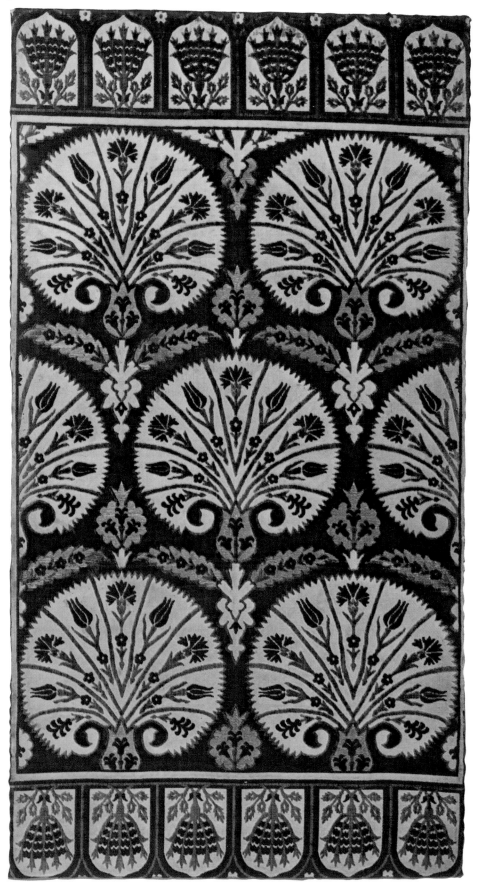

430.

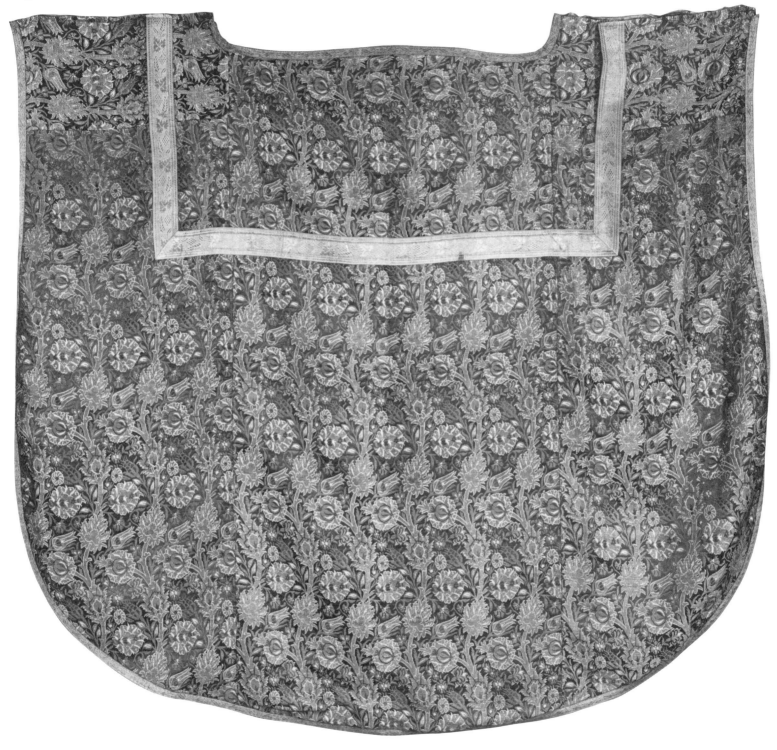

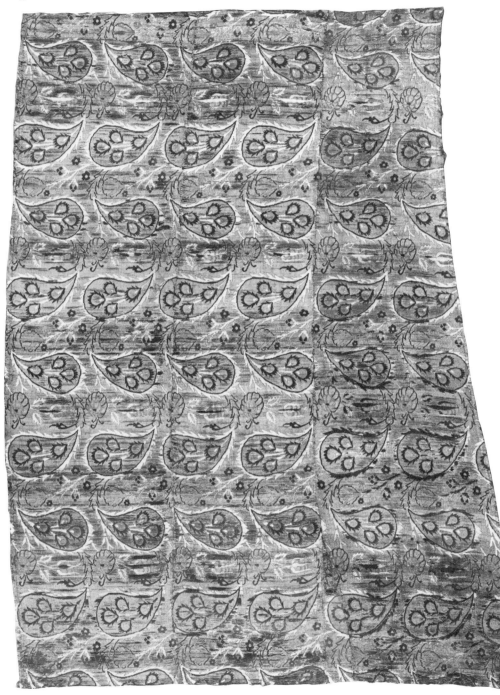

431.

429.
Cushion Cover
Turkey, 1650-1700
Compound weave, satin ground
h: 36 in. (91.5 cm.); w: 24¾ in. (63 cm.)
M.73.5.673

In the field is an ogival network formed by
yellow-green serrated leaves accented with white
on a dark green ground. Within the network
are medallions of conventionalized flowers of light
green, orange, and beige. The border has
an ogival band of light green on a dark green
ground. Each ogive contains a stylized flower which
is alternately orange and beige. The border is
edged with a floral band of yellow-green and dark
green. Both selvages are present.

430.
Cope (illustrated)
Turkey, 17th century
Compound weave, satin ground
Silk, gilt on a yellow silk core
(Border strip — silk, silver on a white silk core;
gilt strips)
h: 54¼ in. (137.7 cm.); w: 62 in. (157.5 cm.)
M.73.5.645

A densely foliated, meandering vinework bearing
several different stylized blossoms occurs in this
cope. The flowers and leaves are gilt outlined
and highlighted with white. Some flowers are also
touched with blue or green.

431.
Fragment of a Dress or Furnishing Fabric
(illustrated)
Turkey, 1775-1800
Compound weave, twill ground
Silk, gilt on a yellow silk core
h: 38½ in. (98 cm.); w: 28¼ in. (72 cm.)
M.73.5.672

This fragment has repeats of alternately facing
palmettes connected by a serrated vinework in green
on a gold ground. Each palmette is outlined by
a serrated edge in white and contains four smaller
palmettes. Interspersed among the palmettes is
(a flower in green outline), a spray with white stem
and green flowers, and a white tulip spray.

432.
Cope
Turkey, 18th century
Compound weave, satin ground
Silk, gilt on a yellow silk core
h: 52 in. (132 cm.); w: 28 in. (71 cm.)
M.73.5.665

On this piece is a dense vinework bearing a variety
of stylized blossoms and leaves against a blue-red
ground. Foliage and flowers are gilt with highlights
in green and outlined with white.

433.
Towel Borders (illustrated)
Turkey, 18th century
Embroidery
Cotton, silk, silver on a white silk core
a.
h: 23½ in. (57.15 cm.); w: 27 in. (68.58 cm.)
b.
h: 25 in. (63.5 cm.); w: 26¼ in. (67.31 cm.)
M.73.5.708 a, b

Gracefully repeating units of delicately arranged
flowers bordered by a narrow band with an
undulating floral stem are embroidered on a natural
ground. The colors used are gilt, silver, white,
light and dark blue.

434.
Panel or Cover
Turkey or Persia (?), 19th century
Embroidery
Gilt on a white core, silk, and cotton on a plain
cotton ground
h: 33 in. (84 cm.); w: 33 in. (84 cm.)
M.73.5.655

This piece is composed of four different pieces.
The field and middle border reveal a common
origin as both use gilt, purple, blue, yellow, white,
and orange to create a design that includes human
figures with elaborate headdresses, houses, and
flowers. The border surrounding the field is
decorated with a geometric pattern of red quatrefoils
enclosed within blue and yellow hexagons
alternating with hourglass figures of red, white,
and black. The outside border is made from two
different stripes, has geometric motifs, one in red,
white, and blue, the other adding green and yellow.

433.

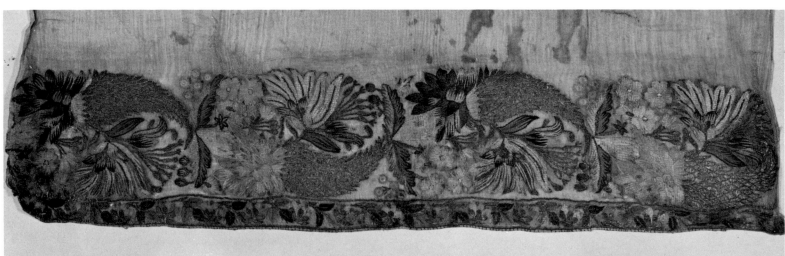

435.
Panel or Cover
Turkey or Persia (?), 19th century
Embroidery
Silk on an undyed linen ground
h: 42½ in. (108 cm.); w: 37½ in. (95.5 cm.)
M.73.5.644

Two floral units composed of different types of blossoms paired diagonally and encircling a center flower are represented here. A border of alternately colored blossoms on an undulating stem surrounds the field. The flowers are blue, red, or purple with yellow highlights, and the stems green or blue-green. An orange fringe has been attached at two ends.

436.
Fragment of a Dress or Furnishing Fabric
Persia, 13th-14th century
Compound weave
Silk
h: 11 in. (27.9 cm.); w: 21½ in. (54.6 cm.)
irregular
M.73.5.611

This fragment has an ogival framework of Kufic lettering enclosing affronted peacocks with arched tail feathers that meet above the birds to form a palmette. The ogival shaped interspaces are filled with addorsed winged sphinxes.

437.
Panel
Persia, about 1550
Compound weave, satin ground
Silk
h: 14 in. (35.66 cm.); w: 52½ in. (133.4 cm.)
M.73.5.691

Depicted on this piece are repeats of a cup-bearer standing by a cypress tree on a yellow-tan ground. He wears a white turban and is dressed alternately in red and yellow with undergarments in green and blue. Completing the landscape are an additional green cypress, a flowering tree with red, white, and blue blossoms, and a fish pond. Nearby are a yellow lion, a spotted white leopard, and a light blue gazelle. Two phoenixes in red, white, and blue appear to have flown past the prince, whose eyes follow them. Other examples of this piece are LACMA M.66.74.1 and The Metropolitan Museum No. 08.109.3.

438.
Fragment of a Dress or Furnishing Fabric
Persia, 1550-1600
Compound weave, satin ground
Silk, gilt on a white silk core
h: 5 in. (13 cm.); w: 4 in. (16 cm.)
M.73.5.640

This fragment with its single lobed medallion depicts a scene in which a man is offered a plate of fruit in a landscape of swaying flowers and trees. Beige, blue, green, and red outlined with brown are used against the gilt ground of the medallion which is placed on a red field.

439.
Carpet
Persia, 16th-17th century
Sehna knot
Wool
h: 42½ in. (110.5 cm.); w: 63¾ in. (162 cm.)
M.73.5.705

Composed of sections of what was originally a larger piece, this carpet is decorated with several kinds of flowers and foliage emerging from a small vase at center bottom. Richly stylized blossoms grow up through the center, and serrated leaves and floral stems form curved arabesques. The border is composed of an undulating stem bearing rosettes and irises interspersed with serrated leaves. Narrow stripes which flank the border have an alternating pattern of leaves and three dots. Red, green, blue, and white are used throughout the piece.

440.
Fragment of a Carpet Border
Persia, 16th century
Sehna knot
Wool
h: 32½ in. (82.5 cm.); w: 23¼ in. (59 cm.)
M.73.5.689

A red palmette motif occurs against a blue ground enriched with scrolling floral stems in this fragment. Contained within the motif is an iris, primarily in blue and brown, and white floral sprays. The light blue guard strip above has an undulating vine and blossom motif, and below is a red motif with stylized blossoms on a green ground.

441.
Fragment of a Dress or Furnishing Fabric
Persia, 1600-1650
Compound weave, satin ground
Silk
a.
h: 41½ in. (105.5 cm.); w: 25½ in. (60.5 cm.)
b.
h: 33¾ in. (86 cm.); w: 12¾ in. (32.5 cm.)
M.73.5.653 a, b

In this piece are gold lobed ogival medallions containing a stylized green and black vine and leaf scrolls, and set off by an ogival framework composed of gold blossoms. The background is green, filled with small black scroll motifs. Both selvages are present.

442.
Fragment of a Cover (?)
Persia, 1600-1650
Embroidered velvet
Silk, silver on a white silk core
h: 40 in. (101.5 cm.); w: 27 in. (68.5 cm.)
M.73.5.657

In the field of this piece is an all-over pattern of lozenges formed by silver serrated leaves on a dark red ground. Each lozenge contains one of a variety of stylized flowers combining silver with orange, purple, blue, yellow, and shades of green. A blue scrollwork alternating with a small silver blossom occurs between the lozenges. Bordering the field are bands of silver curved-leaf ovals with alternating blossoms colored identically to those of the field.

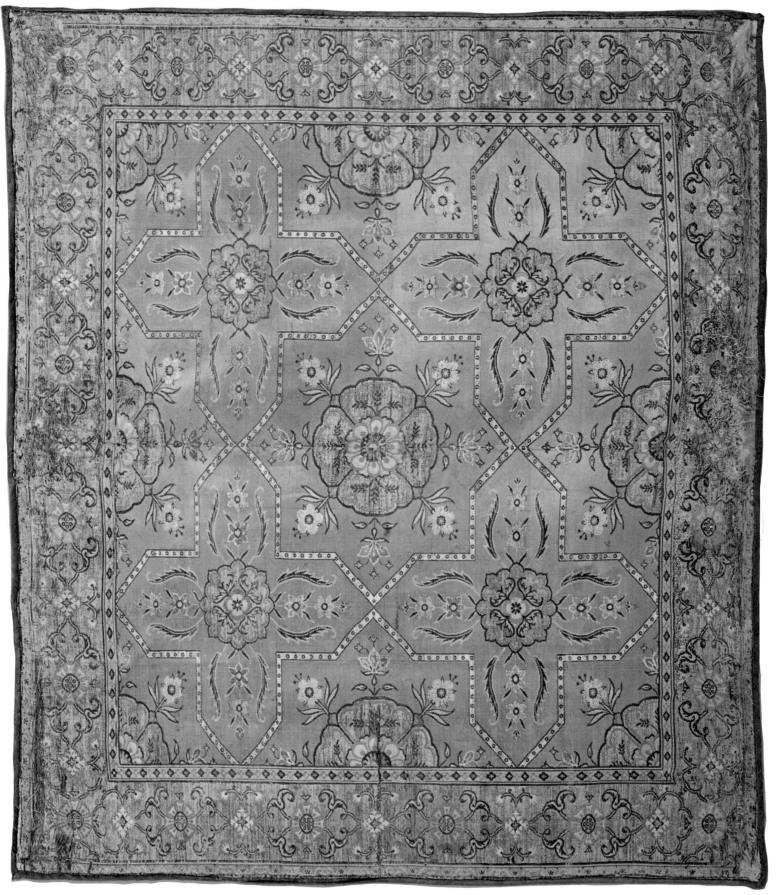

444·

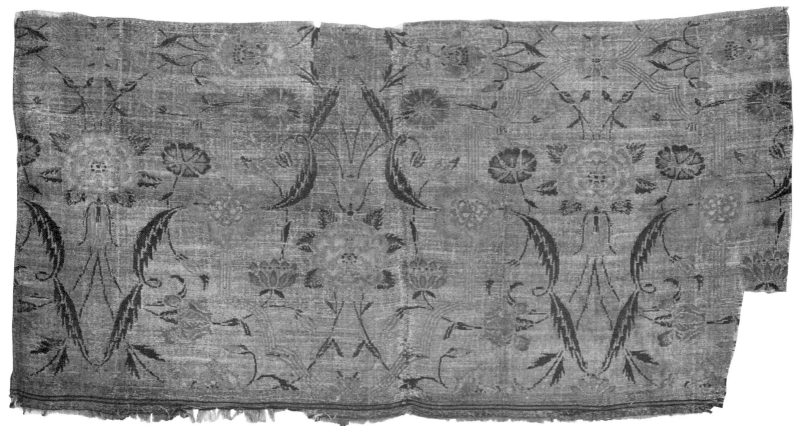

Cover (illustrated)
Persia, 1600-1650
Compound weave, twill ground
Silk gilt on a yellow silk core, silver on a white
silk core
h: 31 in. (79 cm.); w: 26½ in. (67.5 cm.)
M.73.5.658

In this piece large rosettes are centered within an
eight-point star on a field of light orange. Smaller
rosettes are interspersed throughout the star
framework. Pink and orange blossoms with
highlights in blue and gold are centered against the
gilt ground of the rosettes which are touched
in orange and outlined in orange and green-blue.
Eight floral sprays radiate from the large rosettes in
alternating colors of pink and blue outlined
with silver. Sprays with two blossoms in blue and
pink and topped with a blue bud radiate in four
directions from the smaller rosettes. The border is
flanked by two narrow stripes with alternating
blue and orange blossoms on a pastel green ground
and on an undulating vine of light green bearing
blossoms alternately of white outlined with light
blue and pink outlined with orange against a gilt
ground. The formalized pattern of the central field
appears to extend beneath the borders of the
frame. As it is not cut, what appears suggests a
more enduring, perhaps even an infinite pattern.

444.
Fragment of a Dress or Furnishing Fabric
(illustrated)
Persia, 1600-1650
Compound weave, twill ground
Silk, silver on a white silk core
h: 9¼ in. (23.5 cm.); w: 18½ in. (47 cm.)
M.73.5.678

A graceful design of scrolling blue lancelot leaves
and stems bearing a variety of blossoms and
buds decorates this fragment. An orange arabesque
framework balances the curves of the leaves.
Rose blossoms, carnations, and various unidentified
flowers at center are shaded with silver, yellow,
orange, pink, and tan and have blue centers. Other
blossoms, including an iris and a lotus, are
silver and shades of brown or light and dark blue
with orange highlights. The ground is silver.
The left selvage and beginning header stripe are
present.

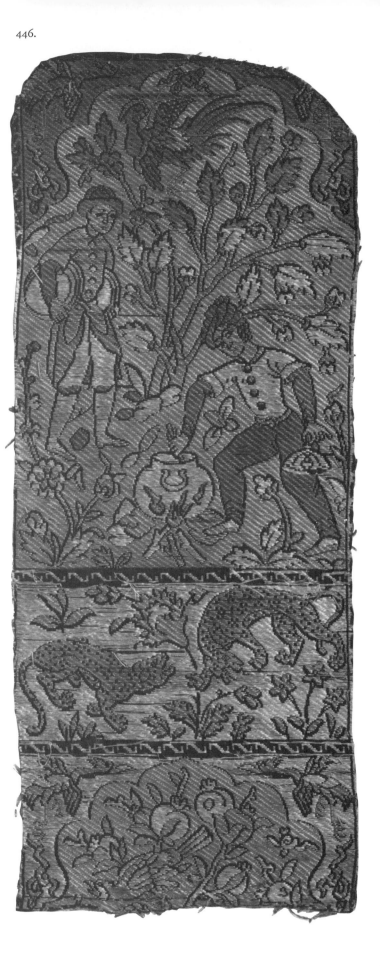

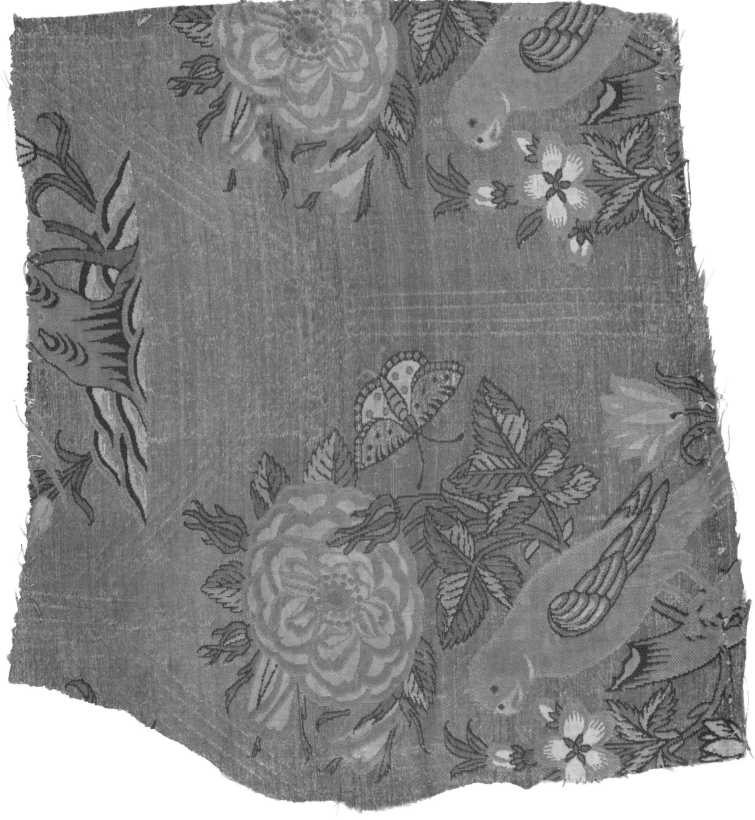

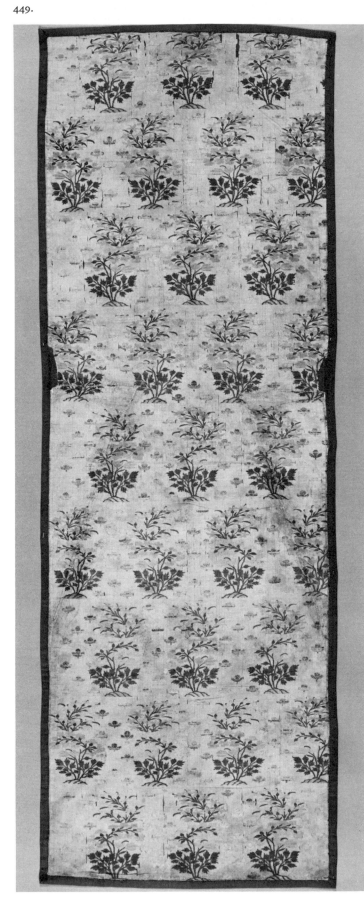

445.
Trimming Band
Persia, 1650-1700
Brocaded compound weave
Silk, silver on a white silk core
h: 2⅞ in. (7.3 cm.); w: 29⅜ in. (74.6 cm.)
M.73.5.633

An undulating vine bearing four different blossoms
in lavender with green leaves decorates this band.
All are outlined with blue and placed on a silver
ground. On the guard stripes are undulating vines
bearing orange blossoms and green leaves
alternately.

446.
Fragment (illustrated)
Persia, 1650-1700
Compound weave, twill ground
Silk
h: 9 in. (22.8 cm.); w: 3½ in. (8.9 cm.)
M.73.5.637

This fragment was one of many compartments
that were part of a larger piece in the Victoria and
Albert Museum. On it is a scene with figures
in a landscape of flowers and trees and a phoenix
flying above. The ground is beige; the figures
and foliage shades of green, brown, purple, and
pink. Below is a band with two beasts
in pink and blue-grey, cavorting on a flowered
pastel green ground. A section of another figured
panel begins below.

447.
Fragment of a Dress or Furnishing Fabric
(illustrated)
Persia, 1650-1700
Brocaded compound weave
Silk, gilt on a yellow silk core, silver on a white
silk core
Stamped
h: 9⅛ in. (23.2 cm.); w: 8¼ in. (21 cm.)
M.73.5.642

Depicted on this fragment is a parakeet perched on
a rose bush with a butterfly above. The ground
is gilt. The bird is in shades of orange and
lavender-pink with the beak and neck highlights
in yellow. The eyes are blue-green outlined in
gilt, and the wing feathers yellow and green
outlined in blue-green. The bird is perched on a
brown stump which has yellow and blue-green
highlights and grows from a mound of silver, white,
and blue-purple. Tulips in white, outlined by
blue-purple, and yellow, outlined with orange and
lavender-pink, grow at each side. The rose
blossoms above and the unidentified flower in the
center are combinations of white, orange, and
lavender-pink with green and silver highlights. The
leaves are yellow and green outlined in blue-green.
The butterfly alone has a yellow and green body,
silver and white wings, is outlined with blue-green,
and has highlights in lavender-pink. A stamped

hexagonal pattern frames each motif. Probably
the fragment is based on a design by Shafi-i-Abbasi.

448.
Fragment of a Dress or Furnishing Fabric
Persia, 1650-1700
Compound weave, satin ground
h: 26 in. (66 cm.); w: 27¼ in. (69.2 cm.)
M.73.5.648 a, b

This fragment has alternating rows of delicately
drawn floral plants on a silver ground. The large
single blossom is orange and light and dark blue
touched with silver; the smaller blossoms are
orange and yellow with green-blue highlights. The
foliage of both plants is light green outlined in
green-blue. Both selvages are present.

449.
Fragment of a Dress or Furnishing Fabric
(illustrated)
Persia, 1650-1700
Brocaded plain weave
Silk, silver on a yellow silk core
h: 47½ in. (120.5 cm.); w: 15½ in. (39.5 cm.)
M.73.5.666 a, b

On this piece are regular repeats of a gracefully
swaying naturalistic plant on a light blue ground.
The blossoms and mound are pink-orange, the stem
and leaves green. Small leaf sprays of silver are
placed diagonally across the field.

450.
Fragment of a Dress or Furnishing Fabric
Persia, 1650-1700
Compound satin weave
Silk gilt on a yellow silk core, silver on a blue
silk core
h: 30¾ in. (91 cm.); w: 22¾ in. (58 cm.)
M.73.5.671

A staggered repeat of stylized flowers and sprays
are so arranged that the curve of the stem creates
undulating lines diagonally across the textile.
The prominant flowers are either gilt or silver. Both
are highlighted in orange, which is also used for
the leaves and smaller blossoms. All colors are
outlined in a brown slightly darker than that of the
background.

453.

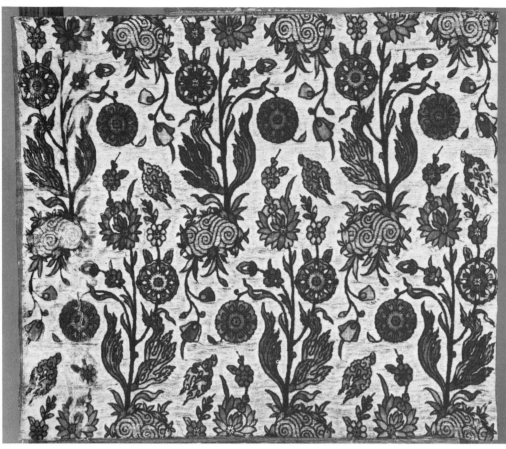

454.

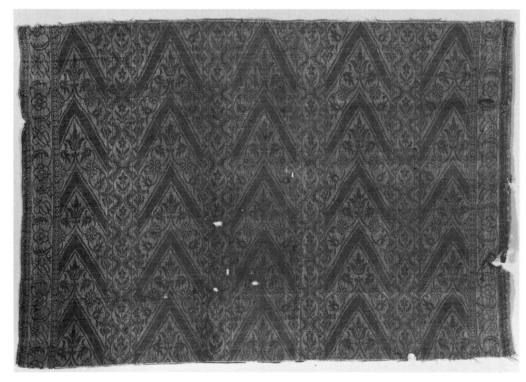

451.
Fragment of a Tomb Cover
Persia, 1675-1700
Compound plain weave
Silk
h: 27¼ in. (69 cm.); w: 17½ in. (44.5 cm.)
M.73.5.683

Several Naskhi inscriptions in blue on white and
yellow grounds and in shades of red occur on
this fragment. The vertical stripes repeat the words:
"Oh, the martyred Hussein." The cartouche
above the red panel contains the beginning of a
Koranic Surah, and the four cartouches at the
right repeat the names of the three deputy prophets
of the Shiite sect: "Ali, Hassam, Hussein."

452.
Fragment of a Dress or Furnishing Fabric
Persia, 1675-1700
Brocaded compound weave, twill ground
Silk, gilt
h: 11½ in. (29 cm.); w: 11 in. (28 cm.)
M.73.5.681

Repeated on this fragment is a symmetrical plant on
a ground of yellow originally interwoven with
gilt wefts. Many different floral blossoms appear on
the same plant in white or light pink outlined
with dark pink. The light green leaves are outlined
with dark green.

453.
Fragment of a Dress or Furnishing Fabric
(illustrated)
Persia, 17th century
Brocaded cut voided satin velvet
Silk, silver on a white silk core
h: 22⅜ (57 cm.); w: 26¼ in. (67 cm.)
M.73.5.610

A flowering plant growing from the edge of a
pond is repeated on this fragment. The varied
blossoms and leaves combine orange, green, grey,
and tan – all outlined in black. The pond is
silver, and the background, now tan, was originally
gold.

454.
Fragment of a Tomb Cover (illustrated)
Persia, 17th century
Compound plain weave
Silk
h: 13¼ in. (33.5 cm.); w: 19¾ in. (49.5 cm.)
M.73.5.664

The field consists of two alternating stripes, one
of vertically placed flowering plants and one
of chevrons and an undulating vine. Two guard
stripes at each selvage are decorated with an
undulating vine with blossoms. The two colors,
green-blue and gold, are reversible from one
side of the textile to the other.

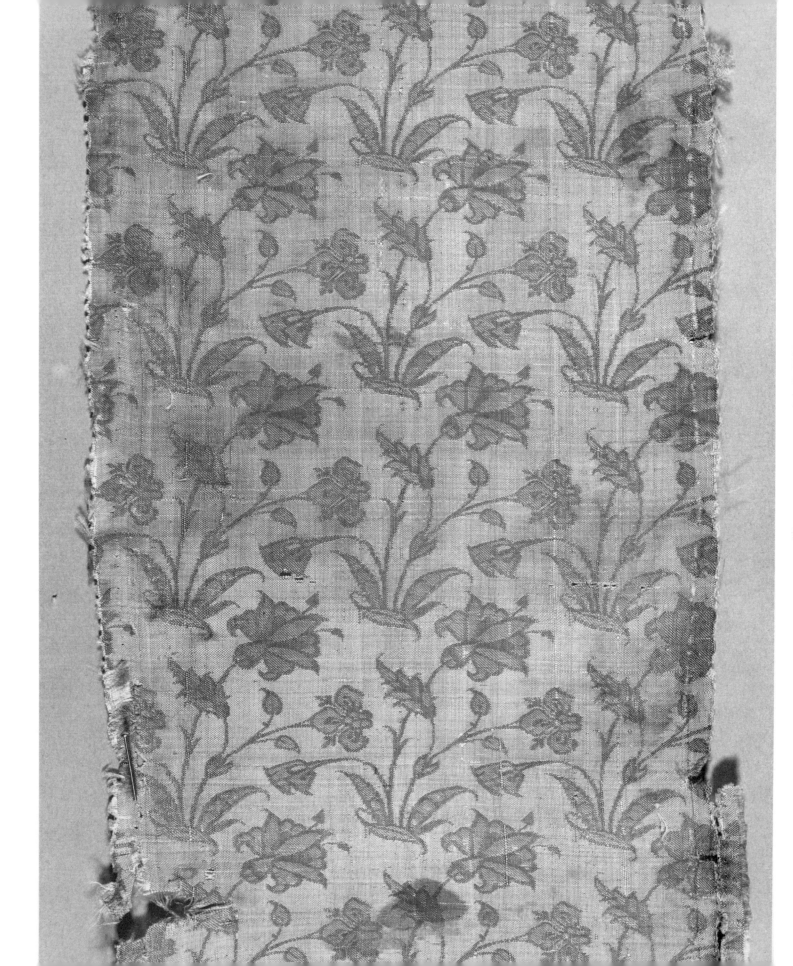

456.

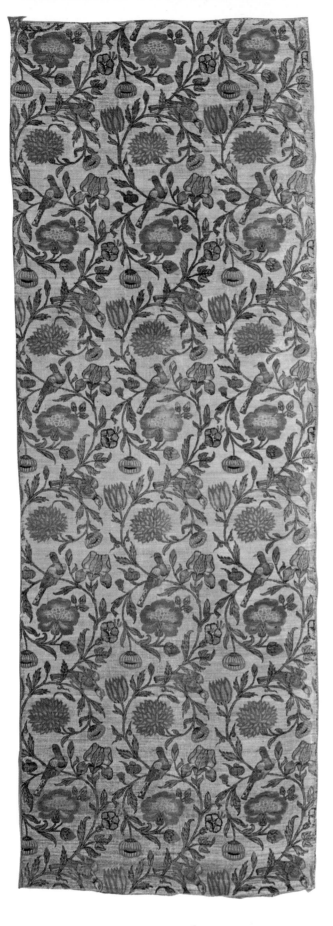

455.
Fragment of a Dress or Furnishing Fabric
(illustrated)
Persia, 17th century
Double cloth
Silk
h: 11¾ (30 cm.); w: 5½ in. (14 cm.)
M.73.5.680

Closely packed repeats of a floral plant in brown
on a green ground occur on this fragment in which
the colors are reversed on the opposite side.

456.
Fragment of a Dress or Furnishing Fabric
(illustrated)
Persia, 17th century
Brocaded compound weave
Silk, silver on a white silk core
h: 59½ in. (151.13 cm.); w: 20½ in. (52.07 cm.)
M.73.5.783

This fabric shows a meandering vine with flowers,
parakeets, and other birds. The ground is silver.
The flowers are in shades of pink, orange, grey, and
blue; the birds are in pink and grey, some with
light blue highlights. The foliage is light green
outlined in dark green.

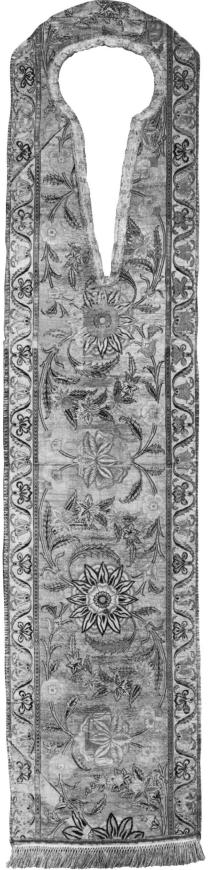

457.
*Originally a Wide Border Made Into an
Ecclesiastical Garment* (illustrated)
Persia, 17th century
Brocaded compound weave, twill ground
Silk, silver on a white silk core, gilt on a yellow
silk core
h: 57¾ in. (146.5 cm.); w: 13¼ in. (33.5 cm.)
M.73.5.701

In the field are undulating stems of light
yellow-green and green outlined with blue-green.
They bear large stylized blossoms centrally placed
against a gilt ground. Leafy sprays alternately
bearing pink and orange blossoms bud from
light blue and silver leaf mantles. Yellow and
orange blossoms bud from blue and silver leaf
mantles. The central flowers are composites: one
combines petals of silver and blue, orange and
white, and yellow and orange; the other — in the
form of a rosette — places an orange and white
blossom with a gold and green center upon
radiating petals of blue and silver with yellow
and orange lobed petals seen below. The layered
use of contrasting color gives this blossom a
particular prominence in the field. Narrow borders
along the edge have an undulating vine of
serrated leaves in the same green as the central
field. The other bears alternately an iris of white
and blue and a white lily on an orange ground with
highlights in light and dark blue.

458.
Fragment of a Tomb Cover (illustrated)
Persia, 1675-1700
Compound plain weave
Silk
h: 27¼ in. (69 cm.); w: 17½ in. (44.5 cm.)
M.73.5.683

This piece shows varied Naskhi inscriptions in blue
on white and yellow grounds and in shades of
red. The vertical stripes repeat the words, "Oh, the
martyred Hussein"; the cartouche above the red
panel contains the beginning of a Koranic Surah,
and the four cartouches at the right repeat the names
of the three deputy prophets of the Shiite sect,
"Ali, Hassam, Hussein."

459.
Portion of a Sash
Persia, ca. 1700
Brocaded compound weave
Silk, silver and gilt
h: 66½ in. (160.9 cm.); w: 22½ in. (50.7 cm.)
M.73.5.646

The field is composed of three wide stripes decorated
with an all-over pattern of small dentate leaves
in gilt on an alternately blue and brown ground.
At one end there is a rectangular panel with
a row of five plants that have alternating blossoms
(carnations?) of white and orange, and pink and
orange outlined with lavender-pink. Each plant also
bears a blue blossom with orange center and
yellow and green leaves outlined with brown.
Narrow borders with undulating stems bearing
carnations in white and blue-grey outlined with
brown, roses in shades of orange and pink, and
varied blossoms in shades of blue, white, and grey
divide the stripes of the field and run along the
outer edges of the sash and also along the inner
edge of each panel. (The ends are trimmed with an
applied fringe of gilt yarn.) That the sash was
worn folded in half accounts for the fact that the
halves of the field face in opposite directions.

460.
Fragment of a Dress or Furnishing Fabric
Persia, ca. 1700
Brocaded compound weave, twill ground
Silk, gilt and silver on a white silk core
h: 41 in. (106.7 cm.); w: 55 in. (139.7 cm.)
M.73.5.647 a, b, c

On this fabric are closely packed repeats of
symmetrical flowers arranged vertically against a
ground of silver. Three different blossoms are
illustrated, each alternately using shades of blue,
pink, orange, and brown with highlights in silver.
The foliage is green-yellow outlined in blue-green,
and the vase, gilt with highlights in pink,
green-yellow, and blue-green. The fabric is pieced,
with some selvages present.

461.
Fragment of a Dress or Furnishing Fabric
Persia, ca. 1700
Brocaded warp-faced plain weave
Silk, silver on a green-yellow silk core
h: 38¼ in. (197 cm.); w: 15¼ in. (38.5 cm.)
M.73.5.699

A stylized floral motif in the form of a tree occurs
on a blue-green ground in this fragment. The
many petals of the blossoms are orange and grey
(originally purple); the trunk and leaves are
black. Petals, leaves, trunk, and mound are all
outlined with silver.

458.

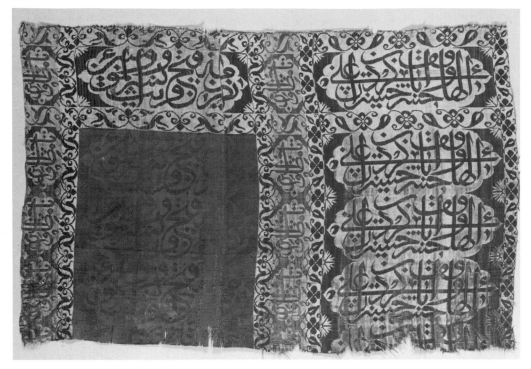

462.
Fragment of a Dress or Furnishing Fabric
(illustrated)
Persia, 17th-18th century
Brocaded compound weave, twill ground, stamped
Silk, silver on a white silk core
h: 28¾ in. (73 cm.) ; w: 8¾ in. (22.5 cm.)
M.73.5.643

On this fragment are sprays of three different
flowers and foliage tied together with a yellow and
orange bow. The blossoms are light pink outlined
with dark pink, light blue outlined with dark
blue, and yellow and orange — all are touched with
blue, white, and silver. A pattern of vertical
lines occurring at half inch intervals was stamped
on after completion.

463.
Fragment of a Dress or Furnishing Fabric
(illustrated)
Persia, 18th century
Brocaded warp face plain weave
Silk, silver on a white silk core
a.
h: 31 in. (78.7 cm.) ; w: 10⅝ in. (27 cm.)
b.
h: 30¾ in. (78 cm.) ; w: 7 in. (18 cm.)
M.73.5.634 a, b

Repeated on this fragment on a light orange
ground are highly decorative plants with a variety of
floral blossoms appearing on each of them.
Two color patterns alternate: one is light and
dark blue with pink and yellow-green; and the other
is pink and brown, with light blue and brown.
In both cases the stem and leaves are green. Small
leaf sprays of silver decorate the field.

464.
Fragment of a Dress or Furnishing Fabric
(illustrated)
Persia, 18th century
Brocaded compound weave, twill ground
Silk
h: 47½ in. (120.65 cm.); w: 12¾ in. (32.39 cm.)
M.73.5.656

A simple, but clear, all-over pattern of floral sprigs
is arranged in rows on a blue ground. The blossoms
are alternately white or yellow with orange,
the leaves yellow outlined in green.

462.

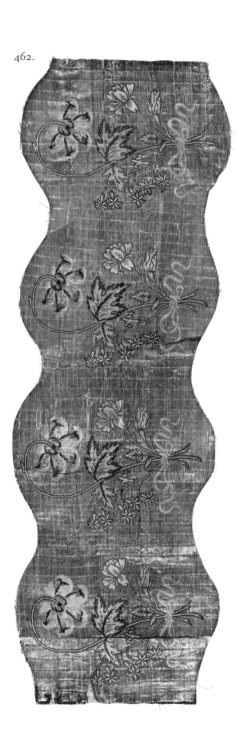

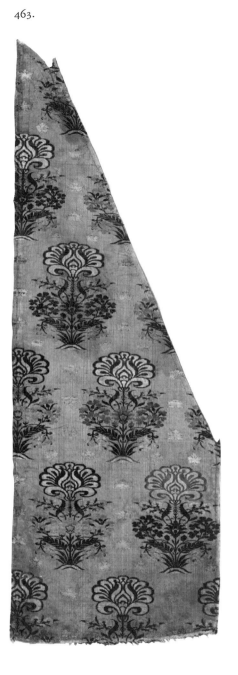

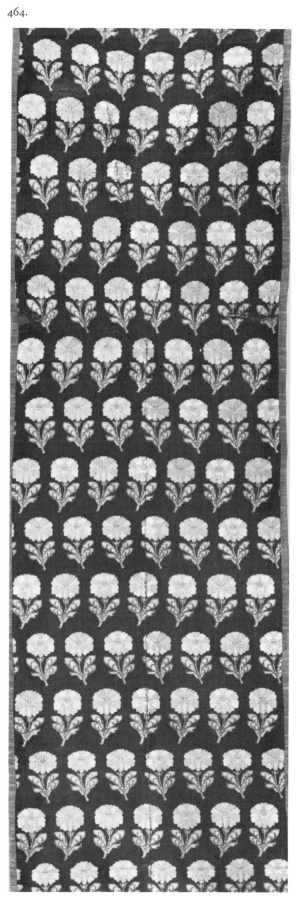

465.
Fragment of a Dress or Furnishing Fabric
Persia, 18th century
Brocaded plain weave
Silk, silver on a yellow silk core
a.
h: 17¼ in. (43.5 cm.); w: 13¾ in. (35.5 cm.)
b.
h: 24⅝ in. (62.5 cm.); w: 7 in. (18 cm.)
M.73.5.659 a, b

This piece has repeats of a stylized floral motif in
the form of a tree on a pink-orange ground.
The single iris at top, central flowers, and mound
are alternately white and blue, white and brown.
The leaves are blue-green. Flowers, leaves, trunk,
and roots are all outlined with silver.

466.
Fragment of a Dress Fabric
Persia, 18th century
Brocaded warp faced plain weave
Silk, silver on a white silk core
h: 14¾ in. (37.57 cm.); w: 15 in. (38.1 cm.)
M.73.5.660

On this piece are repeats of a stylized floral motif
in the form of a tree on a red-brown ground.
The two larger blossoms, the lower leaves, and
trunk are white (originally silver) as are the small
leaf sprays (palmettes?) scattered at regular
intervals through the field. Other blossoms, stem,
mound, and highlights are silver, blue, orange,
pink, and yellow. This horizontal arrangement of
the brocaded color has an economic function and
appears in textiles from the eighteenth century on.

467.
Fragment of a Dress or Furnishing Fabric
Persia, 18th century
Brocaded satin weave
Silk, gilt on a yellow silk core
h: 25¾ in. (65.5 cm.); w: 8 in. (20 cm.)
M.73.5.661

This piece has repeats of a poppy plant on an
orange ground. The blossoms are white and black,
the leaves green. Both are outlined with gilt.

468.
Fragment of a Dress or Furnishing Fabric
(illustrated)
Persia, 18th century
Brocaded satin weave
Silk, gilt on a yellow silk core, silver on a white
silk core
h: 32¾ in. (83.5 cm.); w: 28 in. (71 cm.)
M.73.5.670

Silver cones alternately face rows against a brown
ground on which gilt vines bearing naturally
drawn blossoms meander vertically through the
fabric. Contained within the cones is a plant bearing
blossoms of orange, lavender-pink, and silver
with green center highlights. The leaves are green
and yellow outlined with green. A bird is perched
on one of the lower leaf stems. His gilt body is
outlined by pink with green and yellow highlights;
the tail feathers gilt outlined with green; the
wings yellow and silver outlined by pink, and yellow
outlined by green. The arrangement of the bird
in the flowering tree is related to the work
of Shafi-i-Abbasi, discussed in cat. no. 447. The
scale discrepancy between the bird and the
blossoms and the placement of this motif within
another give it the feeling of a later date. Still
more important is the background vine, which
makes the palmette seem to float above in space.
This fragment is more typical of European
than of Persian textiles of the eighteenth century,
and, indeed, the design concept may have had a
European inspiration.

469.
Fragment of a Dress Fabric
Persia, 18th century
Brocaded warp faced plain weave
Silk, silver on a green-yellow silk core
a.
h: 25¼ in. (64 cm.); w: 10¼ in. (26 cm.)
b.
h: 32 in. (81.5 cm.); w: 18 in. (46 cm.)
c.
h: 25¼ in. (64 cm.); w: 10¼ in. (26 cm.)
M.73.5.676 a, b, c

On this piece is repeated a stylized floral motif in
the form of a tree on a light green ground.
Petals of the flowers are alternately white and
purple, white and pink. The roots are pink and **the**
trunk and leaves green. Petals, leaves, trunk, and
roots are outlined with silver.

470.
Fragment of a Dress or Furnishing Fabric
Persia, 18th century
Compound weave, twill ground
Silk, silver on a white silk core
h: 33¼ in. (84.5 cm.); w: 35¾ in. (91 cm.)
M.73.5.679

A stylized floral spray is repeated in staggered
rows on a silver ground with an all-over pattern of
white palmettes. The blossoms are orange and
yellow with yellow leaves; all are outlined in
dark green-blue.

471.
Fragment of a Dress or Furnishing Fabric
Persia, 18th century
Compound weave
Silk, silver on a white silk core
h: 47¾ in. (121.5 cm.); w: 15¾ in. (40.5 cm.)
M.73.5.682

Within the dense pattern of this fabric is a
gracefully meandering vine bearing roses in shades
of orange and pink and a honeysuckle in shades
of blue and silver, and pink and silver. The ground
is silver, and the leaves green and yellow,
outlined with black.

472.
Fragment of a Dress or Furnishing Fabric
Persia, 18th century
Brocaded compound weave, twill ground
Silk, gilt on an orange silk core
a.
h: 13⅜ in. (34 cm.); w: 12 in. (30.5 cm.)
b.
h: 7½ in. (19 cm.); w: 12 in. (30.5 cm.)
M.73.5.684 a, b

Floral sprays composed of several different flowers
occur in alternating rows in this fragment. From
alternately blue and white mounds grow pink
and brown tree trunks and a branch of blossoms in
pink and orange. A single iris of white and
grey outlined in brown is found in the center. All
the foliage is yellow and green, and the ground
is gold.

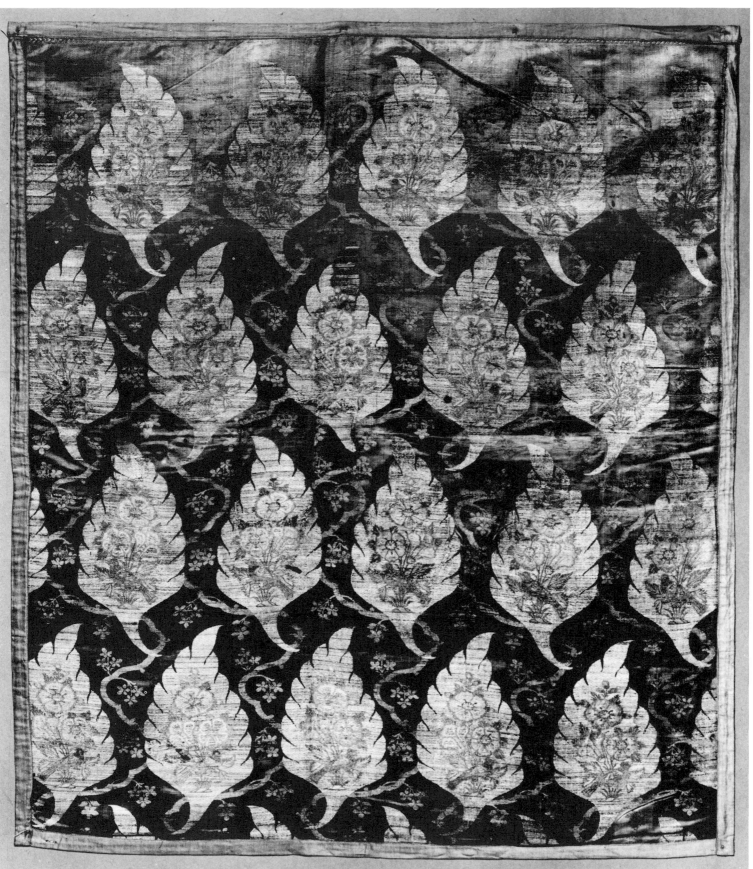

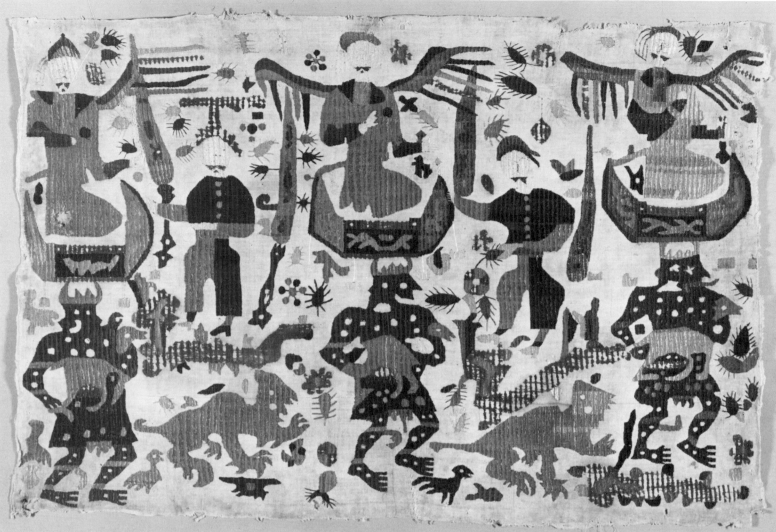

473.
Sash
Persia, 18th century
Compound weave
Silk, silver on a white silk core, gilt on a yellow
silk core, gilt vine
h: 168 in. (427 cm.); w: 23 in. (58.5 cm.)
M.73.5.706

The field is decorated with two narrow bands.
One has an undulating floral vine bearing blossoms
in shades of pink, blue, white, and grey, and the
other a red medallion. Both are on a gold ground.
At each end there is a rectangular panel with
five cusped medallions enclosing wreaths of silver
and pink blossoms and yellow and green leaves.
Within the wreaths an ogival leaf medallion
encloses an outwardly radiating arrangement of
blue flowers outlined in gold on a silver ground.
Narrow borders with an undulating stem — bearing
blossoms colored with the same shades of blue,
pink, white, and grey as those of the bands of the
field — run along the outer edges of the sash and
also along the inner edge of each panel.

474.
Panel or Hanging (illustrated)
Persia, 18th-19th century
Embroidery
Silk on a linen ground
h: 37¼ in. (94.5 cm.); w: 24½ in. (62 cm.)
M.73.5.650

This panel presents a repeat of four figures:
a seated winged figure in Persian dress, a standing
figure in Persian dress, a grotesque figure carrying
a small animal, and a strange quadruped.
Different kinds of insects are scattered throughout
the piece. White, gold, red, blue, and green are
used against a natural ground. It is possible that this
piece depicts a magical dance.

475.
Fragment of a Dress or Furnishing Fabric
Persia, 1775-1800
Compound plain weave
Silk, gilt on a natural silk core
h: 24 in. (60 cm.); w: 20 in. (51 cm.)
M.73.5.662

Two floral (poppy?) plants are repeated in
alternate rows framed by an ogival lattice formed
of leaves on a brown ground that was originally
gilt. The rows of blossoms were alternately orange
and white, and pink and white, outlined in brown;
the foliage is green outlined with brown.
One selvage is present.

476.
Fragment of a Dress or Trouser Fabric
Persia, about 1800
Compound plain weave
Silk, gilt on a natural silk core
h: 23¼ in. (59 cm.); w: 20 in. (57 cm.)
M.73.5.685

In this piece stripes with units of affronted birds
and floral blossoms on a silver ground alternate with
double stripes of blossoms on a blue-green
ground. The birds are blue with orange beaks and
wings; the blossoms orange touched with blue,
and the leaves blue. The paired stripes have repeats
of an orange blossom with blue stem and leaves
outlined with silver on a blue ground.

477.
Shirt
Persia, about 1800
Brocaded plain weave
Silk, gilt on a yellow silk core, silver on a white
silk core
h: 62 in. (157.5 cm.); w: 37 in. (94 cm.)
M.73.5.693

This shirt *(qamis)* is adorned with a front panel
of rows of alternating carnations and iris plants
separated by small gold dots and rows of
blossom-and-leaf motifs on a light blue ground.
The carnation blossoms are white outlined in
orange, light pink outlined in dark pink, and
lavender outlined in dark grey. The leaves are gilt
outlined in green. The iris plant and dots are
gilt on a yellow core; the blossom gilt, and the leaf
silver on a white core. The border at the collar
has an undulating vine with flower and leaf motifs
in orange, blue, and gilt; the hem border has
a vine with lotus and tulips in grey and pink on a
gilt ground. Narrow bands of chevrons in green
and yellow flank the hem border.

478.
Panel of a Dress or Furnishing Fabric
Persia, 19th century
Brocaded twill weave
Silk, gilt on a yellow silk core
h: 41½ in. (104 cm.); w: 39 in. (99 cm.)
M.73.5.677

The panel has an all-over pattern of floral cones
on a gilt ground. A border of blossoms and leaves in
red, white, and blue frames a central spray of
blossoms of the same colors. Green and white
highlights outline the cone.

479.
Rug
Caucasus, 19th-20th century
Soumak brocade on a plain weave ground
Wool
h: 83 in. (211 cm.); w. 74 in. (188 cm.)
M.73.5.690

On both the red field and the blue border of this
piece is a motif consisting of rows of camels,
in rows probably representing a caravan. The border
also has different types of varied smaller animals
as well as geometric forms. Throughout the piece
red, blue, white, yellow, and brown are used.

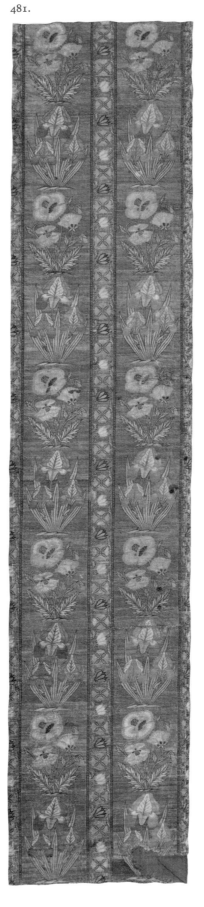

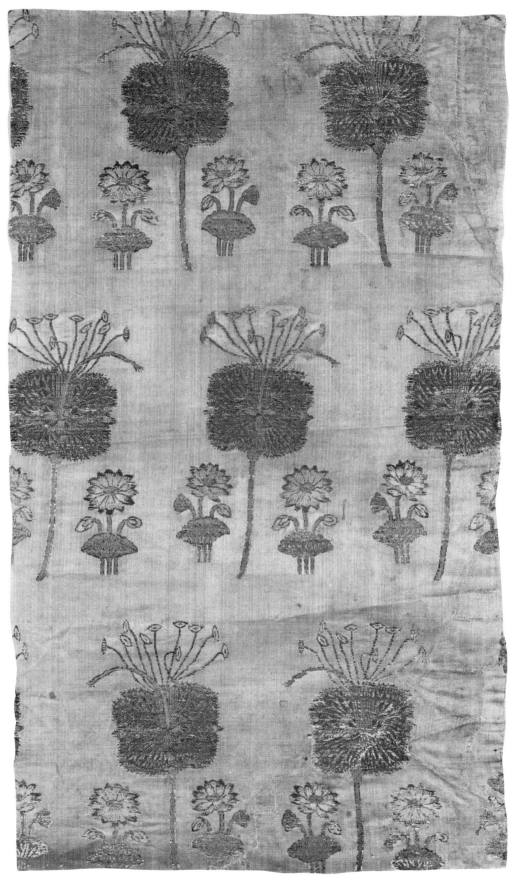

480.
Portion of a Sash
Persia or Armenia, 18th century
Brocaded compound weave
Silk, gilt on a yellow silk core and silver on a white
silk core
h: 90 in. (228.5 cm.); w: 24⅜ in. (62 cm.)
M.73.5.695

The field is orange decorated with an all-over
design of stylized gold flowers partially outlined in
dark brown. At one end of the field is a rectangular
panel with a row of five composite floral
arrangements including carnations, roses, and
irises on a gold ground. The blossoms are orange
with lavender-pink outlines, grey and silver
touched with blue or yellow and outlined in dark
brown. The leaves are yellow outlined in green.
Narrow borders with an undulating stem bearing
blossoms colored like those in the panels and
on a gold ground run along the outer edges of the
sash and also along the inner edge of the end panel.

481.
Banded Fragment (illustrated)
Persia or India, 1650-1700
Brocaded compound weave, twill ground
Silk, gilt on a white silk core
h: 54 in. (137 cm.); w: 11¼ in. (28.5 cm.)
M.73.5.709

Vertical repeats of an iris and a poppy plant
alternate on the silver ground of this fragment.
The poppy is in shades of pink with blue and
green center highlights, and the iris light lavender
and pink outlined with grey. Both have light
green leaves. On the guard stripes blue, pink, and
yellow blossoms alternate on an undulating
vinework in light green against a ground of silver.

482.
Fragment of a Dress or Furnishing Fabric
(illustrated)
Persia or India, 1675-1700
Brocaded satin weave
Silk, gilt on a white silk core
h: 21 in. (53.3 cm.); w: 11⅞ in. (30.2 cm.)
M.73.5.632

This piece has a rhythmic quality which results
from the angle of the dominant purple-red flower
with swaying orange-tipped stamen on a green
ground. At each side are small flowers with a
blossom and one or two buds in orange. Stems,
leaves, and blossom centers are dark green.
All the colors are outlined with gilt.

483.
Fragment of a Dress or Furnishing Fabric
Persia or India, 1775-1800
Brocaded satin weave
Silk, gilt on a yellow silk core
a.
h: 28 in. (71 cm.); w: 5¾ in. (14.5 cm.)
b.
h: 18 in. (46 cm.); w: 7 in. (18 cm.)
M.73.5.663

Repeats of a cone motif and a floral spray occur
alternately in rows against a dark blue ground. The
cone, outlined in gilt, contains a compact
arrangement of red and blue flowers also outlined
in gilt. The sprays are completely of gilt.

484.
Length of Dress or Furnishing Fabric
Persia or India, 18th century
Brocaded and stamped plain weave
Silk
h: 14⅝ in. (37 cm.); w: 15⅛ in. (38.4 cm.)
M.73.5.629

On this fragment are rows of small floral sprigs
with white flowers and green leaves outlined in red.
Above each sprig is a yellow design outlined in
dark green. The beige ground presents a secondary
pattern of stamped lozenges.

485.
Fragment of a Dress or Furnishing Fabric
Persia or India, 18th century
Brocaded satin weave
Silk, gilt on a yellow silk core
h: 14¾ in. (38 cm.); w: 14⅝ in. (37 cm.)
M.73.5.675

This piece has an all-over pattern consisting of
a floral sprig on a purple-red ground. The yellow
blossoms and the green-blue stems and leaves
are both outlined with gilt. The fabric is bordered
by a trimming band of a later date which is
decorated with an undulating vine in blue that
bears blossoms in orange, brown, and purple
on a gilt ground.

486.
Sari (?)
India, date unknown
Field, block printed; border, block-resist and
dye-painted
Cotton
h: 67¼ in. (171 cm.); w: 34 in. (186.5 cm.)
M.73.5.694

The field of this piece consists of an all-over floral
. pattern in brown on a natural ground. The red
border framing the field has a lozenge pattern. On
the end borders circles and an undulating stem
bearing stylized leaves are repeated.

487.
Hanging or Cover (illustrated)
India, 1650-1700
Cut voided velvet, twill ground
Silk, silver on a white silk core, gilt on a yellow
silk core
h: 49 in. (124.5 cm.); w: 26½ in. (93 cm.)
M.73.5.703

Upon the field of this hanging are scrolling
stems and flowers encircling a medallion of stylized
blossoms that in turn enclose a center rosette.
White, tan, orange, red, green, and blue are used
against the silver ground. In the floral border
an undulating floral vine — using the same colors
that are used in the field — occurs against a gilt
ground.

488.
Cover, Possibly for a Canopy or Table
India, 17th century
Brocaded compound weave, satin ground
Silk
h: 66 in. (168 cm.); w: 47½ in. (121 cm.)
M.73.5.704

This piece is decorated with lobed medallions of
scrolling leaves containing floral motifs against
a light brown ground woven with a lozenge pattern.
Interspersed among the medallions are scrolling
stems bearing carnations, lilies, and irises as well as
other flowers. Each medallion contains a rosette
encircled by a chain of eight blossoms. A wide
border containing a motif of palmettes, scrolling
leaves, and flowers, on the same ground as the field,
is flanked by narrow stripes containing an
undulating vine bearing leaves and blossoms on
a dark pink ground. The blossoms of the field
and border combine shades of blue with white, and
yellow with orange, adding touches of blue. The
rosettes and palmettes use yellow or orange outlined
with dark pink, or blues with white or yellow.

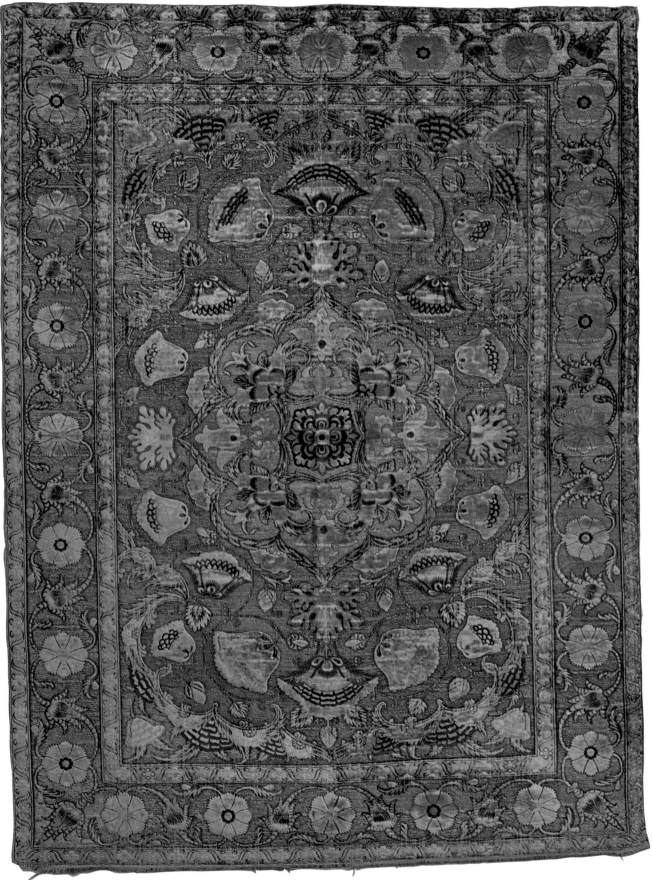

489.
Sash
Thailand, 18th-19th century
Brocaded plain weave
Cotton or linen; gilt on a natural core, silver on
a white core
h: 80 in. (203.2 cm.); w: 17⅛ in. (43.5 cm.)
M.73.5.700

Bands enclosing a variety of repeats of highly
stylized floral and geometric motifs in silver and
gilt on a black background decorate the field of
this sash. Gilt and silver trumpal motifs alternate
at the bottom, and lozenges are used throughout
to suggest dense foliage. A border with geometric
motifs runs along each edge of the piece.
Both ends are fringed with the warp.

490.
Fragment (illustrated)
Spain, 15th century
Compound twill weave
Silk
h: 7¼ in. (18.4 cm.); w: 11⅜ in. (28.8 cm.)
M.73.5.628

This fragment consists of three bands, the largest
of which may originally have been a portion of the
field. This large area consists of an interlacing
of star-shaped polygons and quatrefoils framing
blossoms. The motifs are dark pink on a yellow
ground. On the center band green and white, and
blue and white petals alternate on a grey ground.
The third band has a row of white-pink blossoms
enclosed by dark blue star-shaped polygons.
One selvage is present.

490.

491.
Sash
Spain, 15th-16th century
Plain weave with supplementary weft
Silk, silver on a white silk core
h: 19 in. (48.5 cm.); w: 16¾ in. (42 cm.)
M.73.5.697

The sash has a field of silver stylized flowers on
a blue ground. At each end is a banded border.
Three of the bands have a motif identical to that of
the field, though two include a section of the
floral design in red. The other band shows a silver
and red ogival design on a blue ground. Between
each of these blue bands are stripes, scroll motifs,
and checkerboards. The sash was originally
wider and has been cut and bound on one side.

492.
Fragment
Spain, 16th century
Compound twill, satin ground
Silk
h: 174½ in. (443.23 cm.); w: 12⅝ in. (32.05 cm.)
M.73.5.698

Upon this piece is a repeat of confronting lions
framed by fanciful split-palmette leaves. Both the
leaves and palmettes are dark green outlined
in white. To each side of the palmettes are lions in
yellow outlined in dark green and wearing white
crowns. A white leaf motif intertwining the
palmettes is also outlined in dark green. The
existence of many variations of this design —
divergent from it both with respect to color and
drawing — reflects its popularity in
sixteenth-century Spain.

493.
Fragment of a Skirt Border (illustrated)
Greece, 18th century
Silk embroidery on linen
h: 15⅛ in. (38.4 cm.); w: 14¾ in. (37.5 cm.)
M.73.5.630

Upon this border are birds, a crowned siren, and
an urn with flowers in bright yellows, blues,
red, green, gold, and black. A very similar piece is
illustrated in Gentles, Pl. 49 and 50. The unusual
design is the synthesis of two different aesthetic
influences — the Venetian and the Turkish. Crete was
ruled by Venice first and then until 1897 by
Turkey, and the island's fantastic embroidery
reflects both influences. Specifically, in this instance
the carnation motifs derive from Turkey while
the siren reveals the Venetian influence.

494.
Sash
Poland, 1775-1800
Brocaded double weave
Silk, cotton
h: 181 in. (460 cm.); w: 17¾ in. (45 cm.)
M.73.5.654

Four color schemes were employed in this sash.
Each lengthwise half and the front and back are all
different, allowing the wearer four color options.
The design consists of a field of alternating bands —
one having an undulating stem with blossoms
and the other chevron and circle motifs. On a
border at each end are two flowering trees. One side
has pink and blue flowers and green leaves on a
gold ground, and the other the same color flowers
on a brown ground. The field design has the
same color scheme with pink, brown, blue, and
green alternating with gold bands. A guard stripe of
each lengthwise side has an undulating floral vine
of similarly colored flowers — highlighted by
dark red flowers. The sash is signed in each corner
with "P.J." and a lamb holding a red flag — the
crest of Paschalis Jakubowicz, at whose factory near
Warsaw sashes of a high quality were woven from
1789 to 1794. A fringe is applied to both ends.

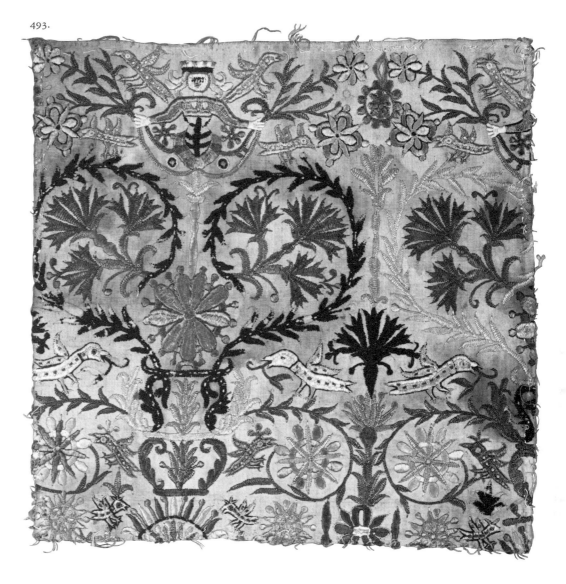

495.
Sash
Poland, 1775-1800
Brocaded double weave
Silk, cotton, gilt on a red silk core
h: 159 in. (404 cm.); w: 17¾ in. (45 cm.)
M.73.5.696

In this sash (cf. cat. no. 494) four color schemes
operate: one side has a gold ground, with designs in
red, white, purple, light green, and blue; the
opposite side has a purple ground and employs
the same colors as the first side, plus gold.
The field consists of alternating bands, one with
scrolling leaves and blossoms, and the other with
medallions and foliage. On a rectangular panel
at each end there are three plants bearing a variety
of blossoms. On the guard stripes bordering the field
are repeats of a parrot perched on small blossoming
plants. At each corner the name Paschalis
appears indicating that the sash was woven in
the same place as was cat. no. 494. A fringe is
applied to both ends.

Selected Bibliography: Books

Aga-Oglu, M.
Safavid Rugs and Textiles
New York, 1941

Arnold, T. W.
Painting in Islam
New York, 1965

Baer, E.
Sphinxes and Harpies in Medieval Islamic Art
Jerusalem, 1965

Barrett, D.
Islamic Metalwork in the British Museum
London, 1949

Bourget, Pidu.
Musée National du Louvre catalogue des étciffes Coptes
Paris, 1964

Boyle, J. A. (ed.)
The Cambridge History of Iran, vol. 5
Cambridge, 1968

Coomaraswamy, A. K.
Miniatures orientales de la collection Goloubew: Ars Asiatica XIII
Paris and Brussels, 1929

Denny, W.
"Ottoman Turkish Textiles"
in *Textile Museum Journal, III,* 3, 1972

Dimand, M. S.
A Handbook of Muhammadan Art (3rd ed.)
New York, 1958

Du Ry, C. J.
Art of Islam
New York, 1970

Erdmann, K.
Seven Hundred Years of Oriental Carpets
Berkeley and Los Angeles, 1970

Ettinghausen, R.
Studies in Muslim Iconography I: The Unicorn
Washington, 1950

Ettinghausen, R.
Arab Painting
Geneva, 1962

Ettinghausen, R. and others.
Turkey — Ancient Miniatures
New York, 1961

Ettinghausen, R. (ed.)
Islamic Art in The Metropolitan Museum of Art
New York, 1972

Gentles, M.
Turkish and Greek Island Embroideries
Chicago, 1964

Gray, B.
Persian Painting
Geneva, 1961

Grube, E.
Muslim Miniature Paintings
Venice, 1962

Grube, E.
The Classical Style in Islamic Paintings
New York, 1918

Grube, E.
The World of Islam
New York and Toronto, n.d.

Grube, E.
Islamic Paintings, The Kraus Collection
New York, n.d.

Hobson, R. L.
A Guide to the Islamic Pottery of the Near East
London, 1932

Kuhnel, E.
Islamic Art and Architecture
Ithaca, New York, 1966

Kuhnel, E. and Bellinger, E.
Catalogue of Dated Tiraz Fabrics
Washington, D.C., 1952

Lane, A.
Early Islamic Pottery
London, 1947

Lane, A.
Later Islamic Pottery
London, 1957

May, F. L.
Silk Textiles of Spain, Eighth to Fifteenth Century
New York, 1957

Mikami, T.
Islamic Pottery, Mainly from Japanese Collections
2 vols., Tokyo, 1962, 1964

Minorsky, V.
The Chester Beatty Library: A Catalogue of the Turkish Manuscripts and Miniatures
Dublin, 1958

Minorsky, V.
Calligraphers and Painters: A Treatise by Qadi Ahmad, son of Mir Munshi
Washington, D.C., 1959

Oz, T.
Turkish Textiles and Velvets
Ankara, 1950

Pinder-Wilson, R. (ed.)
Paintings from Islamic Lands
Columbia, S.C., 1969

Pope, A. U. (ed.)
A Survey of Persian Art, 6 vols.
London and New York, 1938-39

Reath, N. A. and Sachs, E. B.
Persian Textiles
New Haven, 1937

Rice, D. T.
Islamic Art
New York and Washington, 1965

Riefstahl, R. M.
Persian and Indian Textiles
New York, 1923

Robinson, B. W.
*A Descriptive Catalogue of the Persian Paintings
in the Bodleian Library*
Oxford, 1958

Schroeder, E.
Persian Miniatures in the Fogg Museum of Art
Cambridge, Mass., 1942

Stchoukine, I.
Les peintures des manuscrits Timurides
Paris, 1954

Stchoukine, I.
Les peintures de manuscrits Safavis
Paris, 1959

Stchoukine, I.
Les peintures des manuscrits de Shah 'Abbas
1er partie, Paris, 1964

Stchoukine, I.
La peinture Turque d'après les manuscrits illustrés
1er partie, Paris, 1966

Welch, S. C.
A King's Book of Kings
New York, 1972

Wilkinson, C.
Iranian Ceramics
New York, 1963

Wulff, H. E.
The Traditional Crafts of Persia
Cambridge, Mass., and London, 1966

Art Treasures of Turkey
Washington, D.C., 1966

Brief Guide to the Persian Woven Fabrics
London: Victoria and Albert Museum, 1922

Brief Guide to the Persian Woven Fabrics
London: Victoria and Albert Museum, 1950

Masterpieces of Iran, Rugs and Textiles
(R. Ettinghausen), Washington, D.C., 1964

Fifty Masterpieces of Textiles
London: Victoria and Albert Museum

From the Bosporous to Samarkand, Flat-Woven Rugs
(Landreau, A. N. and Pickering, W. R.),
Washington, D.C., 1969

Textiles of Safavid Persia and Mughal India
(Rowe, A. P.), Gallery Guide, Boston:
Museum of Fine Arts, 1971

Velvets East and West
Los Angeles: Los Angeles County Museum
of Art, 1966

Woven Treasures of Persian Art
Los Angeles: Los Angeles County Museum
of Art, 1959

Islamic Art in Egypt 969-1517
Cairo, 1969

Museum für Islamische Kunst Berlin
Berlin — Dahlem, 1971

Ancient Glass in the Museum of Fine Arts
Boston (A. Von Soldern), Boston, 1968

Islamic Art, Guide to the Collections
(M. G. Lukens), New York: The Metropolitan
Museum of Art, 1965

Islamic Art Across the World
(T. Bowie), Bloomington, Indiana, 1970

Persian Art Before and After the Mongul Conquest
Ann Arbor: The University of Michigan Museum
of Art, 1959

Islamic Art from the Collection of Edwin Binney, III
Washington, D.C., 1966

*Islamic Pottery in the Collection of
Sir Eldred Hitchcock*
(A. Lane), London, 1956

*Treasures of Persian Art after Islam
The Mahboubian Collection*
Austin, Texas, 1971

*Persian Miniature Painting from Collections
in the British Isles*
London, 1967

Photography by
Edward Cornachio and John Gebhart
Assisted by
Joe Hazan and Adam Avila

Catalog Assistants:
Catherine Glynn
Abbas Daneshvari

Editorial Assistant:
Joanne Jaffe

Art direction by
Jaymie Odgers

Design by
Rosalie Carlson

Text is set in Garamond No. 3 by
Ad Compositors; the catalog
is printed on Warren Lustro Offset
Enamel Dull and Champion
Carnival Kraft
by Anderson Lithograph,
Los Angeles.